Sculpture of Ancient West Mexico

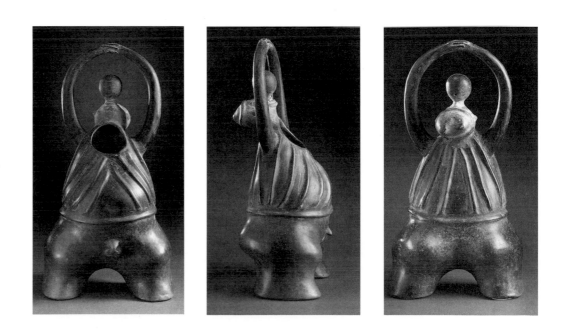

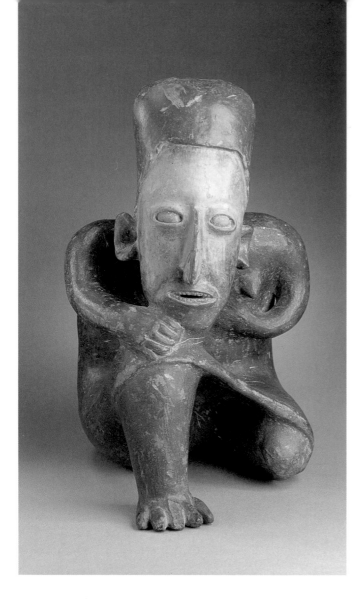

MICHAEL KAN

CLEMENT MEIGHAN

H. B. NICHOLSON

Sculpture of

Crouching Female Figure
Jalisco
cat. no. 88

previous page
Performer
Jalisco (?)
cat. no. 90

cover
Standing Warrior (detail)
Jalisco
cat. no. 79

Ancient West Mexico
Nayarit, Jalisco, Colima

A Catalogue of the Proctor Stafford Collection at the Los Angeles County Museum of Art

Los Angeles County Museum of Art

in association with

University of New Mexico Press

Albuquerque, New Mexico

Copublished by the Los Angeles County Museum of Art, 5905 Wilshire Boulevard, Los Angeles, California 90036 and University of New Mexico Press, Albuquerque, New Mexico 87131

Editors: Lois Smith and Mitch Tuchman
Curatorial consultant: Constantina Oldknow
Designer: Amy McFarland
Photographer: Barbara Lyter
Type set in Original Janson Antiqua and Futura by Mondo Typo, Santa Monica, California
Printed on New Age Matte 127 gsm by Nissha Printing Co., Ltd., Kyoto, Japan

Library of Congress Cataloging-in-Publication Data

Los Angeles County Museum of Art.
 Sculpture of ancient West Mexico.

 Bibliography: p.
1. Indians of Mexico—Art—Exhibitions. 2. Indians of Mexico—Sculpture—Exhibitions. 3. Los Angeles County Museum of Art—Exhibitions. 4. Stafford, Proctor —Ethnological collections—Exhibitions. I. Kan, Michael. II. Meighan, Clement Woodward, 1925– III. Nicholson, H. B. (Henry B.) IV. Title.
F1219.3.A7L6 1989 730'.972'307479494 89-12101
ISBN 0-8263-1175-x (pbk.)

Seated Drummer (detail)
Colima
cat. no. 106

opposite
Kneeling Female Figure (detail)
Nayarit
cat. no. 60

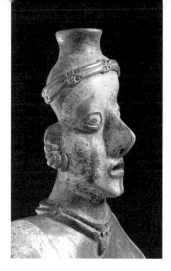

CONTENTS

FOREWORD

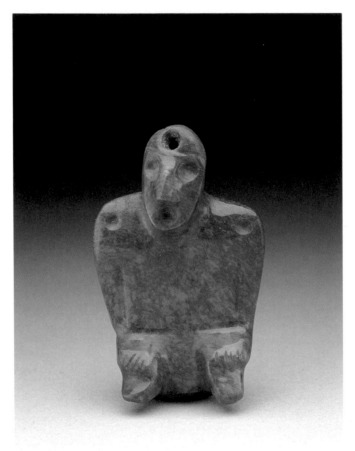

This new, revised edition of the 1970 exhibition catalogue *Sculpture of Ancient West Mexico: Nayarit, Jalisco, Colima* celebrates the museum's acquisition in 1986 of the magnificent collection of pre-Columbian funerary ceramics formed by Los Angeles collector Proctor Stafford. Purchased with endowment funds provided by Mr. and Mrs. Allan C. Balch, the Stafford Collection constitutes one of the most extraordinary groupings of ancient West Mexican tomb sculpture in the world, unique for its size, breadth, and exceptional quality. The Los Angeles County Museum of Art is extremely proud to have acquired this outstanding collection.

The museum's involvement with pre-Hispanic art, as outlined in the foreword to the original exhibition catalogue by former deputy director Rexford Stead, has grown considerably since 1970. In addition to presenting special exhibitions, the museum has assembled an important permanent collection that includes major gifts and purchases: for example, the comprehensive Constance McCormick Fearing Collection of Pre-Columbian Art was acquired in 1983, and the John Wise Collection of Peruvian textiles was acquired from 1974 to 1978. Permanent gallery space in which to display these acquisitions has also significantly increased.

At the time of its first exhibition at the museum, the Proctor Stafford Collection was relatively little known, representing an area of pre-Columbian art that, while becoming fashionable to collect, was still not well understood by scholars. Nineteen years later the Stafford Collection has gained an international reputation attributable to the original exhibition catalogue, and it is now part of a substantially larger corpus of published West Mexican antiquities available to the general public, scholars, and collectors.

The thorough investigation and thoughtful analysis of the archaeology, anthropology, and art history of ancient West Mexico by authors Michael Kan, now executive assistant director and curator, African, Oceanic, and New World Cultures at the Detroit Institute of Arts, and Clement Meighan and H. B. Nicholson, both professors of anthropology at the University of California, Los Angeles, combined to make the original exhibition catalogue the single most important reference on the subject. Most gratifyingly the relevance of the 1970 study, now long out of print, has endured, and we are pleased to make it available to the public in a new, expanded, and updated form.

We are grateful to the authors for their enthusiasm and willingness to return after nearly two decades to their old

Seated Male Figure
Colima
cat. no. 203

essays and catalogue entries with a fresh outlook. The new photography of the Proctor Stafford Collection was expertly accomplished by museum photographer Barbara Lyter, whose innovative ideas and commitment to the catalogue are much appreciated. The dedicated efforts of editors Lois Smith and Mitch Tuchman and museum graphic designer Amy McFarland have produced a superb volume that is as much a pleasure to look at as it is to read. We especially welcome the collaboration with the University of New Mexico Press on the new publication and thank its director, Elizabeth Hadas, for her support of the project.

Special acknowledgment and thanks are due to the individuals on the museum staff who contributed new information or participated in the production of the catalogue: curatorial consultant Constantina Oldknow, associate curator, Ancient and Islamic Art; Deenie Yudell, head graphic artist; Gregory A. Dobie, Publications Department; Pieter Meyers, chief, Conservation Center, and John Twilley, senior conservation chemist; Dale Gluckman, associate curator, Costumes and Textiles; Tom Jacobson, head, Grants and Foundation Giving; the Technical Services staff; and Lesley Donnell, secretary, Ancient and Islamic Art.

E A R L A. P O W E L L I I I
Director
1989

FOREWORD TO THE FIRST EDITION

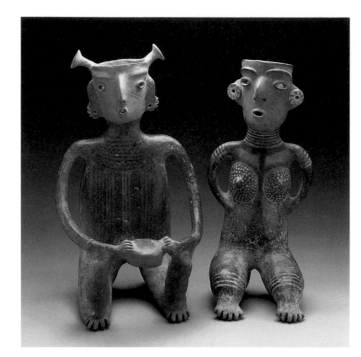

What we know of the ancient artistic tradition of the far west of Mexico, in that arc-like region along the Pacific that includes the present-day states of Colima, Nayarit, and Jalisco, has not come from vast and dramatic temple complexes, or stone sculpture, or frescos and reliefs. They were not typical of the region. Our knowledge of this unique West Mexican tradition has come instead from a profusion of remarkable clay tomb figures and related ceramic "burial furniture" that a people placed with their dead nearly two thousand years ago.

These compelling hollow figures reflect totally human attributes. The pot carriers and "mourners," the embracing couples, the "warriors" and "ball players," even the dogs, the birds, and other animals are in sharp contrast to the awesome and ritualized deity figures of the later and better-known Mesoamerican civilizations.

While the appealing "humanity" of ancient West Mexican clay sculpture has long been recognized, the acceptance of many of these works as true *fine art* has been a slower matter.

In presenting this first public exhibition of the distinguished Proctor Stafford Collection, seen only by specialists and scholars until now, the museum emphasizes its conviction that much ancient sculpture from the far west of Mexico constitutes a high and original form of art. While the works also serve as mute spokesmen for early cultures, they cannot be regarded in a solely historical, sociological, or anthropological context. Some are consummate examples of sophisticated artistry. Indeed, a few are masterworks in their own right. The time has come to regard them for their aesthetic worth.

A superb collection such as this bespeaks much of its assembler. Mr. Stafford began his collection during a long residence in Mexico. He gathered the nucleus in an exciting time, with the help of other knowing eyes, including those of Diego Rivera, who chose to see in these pieces the origins of so much of the humanity and vitality that is the glorious Mexican heritage.

Collecting, for Proctor Stafford, is a highly personal consideration. He is persistent and discriminating at all times; his only criteria have been authenticity, quality, and concentration in a particular area. Like many true collectors, he applies a somewhat anthropomorphic view, and the process of refinement that goes on in all significant collections has often found joy coupled with anguish, for one always has favorites that go by the wayside. The museum is grateful indeed for this opportunity to share with its members and the public the results of his many years of painstaking and fruitful connoisseurship.

8

Seated Couple
Jalisco
cat. no. 99

Perhaps one of the most dramatic recent revelations to be given currency by this exhibition is confirmation by colleagues at the University of California that many West Mexican tomb objects are of a much earlier date than had hitherto been conjectured. Until 1965 it was accepted by many that the substance of this exhibition derived from a Mexican "medieval age," with some observers suggesting that the period extended into the Spanish Conquest. A majority took the view that these appealing works, possibly because of an assumption that sophistication is late in the human scheme, dated variously from the 8th to the 10th centuries. But radiocarbon dating of objects and human bones by the University of California at Los Angeles in 1965, 1966, and more recently has proven that some actually derive from the second century before Christ! Thus we find, in West Mexico, a far longer and remarkably consistent artistic tradition than earlier research had thought possible, from about 200 B.C. through A.D. 500.

The preparation of the exhibition and of this catalogue has been a loving labor for all who have had a hand. Certainly the museum has leaned heavily on Guest Curator Michael Kan, Associate Curator of Primitive Art and New World Cultures at the Brooklyn Museum. Professors Clement Meighan and H. B. Nicholson, Department of Anthropology at the University of California, Los Angeles, who are pioneers in the area of West Mexican archaeology, have been of immeasurable help. Our gratitude extends also to Isabel Kelly, José Luis Franco, and Otto Schöndube for their review of the catalogue index.

Within the museum staff, Exhibitions Coordinator Jeanne Doyle was "worried through" all stages of the exhibition and catalogue. Head photographer Edward Cornachio has applied his usual exacting standards in documenting an exceptionally challenging collection. Registrar Gloria Cortella has had prime responsibility for temporary custody of the objects. The catalogue was designed by Ed Kysar, who also produced its line drawings and map. The exhibition itself was mounted by Associate Curator of Design and Allied Arts William Ezelle Jones with the assistance of Head Preparator James Allen and his able staff. Mr. Stafford has himself been ever available and generous with his advice and time. Appreciation also goes to Ann Koepfli for her constant assistance in the preparation of the catalogue.

The museum also warmly acknowledges a grant from the Ethnic Arts Council of Los Angeles, permitting the inclusion of color plates in the exhibition catalogue. Dr. George C. Kennedy, former Chairman of the Council, was instrumental in securing the original C-14 dates from San Sebastián.

In recent years the Los Angeles County Museum of Art has been privileged to present several major exhibitions of art from pre-Hispanic Central and South America. *The Art of the Ancient Maya* was offered by the museum in 1959. *Masterworks of Mexican Art,* seen by an astonishing 800,000 visitors, was made possible with the extensive cooperation of the government of the United States of Mexico in 1963. And many visitors will recall *Mastercraftsmen of Ancient Peru,* organized by the Solomon R. Guggenheim Museum and presented in Los Angeles with the cooperation of the government of Peru in 1969.

The present exhibition continues the tradition of our concern.

REXFORD STEAD
Deputy Director
1970

9

The Tomb Arc of West Mexico

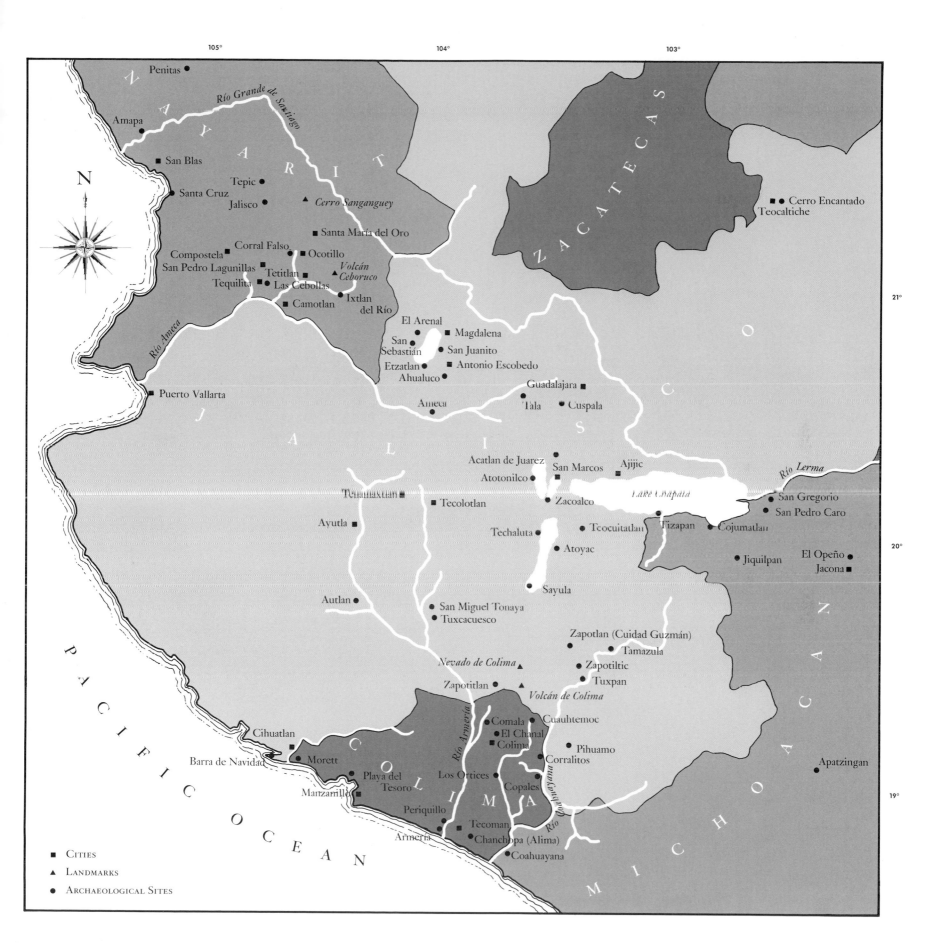

105° 104° 103°

21°

20°

19°

ZACATECAS

NAYARIT

JALISCO

COLIMA

MICHOACAN

PACIFIC OCEAN

N

Penitas

Amapa

San Blas

Tepic
Santa Cruz
Jalisco

Cerro Sanganguey

Santa María del Oro

Corral Falso
Compostela Ocotillo
San Pedro Lagunillas *Volcán
Tetitlan Ceboruco*
Tequilita Las Cebollas
 Camotlan Ixtlan
 del Río

Río Grande de Santiago

Río Ameca

Cerro Encantado
Teocaltiche

El Arenal
 Magdalena
San
Sebastián San Juanito
Etzatlan Antonio Escobedo
 Ahualuco

Puerto Vallarta

Ameca

Guadalajara

Tala Cuspala

Acatlan de Juarez
 San Marcos Ajijic
Atotonilco

Río Lerma

San Gregorio
San Pedro Caro

Tenamaxtlan Zacoalco *Lake Chapala*

Tecolotlan

Techaluta Teocuitatlan Tizapan Cojumatlan

Ayutla

Atoyac

Jiquilpan El Opeño
 Jacona

Sayula

Autlan

San Miguel Tonaya
Tuxcacuesco

Zapotlan (Cuidad Guzmán)

 Tamazula
Nevado de Colima
 Zapotiltic
Zapotitlan Tuxpan
 Volcán de Colima

Comala Cuauhtemoc
 El Chanal
 Colima Pihuamo
Cihuatlan Corralitos

Río Armería

Barra de Navidad Morett

 Playa del
 Tesoro Los Ortices

Manzanillo Copales

 Periquillo M A

 Armería Tecoman
 Chanchopa (Alima)
 Coahuayana

Apatzingan

Río Coahuayana

■ CITIES

▲ LANDMARKS

● ARCHAEOLOGICAL SITES

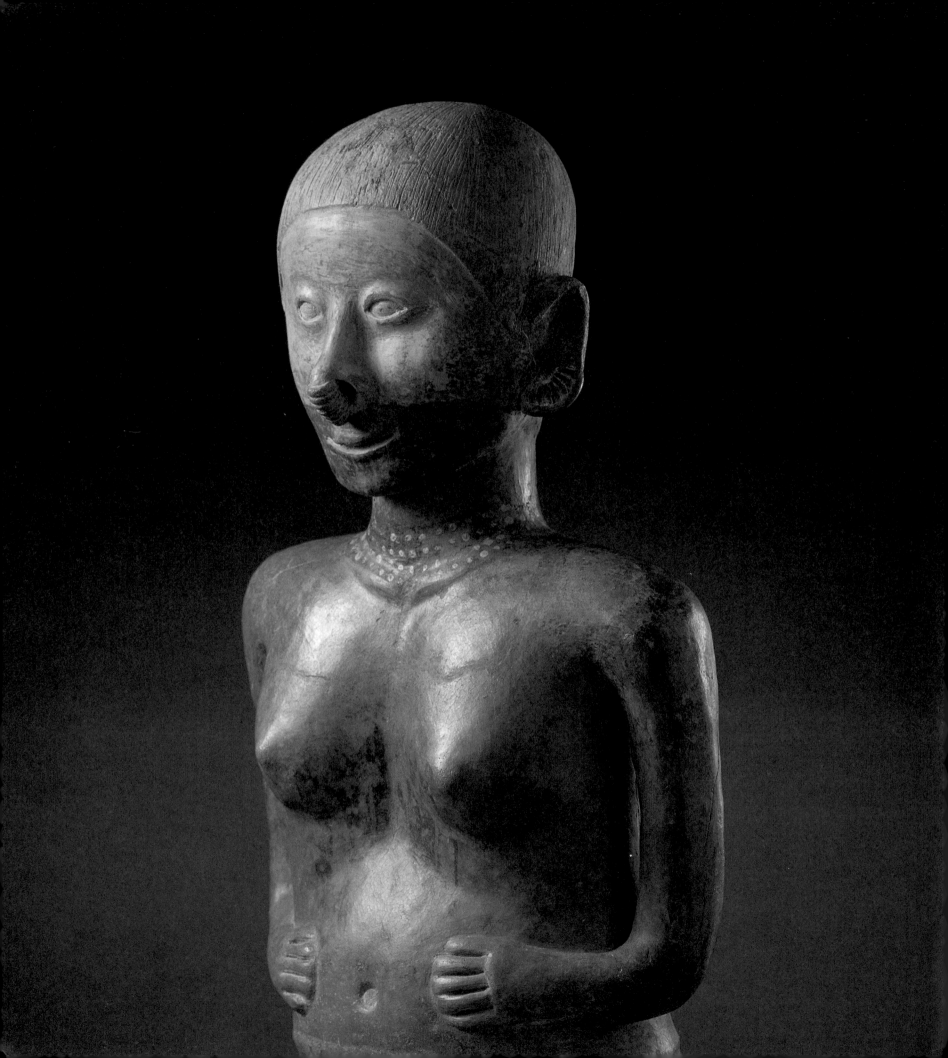

The Pre-Columbian Art of West Mexico:
Nayarit, Jalisco, Colima

MICHAEL KAN

Kneeling Female Figure (detail)
Nayarit
cat. no. 1

PRIVATE art collectors have historically been limited by a number of factors beyond their control, such as the availability of fine material. Proctor Stafford, in assembling this remarkable collection of pre-Columbian art, apparently experienced no such limitation during the 1950s, when a great body of objects was coming out of western Mexico. The group of objects here form a collection that is unique in its scope, depth, and high aesthetic quality and would be virtually impossible to assemble today.

Looking beyond more traditional collectors' judgments that the art of West Mexico is crude and grotesque, Stafford recognized its high aesthetic quality and the artists' extraordinary spontaneity in handling clay. Both artistically and technically the sculptures in the Stafford Collection hold their own with any produced by the ancient cultures of Europe and Asia. The great hollow figures that make up the major portion of this collection were found in the Mexican states of Nayarit, Jalisco, and Colima, which in turn have lent their names to the principal West Mexican style areas.

Art-historical interest in the ceramic art of ancient West Mexico may be said to begin at the turn of the century with the writings of Carl Lumholtz, who devoted several chapters in his renowned *Unknown Mexico* (1902) to a qualitative and aesthetic discussion of the objects he collected, mostly from the region of Ixtlan, Nayarit. Although he mistakenly considered these early figure types to be Tarascan, produced by a people that inhabited West Mexico at the time of the Spanish Conquest, nevertheless he was able to make some intelligent stylistic distinctions on the basis of a small sample of sculptures (pp. 308–9).

Between the era of Lumholtz and the 1930s very little archaeological or art-historical interest was shown in West Mexico. During this period scholars were attracted primarily to the study of those Mesoamerican cultures that had produced writing systems, monumental architecture, and large-scale stone sculpture—all cultural traits associated with the Old World. This bias toward high cultural achievements appears to have been shared by art historians and collectors as well. Until recently the art of West Mexico was referred to as folk art (Bushnell 1965: 102). Even the pioneering Mexican art historian Miguel Covarrubias displayed a certain bias when he stressed the qualities of West Mexican art he called anecdotal (1957: 87) and absurd (p. 89).

In the 1930s and 1940s such important early collectors of pre-Columbian Mesoamerican art as Robert Woods Bliss tended to concentrate on Preclassic- and Classic-period stone sculpture. Powerful Aztec stone carvings and small,

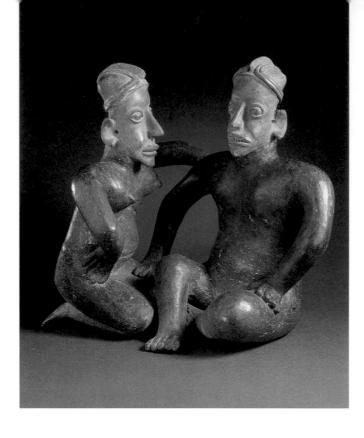

Joined Couple
Jalisco
cat. no. 68

precious Olmec and Mayan jades were the order of the day. If ceramic sculpture was acquired at all, it was probably from the Classic Gulf Coast; even today the Bliss Collection contains only one or two examples of West Mexican sculpture.

Other important American collectors buying in Mexico in the late 1930s and 1940s were Constance McCormick Fearing and Nelson A. Rockefeller. Mrs. Fearing built a collection of well over a thousand items (now housed at the Los Angeles County Museum of Art), many of which were from West Mexico but with primary emphasis on fine stone and ceramics from Olmec to Aztec high cultures. Rockefeller, guided by René d'Harnoncourt, was actively collecting pre-Columbian as well as Mexican folk art to form an extremely broad-based collection that was to be presented in an important show at the Museum of Modern Art in 1940. This group later formed the cornerstone of the collection of the Museum of Primitive Art, founded by Rockefeller in 1954.

The notable exception to the typical collector of thirty or forty years ago was Diego Rivera, whose foresight and vision in collecting pre-Columbian art were shared by Stafford. Rivera's concentration in the West Mexican field enabled him to bring together the first group of Nayarit, Jalisco, and Colima figures that could be formally considered a collection. Rivera's prestige as one of Mexico's foremost painters undoubtedly contributed to the recognition of West Mexican art at the art museum level.

Contradictions are evident in Rivera's pre-Columbian themes in his own work, given his avid interest in West Mexican art (he had acquired some sixty thousand pieces, which were housed in his home-tomb-museum, Anahuacalli). In a recent article Betty Ann Brown pointed out:

> One further point on Rivera's choice of sources. He strongly preferred the elitist images of the most complex pre-Columbian cultures, particularly the Aztecs, to those of the simpler egalitarian societies. Although he employed images from the simple Pre-Classic village society of Tlatilco at the Hospital de la Raza and the Teatro de los Insurgentes and those from the later West Mexico pueblos of Nayarit in the Palacio Nacional, in both cases, he placed figures from these virtually classless agrarian peoples in situations that are clearly Post-Classic in date and Aztec in ambience. I have constantly been puzzled by Rivera's neglect of the agricultural village-dwellers of the pre-Columbian world, especially considering his Marxist politics and his repeated inclusion of modern Mexican peasants in other mural programs. Perhaps he found the pre-Columbian villages insufficient in either exotic visual appeal or cultural sophistication to support his revisionist historical intentions. I am doubly confounded by his neglect of pre-Columbian villagers when I remember that they produced the bulk of the ceramics in Rivera's own collection. (1986: 155)

Seated Couple Preparing and Eating Food
Nayarit
cat. no. 17

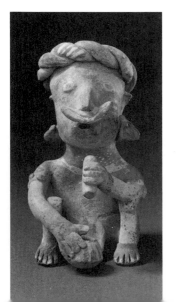 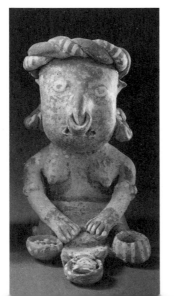

Many years of collecting culminated in 1941 when a book containing Rivera's collection was published (unfortunately the text was unreliable)[1] and, later, when the first exhibition dealing exclusively with the art of West Mexico took place. This was the memorable show based primarily on the Rivera Collection at the Palacio de Bellas Artes, Mexico City, which opened in 1946. Emphasis was on the sculpture of Nayarit, Jalisco, and Colima, but objects from Michoacan were also shown. The catalogue, illustrating more than 150 pieces and including articles by Salvador Toscano, Paul Kirchhoff, and Daniel Rubín de la Borbolla, was an important contribution to the archaeological and art-historical knowledge of West Mexico. Toscano's article was one of the first to differentiate between Tarascan art and the styles associated with Nayarit and Colima. In his scheme, however, Jalisco and Colima were grouped under one heading. Rubín de la Borbolla's article dealt with the Tarascans and the state of Michoacan.

Kirchhoff's work is perhaps the most important from an art-historical perspective, for it was an attempt to study the ancient people of West Mexico through analysis of the costumes and ornaments found on their figural sculpture. On this basis he established three categories that he believed represented distinct social and ethnic groups: (1) "The Nudes," an ethnic group without dress that is major in Nayarit but of inferior status in Colima; (2) "Those with Polychrome Garments," a group that showed a greater variety of costumes and occupied the southern portion of Nayarit; and (3) "Those with Loincloths," whose members were clothed in a variety of breechcloths and were considerably more advanced than the others. Kirchhoff was no doubt influenced in his assessment of this last category by his belief that "Those with Loincloths" may have been essentially the same group that ruled a powerful kingdom in Colima at the time of Spanish contact.

Although Kirchhoff's work is of limited use, in terms of our present knowledge of West Mexico, it was the first serious attempt to arrive at a typological classification of figural sculpture employing stylistic analysis. Unfortunately the majority of the traits he used to characterize his types cut across clearly delineated stylistic differences and totally disregard possible chronological subdivisions.

The Bellas Artes exhibition of 1946 was responsible not only for the recognition of West Mexico as an aesthetic and art-historical entity but also for focusing the attention of Mexican and North American archaeologists on this area. By the end of the year a *mesa redonda* (roundtable conference) was held to gather the scattered archaeological work that had been done in West Mexico. Although the meetings were attended by a few art historians, such as Covarrubias, very little information appeared on the ancient West Mexican sculpture complex. However, well-known archaeologist Isabel Kelly, in a paper entitled "Ceramic

1.

In this book (Médioni and Pinto 1941) the term *Tarascan* was still being used for Nayarit, Jalisco, and Colima; and there is no specific section on the art of West Mexico.

Male figure from *Standing Couple*
Nayarit
cat. no. 16a

15

Mr. Stafford's taste for the sculpture of Preclassic Tlatilco tends to reinforce its visual kinship with West Mexican material.

Provinces of Northwestern Mexico" (1948), introduced the concept of an individual Jalisco style, which she dubbed Ameca after the Ameca Valley in Jalisco state.

Covarrubias's classic work of 1957, *Indian Art of Mexico and Central America*, ordered the art cultures of West Mexico in much the same form as we know them today. The term *Tarascan* was used only to designate the culture that flourished after the tenth century in the area of lakes Patzcuaro, Zirahuen, Cuitzeo, and Yuriria, and not as the earlier catchall term used to cover the ceramic sculpture of the Nayarit-Jalisco-Colima area. He defined this art-culture area as "a compact and fascinating group of cultures with an important art based upon the freehand modeling of small and large hollow clay figures and effigy vessels, made in the Pre-Classic tradition, as offerings to bury with the dead" (p. 87).

Using the same intuitive ability that had enabled him to date Olmec art in the Preclassic period on stylistic grounds, Covarrubias recognized the stylistic kinship between the West Mexican figure complex and the Preclassic figure traditions of the Mesoamerican heartland. Although he was aware that Kelly had dated the figures at Los Ortices (Colima) and Ameca-Zacoalco (Jalisco) in the early Classic period, Covarrubias appears to have been justified in his visual-stylistic point of view (pp. 88–89). The early figures of West Mexico seem totally devoid of Classic traits from areas such as Teotihuacan and are much closer in feeling to Preclassic Tlatilco or Zacatenco-Ticoman.[2]

George Kubler, whose general volume *The Art and Architecture of Ancient America* (1962) devoted considerable space to a discussion of West Mexican art, chose to disregard Covarrubias's classification of Jalisco as one of the three major stylistic subdivisions. Instead, Jalisco (Ameca Valley) figures were classified as "a recognizable group within the Colima style" (p. 109).

One of the most interesting aspects of Kubler's chapter on West Mexico was his attempt to form a typological classification and seriation of the figure complex. Although

Anthropomorphic Tripod Vessel
Jalisco (?)
cat. no. 93

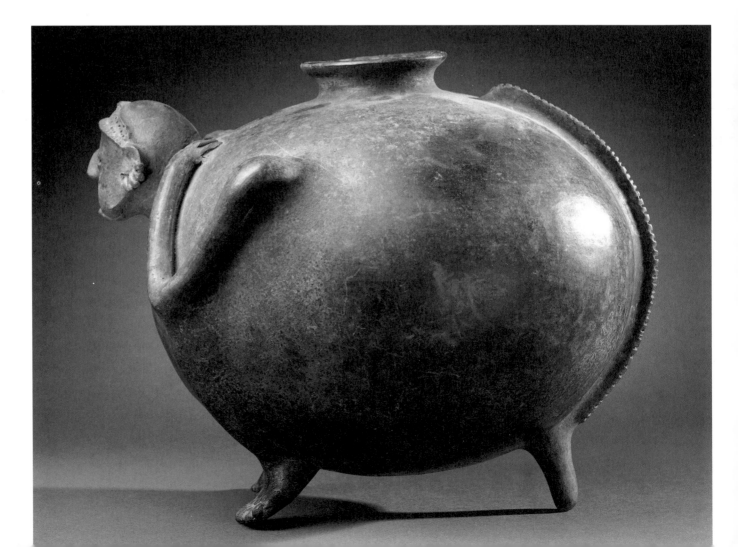

severely limited by the meager and confused nature of his data, Kubler was able to form a seriation based on comparative technical details, differences in texture, and range of figural poses. A developmental sequence spanning several centuries was then suggested for the regions of Colima; Ixtlan del Río, Nayarit; and Ameca, Jalisco. The earliest style was characterized primarily by a coffee-bean eye type; the intermediate period, by a slit eye; and the latest and most developed, by eyes with modeled eyeballs (pp. 108–10).

As opposed to Classical archaeology, which has traditionally belonged to science and the humanities, New World archaeology has always been linked with anthropology. New World archaeologists, such as Herbert Spinden, have contributed greatly to pre-Columbian art history. Thus it is not surprising that two of the most recent and significant art-historical contributions to the knowledge of West Mexican style come from works that were not primarily art historical: the 1966 doctoral dissertations of Stanley Long and Peter Furst.

Long's thesis, "Archaeology of the Municipio of Etzatlán, Jalisco" (1966), contains the most complete stylistic analysis of Nayarit (which he termed San Sebastián Red, pp. 62–79) and Jalisco figures based on a group of seventeen found in Tomb 1 at San Sebastián in the Magdalena Basin. In a comparative study of ninety-one figure attributes ranging from technique and form to ornamentation and objects carried in the hand, Long divided the figures into two major groups (pp. 22–23). He considered the "classic" Nayarit (San Sebastián Red) figure type to be the earliest, judging from both its style and the consistently large and numerous deposits of manganese oxide found on its surface (p. 24).[3] A second and more developed Jalisco style was called El Arenal Brown. This type appeared to incorporate mold-made elements and, because of its more elaborate attributes, was thought to have been produced by a people who were more socially stratified (p. 104). The so-called classic Jalisco figures (Kelly's Ameca Gray) found in other tombs of the area were classified as an intermediate style because they seemed to share the characteristics of the two major groups found in Tomb 1 at San Sebastián (p. 24).

In the tradition of anthropologists such as Spinden, Furst represents a scholar who ably unites the humanistic and anthropological approaches to the art of West Mexico. His work at the important site of Las Cebollas near Tequilita in southern Nayarit provided significant information concerning the dating of the Nayarit shaft tomb complex. It also enabled him to establish a provenience and to perform a complete study of an important Nayarit figure substyle known to the dealers and collectors of Mexico City as Chinesco (1966: 15). These monumental Chinesco figures (some reported to be almost three feet high) were sufficiently limited in their geographical distribution and of such

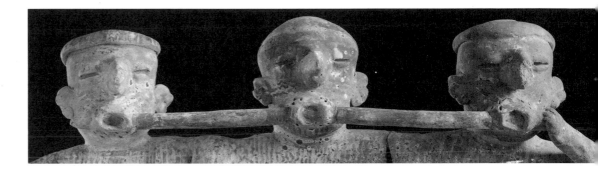

Ceremonial Dancers (?) (detail)
Nayarit
cat. no. 19

outstanding aesthetic quality that Furst suggested they might represent the productions of a single "school," a concept that is certainly more art historical than the anthropologist's view of the "anonymous tribal artist" (p. 35).

Furst's distrust of simplistic interpretations also led him to some highly imaginative hypotheses regarding the iconography of the West Mexican figures. Turning away from the obvious interpretation of a given figure's pose (e.g., male figure holding a club indicates warrior), Furst, borrowing from his ethnographic knowledge of the Huichol, was able to make an excellent case for the importance of shamanism in the iconography of the figure complex (1965c).

Since the publication of the catalogue of the 1970 Los Angeles County Museum of Art exhibition of the Stafford Collection, Furst has produced several articles advancing ethnographic analogy as the key to the mysteries of West Mexican iconography (1974a, 1974b, 1975, 1978). Furst not only taps his extensive knowledge of Huichol and Cora beliefs but turns to Africa and the Yoruba of Nigeria to draw other parallels (1978: 31). His work on West Mexican iconography should not be viewed as authoritative, however, for his intention is to be provocative and to challenge the many concepts and theories that traditionally have gone unchallenged. His use of Cora and Huichol mythology to explain West Mexican animal symbolism is particularly inciteful (1978: 27).

Of the few books and catalogues on West Mexico that have appeared since the 1970 exhibition, those most significant to the understanding of the area's art history are

3.

Because the exact nature of Long's "manganese oxide patina" is not traceable to a single source (Gifford 1950: 200–201), this evidence appears to be inconclusive.

17

Seated Male Figure
Jalisco
cat. no. 78

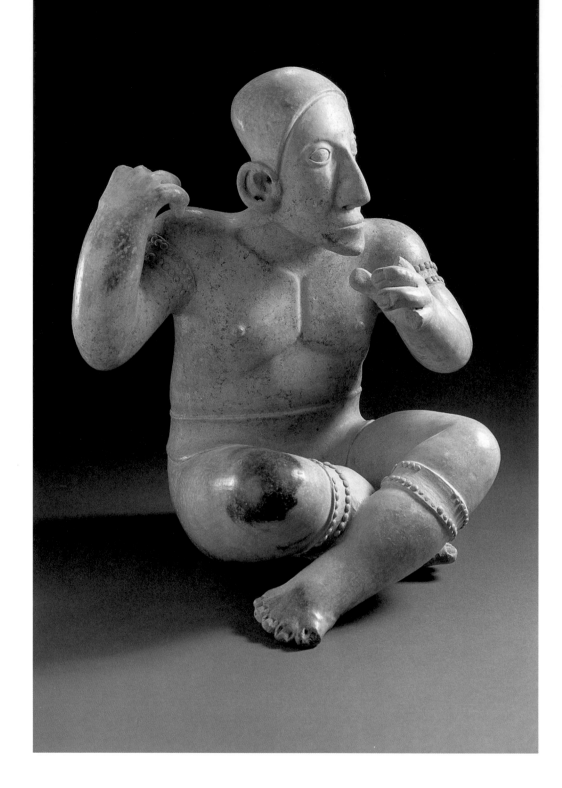

Seated Male Figure with Drum
(detail)
Jalisco
cat. no. 101

Hasso Von Winning's ambitious stylistic study of 1974, *The Shaft Tomb Figures of West Mexico*, and an excellent catalogue, *Companions of the Dead*, by Jacki Gallagher (1983). The latter illustrates two hundred pieces exhibited at UCLA and strikes an impressive balance between anthropology and art history.

In the study of West Mexico and its ancient art, art historians fare no better than their archaeologist colleagues, for, as Professors Meighan and Nicholson point out in the following essay, the scholar is faced with a large body of magnificent clay sculpture from a single Mesoamerican subregion but is limited in interpreting this material in the absence of precise associations or knowledge of origins. An analogy in twentieth-century art history would be the recognition of Picasso's early work but without sufficient documentation to know if the Blue Period (1901–4) preceded or followed the famous *Demoiselles d'Avignon* (1907) and the birth of Cubism.

West Mexico as a Style Area

West Mexican art, for the purposes of this catalogue, is confined to the ceramic figural sculpture found mainly in tombs in the present Mexican states of Nayarit, Jalisco, and Colima. Each of these states in turn has given its name to a major figure type on the basis of certain stylistic traits. However, it should be emphasized that these subdivisions are based on style rather than geography. For example, it is now clear from Long's work in the Magdalena Basin, Jalisco, that typical Nayarit (San Sebastián Red) figures can occur in the same tombs (in the geographic area of Jalisco) with figures of the Jalisco type.

In marked contrast to the rest of Mesoamerica and particularly to the Guerrero style area in the south, the Nayarit-Jalisco-Colima style area is almost devoid of large-scale lithic art. In addition, only a few small masks and carved stone figures and objects such as mace heads are found in areas such as Colima.

After the 1950s relatively few pieces were added to the collection. Stafford was unable to obtain the rare and spectacular life-size stone masks in Colima style, such as the one illustrated in the exhibition *Before Cortés* (1970: pl. 88) from the Josue Saenz collection in Mexico City. These stone masks were not available in the 1960s and the 1970s.

Similarly the monumental (Type A) Chinescos from Nayarit and so-called Zacatecas figures from Jalisco were not available in Mexico in the 1950s; they were added later when the 1970 exhibition was organized. Interestingly in the early 1960s very few of the great objects from West Mexico and other Mesoamerican cultures could be obtained because Mexican collectors such as Saenz were buying them at the highest prices on the world market (André Emmerich, personal communication, August 1988).

In addition to the important unifying cultural features such as the great shaft tombs (found nowhere else in Mexico), West Mexican cultures appear to have focused their creativity on the manufacture of large, hollow and small, solid tomb figures. These clay sculptures share a dynamic and spontaneous force, demonstrating a remarkable ability to capture the essence of a gesture in sculpture and, above all, a unique plastic force in the handling of the ceramic medium. Use of the ceramic techniques of incising and painting in both positive and negative slip colors is original and outstanding in the art of Mesoamerica and of the great pottery-producing areas of the world.

Although the shortcomings of the three generally accepted labels for West Mexico—Nayarit, Jalisco, and Colima—are known to all students of the area, the terms will remain in common use until these areas are better known to archaeology and typological classifications can be made which are meaningful in both time and space. The glaring problem with typological seriations in the earlier literature has been the fact that they were based on the ordering of data taken from objects lacking provenience. Because it was rarely possible to check these data against material for which a reliable chronology had been established, the temporal and spatial significance of the classifications remain in question, and all conclusions based on these classifications have questionable value.

The Scope of the Collection

The following sections are devoted to a stylistic analysis of West Mexican styles, concentrating on the stylistic relationships and distinctions among categories of figures. Although this study is based almost entirely on the large and varied sample of figures represented by the Stafford Collection, it is not offered as a comprehensive and systematic typological analysis. Such an analysis was undertaken by Von Winning in his 1974 monograph, which provides a detailed and exhaustive analysis of the figures of West Mexico in terms of dress and headdress, personal adornments, and weapons and musical instruments used by the figures. Colima figures are classified according to

Female Figure (detail)
Jalisco
cat. no. 86

Vessel
Colima
cat. no. 188

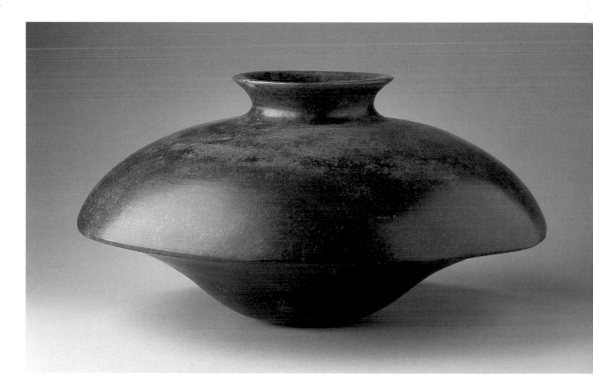

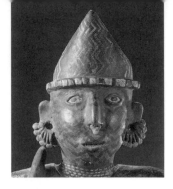

*Standing Warrior Wearing Patterned
Shirt* (detail)
Nayarit
cat. no. 12

subject matter, from horned male figures and hunchbacks, to figures engaged in various activities, to animal types. Jalisco and Nayarit are then similarly classified (pp. 20–28). The study illustrates 345 West Mexican figures and figurines representing all the styles of this area.

The Von Winning monograph also provides a detailed analysis of subgroups, such as the Chinesco style of Nayarit. In addition, he discusses the Pihuamo style of Colima, the Zacatecas style of Jalisco, and forgeries and the tests that can be employed to detect them (pp. 32–47). Von Winning concluded that "any classificatory system that would take into account all facets of the bewildering variety of traits and of their combinations could easily bog down into an unwieldy, and ultimately meaningless, fragmentation into minute units" (p. 80).

NAYARIT

The figures of Nayarit show wide range and variation of style. They are characterized by their generally expressionistic, active forms, with emphasis on both positive and negative painting. Arms usually are rendered in long, thin ropes of clay and are largely devoid of anatomical detail. In the Nayarit figures, relative to other styles, great attention is given to hair, which is created by many fine incised lines. Characteristic articles of male costume include a distinctive shirt reaching to the sex organs, which are frequently covered with a "scoop loincloth" (nos. 13, 16a), and a small mantle tied with a cord over one shoulder (no. 14). Female figures wear a longer loincloth that resembles a sarong. Both sexes wear elaborate, multiple-ring earrings that look like inverted fans, nose ornaments, and a type of facial mutilation that consists of long vertical slits in the cheeks near the mouth (no. 58a–b). In certain instances figures are shown "threaded" together on a horizontal stick through these cheek mutilations (nos. 19, 22) in a ritual unique to Nayarit. This ritual, like other ceremonies involving self-mutilation in Mesoamerica, may have been of a penitential nature.

The Nayarit figure style may be broken down tentatively into three major subcategories: the Ixtlan del Río type of southern Nayarit (nos. 12–23, 25–39);[4] the Chinesco type (nos. 1–11), also of southern Nayarit; and the San Sebastián Red type from both Nayarit and Jalisco (nos. 24, 48–62, 66).

Figures of the classic Nayarit type of Ixtlan were among the first West Mexican ceramic figures to be recognized; Lumholtz illustrated at least seventeen in plates I–IV of the second volume of *Unknown Mexico*. Although he realized

that there were stylistic differences in the group of figures he collected (pp. 308–9), no scholar had ever made a distinction between the more naturalistic (nos. 12, 15) and the more abstract (nos. 13–14, 16–23, 25–39) varieties of Ixtlan figures. If we compare the Stafford male figure of the naturalistic type (no. 12) with a male figure of the abstract type (no. 16a), the differences are immediately apparent. Although the costumes are similar in type (note, for instance, the same conical headdress), the former has more naturalistic body proportions and more realistic modeling of arms and toes. The latter has the typical "elephantine" legs that are also characteristic of the San Sebastián Red category with toes barely indicated. Elaborate designs in white and yellow adorn the short-sleeved shirt, also typical of this abstract variety of Ixtlan figure.

Although authors like Covarrubias termed the abstract category of Ixtlan material absurd and brutal, it is one of the most spontaneous and expressive traditions of clay sculpture ever produced. Covered with sores, these figures (nos. 23, 38) are grotesque, but they are also highly expressive and poignant. The variety of activities is virtually endless: couples preparing and eating food (no. 17a–b), men

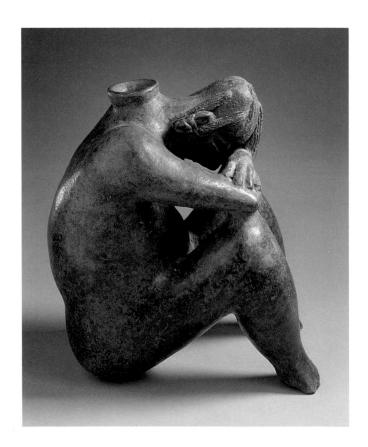

4.

The term *Ixtlan del Río*, though widely used, is ill-defined and for this reason not used in this catalogue to refer to a particular style.

20

Mourner (?)
Nayarit
cat. no. 48

Male figure from *Standing Couple*
(detail)
Nayarit
cat. no. 16a

*Standing Female Figure with Hands
on Abdomen* (detail)
Nayarit
cat. no. 62

Crouching Female Figure (detail)
Nayarit
cat. no. 6

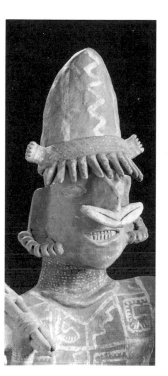

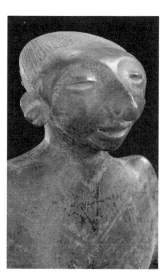

with dogs (no. 35), a full-scale West Mexican version of a ball game complete with spectators (no. 33), and the intriguing house scenes (nos. 26, 29, 37), unmatched for the wonderful tales they depict. One house group (no. 29) is particularly imaginative: a group of ravens and parrots perch on the rooftops and eaves. Another striking group scene shows what appears to be the West Mexican version of the ancient *volador* ceremony (a pre-Columbian spectacle, probably a reenactment of some cosmological event, which has survived to modern times; see no. 34) and is a tiny masterpiece of asymmetry and sculptural balance. The clay has been handled so deftly that the figures give the impression of arrested movement.

Chinescos or Chinescas represent a major substyle of Nayarit that occasionally appears in early collections of Nayarit material but did not become widely known until the 1960s. Such figures are known to have been found in south-central Nayarit to the north of its border with the state of Jalisco (Furst 1966: pls. 53–75).

In the 1970 catalogue four subcategories were recognized. Von Winning (1974: 70–71) classified them as Type A—monumental figures; Type B—monochrome "Martians"; Type C—triangular round heads; and Type D—rectangular heads (pp. 70–71). This classification is now widely in use and can be applied to the Stafford Collection.

First, the Type A or so-called classic Chinesco is characterized by a high degree of naturalism (relative to Ixtlan del Río) and majesty of pose, with subtly modeled eyes and face planes. The Stafford example (no. 1) possesses great monumentality but is also exquisitely modeled. Type A figures differ from the average West Mexican figure; more akin to the high-culture art of Mesoamerica, their calm, subtle exteriors suggest rather than demonstrate emotion. The poses are generally static; female figures are typically shown with legs tucked under or thrust to the side. Arms and hands retain the ropelike Nayarit characteristic and are not as naturalistically rendered as the eyes and other facial features. Perhaps the most extraordinarily naturalistic feature of this type is the way in which the half (or archaic) smile is suggested with such haunting realism. The famous seated "sister" to the Stafford Chinesco female in the National Museum of Anthropology in Mexico City is so similar that both may have been created by the same master, consistent with Furst's view.

Type B (Martian) Chinescos (no. 6) are rare in the Stafford Collection but quite common in other collections. They are usually treated with a deep red slip either underpainted or overpainted with a cream slip. Bodies are often rounded, voluminous forms, giving them an inflated look. Faces have exaggerated features, and thinly modeled arms and legs are found in a variety of positions. The seated figures have a distinctive feature consisting of a concave

Drummer
Nayarit
cat. no. 5

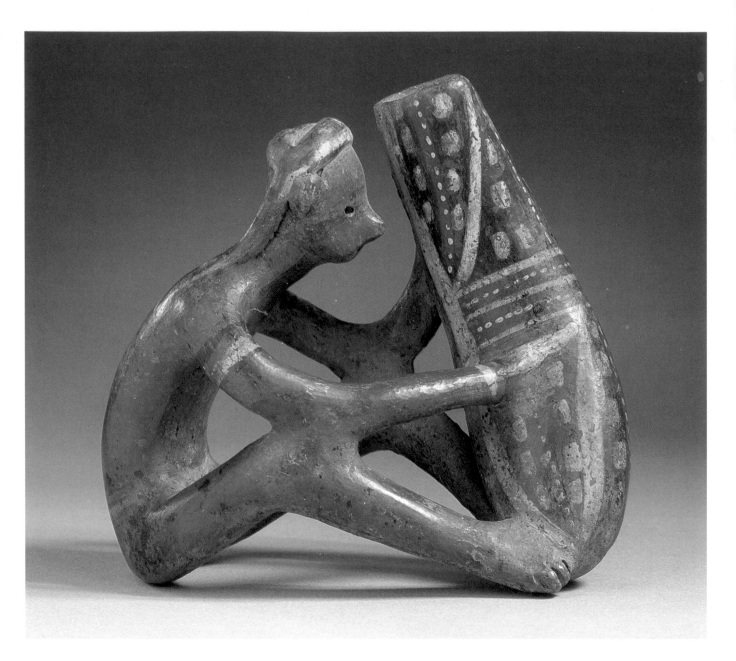

5.

This type of Chinesco is the only other type besides Type A that has the highly burnished white kaolinitic slip associated with Tlatilco and Las Bocas hollow figures in Olmec style. Type E figures also exhibit greater refinement of modeling and detail.

depression under their buttocks, which permits them to sit without tipping over (Von Winning 1974: 71).

Figures of the Type C variety are characterized by heads that are wide at the top narrowing to a pointed chin (no. 2, possibly no. 5). They frequently assume a seated pose with thin, ropelike arms folded over bulbous legs. Face and body painting is common and generally in red, black, and white on buff.

The Stafford Collection is rich in Type D figures (nos. 3–4, 7, 11), which are typified by broad, rectangular heads wider at the top than across the jaw. Legs are almost always shown outstretched and extended in female figures and are often decorated in cream and red slip.

Gallagher (1983) makes an excellent case for a fifth Chinesco type, E, which is "characterized by a cream slip decorated sparingly with red paint.... Eyes are often puffy as well, with very thin slits, in contrast to the punched rectangular slits common to other Chinesco styles" (p. 108). What is difficult to describe about Type E figures is the extraordinary refinement and subtle expressiveness of their features. This quality, coupled with the highly burnished white slip (usually stained a rich golden yellow from contact with iron oxide) and fine hair treatment, recalls the magnificent and monumental Type A figures more than any other.[5]

Animals are rare in the Chinesco subcategory. Among the few are a toad (no. 10) and a charming dog (no. 9), which

is difficult to classify because its highly burnished surface is largely covered with burial patina.

One of the most familiar subcategories of Nayarit is San Sebastián Red, a type that may be more at home in Jalisco than in Nayarit. Figures in the San Sebastián Red style, with their dynamic, expressive poses, are among the most familiar within the Nayarit tradition and most numerous among West Mexican sculpture collections. Classic figures (nos. 24, 48–50, 53–58a-b) are characterized by deep red paste color clouded with black inclusions (black manganese deposits), positive and negative painting primarily in black and cream slip, no navels indicated, only occasional nose rings (unlike Ixtlan), elaborately incised indications of hair, and eyes and mouth indicated by punched, wide slits. Two variants can be noted in the Stafford Collection: first, what Long calls the Ojos variant (1966: 35–36), which is intermediate between San Sebastián Red and classic Jalisco (Ameca Gray) and is distinguished by its eye type with appliqued ridges, naturalistic mouth, and an indication of teeth (nos. 51 and 60); and second, the "pointed ears" type (nos. 61 and 66), which seems to have Jalisco characteristics.

San Sebastián Red figures bring to mind, almost more than any other West Mexican sculpture, the highly expressive qualities of clay modeling. Some, like the small reclining male figure (no. 54), convey arrested movement; others, like the three emaciated "mourners" (no. 56a-c), are more static in pose but just as expressionistic in the way in which the composition suggests tension. The standing couple (no. 58a-b) are perhaps the most classic examples of the substyle; the female, her body covered with both positive and negative painting, and the male, sporting his bicorn helmet and body armor, create an interesting abstract composition.

JALISCO

Jalisco is home to a variety of styles. Foremost among them is Ameca Gray (nos. 67–69, 71–72, 74–78, 88, 92), which can be considered the most numerous and classic Jalisco style. Then there are Long's El Arenal Brown (nos. 79, 82a-b, 91) and San Sebastián Red (nos. 81, 87, 89–90) types, the "sheep-faced" style, the San Juanito style from the *municipio* (town) of Antonio Escobedo (no. 80), and finally the strange Zacatecas figures (nos. 99–102) attributed by Bell (1974) to northeastern Jalisco on the Zacatecas border (pl. 88).

Zacatecas figures are so different from other West Mexican types that they constitute a style in their own right. They usually occur in seated pairs, males with hands folded or holding drums and females with arms at their

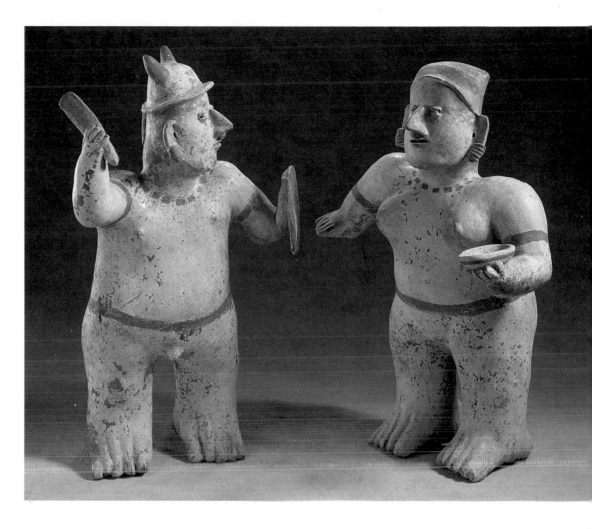

Standing Couple
Jalisco
cat. no. 82a-b

Standing Female Figure (detail)
Nayarit
cat. no. 66

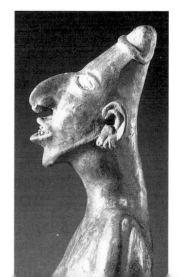

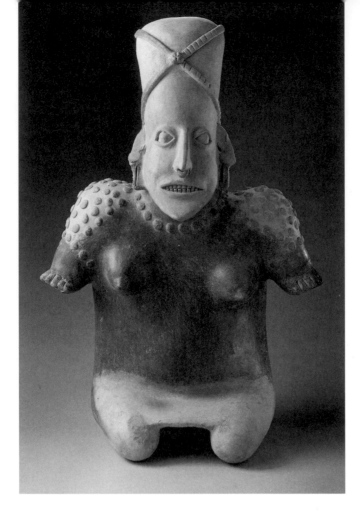

Kneeling Female Figure
Jalisco
cat. no. 69

Seated Male Figure (detail)
Jalisco
cat. no. 100

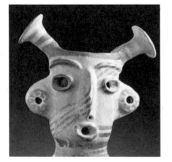

24

sides. Bodies are often naked and resist-decorated in black, white, and yellow on buff and red slip. Flat-topped heads are unique in that ovoid eyes and mouth are perforations in elongated, square, masklike faces. Males are distinguished by a pair of mushroom-shaped "horns" that grow from either side of the head.

The masklike quality of these faces with their long, thin noses, and thin, raised, and arched eyebrows are unique to the figure complex, paralleling only the stone masks from Sultepec (Chontal variant). An example is the famous Spratling mask, now in the collection of the National Museum of Anthropology (Easby and Scott 1970: cat. no. 87).

Ameca Gray Jalisco figures are cream or red slipped or both (no. 69). One of the most distinctive features is the extreme elongation of the occipital bone. These deformed areas are decorated with appliqued ornamentation that crisscrosses the head. Male figures are frequently shown wearing a crested helmet (see the larger figure in no. 76). Female figures usually have large breasts tattooed with spiral designs and nipples modeled in applique (no. 74). Other distinctive features of the head include large, staring eyes rimmed with thick fillets, an aquiline, almost hatchet-shaped nose, and a large, open mouth in which the teeth are clearly defined.

An exception to the interesting yet static poses of most classic Jalisco figures is the magnificent crouching male holding a striped shield in one hand and a mace or dagger in the other (no. 67). A second figure, outstanding for its scale and high surface polish, is the seated male figure (no. 78), which is much less frontal and rigid than the average Jalisco figure of the Ameca Gray type. Like its Olmec counterpart, the famed *Corona Wrestler*, its balanced but flowing, asymmetrical composition hints at great physical power and suppleness of limb. Without suggesting cultural or stylistic ties, the highly burnished light cream surface of this figure, spotted in fire-clouded areas with darker gray and reddish blushes is highly reminiscent of the well-known hollow "baby face" Olmec figures from Tlatilco and Las Bocas.

Several poses (or, perhaps more aptly, themes) occur with some regularity, such as the warrior and captive (no. 76), crouching male (no. 92), joined couple (no. 77), and "thinkers" (e.g., no. 88), which are almost always women with long, sarong-type garments that drape gracefully over one raised knee. Solid figures in the classic Jalisco style (e.g., no. 87) possess a more spontaneous quality than the large, hollow ones but cannot rival the solid-figurine traditions of Nayarit (Ixtlan) or Colima in the elaborateness of group activity scenes.

Long believed the society that produced the El Arenal Brown substyle was more advanced than any other in this area and that it was highly stratified (1966: 23–34). When one studies the thirty-seven-inch warrior figure (no. 79),

one can imagine that this impressive character must have been a king (p. 79).[6] Another El Arenal Brown figure in the collection (no. 91), though smaller, also seems to be filled with latent energy. The figures of this substyle are almost always slipped red with details such as eyeballs painted in white. Apparently El Arenal potters developed great control of their firing methods; the coarse-textured brown paste, though fired only to low temperatures, must have been difficult to handle in an enormous figure such as no. 79.

A type of seated nude female figure with hands up-raised and legs extended (e.g., no. 80) combines a number of Jalisco and Nayarit features. The extreme elongation of the head, long, hatchet-shaped nose, and large breasts with appliqued nipples are characteristic of Jalisco, while the general pose, treatment of eyes and mouth, and fan-shaped multiple earrings suggest the Nayarit style. The figures are said to have come from the region of San Juanito, municipio of Antonio Escobedo (Parres Arias 1962).

Numbers 89–90, 93, and 98 have been grouped on the basis of their color, which can best be described as burnished brown, brown-black, or black, and because two of them (nos. 89–90) have the large legs associated with San Sebastián Red. The long, ropelike arms are another Nayarit character-istic, yet the head of the figure carrying a bowl on its shoulder (no. 89) suggests Jalisco proportions. With his head tilted back and a ball balanced on the end of his nose, his hands raised in an arc over his head, the performer (no. 90) is an expressive masterpiece.

San Sebastián Red–Ameca Gray characteristics can be recognized immediately in the standing couple (no. 82a–b). The bicorn helmet worn by the male and the large elephan-tine feet of both figures are derived from the Nayarit style. The facial features, general body proportions, and cream-slipped surface painted in red are typically Jalisco.

COLIMA

Early Colima is probably the most homogeneous of West Mexican styles, for its famous hollow figures are unified by the familiar light orange to deep red burnished slip with black patina spotting the surface. On occasion the black spots are so numerous as to make black the dominant color. Black is also frequently achieved through reduction firing.

Besides the classic Colima pieces are those in the Coahuayana Valley substyle (e.g., no. 127), the Pihuamo style (not represented in the Stafford Collection), and a hollow figure (no. 122) that may be of the Postclassic period. In addition, there are a number of small objects in shell (no. 200) and stone (no. 203), which are said to have been found with classic Colima figures.

6.

Long believed that helmeted warriors were not represented in El Arenal Brown. This warrior type, because of his pose, must be closely related as an iconographic type to the typical San Sebastián Red warrior type with the bicorn helmet.

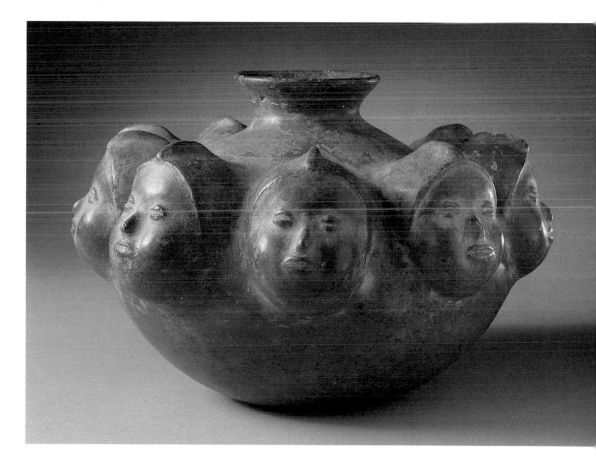

Vessel with Nine Heads
Colima
cat. no. 125

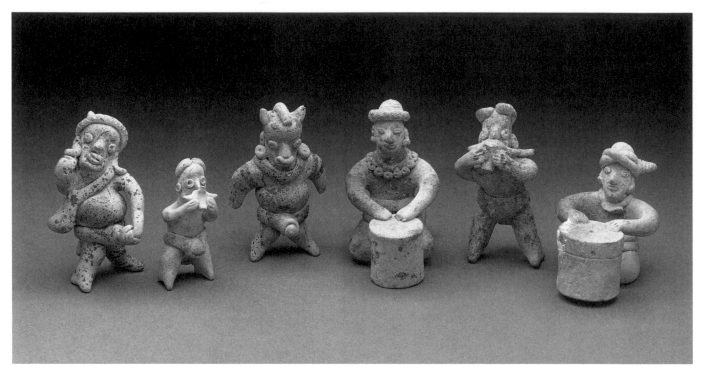

The classic Colima tradition provides a dazzling variety of human and animal figures along with an equally amazing selection of pots ranging from elaborate effigy vessels (nos. 116–17) to masterpieces of abstract form (no. 188).

Human figures, though shown in a wide range of poses, have a more mannered and less exuberant quality than the Nayarit figures of the San Sebastián type. Like Chinese opera singers on a stage, Colima figures, such as the magnificent drinker (no. 119), appear to be frozen in a mannered posture rather than in motion. An orange slip was first applied over the whole figure, then details of costume such as the head-strap and mantle were over-painted in red. The piece would then be burnished, often with a smooth stone on the unbaked surface (see burnishing stones, no. 47a-c). The darker areas were then incised with fine lines after firing to provide an exquisite network of delicate lines (also no. 121). It's no wonder Colima figures have been prized for their great polish and elegance.

Another masterpiece (no. 131), the seated hunchback dwarf, is the essence of pent-up force of the type associated with Olmec sculpture. The rounded volumes of the powerful but shrunken body are perfect complements to the disproportionately large, brooding head. No form of incising or other decoration has been introduced to conflict with this monumental statement of pure form.

Figures such as nos. 106 and 113 represent an interesting and more elaborate variation of classic Colima types. These figures sport unusually elaborate costumes, have eyes that may have originally held shell inlay, and are generally more angular in their facial planes than the average Colima figure. This type may represent an important ritual personage of some sort, a priest or shaman.

Colima is particularly noted for its wide range of zoomorphic representations, the most famous of which are dogs (nos. 143b, 148–50, 152–55). They are thought by some scholars to represent the emissaries of Xolotl, the god of death, who led the dead on their journey to the underworld (Toscano 1946: 24). Another indication of the iconographic importance of the god within the funerary context is the fact that it is the only animal shown in Colima art wearing a human mask (no. 150). Life-size human masks in ceramic similar to that worn by the masked dog are known in Colima art (nos. 144, 146). Among the animals portrayed one finds the gopher (no. 158), crab (no. 160), horned toad (no. 161), snake (no. 167), parrot (no. 172), duck (no. 173), and owl (no. 174).

Classic Colima ceramic art comprises an extensive range of vessel forms, from outright representations of figures, objects, animals, fruits, and vegetables, to effigy vessels in which supporting elements are modified into represen-

tations, to pots with beautiful abstract forms. The open-mouthed man (no. 145) is a good example of the first variety; the whole vessel has been cunningly worked into the form of a human head with the open mouth serving as the orifice. The finely detailed skeuomorphic ceramic replica of a double-headed stone mace (no. 147) is another example; for all its naturalism and detail, one never loses sight of the fact that it could be a container.

The second variety includes the well-known tripod vessels (nos. 124–25, 162, 185–86) to which animal or human elements are added as legs or simply as modifications to the body of the vessel. In other examples the body of the vessel itself is modeled or modified into the shape of a fruit or vegetable (nos. 175–79, 181). Objects of the third type are simple, highly sophisticated ceramic vessel forms (e.g., no. 183), some with pure, dynamic outlines that rival the pottery of Song China (nos. 187–88).

Solid figures in the Colima tradition can be visually subdivided into three rough categories: the flat, highly burnished brown-buff figures with athletic builds and bowed legs (no. 140); the flat, unslipped, and unburnished "cookie" types (nos. 129, 137–39, 141–42); and the solid, unburnished figures in more three-dimensional poses (nos. 133–36, 143). Because of the similarity of their highly burnished surfaces, one might place the first category with the large, hollow Colima figures of classic type and be tempted to place the second category in an earlier time with similar Preclassic figurines from Michoacan. The third category has many of the qualities of the Nayarit and San Sebastián Red style. Figures such as the acrobat (no. 134) and joined couple (no. 133) represent the epitome of vivacious movement.

A single large, hollow figure in the Coahuayana Valley style (no. 127) is clearly of a different type than the classic Colima red-ware figures. Its seated pose on a four-legged stool is closely related to two well-known Colima figures in the Diego Rivera Collection (Mexico: Secretaría de Educación Pública 1946: pl. 43). One of the latter is the marcelled type and holds a bowl in its extended right hand, as does a similar figure in the collection of the National Museum of Anthropology, Mexico City (Bernal 1967: pl. 290).

Colima art objects of the Postclassic period are beyond the scope of this study. A type of sculpture loosely referred to by collectors and dealers as the El Chanal style includes the incense burner (no. 196), a grotesque sculpture decorated with black paint.

CONCLUSION

The permanent installation of the Proctor Stafford Collection at the Los Angeles County Museum of Art provides as important a resource for the history of West Mexican art studies as did the historic Palacio de Bellas Artes show in Mexico City in the 1940s. For the first time in the United States groups of select examples of figure art from Nayarit, Jalisco, and Colima have come into focus rather than being dispersed among the other art styles of Mesoamerica.

Unfortunately the scope of this essay does not permit a detailed discussion of the fascinating iconography of the West Mexican figure complex. It is hoped, however, that the stylistic studies included here, cursory though they are, will aid in a small measure in the great task of classification that lies ahead of us.

On a final note, let us remember that these magnificent clay sculptures are only a small part of the artistic output of this ancient people. Gone are their music and oral literature, their sculpture in wood, and their textiles. Although we will never know the names of their Michelangelos and Brancusis, we can be aware that we are looking at the work of great masters.

Vessel in the Form of a Head with Open Mouth
Colima
cat. no. 145

27

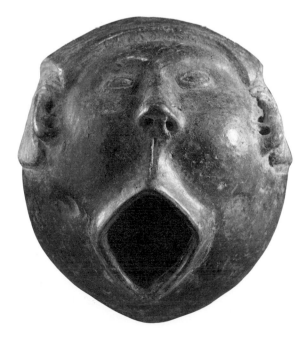

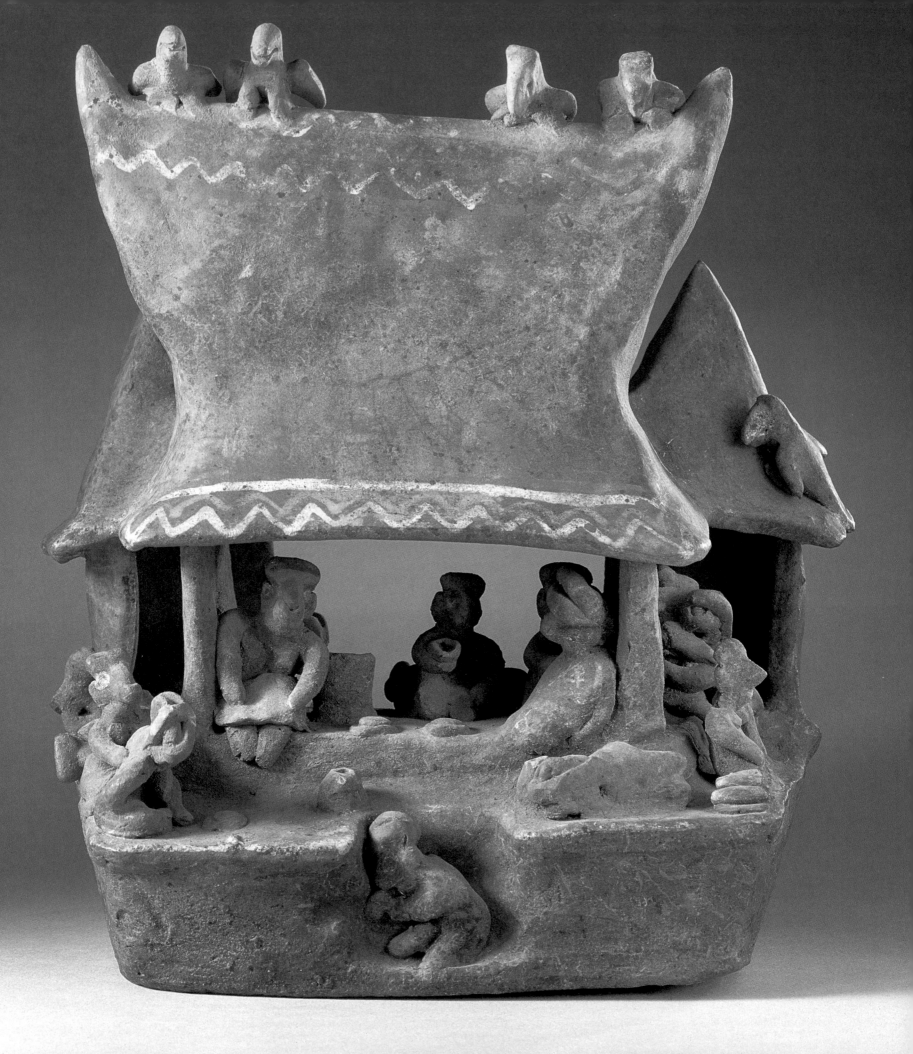

The Ceramic Mortuary Offerings of Prehistoric West Mexico:

An Archaeological Perspective

CLEMENT W. MEIGHAN

AND

H. B. NICHOLSON

House Group
Nayarit
cat. no. 29

INTRODUCTION

O U R understanding of the extraordinary lost world of ancient West Mexico is only incipient. One of the greatest contributions that can be made to increase knowledge is the opening of important private collections to scholars. The Proctor Stafford Collection, acquired by the Los Angeles County Museum of Art in 1986, constitutes an outstanding assemblage of pre-Hispanic West Mexican art. This revised and updated catalogue is the result of a reappraisal of our present knowledge of the ancient cultures of West Mexico, whose patient, skilled craftsmen produced these remarkable creations in clay. We hope to provide sufficient archaeological background to enable those who view the figures to better understand their broader cultural context. The catalogue also provides an opportunity to combine archaeological and aesthetic approaches to pre-Hispanic West Mexican art. In this essay we discuss the Stafford Collection from the viewpoint of the archaeologist, leaving the discussion of artistic style to the earlier analysis by Michael Kan.

The term *West Mexico* is a general one and can be variously defined. Our focus is on the far western coastal states of Nayarit, Jalisco, and Colima. The region encompassed by these modern Mexican political subdivisions has been referred to as Trans-Tarascan Michoacan West Mexico (Taylor, Berger, Meighan, and Nicholson 1969). In terms of present knowledge, the pieces in the Stafford Collection derive from this region.

Until recently it was not possible for archaeologists to contribute much to studies of prehistoric West Mexican art because few formal archaeological studies had been pursued in the region. Only within the past few decades has it been possible to ascertain in some detail the age, provenience, and cultural context of most of the objects in the Stafford Collection. In light of recent investigations this collection has much archaeological significance for several reasons. First, it is a largely unified collection, the major portion being from one well-delimited region (Nayarit-Jalisco-Colima) and one principal time period (the centuries just before and after the start of the Christian era). It differs, therefore, from most large Mesoamerican collections, which are more eclectic and diversified and contain objects from many distinct cultural and artistic traditions.

Second, in its specialization and concentration on a group of closely interrelated styles, the Stafford Collection excels in both breadth and depth for this section of West Mexico. The collection includes specimens of nearly all the recognized major varieties of West Mexican ceramic sculpture and often several examples of each type. It thus provides a generally representative sample of ancient far West

Mexican art that no single excavation or group of excavations could hope to obtain.

Third, in selecting pieces primarily on the basis of aesthetic quality, Mr. Stafford has assembled an excellent cross-section of the best productions of these ancient artists. This is an assemblage not of ordinary manufactures but of objects on which the craftsmen lavished particular care and skill. Hence the collection includes one of the largest of the known tomb figures (no. 79) and many examples of the most carefully modeled and most elaborately decorated. Such a collection has real value to culture-historical studies in defining the upper limits of ability in certain areas of human activity. It provides a basis for comparative study from which the finest productions of one group of people may be compared with the best produced at another time and place.

Archaeologists can contribute to a greater understanding and appreciation of the Stafford Collection in various ways. Above all they can provide an approximately accurate chronology so that we know when the pieces were made. This is important historically, but until recently a correct temporal assignment was not possible. West Mexican artifacts were attributed to widely varying periods spread over considerably more than a thousand years. We now know from radiocarbon dating that most of the types in the collection were made in the period from about 200 B.C. to A.D. 500 (see chronological chart, p. 68).

Archaeologists can also contribute significantly to the reconstruction of the cultural context within which the art objects were made and used. We can assess to some extent what the pieces were intended to represent, why they were made, and what they meant to the people who made them. These ceramic figures constitute an unintentional message from the past—from groups who left no written records of any kind—for these representations convey in artistic form many of their activities, manufactures, and customs. It is worth stressing, however, that the makers of these objects had no intention of transmitting information about themselves to later generations. What we can reconstruct concerning their vanished life-styles depends upon archaeological interpretation.

Genuine civilization was reached in only two areas of the aboriginal New World: Andean South America and Mesoamerica. Within the latter area, West Mexico is perhaps the most sharply differentiated subarea on the basis of both negative and positive criteria. Although displaying many of the most fundamental distinguishing marks of Mesoamerican civilization, West Mexico appears to have occupied a somewhat peripheral and less developed position vis-a-vis the Mesoamerican "heartland" to the east, particularly in the aesthetic, intellectual, and religious-ritual

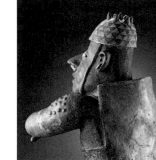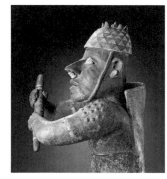

30

Standing Warrior (details)
Jalisco
cat. no. 79

spheres. On the positive side, a unique mortuary complex with no close parallels elsewhere in Mesoamerica flourished at an early period in one major sector of West Mexico: the shaft-chamber tombs with rich ceramic offerings.

Serious scholarly interest in pre-Hispanic West Mexico developed slowly in comparison with interest in many other areas of Mesoamerica. Generally lacking the spectacular surface sites that gave impetus to archaeological investigations elsewhere, the relatively modest remains of the far west only gradually came under systematic scrutiny by professional scholars. Even today knowledge of the area is spotty and far from satisfactory. It is ironic that principally beginning about 1927 with the completion of the western coastal railroad, an extraordinary quantity of superior ceramic figures and vessels has flowed out of this region. Probably for no other region of Mesoamerica, in fact, is there available for study so many complete ceramic specimens. The great majority were removed from tombs and burials for sale by nonarchaeologists and thus were extracted without recorded observations of their context. Archaeologists are therefore confronted with a challenging problem: they have available a remarkably rich mass of information from the past in one major Mesoamerican subregion. They face formidable difficulties, however, in utilizing it to reconstruct and explain that past, knowing virtually nothing about the precise proveniences and associations of most of the numerous pieces now scattered throughout hundreds of private and public collections. In short, archaeologists are simultaneously delighted and frustrated.

The obvious solution to this archaeological dilemma would involve a comprehensive research program on three principal fronts: (1) field investigation, including systematic excavations, of as many of the cemetery areas and their associated occupation sites as possible; (2) the compilation of a comprehensive archive of photographs of all known pieces, which would include all reliable provenience data; and (3) more systematic analysis (technological, chronological, typological, ethnographic-interpretational) of currently available pieces utilizing all relevant modern techniques and sources of information. In a broad sense, such a program—however uncoordinated and diffuse—has been under way since the first adequate publication, in the second half of the last century, of a West Mexican tomb piece in a generally available publication. Although our understanding of the ancient sculpture of West Mexico is still in its infancy, hundreds of pieces have now been illustrated, a few of the tombs (unfortunately almost all at least partially looted) have been carefully investigated and recorded, and general archaeological knowledge of the area has steadily increased.

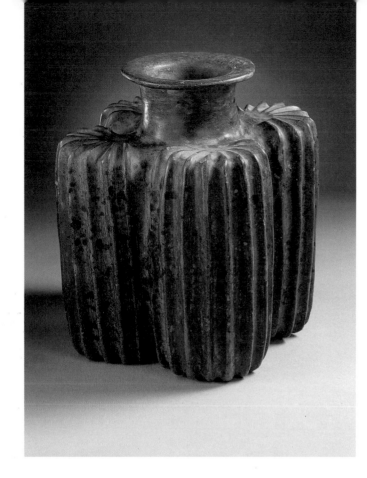

Organ Cactus Vessel
Colima
cat. no. 175

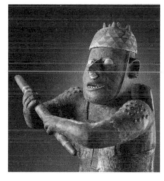

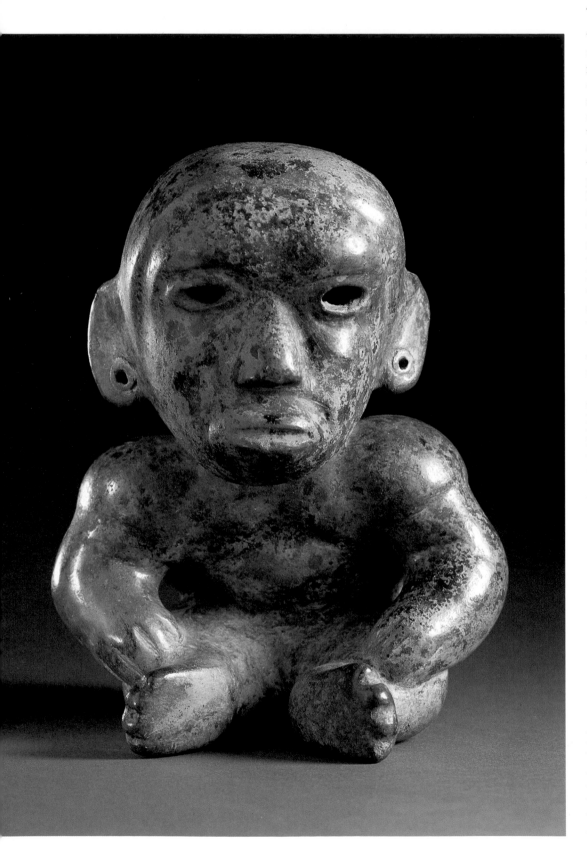

The Region and the Environment

The far western coastal states of Nayarit, Jalisco, and Colima (map, p. 11) do not form a geographical unit. Apart from numerous microenvironments, they consist primarily of two fundamental zones: a highland region with elevations averaging about five thousand feet and a relatively narrow coastal plain of tropical lowlands. The vegetation cover varies from savanna grasslands and deciduous tropical forests in the coastal regions, especially in Nayarit, to the vegetationally sparser parklands, upland grasslands, and pine-oak forests of the plateau basins and valleys. The highlands are largely volcanic in origin and form the western margin of the great Mesa Central, which comprises most of Central Mexico. From the high country there is often an abrupt drop to the coastal plain, particularly in the region of the southern Nayarit coast. Beyond the great trough of the lower Banderas Valley (where Puerto Vallarta is located), to the south, in Jalisco, a rugged mountain barrier rises abruptly from the sea. As one moves south along the coast, the narrow plain alternately widens and narrows until, in Colima, it constitutes a broad coastal flatland ending abruptly on the coast of Michoacan, where a rugged massif again rises precipitously from the ocean.

Four major river systems drain the upland interior regions where the majority of the cemetery sites are located. In the north is the Río Grande de Santiago, the longest river in Mexico, which issues from Lake Chapala in highland Jalisco-Michoacan and debouches on the coast north of San Blas, Nayarit. The southern Nayarit plateau and the highland area of central Jalisco, extending almost to Guadalajara, are drained by the Río Ameca system, southeast of which is a chain of north-south-trending highland basins of interior drainage containing shallow lakes (Atotonilco, San Marcos, Zacoalco, Atoyac, Sayula, and Zapotlan). West and southwest of this lake zone is the drainage system of the Río Armería, which bisects Colima. To the southeast, constituting in its lower reaches the Colima-Michoacan boundary, is the Río Coahuayana system, which drains eastern Colima, southern Jalisco, and southwest Michoacan. Three famous volcanic peaks dominate different sectors of the landscape: in the north, in southern Nayarit, Sanganguey and Ceboruco, and, in the south, the twin peaks of the Volcán and Nevado de Colima.

Some years ago rather simple shaft-chamber tombs were located close to the coast near Puerto Vallarta (Elerth Erickson, personal communication), but they do not appear to be common anywhere in the coastal plain. The West Mexican highlands constitute a zone of generally temperate climate with substantial rainfall in most areas and fertile volcanic soil. The shallow lakes are now mostly dry, partly through gradual desiccation resulting from progressive climatic aridity and partly from intentional drainage in

relatively recent times to reclaim agricultural land. Two to five thousand years ago the region was apparently better watered and must have supported an abundance of game (deer, peccary, rabbit, squirrel, opossum) and migratory waterfowl. It was undoubtedly a favorable environment from the standpoint of its earliest settlers, both hunter-gatherers and cultivators. Although direct evidence for the beginnings of farming has not yet been found, it is probable that early agriculture was practiced in this zone for many centuries before the Christian era. In any case, by the time of the birth of Christ, when mortuary ceramic art was apparently flowering, considerable land must have been under cultivation and native game animals became much less important as a food source than the products of farming.

EARLY DISCOVERIES

Precisely when the first West Mexican mortuary pieces came to general attention is somewhat obscure. Certainly most of the early works on Mexican archaeology virtually ignored this peripheral area. Few pieces were adequately illustrated before the turn of the century. Then in 1902 *Unknown Mexico* appeared, the classic account of the travels of a Norwegian explorer, Carl Lumholtz, in northwest Mexico. Lumholtz (1902, vol. 2. passim) was the first to illustrate a sizable number of mortuary pieces he collected in Nayarit and Jalisco with fairly specific proveniences. He also included the first generalized description of the type of shaft-chamber tomb common in the Ixtlan del Río area, a rifled example of which he visited in 1896. Already in his time widespread ransacking of tombs and burials was being actively pursued by the local populace. Although not the first to employ it, Lumholtz probably as much as anyone contributed to the propagation of the inaccurate and misleading label Tarascan for the large West Mexican mortuary ceramic figures, even though he was well aware they were from areas west of any region known to have been occupied by Tarascan speakers.

In 1903 British artist-archaeologist Adela Breton published an account of the 1896 discovery on the hacienda of Guadalupe (about ten miles north of Etzatlan, Jalisco) of a large mound with rich mortuary offerings, including more than twenty large ceramic figures. Drawings of three of these were included, as well as some shell ornaments. Breton's brief article was important, for it pinpointed with unusual specificity the provenience and *in situ* associations, however general, of two of the most important Jalisco types of large, anthropomorphic figures (Long's San Sebastián Red and El Arenal Brown).

During the next few years steadily growing numbers of mortuary pieces flowed out of the rich West Mexican earth. Increasingly works on Mexican archaeology included them in their coverage; Colima also received appropriate attention (a discussion of musical instruments in a Colima collection, which reached Berlin through the local German consul, was published by Hugo Kunike as early as 1912). Local West Mexican historians often included general notices on local antiquities, occasionally supplying illustrations. One historian, Miguel Galindo (1922, 1923–24, 1925), published the first general discussion of Colima archaeology to feature illustrations of mortuary figures—including the famous dogs—and the first generalized account of a Colima shaft-chamber tomb. Growing appreciation for the aesthetic quality of the West Mexican mortuary pieces was signaled by the inclusion of ten plates illustrating Nayarit, Jalisco, and Colima ceramic figures in one of the first comprehensive surveys of pre-Columbian art (Basler and Brummer 1928).

opposite
Hunchback
Colima
cat. no. 131

Reclining Male Figure
Nayarit
cat. no. 55

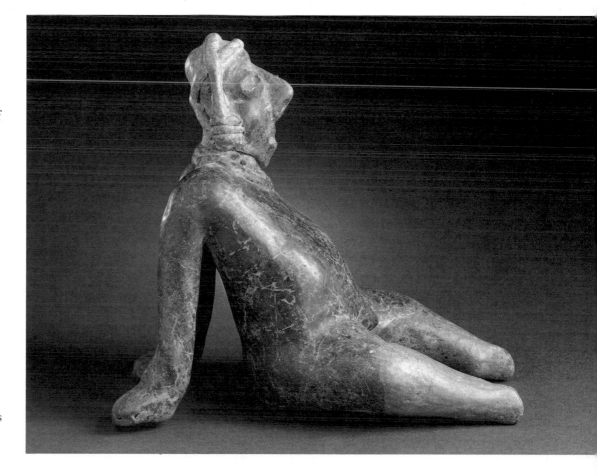

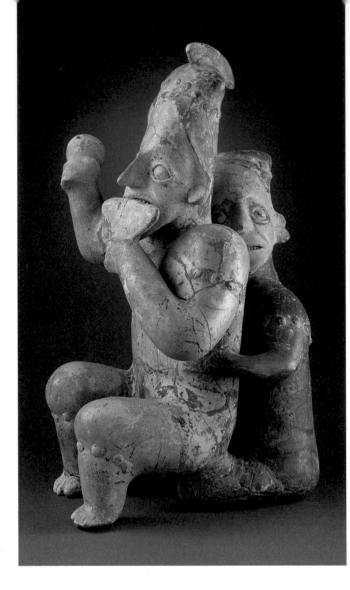

Joined Couple
Jalisco
cat. no. 77

An influential event occurred in 1927: the completion of the western coastal Southern Pacific of Mexico railroad. This opened the whole area to a more intensive form of tourism, which in turn stimulated the search for salable archaeological pieces. A more significant event in terms of professional archaeology occurred in 1930 with the entry of the University of California, Berkeley, into the field led by Carl Sauer and Donald Brand (1932). However, they concentrated initially on the far northwest (Sinaloa); in the early stages of the UC program (subsequently carried on principally by Isabel Kelly) virtually no attention was devoted to the tombs and burials and their contents of the area farther south.

During the 1930s some of the most important private collections were being formed, above all that of the Mexican artist, Diego Rivera. Pieces from these collections increasingly found their way into exhibitions of pre-Columbian art and into books and journals concerned with Mexican art and archaeology. In 1935 a local historian, José Ramírez Flores, published a short article illustrating and describing a selection of ceramic figures and vessels from the lake region of east-central Jalisco (Zacoalco, Techaluta,

Teocuitatlan, Atoyac). This contribution was of considerable importance because, like Breton's much earlier article, it pinpointed geographically a significant tradition distinct from those of Nayarit and Colima (although the author does not seem to have recognized the specific mortuary origin of these pieces).

SCIENTIFIC ARCHAEOLOGY

A significant event in the development of a more scientific approach to West Mexican archaeology occurred in 1932 when a German archaeologist, Hans Disselhoff, published the first detailed descriptions and diagrams of Colima tombs based on field reconnaissance. Accompanying the article was a map indicating cemetery sites and illustrations of ceramic figures with specific proveniences given (see also Disselhoff 1936, 1960). He suggested a typology of four principal forms of tombs, two of which were of the shaft-chamber variety. Remarkably Disselhoff's articles remained the only detailed treatments of Colima tombs derived from actual field investigations until the publication in 1978 of Isabel Kelly's well-illustrated account of her excavations of seven Ortices/Comala-phase tombs at El Manchón, just south of Los Ortices in central eastern Colima. (Kelly pioneered scientific archaeology in West Mexico beginning in the 1930s.)

In 1938 a leading Mexican archaeologist, Eduardo Noguera, conducted investigations in El Opeño, a cemetery near Jacona (northwestern Michoacan), excavating and recording five shaft-chamber tombs with sloping entrance tunnels. Their contents were distinct from those of the shaft-chamber tombs of Nayarit-Jalisco-Colima, however, and their discoverer suggested ties with the Preclassic traditions of Central Mexico (1942, 1975: 367). Today, after additional work at El Opeño (Noguera 1970, 1971; Oliveros 1974), some ties with the pre-shaft-chamber tomb Capacha phase in Colima are also evident (Kelly 1980: 30–31).

Beginning in 1939, as an extension of her work in Sinaloa, Kelly conducted reconnaissances and excavations through 1944 in various portions of the regions that yielded the elaborate ceramic mortuary pieces (Kelly 1944, 1945, 1947a, 1947b, 1948, 1949). One of her most significant finds (Kelly 1949: 195) was a large, restorable Teotihuacan-style Thin Orange jar at the edge of a looted tomb near Chanchopa in southeast Colima. This discovery became one of the principal supports for equating the period of the West Mexican shaft-chamber tombs and the ceramic pieces found therein with Classic Teotihuacan (Kelly 1980: 7). It was in 1940 that she excavated seven shaft-chamber tombs at El Manchón,

near Los Ortices (Kelly 1978b); Kelly also advanced a scheme of four sequent phases for Colima: the Ortices (Late Preclassic/Classic) phase (i.e., the shaft-chamber tomb period to which most of the pieces in the Stafford Collection relate); the Colima and Armería phases (both Early Postclassic); and the Periquillo phase (Late Post-classic). This phasing, only briefly summarized in some of her publications, served for years as the "standard" Colima archaeological sequence. She later added two more major phases: Comala, equated with the Classic period and characterized as the phase *par excellence* of the shaft-chamber tombs, just subsequent to Ortices, which she assigned to the Late Preclassic; and Chanal, overlapping but probably largely subsequent to Armería (Kelly 1980). Kelly also surveyed and excavated during this period in the Autlan-Tuxcacuesco-Zapotitlan zone of Jalisco, north of Colima, where, in the eastern portion of this zone, cemetery sites yielding mortuary pieces similar to those of Colima are not uncommon. Accordingly she proposed that the earliest phase of the Tuxcacuesco region (designated by that term) was contemporaneous with the shaft-chamber tomb period of Colima.

In 1941 a book devoted entirely to Diego Rivera's extensive collection was published, which included photo-graphs of a large number of his West Mexican specimens (Médioni and Pinto 1941; also Artes de México 1960). Although unrelated to scientific archaeological research, this book made available to students a considerably enlarged corpus of West Mexican mortuary pieces.

In 1946 Gifford (1950) conducted a surface survey of the Ahuacatlan River drainage of southeastern Nayarit. The purpose was to provide a suitable archaeological context for a large collection of pieces from this region acquired by the University of California, Berkeley, in 1931. He worked out a three-phase sequence—Early, Middle, and Late Ixtlan—the earliest of which corresponded to the period of the shaft-chamber tombs. He did not investigate the tombs them-selves, however, other than to inspect briefly some emptied ones. Many figures of the so-called Ixtlan del Río type are illustrated in this useful monograph, as well as various vessels and other objects associated with them. Gifford's descriptions of the ceramics of Early Ixtlan have never been superseded.

A major event of the same year was the first large exhibition devoted entirely to pre-Hispanic West Mexican art at the Palacio de Bellas Artes in Mexico City, sponsored by the Dirección General de Educación Estética. The majority of the pieces were from the Diego Rivera collec-

Phallic Dancer (detail)
Colima
cat. no. 111

Tomb,

Colima

(after Disselhof 1932)

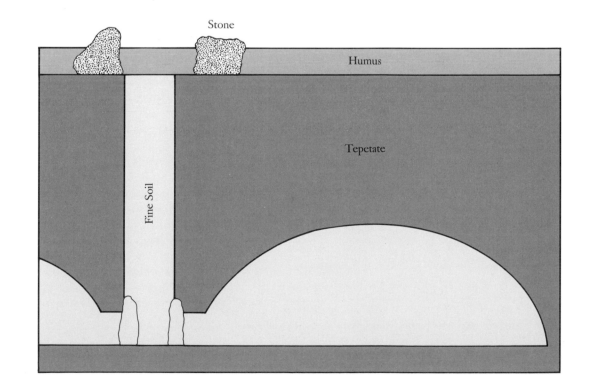

Stone

Humus

Tepetate

Fine Soil

tion. The well-illustrated catalogue (1946) included three important essays by Salvador Toscano, Daniel Rubín de la Borbolla, and Paul Kirchhoff. Toscano concentrated on an aesthetic appreciation, but he also dealt to some extent with ethnographic and iconographic aspects. Rubín de la Borbolla devoted his attention solely to Michoacan (east of the area that concerns us here). Kirchhoff concentrated on ethnographic interpretations. His article constituted the most serious discussion of this aspect hitherto published and is filled with valuable and perceptive observations. However, his basic breakdown of the anthropomorphic ceramic figures into three principal groups—"The Nudes," "Those with Polychrome Garments," and "Those with Loincloths"—leaves much to be desired and is obviously somewhat distorting in its spatial-temporal connotations. Noteworthy is the failure anywhere in the volume to recognize the Jalisco tradition as being essentially distinct from those of Nayarit and Colima. Overall, however, this small volume represented the most important single contribution to the subject published up to that time.

Emphasizing the greatly increased interest in West Mexico at this time was the Sociedad Mexicana de Antropología's *mesa redonda* (roundtable conference) devoted to this area in the fall of 1946. The tombs and their offerings, however, received little attention in the conference report published in 1948. Only Kelly, in her important article on ceramic provinces of northwest Mexico, devoted some discussion to this topic. She clearly recognized the distinctiveness of the Jalisco traditions, the most common of which she labeled Ameca. She also hypothesized a more or less continuous arc of tomb cemetery sites, which yielded the large ceramic figures as characteristic mortuary offerings, from Colima north through the Autlan-Tuxcacuesco, Sayula-Zacoalco, and Ameca-Etzatlan zones to the "Nayarit Hinterland."

Apparently in the 1940s José Corona Núñez conducted investigations of various cemeteries in Nayarit, including some with shaft-chamber tombs. He described three principal types—bottle-shaped, "simple grave," and shaft and chamber—plotting their distribution on a map. His article (not published until 1954) included the first published diagrams of Nayarit shaft-chamber tombs: a double-chambered example in a cemetery at Corral Falso near Ocotillo in the *municipio* (town) of Santa María del Oro and a single-chambered one at a site Corona Núñez designated Los Chiqueros, Ixtlan. He also suggested an intimate association between shaft-chamber tombs and agricultural terraces in the municipios of Santa María del Oro, San Pedro Lagunillas, and Compostela.

In 1955 the most spectacular tomb hitherto discovered (with three chambers and a shaft fifty-two feet deep), at El Arenal near Etzatlan, Jalisco, was robbed. The find was recorded and a report published by Corona Núñez (1955), together with photographs of some objects supposedly found in it. In 1962, at the suggestion of Nicholson and under the general sponsorship of UCLA, Stanley Long initiated an archaeological reconnaissance-excavation project in the Magdalena Basin, where Etzatlan is located. A major purpose was to locate and excavate an undisturbed deep shaft-chamber tomb. Working two seasons (1962, 1963–64) with a proton magnetometer and a seismic hammer, Long failed in this objective but carefully investigated and recorded basic data on ten shaft-chamber tombs at five different sites in the basin. The more or less intact contents of one, San Sebastián Tomb 1, stripped in 1963 while Long was in the United States, were acquired by a U.S. museum and were intensively studied by Long (1966). Working with an informant, he was able to reconstruct with considerable accuracy the original layout of the mortuary offerings. Long's Etzatlan project was a landmark in West Mexican archaeology.

Tomb,

El Arenal,

Etzatlan,

Jalisco

(after Corona Núñez

1955)

36

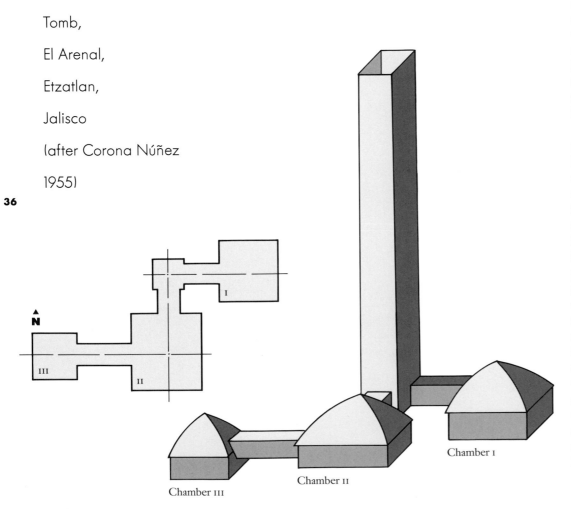

N

Chamber I

Chamber II

Chamber III

Tomb I,

Las Cebollas,

Tequilita,

Nayarit,

seen from the east side

(after Delgado 1969)

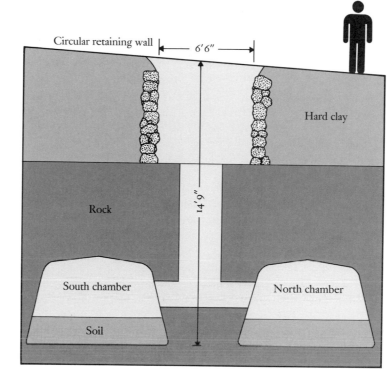

Tomb I,

San Sebastián,

Etzatlan,

Jalisco

(after Long 1966)

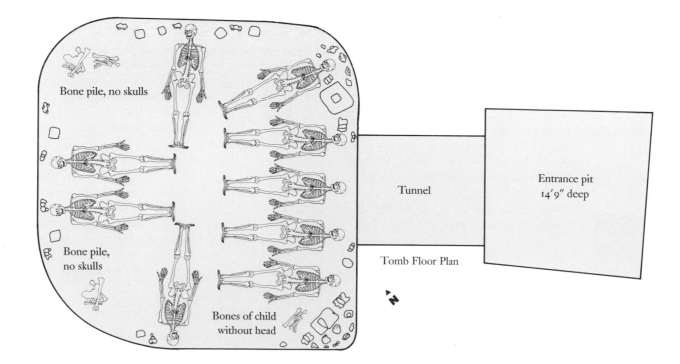

37

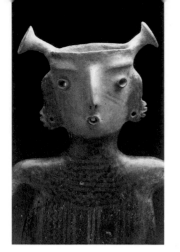

Male figure from *Seated Couple*
(detail)
Jalisco
cat. no. 99a

Female figure from *Seated Couple*
(detail)
Jalisco
cat. no. 99b

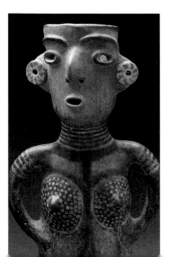

In 1965 Peter Furst and Diego Delgado salvage-excavated a partially looted two-chambered shaft tomb in an extensive cemetery at Las Cebollas near Tequilita, southern Nayarit (Furst 1965d, 1966; Delgado 1969). It contained several large ceramic figures of the type nicknamed Chinesco by dealers, 125 conch shells, nearly 30 slate discs encrusted with pyrites, and various other mortuary offerings. During this period Furst and Delgado also surveyed a large number of sacked tomb cemetery sites in a region centered in San Pedro Lagunillas, Nayarit (Furst 1966, 1967).

Additional field investigations of other cemetery sites, including the excavation of four unlooted shaft-chamber tombs in two different locations, were undertaken by Delgado (1969). All four were of the type referred to by looters as *tumbas de la cueva* (cave tombs). Three were located near Cuspala, about ten miles southwest of Guadalajara; the fourth was found at San Miguel Tonaya, approximately the same distance northeast of Tuxcacuesco. According to their discoverer, all contained the figures known popularly as *muertos*, small effigies of humans strapped to platforms (nos. 94–95). A variety of vessels were also found in the Cuspala tombs, and the Tonaya chamber yielded a large, hollow Colima-style figure and a house model. Delgado also excavated a burial at Cerro Encantado near Teocaltiche, northeastern Jalisco, which reportedly contained an assemblage of so-called Zacatecas ceramic pieces, including a horned figure (nos. 99–101), three conch shells, and other objects.

Two radiocarbon dates, one on charcoal and the other on one of the shells, indicated a date in the second century A.D. for this burial, which would make it contemporaneous with the shaft-chamber tombs farther west (Delgado 1969). This was generally corroborated by well-controlled excavations at the site in 1970 by Betty Bell (1972a, 1974), who found a male-female pair of the horned figures in a burial and a burned antler that was dated by a radiocarbon test at about A.D. 100–150. In 1971–72 Bell also supervised a survey of sites in the Magdalena Basin, Jalisco, in which a cesium magnetometer was used to attempt to locate undisturbed shaft-chamber tombs. She met with no more success, however, than did Long a decade earlier (Bell, Bevan, and Ralph 1971; Bell 1973).

The most intensive recent field archaeological work in the northern highland lake zone of Jalisco that constitutes the center of the "tomb arc" has been undertaken by Phil C. Weigand and his associates beginning in the late 1960s. Commencing with a primary interest in clarifying the sociopolitical context of the tombs that contain the spectacular mortuary art, the Weigand project developed over the years into a wide-ranging investigation of nearly every major facet of the rich archaeology of the area: cultural ecology, settlement patterns, demographics, commercial exchange systems, and rare resource procurement and distribution (Weigand 1974, 1976, 1979, 1985; Weigand and Spence 1982; Spence, Weigand, and Soto de Arechavaleta 1980). Hundreds of sites were surveyed and mapped using both aerial photography and ground reconnaissance, and a site typology and hierarchy was developed that provided the basis for various hypotheses concerning sociopolitical aspects of the prehistoric cultures. Weigand developed a six-phase sequence for the region culminating in what he designated the Teuchitlan tradition of the Late Classic. No fewer than 128 shaft-chamber tombs, all previously rifled, were entered and recorded in the course of the project. Thousands of photographs were taken of ceramic figures of the types characteristic of the tombs, recording as much information as possible concerning their provenience.

Although these zones are somewhat peripheral vis-a-vis the shaft-chamber tomb arc, Joseph Mountjoy's coastal projects deserve mention: the first in the San Blas, Nayarit, area in 1967–68 and the second in the Río Tomatlan basin in Jalisco in 1975–77 (Mountjoy 1970a, 1970b, 1974, 1982a, 1982b, 1983; Mountjoy, Taylor, and Feldman 1972; Mountjoy and Torres 1985). During the first Mountjoy discovered bottle-shaped shaft tombs that contained ceramics related to the Early Ixtlan phase of the Nayarit highlands, including hollow Chinesco-style ceramic figures (Mountjoy 1970a: figs. 50–51; Von Winning's Type D, 1974: figs. 1, 4, 7).

Kelly devoted the last years of her life to further research in Colima and published several important papers before her death (Kelly 1970, 1974, 1978a, 1978b, 1980, 1985; Kelly and Braniff de Torres 1966; Matos Moctezuma and Kelly 1974). In 1978 her article "Seven Colima Tombs: An Interpretation of Ceramic Content" appeared, which reported work done many years previously but represents an important contribution by one of the few archaeologists who had actually excavated tombs in Colima and recovered key materials in the field, including the only example of one of the famous Colima ceramic dogs (nos. 143, 148–50, 152) that has ever been found *in situ* by a trained professional. Kelly's 1972 and 1974 papers—and especially her detailed 1980 monograph (see also Greengo and Meighan 1976)—describe and illustrate an important new Colima archaeological assemblage, which she called Capacha, a very early phase with possible South American ties that extends the known sequence of West Mexican archaeology back to 1000–2000 B.C., a period apparently well antedating the shaft-chamber tomb material described here.

This brief historical résumé is not intended to be exhaustive but, we hope, includes some mention of most of the significant investigations and publications concerning the Nayarit-Jalisco-Colima zone particularly characterized by shaft-chamber tombs and burials containing elaborate ceramic offerings.[1] It would be incomplete, however,

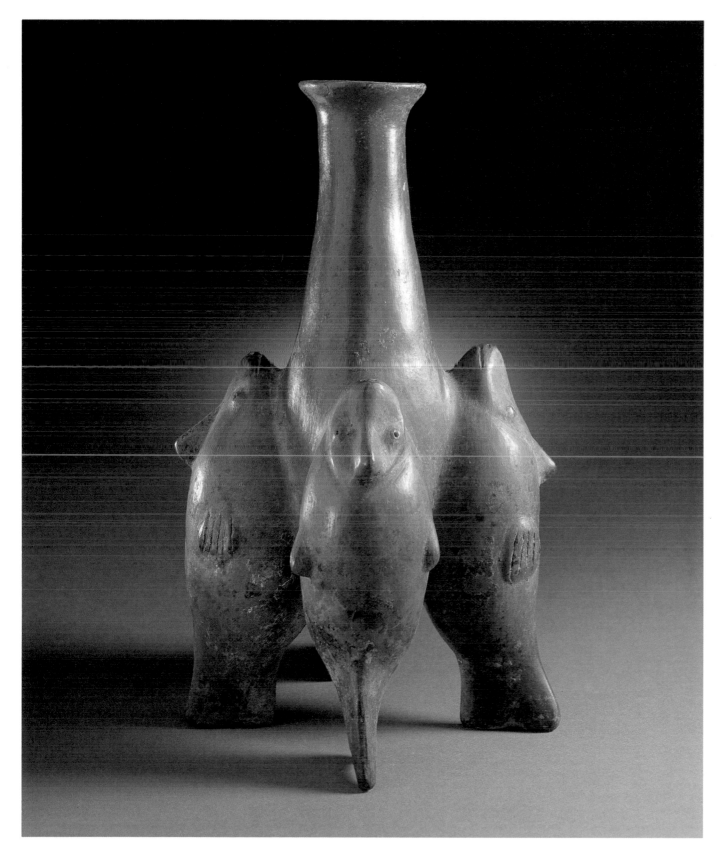

Vessel with Four Fish
Colima
cat. no. 162

1.

Although not directly concerned with the problem of the tombs and their contents, UCLA's 1960–62 coastal surveys and excavations along the West Coast (mouth of Río Grande de Santiago to Río Balsas delta; Meighan 1961; Nicholson and Smith 1962; Nicholson 1963; Long and Wire 1966; Nicholson and Meighan 1974)—particularly the excavation of the Morett site near Manzanillo, Colima (Meighan 1972)—added substantially to our knowledge of West Mexican archaeology. Especially relevant to the present topic were the data from the Morett site, where a series of radiocarbon dates (Taylor, Berger, Meighan, and Nicholson 1969: 25–27) confirmed a very early occupation (beginning c. 300 B.C.?). Morett ceramic types also display numerous cross-ties to those of the earliest Colima-southern Jalisco phases, particularly Tuxcacuesco, worked out by Kelly.

39

without citing a number of publications of the past two or three decades not directly related to field investigations but which contain many valuable illustrations and descriptions of mortuary figures and vessels (apart from numerous volumes devoted to pre-Hispanic Mesoamerican or general pre-Columbian art that almost invariably contain sections on West Mexico). Some of the most important of those devoted primarily to or including a substantial coverage of our area are by Médioni (1952), Collier (1959), Piña Chán (1959), Artes de México (1960), Corona Núñez (1960), Ramos Meza (1960), Instituto Jalisciense de Antropología e Historia (1964), Messmacher (1966), Alsberg (1968), Marks (1968), Schöndube Baumbach (1968, 1969), Bray (1970), García Cisneros (1970), Eisleb (1971), Von Winning (1971, 1974), Baer (1972), Von Winning and Hammer (1972), Stern (1973), de la Fuente (1974), Dwyer and Dwyer (1975), Krutt (1975), Baus Czitrom (1978), Furst (1978), Furst and Furst (1979), Nicholson and Cordy-Collins (1979), Crossley-Holland (1980), Gallagher (1983), and Lynton and Lynton (1986).

Of special importance among these works are some that include significant analysis and interpretation in addition to providing illustrations and descriptions of the pieces. Three (Von Winning 1974; Krutt 1975; and Baus Czitrom 1978) are serious efforts to construct comprehensive typologies of many categories of West Mexican ceramic figures. The Von Winning monograph is particularly noteworthy because it sets up categories and itemizes the diagnostic attributes of every important type of figure from the tomb arc zones of Nayarit, Jalisco, and Colima. His 1972 catalogue also constitutes the most extensive treatment of the Nayarit house models (nos. 26, 29, 37) and related pieces yet published (see also Von Winning 1969a, 1971).

Also worth special mention for the important information they provide concerning the provenience of the "Jalisco types" are a series of notes in *Eco* (journal of the Instituto Jalisciense de Antropología e Historia), principally by Parres Arias, which illustrate and briefly describe pieces in the Museo de Arqueología del Occidente de México, Guadalajara.

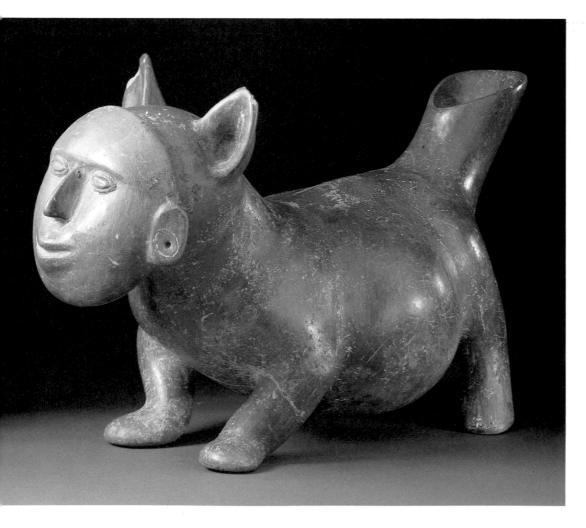

Corpus of West Mexican Tomb Figures

Together with the older publications and the present catalogue (illustrating more than 230 specimens), there is a published corpus of well over one thousand ceramic mortuary pieces of the types found in the shaft-chamber tombs defining their stylistic variations. The majority are hollow figures, but there are many small, solid figures as well as vessels and other ceramic forms. This is a sizable body of complete specimens, and it allows detailed analysis of the elements of artistic style. Unfortunately a characteristic of all these published collections is that virtually none of the pictured specimens was obtained under controlled conditions or seen by an archaeologist at the time it was excavated.

We have more secure evidence for the small, solid figurines; many such specimens have been found and described in well-controlled excavations. Many of these smaller figurines can be accurately dated and arranged in a sequence of styles (Baus Czitrom 1978). They can also be compared stylistically with the large, hollow figures to yield some indirect estimates for the age of the latter. Meighan compared small figurines from the Early Morett levels of Colima (c. 100 B.C.–A.D. 300) with the large, hollow figures from the shaft-chamber tombs (1972: 66). He identified

twenty attributes that are shared and concluded that the smaller, solid figures are simpler versions of the large figures. These small Late Preclassic figurines are widely known and include Tuxcacuesco and Ortices types as well as those found at the Morett site. They are common in midden refuse but sometimes occur as burial offerings in simple graves (Meighan 1972: pl. 50). They have also been found in prepared tombs at sites such as El Opeño, Michoacan (Oliveros 1974: 192), and Tabachines, Jalisco (Galván 1976: pl. 7k). Although these latter sites contain prepared tombs with an entrance shaft and a tomb chamber, they are much shallower and simpler than the deep shaft-chamber tombs from which most of the large, hollow figures derive. Hence the tombs with small, solid figurines can be interpreted as simpler versions of the more elaborate grave complex reserved for high-status persons. It is important to recognize that most of the figures in the Stafford Collection represent the highest aesthetic achievements of peoples whose ceramic traditions included thousands of smaller, less elaborate figurines, as well as gradations of complexity in tomb construction, ranging from simple pits through small shaft tombs to major shaft-chamber constructions.

It may be of interest to note that the vast majority of West Mexican ceramic figures of the styles included in this catalogue were collected many years ago, nearly all before 1960. The antiquities market was filled with this material for years, and it was a favorite item for collectors of pre-Columbian art. The declining interest in these styles is probably attributable to a number of factors. Perhaps collectors' interests have shifted to other styles, making West Mexican pieces no longer so popular. More important may be the existence of numerous forgeries (see especially Von Winning 1974: 76 79), which has forced collectors to proceed with extreme caution.[2]

The population of West Mexico two thousand years ago was substantially smaller than it is now, and consequently there were fewer people to produce the ceramic art. We do not know enough to quantify this variable exactly, but there is no question that the archaeological sites of the shaft-chamber tomb period are fewer in number and smaller in area than sites of later times. Most of the shaft-chamber tomb sites contain a limited number of tombs. None can be called a vast necropolis as is the case with some ancient sites in Egypt and South America.

It is almost certain that only the rulers or aristocracy, perhaps members of powerful lineages who controlled the many chiefdoms that probably characterized this era, were accorded the shaft-chamber tombs and their elaborate offerings. It appears that the larger tombs, up to fifty feet or more in depth, were family crypts and used over a period of time. The labor required to construct such tombs would

2.

All the larger collections in and out of museums contain some counterfeit pieces. Some private collections of a dozen or more examples consist entirely of falsifications. In examining pieces brought in for authentication, it is clear that many collectors have paid large sums for forgeries that range from absurdly crude copies to pieces that are so well done that they defy detection. Meighan has visited two factories in Guadalajara that produce replicas of museum pieces, including most West Mexican styles. These are sold as copies and not represented to be genuine, but they are superbly done and can be detected as reproductions only by very subtle features. It is possible (and has probably happened) that a piece was sold as a replica in Mexico and found its way onto the market, where it was resold as a genuine piece for thousands of dollars. In any event, the massive extent of this fakery certainly has had a depressing effect on market value and collector interest. One of the features of the Stafford Collection that makes it so valuable is its authenticity. Most of the pieces were acquired before the styles became widely popular with international collectors and before large-scale, systematic production of forgeries had begun.

Another possible reason for diminishing interest in West Mexican art is that the major part of the art represented by these styles has already been excavated and that there is little more of it to be found. Massive and systematic looting of shaft-chamber tombs, supported by market demand both in and out of Mexico, has completely destroyed many major sites. Archaeologists nevertheless believe there is always more to be

found, and isolated discoveries, some of major scope, will no doubt be made in the future. Yet a number of archaeological considerations support the idea that the declining amount of this art may be attributable to exhaustion of the supply.

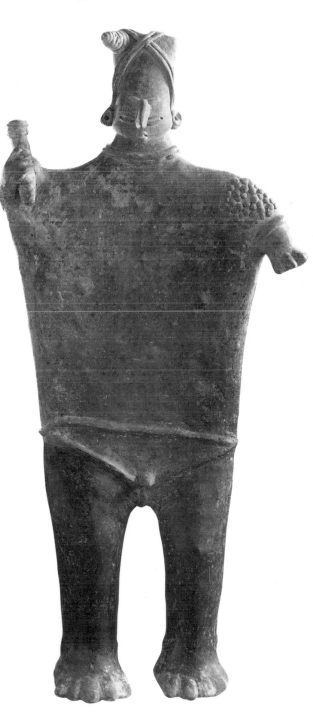

Standing Male Figure
Colima
cat. no. 132

41

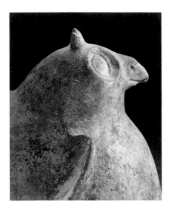

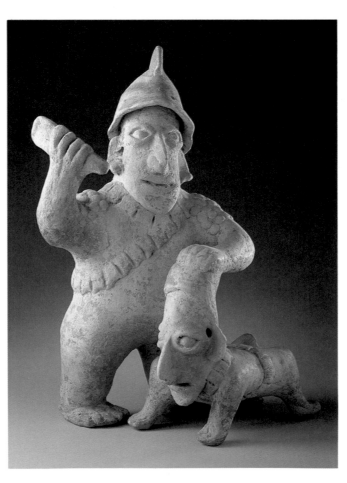

preclude such elaborate burials for the common people. Archaeological evidence from many sites, such as Morett in Colima, indicates that the common people were buried in ordinary graves. They were accompanied by simple mortuary offerings of vessels and small, solid figurines but were not buried with the large, hollow figures found in the shaft-chamber tombs. In sites where the latter occur, many graves are found that are not shaft-chamber tombs, paralleling the situation in many areas of the world where persons of lesser social rank are buried in proximity to the elaborate tombs of important people. Although large, hollow figures of the types included in this catalogue are occasionally found in ordinary graves, the available evidence indicates that they are much more commonly associated with shaft-chamber tombs (which sometimes also contain examples of small, solid figurines).

Most of the material removed from the shaft-chamber tombs seems to have been intended only for mortuary purposes, as evidenced by the lack of fragments found in village excavations that would suggest they had any domestic or everyday use.

It must be concluded, therefore, that these special manufactures, made for a small subset of a relatively small population, must be limited in number. We do not know how many figures occurred in each tomb, but fragmentary and indirect information suggests that the number was not tremendous. If we assume an average of five to ten such figures per large shaft-chamber tomb, perhaps one to two hundred are represented by the published pieces. That may be a large proportion of the total number that exist.

Weigand (1974: 120) personally surveyed 107 looted tombs in the Etzatlan (Jalisco) area (not all of them of the larger shaft-chamber type), and he believes that from that region alone some eight to ten thousand figures have been looted and sold. If this scale of digging has been general throughout the shaft-chamber tomb arc, a large proportion of the total number of large, hollow ceramic figures in existence may already have been found. If these estimates are correct, however, one would also have to conclude that well over 90 percent of the tomb figures are in the hands of private collectors and are unknown to scholars or museums. This is possible but seems unlikely considering that the aesthetically superior pieces tend to be shown to museums and/or archaeologists and in fact usually emigrate to museums over a period of time. It is unquestionable, however, that uncontrolled collecting has greatly impaired our ability to make scientific interpretations.

Based on his discussions with looters who found emptied tombs, Weigand suggested that not all this collecting activity has been recent but may well have occurred even in prehistoric times, with objects being taken from earlier tombs and deposited in later ones (1974: 127). Such a pattern is well known in other areas of the world, such as Egypt,

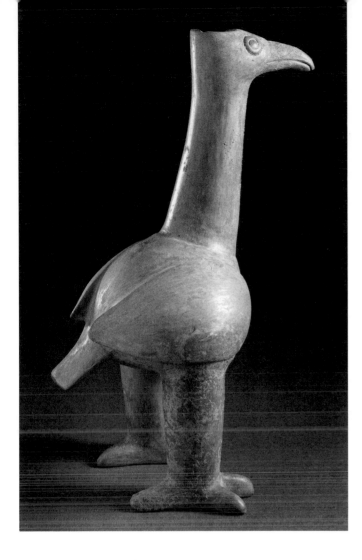

but not much field evidence from West Mexico exists to estimate the extent of such behavior.

Although many of the foregoing observations are somewhat speculative, to the extent they are correct it is obvious that the value of the Stafford Collection is greatly enhanced. Certainly no one has made, or is likely to make in the future, another collection of this size, scope, and overall level of artistic excellence.

Water Bird Vessel
Colima
cat. no. 168

Native Peoples and Cultures at the Time of the Spanish Conquest

The shaft-chamber tomb cemetery sites are concentrated in an area that can best be described as a great arc extending north from Colima through southern-central Jalisco and, veering to the northwest, into south-central Nayarit. This extensive zone was well populated when the Spaniards arrived between 1522 and 1525. The first exploring parties in 1522–23 just penetrated the eastern outposts of this area. They were commanded by Cristóbal de Olid, the lieutenant of Cortés sent to take over the Tarascan empire of Michoacan, and by his second-in-command, Juan Rodríguez de Villafuerte. The definitive conquest of Colima by the energetic Cortesian "constant captain," Gonzalo de Sandoval, occurred in 1523. An Amazon-hunting *entrada* (expedition) more or less paralleling the arc on the west from Colima to the Ameca-Etzatlan zone, then squarely following it to just south of the Río Grande de Santiago, was led in 1524–25 by the *alcalde mayor* (chief magistrate) of the fledgling Spanish villa of Colima, Francisco Cortés, cousin of the great conqueror. Descriptions of native cultures of the area written in connection with these expeditions of conquest are frustratingly meager, but various accounts contain spare but precious ethnographic information (summarized in Nicholson, n.d.). Although many significant changes had obviously occurred between the period of the shaft-chamber tombs and the Conquest, fundamental culture patterns were probably similar; many may have survived from the earlier era. Consequently, in spite of the unsatisfactory state of our knowledge of the Contact peoples, existing documents describing their way of life perhaps can aid us in interpreting the significance of the extraordinary objects that were placed in the tombs centuries before the conquistadores arrived. A brief résumé of what is known about the Contact peoples of the tomb arc is therefore in order.

Beginning in the south at the time of Contact, Colima was particularly thriving and populous (Sauer 1948: 81 estimated a total population of three hundred fifty thousand for "Greater Colima"), although reports in the uncritical

43

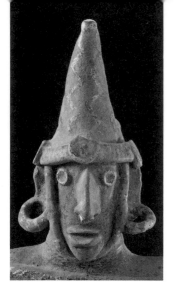

*Seated Male Figure Wearing Large
Mantle* (detail)
Nayarit
cat. no. 27

and romantic later colonial chronicles of a great "kingdom" of Colima are obviously false. A cluster of essentially autonomous, small polities, the most important of which the Spaniards called Alima, Tecoman, Colimotl (after the native ruler), Tepetitango, and Cihuatlan, constituted the overall "province" of Colima (Sauer 1948). In return for military assistance against those potent imperialists, the Tarascans, they may have paid a small token tribute to the Empire of the Triple Alliance (Tenochtitlan-Tetzcoco-Tlacopan). Apparently a rustic version of the Nahua, or Aztec, language served as a relatively recently imported lingua franca for the entire zone, which was otherwise characterized by a high degree of linguistic diversity.

The native culture in general appears to have represented a kind of reduced and simplified version of the typical high culture of western Mesoamerica, such as that of the Basin of Mexico ("Aztec culture"). A well-established village way of life based on productive agriculture was flourishing. The capitals of the major provinces were large towns (perhaps five to ten thousand). Their dependencies ranged from sizable villages to tiny *ranchitos*.

The usual Mesoamerican triumvirate of staple food plants—maize, beans, and squash—was supplemented by nutritious root crops such as the sweet potato, manioc, and peanut. Also important were grain amaranth, chia, tomato, chile pepper, cacao (the beans used both as a source of chocolate and probably for currency, as elsewhere in Mesoamerica), and various fruits: pineapple, *zapote*, guava, and plums. Cotton was grown in quantity; the bottle gourd was cultivated for containers; and tobacco, used in rituals and also believed to possess curative powers, was raised. Irrigation was practiced where conditions permitted, and two annual crops were not uncommon in more favored locations. Turkeys, Muscovy ducks, and bees (honey production was important) were domesticated, as was the dog, one breed of which was probably castrated, fattened, and eaten.

Little specific information is available concerning native crafts, but it is clear that weaving was well developed, as were featherwork, ceramics, basketry, and probably woodworking. Architecture apparently was not very advanced. The typical dwelling was a small wattle-and-daub structure with a peaked, thatched roof. Rulers undoubtedly possessed fairly large abodes but probably of the same general type as those of their subjects. Ceremonial structures were obviously important, but they are virtually undescribed. Certainly there was no elaborate stone and stucco ceremonial architecture of the type for which more highly developed regions of Mesoamerica are famous, nor was stone sculpture important, elsewhere one of the most brilliant arts of Mesoamerica.

Knowledge of the economic, sociopolitical, and religious-ritualistic aspects of the culture is poor. Markets and intra- and intercommunity trade were important in adjoining

regions, as they must have been in Colima. Rulers, particularly the paramount provincial chiefs, were undoubtedly supported by tribute, but details are lacking. Although it is unlikely that Colima's social structure was as complex as in the nuclear areas to the east, a certain amount of stratification must have characterized the society. Chieftainship was well developed, and it is likely that some kind of native aristocracy played a significant leadership role. Unless Colima was completely atypical, religion and ritual must have been of great importance. One late colonial source from an immediately adjoining area reports the cult of the basic Mesoamerican mother goddess of fertility and an opposing and contrasting fire god who was believed to dwell in the Volcán de Colima.

Human sacrifice was prevalent in nearby areas and very likely was also important in Colima. Militarism in general must have been well developed. The Tarascan threat from the east had been successfully repelled, and at Tecoman the first invading Spanish party, under Juan Rodríguez de Villafuerte, was defeated. In West Mexico in general basic weaponry consisted of the bow and arrow, spear-thrower (*atlatl*), sling, club, and mace. For protection, shields of tough, woven cane and padded-cotton body armor were employed. Undoubtedly the Colima warrior was similarly accoutered.

Directly north of Colima was a zone of rugged topography extending to the upper Río Ameca Valley and comprising the higher drainage of the Armería River. Various provinces were recognized by the Spaniards: Amula, Autlan-Milpa, Ayutla, Tenamaxtlan, and Tecolotlan among others. All seem to have been politically autonomous, although eastern Amula for a time seems to have been subject to Tarascan control not long before the Conquest. Generally the culture of this zone appears to have been somewhat more rustic than that of Colima. Various dialects of a language called Otomi dominated the linguistic scene, although Nahua was certainly in some general use. Whether this Otomi was the same as the widespread important language of that name in Central Mexico is uncertain. The Autlan-Milpa zone seems to have constituted an enclave of somewhat more advanced culture. Autlan was called a city by the earliest Spaniards to reach it and was credited with twelve hundred houses, certainly a large community for West Mexico.

Northeast of Colima was another important province dominated by three large communities: Tamazula, Zapotlan, and Tuxpan. The Spaniards considered them to be characterized by a superior culture; they were also reputed to be active mercantile centers. Important silver mines existed near Tamazula, the first significant sources exploited by the Spanish in Mexico. The mines also apparently served as the major silver source for the Tarascan dynasts of Tzintzuntzan. The linguistic situation in this area was particularly

complex, with each major capital bilingual, trilingual, or even quadrilingual, although Nahua was in general use. Tarascan was also spoken to some extent, for the area was politically controlled by Tzintzuntzan at Contact. A little more is known of the religion of this area (Schöndube Baumbach 1974a). A mother goddess appears to have played a pre-eminent role, and certain cosmological notions displayed a close similarity to those typical of Central Mexico.

To the northwest, directly east of the northern portion of the Otomi zone, in the lake district of east-central Jalisco, was a group of substantial native communities that became known in early colonial times as the Avalos province, after the relative of Cortés, Alonso de Avalos, who held most of the pueblos of this zone in *encomienda* (in trust, to receive their tribute). Probably not an integrated political unit, the region was apparently composed of more or less independent *cabeceras* (head towns) that were linked—perhaps by political alliances—by their common determination to preserve their independence against the formidable military power of the Tarascan empire.

As is typical for far West Mexico, linguistic variety characterized the area, but two languages appear to have been dominant: Coca ("Pinome") in the north and Sayulteca (from Sayula, one of the major towns) in the south. The former may have been a Uto-Aztecan tongue related to Cahita (Yaqui, Mayo, etc.), whereas the latter may have been closely related to Nahua, if not merely a dialect of it. Ethnographically this zone is even more poorly known than those previously discussed. The general level of culture, however, appears to have been relatively high, comparing quite favorably with Colima and the Tuxpan-Tamazula-Zapotlan area.

Following the tomb arc before it turns sharply to the northwest, the next zone consists of the upper Ameca Valley, the Magdalena Basin (with another large, shallow lake), and the rolling plateau country to the east extending beyond Guadalajara. Ameca, which gave its name to the river on whose banks it stood, was the southernmost outpost of the famous Cazcan, who seem to have spoken a language closely akin to Nahua and whose center was in northern Jalisco-southern Zacatecas. Their formidable uprising in 1541 ("Mixton war") was the first great nativistic movement in the history of the New World—and had to be crushed by a large Spanish army led by Viceroy Antonio de Mendoza himself. Etzatlan, on the south shore of the lake of that name, dominated the Magdalena Basin, which was both Nahua (Cazcan?) and Otomi (Tecuexe?) in speech. The first Spaniards reported a ceremonial center on an island in the lake with stone substructures for shrines similar to those in the Basin of Mexico, indicating a relatively high cultural level for the area.

To the east was the great cluster of Tecuexe (linguistic affiliation uncertain) and Coca towns, extending well past Guadalajara and the Río Grande de Santiago to the frontiers of the Gran Chichimeca, the great arid steppes of the north, the haunt of the fierce hunting-gathering peoples (Baus Czitrom 1982, 1985). A high degree of local political autonomy seems to have prevailed in this extensive area, where Nahua again was in widespread use. The general way of life was quite similar to that which prevailed in the Ameca-Etzatlan area and the Avalos province to the south. This area had also successfully resisted Tarascan imperialistic encroachment.

The northwest segment of the arc begins west of a rugged mountain knot along the Jalisco-Nayarit border, in the Ahuacatlan Valley. Rounding to the north of the great Ceboruco volcano, the plateau of Tepic is reached, which drops off sharply to the lowland zone around San Blas. This region was characterized by a broad strip of substantial native communities rimmed on the north by the deep canyon of the Río Santiago and on the south and west by rugged country that comprised the northern edge of the Río Ameca Valley and the mountainous escarpment overlooking the Pacific coastal plain. The area is perhaps the poorest known from the standpoint of ethnographic specifics.

The Ahuacatlan Valley was well populated with Iztlan (modern Ixtlan del Río) and Ahuacatlan in the valley proper and Camotlan and Tetitlan (south and north of the valley, respectively) dominating the scene. The indigenous speech of Iztlan is uncertain, but Tecual (Tecualme), possibly a dialect of Huichol (concentrated in the mountain mass north of the Santiago River), prevailed in the other three provinces, although some Nahua was also in use. At the farthest end of the arc, near the north edge of the southern Nayarit highland, the famous twin towns of Xalisco and Tepic headed rival polities of considerable importance. The former spoke Tecual (called Otomi in the earliest records); the latter, at least some Nahua. In spite of their renown,

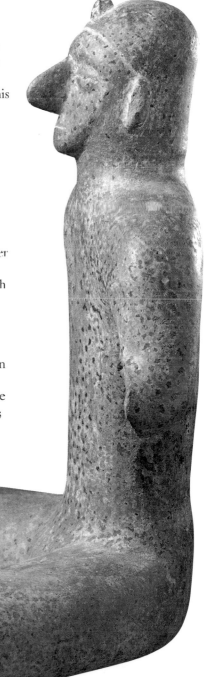

Seated Male Figure
Colima
cat. no. 114

Drummer
Nayarit
cat. no. 24

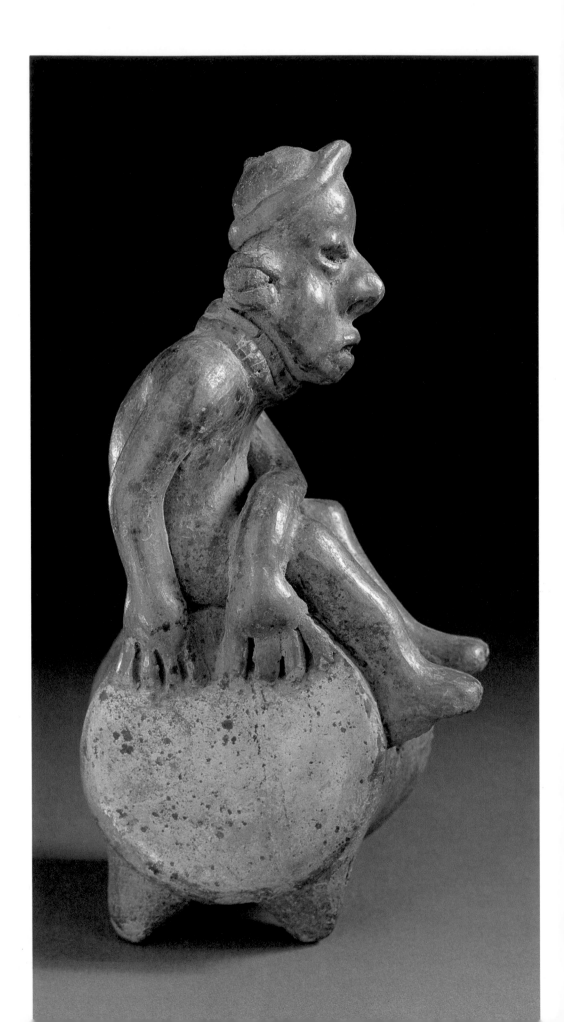

little is known about them beyond the fact that they were both warlike, particularly Xalisco, which put up stiff resistance to Spanish domination. Considerable trade between the highland and lowland pueblos also characterized aboriginal southern Nayarit.

In general it can be said that the native people of the arc where the shaft-chamber tomb cemeteries are concentrated exemplified a way of life that was typically Mesoamerican in its most essential aspects, particularly subsistence patterns. Lacking, however, were many of the more elaborate developments of the nuclear Mesoamerican zones to the east, especially in ceremonial art and architecture and in certain intellectual attainments (complex calendric and hieroglyphic writing systems and screenfold books). The area, as was true of all West Mexico west of the Tarascan imperium, was also characterized by a high degree of political fragmentation. Undoubtedly related to this was the considerable linguistic variety. All this is clearly reflected in the archaeological record, to which we now turn.

GENERAL FEATURES OF WEST MEXICAN ARCHAEOLOGY

Up to about the beginning of the Christian era West Mexico appears to have shared with most of Mesoamerica the general Formative or Preclassic pattern of village agriculture, perhaps introduced as early as some time in the second millennium B.C. About the period when such great Classic centers as Teotihuacan and Monte Albán were flowering and exerting powerful influences throughout extensive areas, however, distinctive kinds of communities, art styles, and probably religions prevailed in the west. Protoclassic and Classic Central Mexico, as well as other nuclear Mesoamerican regions, were characterized by towns and small cities with ceremonial centers dominated by large mound constructions, often with stone and/or plaster facings, arranged around plazas; sculptured stone monuments; smaller carved items of jade and jadelike stones; and much outstanding religious art in general. West Mexico stands somewhat apart, for its communities were obviously smaller on the average, lacking truly monumental mounds and sophisticated stone-plaster architecture. Although relatively simple architecture—some of it probably religious in function—was present in certain areas, particularly the northern lake district of Jalisco (Weigand 1974, 1976, 1979, 1985), perhaps even more important as ritual constructions were the shaft-chamber tombs. Higher-level aesthetic expression seemed to be largely concentrated on ceramic sculptures. Ritual practices may have centered on a cult of the dead, perhaps a kind of ancestor worship, rather than on

a complex hierarchy of powerful independent deities as was typical elsewhere in Classic Mesoamerica.

One of the principal barriers to understanding West Mexican archaeology has been the tendency to assume that West Mexico was merely a marginal appendage to Central Mexico and that the culture histories of the two regions were essentially the same except for minor stylistic differences. This misconception was easy to maintain in view of the geographic proximity of the two regions, as well as the fact that in later periods West Mexican cultural traditions—especially during the Postclassic—became increasingly similar to those of Central Mexico and were strongly influenced from this quarter. These factors promoted the tendency to exaggerate the similarities between the shaft-chamber tomb cultural complexes and contemporaneous general Mesoamerican developments, rather than recognizing the many basic differences that existed.

It was during the period of relative separation from the main currents of Classic Mesoamerican civilization that most of the pieces in the Stafford Collection were produced. Ceramic art, especially mortuary sculpture, represented the pinnacle of the ancient West Mexican aesthetic achievement. Other media—at least what was imperishable—were much less developed. The artistic energies and capabilities of the region's craftsmen appear to have been largely devoted to the production of great quantities of ceramic figures and vessels designed to accompany the dead as mortuary offerings.

West Mexico was not entirely isolated from influences of the great Classic Mesoamerican civilizations to the east, particularly Teotihuacan, at least in Colima (Von Winning 1958; McBride 1969b; Matos Moctezuma and Kelly 1974; McBride and Delgado, n.d.), but these influences do not seem to have been very great. Interestingly, the vigorous tradition of the shaft-chamber tombs and their elaborate ceramic offerings appears to fade substantially at about the same time (c. A.D. fifth–seventh centuries?) as that of the maximum spread of Teotihuacan influence. Whether these events were interrelated is questionable. At any rate, in the Early Postclassic, probably beginning about A.D. 800–900, many Toltec and Mixteca-Puebla influences effectively penetrated West Mexico, especially in the northwest. From this time forward the area obviously participated much more fully in pan-Mesoamerican developments. The distinctive local traditions in ceramic mortuary figures and vessels were absorbed or dominated by these eastern traditions, and the elaborate shaft-chamber tombs apparently were no longer constructed. Perhaps the introduction of new religious-ritual systems from the east, along with associated socioeconomic patterns, was responsible for the demise of the shaft-chamber tomb complex. Whatever the explanation, a unique cultural tradition passed into oblivion. Even after contact with Central Mexico was again largely

Standing Female Figure with Dog (detail)
Colima
cat. no. 139

47

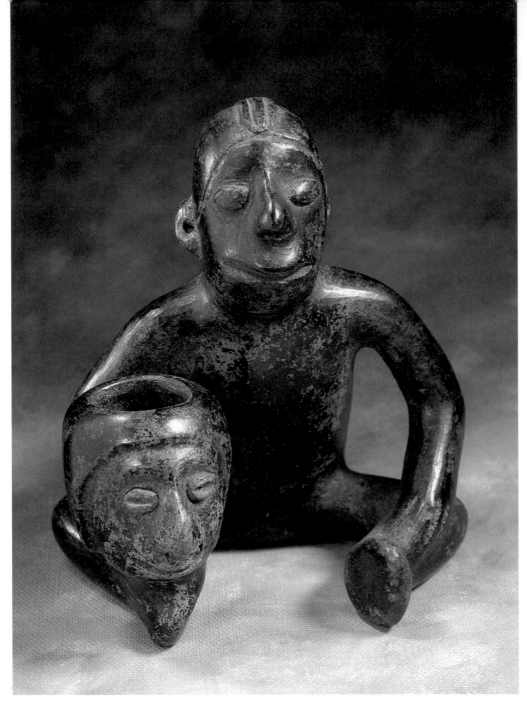

Seated Male Figure Holding Head
Pot
Colima
cat. no. 126

cut off by the rise of the Tarascan empire of Michoacan in the fifteenth century, the art styles of the subsequent cultures of the area lost much of their originality and creative freshness as they joined, as peripheral "country cousins," the larger aesthetic universe of Mesoamerica as a whole. A remarkable world had disappeared, leaving behind a rich legacy in the astounding quantity of highly expressive and variegated ceramic pieces that now grace mantelpieces and museum cases around the world.

THE SHAFT-CHAMBER TOMBS: PHYSICAL FEATURES

The shaft-chamber tombs throughout the arc of their distribution vary greatly in size and form (see figs. pp. 35–37). The shafts reach to a depth of as much as fifty-two feet, and the number of chambers varies from one to five. A short entrance passage almost invariably connects the chamber with the shaft. Most of the tombs were carved into *tepetate*, a water-deposited volcanic tuff, or a similar dense, compacted soil layer. Stone slabs often cover the chamber entrances, and the shafts are usually filled to the surface opening. That great effort was involved in their construction is clear from their often considerable depths and the care with which the chambers were hollowed. According to Furst (1966: 269–72), some shaft-chamber tombs in southern Nayarit contain *claraboyas*, small shafts connecting chambers or connecting a chamber with the surface (the latter for feeding the dead?). He also suggested the possibility that a small shrine was erected over the tomb, where periodic ceremonies could have been held to honor the ancestors below. He believed he had discerned possible traces of such constructions, particularly over Las Cebollas Tomb.

In the northern lake district of Jalisco the shaft-chamber tombs were often excavated below the characteristic circular platforms of the region (Weigand 1985: 67, fig. 2.6); elsewhere there is often little or no surface indication of most of the tombs. Because they usually occur in cemeteries containing as many as fifty tombs or more, occasionally laid out in patterned alignment, once the first is located, diggers continue working in every direction until they have found all the tombs in the cemetery. These cemeteries are often located on elevations higher than the villages where the people lived. There is great variation in the tomb contents. Some have apparently been found empty or virtually so. Smaller tombs sometimes contain only a few items. In others, particularly the multichambered examples, dozens of large, hollow ceramic figures and vessels

and many shell and stone objects are found. There seems to be no positive correlation between the richness of the offerings and the depth of the tomb, although it is unlikely that any over sixteen feet deep was not provided with important objects.

The precise spatial distribution of the shaft-chamber tomb sites remains to be plotted in detail. In spite of certain obvious gaps, they seem to be extensively distributed throughout the oft-mentioned Nayarit-Jalisco-Colima arc. The northern boundary is fuzzy. Tombs may extend as far north as southern Sinaloa (Furst 1966: 208), but this has never been verified. The eastern boundary is also somewhat indeterminate; the tombs extend to the vicinity of Guadalajara and possibly beyond. Aside from the special case of El Opeño, and perhaps just across the Colima border along the lower Río Coahuayana, they apparently have not been found in Michoacan. On the west they extend to the coastal plain, at least in the Ameca Valley, but they are obviously rare there. Certainly the great concentration is in the inland, mostly highland arc between Colima in the south and the Tepic area of Nayarit in the north.

Nearly all the archaeological art objects of West Mexico have been recovered by local farmers and other persons hunting for salable specimens. Although it was known that most were found in tombs, until recently no professional archaeologist had actually excavated a completely undisturbed example of any importance and published the results. Little was understood, therefore, of the precise way in which the figures were arranged in the mortuary chambers. Even more important, the age of the tombs and their contents was uncertain.

Although Disselhoff (1932, 1960) and Corona Núñez (1954, 1955) had contributed to a better understanding of the actual forms of the shaft-chamber tombs and the layouts of their contents, a more intensive kind of investigation was clearly indicated. This came in 1962–64 with the UCLA Magdalena Basin (Etzatlan) Project, directed in the field by the late Stanley Long (Nicholson 1962; Long 1966; Long and Taylor 1966a).

The key tomb was San Sebastián 1, which provided detailed, generally reliable information concerning the interments and associated offerings. Long, in addition to inspecting the original tomb carefully, could analyze what survived of the bones of nine adults (two males, seven females?), two fetuses, and nearly all the objects removed from the single chamber. In addition to many pottery vessels and objects of shell and stone, no fewer than eighteen large, hollow, ceramic male and female figures were found, seventeen of which were available for study. These were of two distinct types, labeled San Sebastián Red (seven) and El Arenal Brown (ten) by Long. The former affiliated with types commonly found in the

Ahuacatlan Valley, to the west in Nayarit; the latter was a well-known Jalisco type. In itself, the presence of these two distinct types suggested to Long the possibility that this tomb—and probably others in the vicinity—were family crypts or saw some other kind of periodic reuse. Because the San Sebastián Red figures consistently displayed a greater amount of manganese dioxide patina, he deduced that they predated the other type. Radiocarbon dates on three shells, obsidian hydration measurements of some of the obsidian artifacts, and ultraviolet fluorescence and organic nitrogen content analysis of the bones also tended to support the hypothesis of reuse. Accordingly, Long suggested the likelihood of at least three reopenings of the tomb and new interments following the original burial extending over a period perhaps greater than two hundred years, the last of which might have been a retainer burial (one male, four females). Others (e.g., Furst 1966) have questioned the reuse hypothesis, suggesting that diverse styles and types of objects were customarily assembled for single tomb interments (see also Weigand 1974; Taylor 1970b).

Long also investigated nine shaft-chamber tombs in four other cemetery sites, making accurate diagrams, recovering objects (both complete and fragmentary, including large ceramic figures) left behind or not discovered by the tomb robbers, photographing tomb pieces in private possession, and interrogating informants who were in a position to provide relevant information concerning the original loci of objects in the mortuary chambers. Some of these tombs had contained a third major Jalisco (?) type of large, hollow figure, which Long, following Kelly's suggestion, labeled Ameca Gray. Because this type displayed features of both of the others, he suggested it occupied an intermediate temporal position.

Although not all the shaft-chamber tombs are of great depth, it appears that many of the ceramic mortuary offerings of the type featured in the Stafford Collection are found within them. Modern tomb robbers take approximately one week to excavate a deep tomb, and the original digging must have taken much longer given that the ancient workmen had no metal shovels or picks (and perhaps worked with only pointed sticks and/or stone picks). It seems likely that the larger tombs were prepared in advance of the death,

49

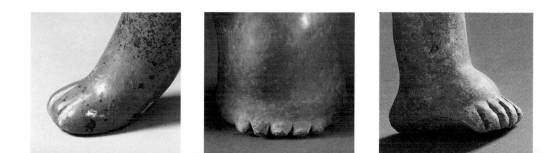

and as previously mentioned, it is also possible that in some cases the tombs were reused and served as family crypts.

The whole shaft-chamber tomb complex is essentially alien to Mesoamerica, and—with one partial exception, the small "*sótanos*" (tombs) of the Mixteca Alta of northwestern Oaxaca (Bernal 1948–49), which occur much later (Late Postclassic)—are found nowhere else in Mesoamerica. Following upon the stimulating discussions of Corona Núñez (1955), Noguera (1955), Furst (1966, 1967), and others, Long (1967a) plotted in an important paper the New World distribution of this type of subterranean mortuary structure and set up a comprehensive typology. The structures are most common and elaborate in northwestern South America, particularly in Colombia and Ecuador. Because some South American tombs are of the same age and occasionally also contain large, hollow figures (usually quite different in style, however, from the Mexican ones), some archaeologists suggest that there may have been a historical connection between the shaft-chamber tomb complexes of the two areas. Although such historical linkages are not currently demonstrable, they remain an intriguing possibility for future verification (see also Meighan 1969, 1974; Smith 1978).

The archaeology of Colombia has yielded many shaft-chamber tombs, large, hollow ceramic figures, and many generic artifact similarities with West Mexico (Labbé 1986). The great diversity of Colombian archaeology and the fact that most of the known comparative material postdates the West Mexican shaft-chamber tomb complex, however, make specific linkages impossible to demonstrate convincingly at present.

Lathrap, in his analysis of ancient ceramics from Ecuador, discusses the origin of hollow figures, concluding that coastal Ecuador may have been the point of origin for such figures beginning with those of the Manabí/Chorrera phase (1975: 55). Chorrera tombs are dated to 1000 B.C., too late for the earliest hollow figures in Mesoamerica but certainly old enough to contribute to the West Mexican assemblages discussed in this essay. Because shaft-chamber tombs and the associated large, hollow figures are not found in Central America, Lathrap suggests that contact with Mesoamerica was probably by sea, a hypothesis that concurs with those of archaeologists who look to South America as an important cultural influence in the introduction into West Mexico of the shaft-chamber tombs and their associated cultural features.

According to the principal alternative hypothesis, the West Mexican tradition would derive from Preclassic Central Mexico via Chupícuaro (Porter 1956, 1969; McBride 1969a) and El Opeño. There are undeniable resemblances in the ceramics of these areas on an early time horizon. Such a derivation, however, would still leave the shaft-

chamber tombs themselves unaccounted for given that they are lacking in Central Mexico, including the Chupícuaro area of northeastern Michoacan/south Guanajuato. In any case, it is clear that both the tombs and their contents were quite distinct from the mortuary patterns contemporaneously prevailing in the rest of Mesoamerica. Some explanation must be sought for the unique tomb-excavating cultures that flourished in West Mexico during this early period.

THE SHAFT-CHAMBER TOMBS: CHRONOLOGICAL EVIDENCE

When the first striking ceramic sculptures of West Mexican origin began appearing in private and museum collections, there was no basis for determining their age other than speculation. Only within the last couple of decades has it been possible to provide real evidence for the period during which these ancient cultures flourished. Because so few of the characteristic objects have been collected under controlled conditions, there are still many uncertainties in the chronology. However, recent efforts by many scholars have provided solid dating evidence for numerous sites and finds.

The lines of evidence that have been applied to determining the age of West Mexican cultures include the use of "time markers," objects or styles of known age that occur in association with West Mexican archaeological finds. An example is the Thin Orange vessel of Teotihuacan age found by Kelly in 1940 in the backdirt of a looted tomb at Chanchopa near Tecoman, Colima; indeed, it was the first substantive evidence for dating the shaft-chamber tomb complex. This became the principal support for equating the period of the West Mexican shaft-chamber tombs and their ceramic pieces with Classic Teotihuacan. Because the Thin Orange vessel was not found under controlled conditions and could not be proved at the time to have been part of the offerings in a shaft-chamber tomb, there was room for skepticism about the dating. The age has been confirmed by subsequent studies, and the association now seems quite secure. The vessel remains unique, however, in light of the fact that no similar clear-cut associations of Teotihuacan-style objects with shaft-chamber tombs have been reported, and none of the tombs for which reliable inventories exist has contained any Teotihuacan or other Central Mexican trade pieces.

Once a given style has been dated in one place, it becomes a time marker in its own right and can be used to date occurrences elsewhere. This is why dated tomb lots of

50

Seated Male Figure (detail)
Jalisco
cat. no. 91

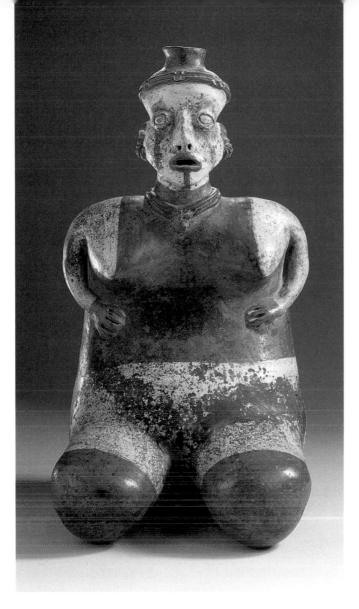

the kind studied by Long are so important: their dates can be extended to many other "unknown" pieces, including those for which information concerning the circumstances of their discovery is lacking.

Radiocarbon dating is the best method for determining the absolute age of archaeological specimens, but it must be noted that many radiocarbon dates are "associational" dates; that is, they do not apply directly to artifacts but rather to charcoal from an ancient cooking fire or some other material presumed to be of the same age as the associated artifacts. This assumption of contemporaneity is the weak link in many age estimates and affords many possibilities for mistakes. It must also be remembered that radiocarbon dates require a sample of organic material: wood, charcoal, basketry, shell, bone, or anything that was once living material. The Stafford Collection is composed mainly of ceramic objects, and because clay is an inorganic material, these cannot routinely be dated by radiocarbon methods. In an interesting and revolutionary experiment Taylor (1970a, 1974) obtained radiocarbon dates directly from sherds, extracting the charcoal that was present from cooking and kiln fires and deriving a date that represents the time the pottery was made and used. This approach resolved an important dating problem at the Morett site in Colima (Meighan 1972), but it is not practical for direct dating of individual museum specimens because it requires several pounds of sherds to yield enough charcoal to enable radiocarbon dating tests to be conducted.

The first application of radiocarbon dating to objects found in West Mexican shaft-chamber tombs occurred in 1965, when three shells from San Sebastián Tomb 1 were dated at the UCLA Isotope Laboratory of the Institute of Geophysics and Planetary Physics (Furst 1965a, 1965b; Long 1966; Long and Taylor 1966a, 1966b). Two determinations on human bones from the same tomb were later added. One of the conch shells from Las Cebollas Tomb 1 was also dated at this time (Berger and Libby 1966: 475). Ranging between 200 B.C. and A.D. 330, these C-14 tests established the chronology of the tomb period of West Mexican archaeology on a reasonably firm basis for the first time. What some had suspected but could not convincingly demonstrate was now virtually certain: at least part of the period of the West Mexican shaft-chamber tombs, with their characteristic mortuary offerings, was coeval with the Late Preclassic and Early Classic periods of Central Mexico.

Taylor (1974) reviewed all the radiocarbon dates from West Mexico including sixty radiocarbon dates from twenty-seven archaeological sites. Many of these dates and sites are not part of the shaft-chamber tomb tradition, but they do relate it to the general history of culture in the region. The site of Cerro Encantado (Jalisco) was reported by Delgado (1969) to have yielded two radiocarbon dates

left
Kneeling Female Figure
Nayarit
cat. no. 60

below
Trumpet
Nayarit
cat. no. 45

3.

All available radiocarbon dates from Trans-Tarascan Michoacan, West Mexico, including those from the tomb cemetery sites, were first listed and discussed in 1969 by Taylor, Berger, Meighan, and Nicholson. This information was substantially expanded and updated by Taylor (1974). A few additional dates are known to us but not discussed because some essential facts (e.g., laboratory numbers) are lacking.

left
House Group (detail)
Nayarit
cat. no. 37

center
Male figure from *Standing Couple* (detail)
Nayarit
cat. no. 16a

right
Mourner (?) (detail)
Nayarit
cat. no. 56a

that he believed dated the large, hollow figures to the second century A.D.; and Bell (1972a, 1974: 158) reported another radiocarbon date (UCLA 1647) from the same site of 1,800 ± 80 years, suggesting that it applied to the horned Zacatecas ceramic figures she discovered in a grave (not a shaft-chamber tomb).[3]

Thermoluminescence is another technique that allows exact dating and applies to all fired clay. This method measures the time since the pottery was fired. Nevertheless, several problems exist in the application of this method in dating pre-Columbian ceramics, which may be grouped into the following categories: some clays are composed

of minerals that exhibit very low or no susceptibility to thermoluminescence; others contain minerals (especially volcanic ones) that show anomalous thermoluminescent behavior. Many clays containing minerals showing low susceptibility to thermoluminescence cannot be dated accurately, but forgeries can be identified and distinguished from authentic ceramics. Some ceramics can be dated. Many of the tests run on West Mexican ceramics tend to fall into the first category. Some thermoluminescence tests on West Mexican archaeological material were reported by Taylor (1974).

Obsidian dating, which measures a hydration layer on the surface of obsidian objects (including chipping waste), can provide age estimates for the time when the obsidian was chipped and a fresh surface exposed. This cannot provide a direct age for ceramic objects, but because West Mexican archaeological sites (including those with shaft-chamber tombs) frequently include quantities of obsidian objects and detritus, there is the possibility of dating site layers, tombs, and graves that contain obsidian. As with the radiocarbon method, these are associational dates that might be erroneous if the apparent associations with tomb remains are inaccurate. There is also a problem in calibration of obsidian

dates and the determination of a correct formula that will yield correct "years ago" answers. In addition to the general problem of determining the rate of hydration, obsidian from different sources (and therefore different chemical composition) may form its hydration bands at varying rates.

Obsidian dates are calibrated empirically by aligning them with radiocarbon dates from the same context as the obsidian pieces; this allows application of obsidian dating to finds for which associated radiocarbon dates are lacking. In spite of the complexities of using this method, it is potentially one of the best ways to date West Mexican archaeological sites and tombs because of the near-universal presence of obsidian in the sites. In addition, from the hundreds of pieces found in a single site, archaeologists can derive hundreds of different age determinations. The method has been widely applied in West Mexico (Meighan, Foote, and Aiello 1968; Meighan 1978). Nearly all published obsidian hydration readings for West Mexico are in the catalogues published by the Institute of Archaeology at UCLA (Meighan, Findlow, and de Atley 1974; Meighan and Vanderhoeven 1979; Meighan and Russell 1981; Meighan and Scalise 1988).

There is no doubt that obsidian dating yields correct ages according to radiocarbon and other dating evidence. Application of the method to the present collection is limited by the failure of those who originally obtained these pieces to retrieve obsidian and keep records of what objects were found together in the tombs. However, there is some indirect evidence relevant to tomb finds, and the method will be very valuable if more tomb lots containing obsidian artifacts are discovered and the obsidian is kept with the rest of the items from the tomb.

THE MORTUARY OFFERINGS: REGIONAL-TEMPORAL TRADITIONS AND TYPES

The mortuary offerings found in the shaft-chamber tombs consist, aside from human and animal skeletal remains, of both ceramic and nonceramic objects. The latter include numerous ornaments and other objects of shell and, occasionally, bone (e.g., trumpets, necklaces, armlets and bracelets, nose rings and earrings, pectorals, and atlatl finger-loops) and stone (e.g., *metates*, or grinding slabs, and *manos*, or grinding stones; axes; obsidian cores, flakes, scrapers, blades, points, and "mirrors"; slate "mirrors" with encrusted pyrites; necklaces; pectorals; and small anthropomorphic and zoomorphic images). Objects made of other

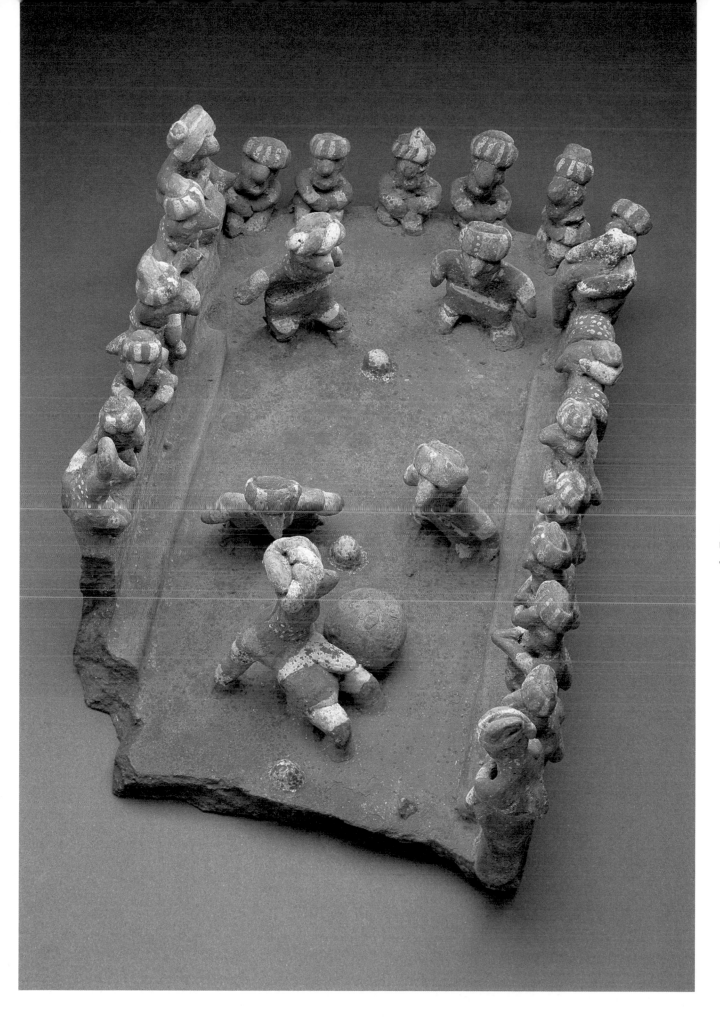

Ceremonial Ball Game
Nayarit
cat. no. 33

53

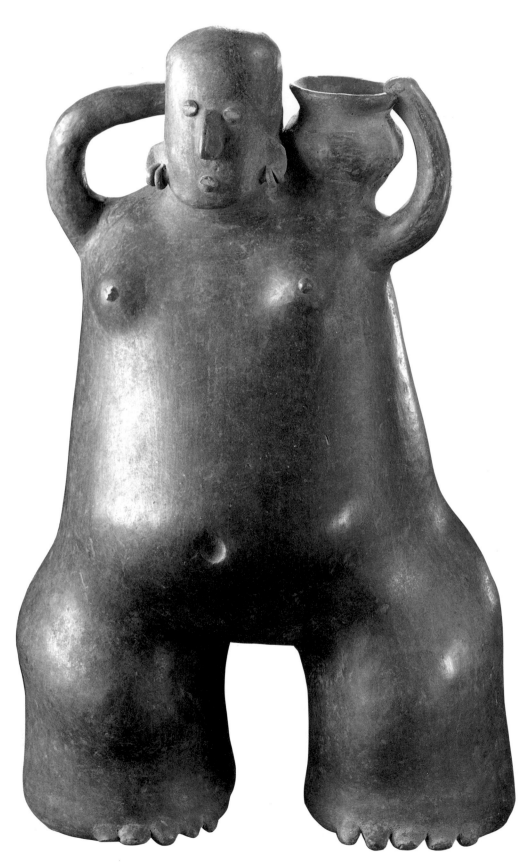

materials (cloth, feathers, wood, basketry, and matting) and foodstuffs and liquids also undoubtedly were placed in the tomb chambers, but these have not survived.

The most important objects from an archaeological and artistic standpoint are the ceramic pieces. These consist principally of anthropomorphic and zoomorphic figures (a few represent inanimate objects), both hollow and solid (the former usually much larger), and vessels. Especially in Colima, the large, hollow figures often served as vessels; sometimes the vessels display figures modeled on their surfaces.

The most comprehensive typology of West Mexican ceramic mortuary pieces yet published is that of Von Winning (1974), to which the reader is referred (see also Krutt 1975, Baus Czitrom 1978). In this brief essay a few general remarks must suffice. Certain broad distinctions have long been generally accepted, particularly the basic tripartite division into Nayarit, Jalisco, and Colima traditions (although the first two have often been merged). They share certain modes, such as the applied shoulder pellets, which are occasionally encountered even on Chupícuaro figures. Finer typological subdivisions have been recognized within each of these major traditions, particularly by Von Winning, Krutt, and Baus Czitrom building on the pioneer efforts of Toscano (1946), Kirchhoff (1946), Kelly (1948, 1949), Gifford (1950), Kubler (1962), Long (1966), and others.

Beginning with Colima, certain gross categories are immediately apparent: (1) the large, hollow, anthropomorphic and zoomorphic figures (often effigy vessels), most commonly of slipped and polished redware (nos. 103– 4, 106–23, 126, 128, 130–31, 147–49, 152, 189, 195; skeuomorphs of inanimate objects (nos. 105, 147, 191[?], 195); (2) large, flattish, solid anthropomorphic figures, both slipped and unslipped (nos. 129, 132, 138, 140); (3) with no sharp division from the last category, small, usually unslipped figures (including zoomorphs), commonly whistles (nos. 133–35, 137, 139, 141–43a-h, j-o, 169, 171), often performing various activities (dancers and other ritual performers, warriors in full regalia, acrobats, women performing household chores and tending babies, musicians), sometimes in joined groups (e.g., dance groups and figures on palanquins carried by bearers) but more often individual or paired (see Kelly 1949: 111–24, for a useful discussion of southern Jalisco-Colima figurines of these two types); (4) rather abstract masks (nos. 144, 146); (5) miscellaneous musical instruments: whistles, flutes, ocarinas, rattles (no. 198), skeuomorphs of conch shell trumpets and drums, among others (Kunike 1912; Van Giffen-Duyvis 1959); (6) house groups (rare and usually with no accompanying figures); (7) an unslipped, grotesque type of anthropomorphic "Janus" *incensario* with loop handles (no. 196; Postclassic?; see discussion of this type

in Disselhoff 1960); (8) "simple" vessels (nos. 187–88) with unsupported olla, jar and bowl forms predominating but also including various exotic and abstract forms (nos. 105, 180, 182–83, 191–92, 194), usually monochrome (sometimes incised but occasionally bichrome and polychrome); (9) vessels with effigy additions, both anthropomorphic, especially rows of heads (nos. 124–25), and zoomorphic (nos. 162, 166); (10) globular vessels, usually somewhat flattened, often ribbed, with zoomorphic (especially parrots) or anthropomorphic tripod supports (nos. 185–86); and (11) phytomorphic vessels (nos. 175–79, 181, 190), almost invariably monochrome.

Within each of these broad categories (a selective, not exhaustive, list) many subtypes can be distinguished based on various criteria: formal qualities, especially configuration of the eyes, posture, costume, activities portrayed (if any), and so on. Worth special mention are the phallic figures (nos. 112, 143c-e)—apparently unique to Colima—and, among the inanimate objects represented, the strange aviform *reclinatorios* (backrests: nos. 108, 143f, l-m). Some of these subtypes undoubtedly have chronological implications, but without the control of systematic excavations, seriations based wholly on pieces removed by nonarchaeologists must be considered tentative, however logical.

The range of zoomorphic representations, including grotesque, double-headed (no. 167) and merged (no. 153), is especially remarkable. Aside from the famous dogs, most of the animals prominent in the environment are represented: armadillo, bat, coati (no. 151), crab (no. 160), deer, fish (no. 162), frog/toad (nos. 163, 165), gopher (no. 158a-b), jaguar, various types of lizards (nos. 156, 161, 166), lobster, monkey, mouse (no. 164), peccary, shrimp, snake (no. 167), squirrel, and turtle (no. 159); and various birds: duck (nos. 170, 173) and other aquatics (no. 168), owl (no. 174), parrot (no. 172), swallow, and turkey (no. 169). The phytomorphic vessels also represent a broad range of plants, especially cacti and food plants (particularly fruits); precise botanical identifications, however, are often difficult. The noneffigy pottery vessels exhibit considerable variety in form and decoration.

As indicated, various subtypes within the Jalisco figure tradition of the Magdalena Basin and adjoining territory were proposed by Long (1966; compare Von Winning 1974: 49–60), who suggested they were chronologically sequent (but probably with some overlap): San Sebastián Red (nos. 24, 48–50, 52–59, 61–62, 66) and its Ojos variant (nos. 51, 60), both classified with the Nayarit tradition in this catalogue; Ameca Gray (nos. 67–69, 71–72, 74–78, 88, 92); and El Arenal Brown (nos. 79, 82a-b, 91). In contrast to Colima, where painted decoration of figures is rare, they are frequently decorated in complex layouts, including much resist, or negative, painting. Other types from this general region, including a number of smaller, solid varieties (nos. 70, 83–

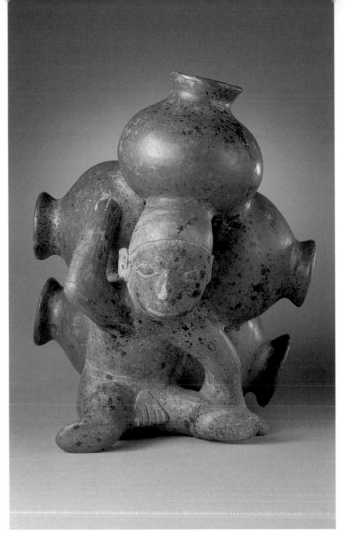

opposite
Female Figure Carrying Bowl
Jalisco (?)
cat. no. 89

left
Seated Male Figure with Five Pots
Colima
cat. no. 117

below
Joined Couple (detail)
Colima
cat. no. 133

55

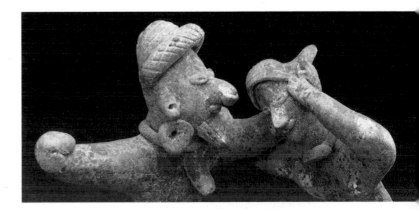

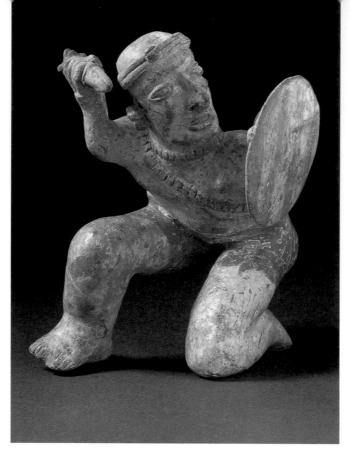

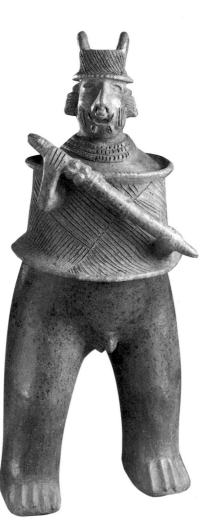

87, 94–95, 97), are also apparent but have yet to be assigned specific labels. Examples are a particularly long-faced type (no. 80) attributed (Parres Arias 1962) to San Juanito, also in the Magdalena Basin (municipio of Antonio Escobedo), and a distinctive type (unrepresented in the Stafford Collection, referred to by Von Winning [1974: 56–57] as the "Sheep-Faced Type"; for typical examples see Gifford 1950: pl. 2d; Parres Arias 1963b, 1965b; Marks 1968: 15, upper left; Von Winning 1974: figs. 176–79) painted in white with elongated heads, headbands or turbans, round earspools, and usually rather pointed ears and facial features, some examples of which have been attributed to the Guadalajara region. A more generalized type, characterized by a brown, brown-black, or black slip—sometimes featuring figures with enormous legs—also appears to belong to this broad Jalisco division (nos. 89–90, 93, 98).

In general, these Jalisco figures display less variety of form and activity than those of Colima and Nayarit. They are often quite large. Male-female pairs, sometimes joined, are known (no. 77). Probably the most striking single representation is the standing warrior (no. 79), wearing helmet (sometimes bicorn) and armor and holding a club, mace, or stabbing spear. It crosscuts Long's types, although it is rare in El Arenal Brown. Animals are uncommon in this tradition—and then usually only the dog (nos. 63–65), here classified as Nayarit. Whether house groups are present is doubtful; if so, they are extremely rare. Although he described in detail many complex or fragmentary vessels from the tombs, Long did not attempt a systematic typology. The unsupported bowl is the commonest form, often decorated in bichrome and polychrome, abstract and stylized design layouts, including those applied with the resist technique.

The Nayarit (often called Ixtlan del Río) types are, like those of Colima, quite diversified (which again may reflect temporal differences). Large, hollow and small, solid anthropomorphic and zoomorphic figures predominate. The zoomorphic figures, confined mostly to the dog (nos. 9, 28) and frog/toad (no. 10), are rare. Conversely, the quantity and variety of the anthropomorphic figures are remarkable. The San Sebastián Red type can also be placed within the broad Nayarit tradition (and is almost invariably so assigned); it can perhaps best be designated Nayarit-Jalisco.

The addition of painted decoration is also common in the Nayarit type, particularly designs (including resist) in white, yellow, and black. Male-female pairs, separate or joined, are especially common in this tradition (nos. 14, 16–18, 20–21, 58). In terms of realism, the larger human figures vary widely. Some strike modern observers as virtual caricatures (nos. 14, 16a-b–18), whereas others are subtly modeled in a more naturalistic mode (nos. 12, 15, 20–21).

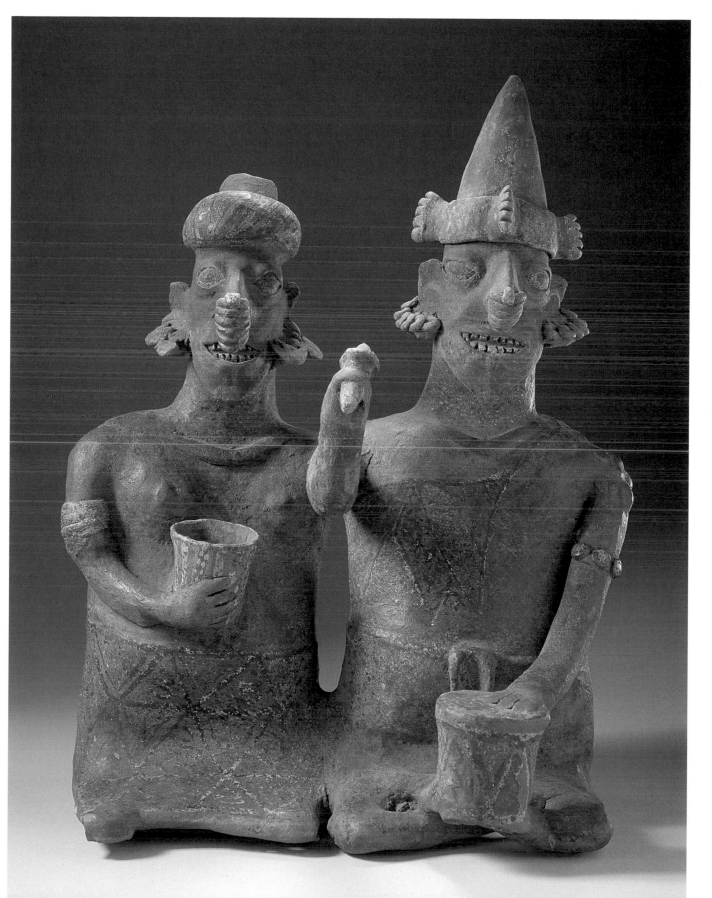

Joined Couple
Nayarit
cat. no. 14

There are many gradations, making it difficult to divide them sharply into distinct categories. The so-called Chinesco group (nos. 1–7, 11) has been broken down by Von Winning (1974: 69–74) and Gallagher (1983: 108) into various subcategories, although the groups merge in a rather complex fashion.

The so-called armed warrior, often with a bicorn helmet, is common among Nayarit figures. Another frequent male headdress—on armed warriors as well as other types of figures—is conical or peaked, often with a kind of heavy fringe depending over the forehead (nos. 12, 14–16a, 27, 34). The twisted headband is worn by both sexes (no. 17a-b). Plain headbands, however, constitute the commonest headgear (no. 18). Diseased and emaciated figures (nos. 23, 38; Ramos Meza 1960; *Pfizer Spectrum* 1965; Weisman 1966; Von Winning 1986) are frequent, as are those, both male and female, exhibiting remarkable mutilation patterns, usually parallel groups of slits on the cheeks and around the mouth (e.g., in the Nayarit-Jalisco San Sebastián Red type, nos. 57–58a-b). An extraordinary, penitential, "joining" ritual involves groups of such figures (nos. 19, 22). Some features of costume and ornamentation are particularly characteristic of the Nayarit tradition; for example, the short-sleeved shirt for males not quite reaching to the crotch (nos. 12, 15; a similar garment, somewhat longer, was worn by the historic Tarascans of Michoacan); very short trousers with scoop loincloth, also worn by males (nos. 14, 16a); a small mantle tied over one shoulder with cords—in contrast to the mantle knotted over one shoulder in the rest of Mesoamerica (no. 18); the female loincloth (nos. 20, 23); the curved or angular nose bar (nos. 16a, 17b); and nose rings and earrings in profusion (nos. 12, 14, 15, 17a-b–18, 23).

The complex scenes involving numerous small, solid human and animal figures (nos. 25, 30, 32, 35)—particularly the house groups (nos. 26, 29, 37; Borhegyi 1964; Lehmann 1964; Von Winning 1969a, 1971; Von Winning and Hammer 1972), the ball court scenes (no. 33; Taladoire 1979), the funeral processions (Von Winning and Stendahl 1968: pls. 156–57), the pole ceremony (no. 34; Bernal 1949), and the battle scenes (Von Winning 1959; Von Winning and Stendahl 1968: pl. 154)—constitute an especially striking type within the Nayarit tradition. In detail and elaboration there is nothing fully comparable with them in the entire pre-European New World. Their ethnographic value is enormous. The most common forms of vessels associated with the figures are unsupported bowls, jars, and ollas, but more complex shapes (nos. 40–41), including tripod vessels, are also known. Bichrome- and polychrome-painted decoration (including resist) is common. Gifford (1950) has worked out a preliminary typology for Early Ixtlan based on surface-collected and stolen pieces, which has been refined by Von Winning and Krutt. It is hoped that future strati-

graphic excavations will clarify the sequential relationships among the different Nayarit types.

Of interest is the question of whether the tomb offerings were made specifically to be buried with the dead or whether some at least might have been household possessions that were used prior to being placed in the mortuary chambers. It was suggested earlier that the former view is correct. However, occasionally some of the tomb pieces show signs of wear and must have been used to a certain extent prior to their tomb deposition. And it is not impossible that some of the anthropomorphic ceramic figures represented specific individuals, perhaps including ancestors. They might have been kept in the homes of the people—or even in shrines—until their use in a mortuary ritual. Notwithstanding the salutary surveys of Weigand and others, we appear to lack detailed information concerning the domestic lifeways in the villages occupied by the excavators of the shaft-chamber tombs that might answer this question. In any case the deepest and most elaborate shaft-chamber tombs were probably prepared during the lifetime of the individuals who were to be buried there, as in ancient Egypt and in other early cultures that placed great stress on mortuary ritual and a continued life in the afterworld.

The Shaft-Chamber Tombs: Ethnographic and Iconographic Features

Finally we come to the problem of ethnographic and iconographic interpretations, a complicated and difficult topic that can only be briefly outlined here. In general, the great ethnographic value of these mortuary offerings is so obvious as to almost constitute a cliché. They illustrate a wide range of sociocultural patterns (although important sectors of the culture are not depicted), more so certainly than any other Mesoamerican tradition (in Mesoamerica approached only by the Gulf Coast cultures and that of the makers of the Jaina figurines). In the pre-European New World probably only the Moche-Chimu tradition of North Coast Peru provides a more complete cultural "ceramic picture book." A partial list of principal topics portrayed would include physical appearance of the population, clothing, and ornamentation (including mutilation and the effects of disease); many tools, weapons, and other artifacts; dwellings and probably ceremonial and other structures and activities within or associated with them, including food preparation and child care; rituals (including funerals and possibly weddings); games; military activities; and wild and domestic animals and plants in their environment (mostly confined to Colima).

Male figure from *Joined Couple*
(detail)
Nayarit
cat. no. 18

58

The problem is to decide which ethnographic analogy is appropriate to the objects found in the ancient West Mexican shaft-chamber tombs. We must project our comparisons to a time about two thousand years ago. This always poses serious problems; comparisons with more recent peoples may not be apt because meanings and functions of ancient objects may have changed with time (see Kubler 1970, invoking Panofsky's principle of disjunction). Nevertheless, archaeology depends heavily on ethnographic analogy. In this case ethnographic analogies may be sought among three disparate groups of historical peoples: the sixteenth-century peoples of western and Central Mexico; the remnant and marginal groups, such as the Huichol, who still live in the highlands of western Mexico north of the tomb arc; and, further afield, the native peoples of northern South America, where shaft-chamber tombs and their related mortuary traditions are also found. Each of these

analogies offers some insights in the interpretation of the shaft-chamber tomb complex, but each also has significant weaknesses and potential sources of incorrect perceptions.

Traditional interpretation has related the West Mexican area to the more highly developed region of Central Mexico and has assumed that early West Mexico was primarily a recipient of the developing civilizations of Mesoamerica, whose heartland lay to the east. This does not seem to have been the case for the shaft-chamber tomb era, during which time West Mexico appears to have been essentially a culturally distinct area with its own local traditions. Thus probably only limited use can legitimately be made of analogies with the sixteenth-century populations of western Mexico because the cultural patterns of many of these groups by that time had been heavily influenced from Central Mexico and neighboring areas to the east.

Ceremonial Dancers (?)
Nayarit
cat. no. 19

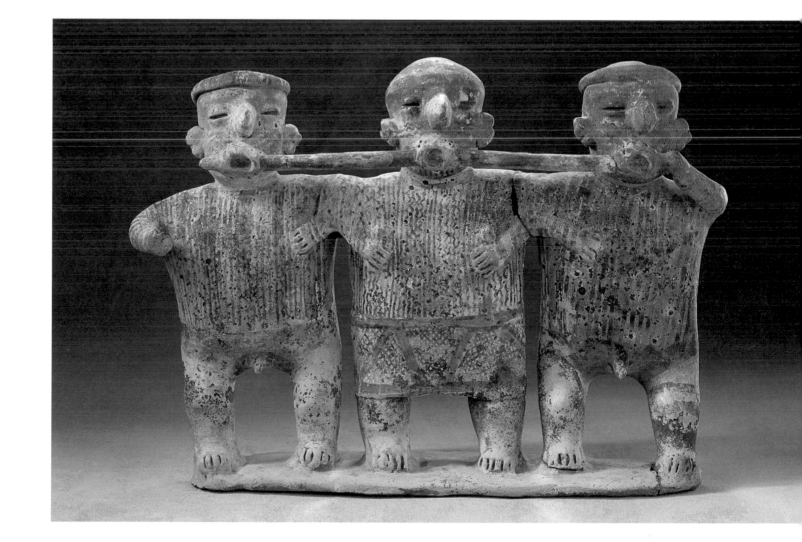

4.

A Colima effigy piece (Von Winning and Stendahl 1968: pl. 83) represents a kind of grotesque face, probably a mask (see also cat. no. 111), which displays features vaguely resembling those of Ehecatl, the wind/fertility deity of various late Mesoamerican cultures. This similarity may be fortuitous.

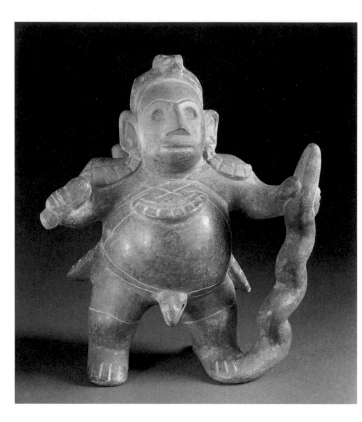

Shaman (?)
Colima
cat. no. 113

Acrobat
Colima
cat. no. 134

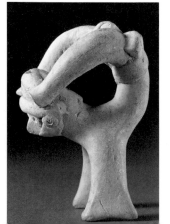

The analogies stressed by Furst (e.g., 1965c, 1966, 1973, 1974b, 1975, 1978, 1985) and others are based on the assumption that the existing marginal tribal peoples, particularly the Huichol, are most likely to be the descendants of the ancient people who created the shaft-chamber tombs and that modern Huichol concepts of shamanism and religion may well include survivals of the ancient West Mexican belief system, thus providing the best ethnographic analogy we are likely to have. Although this approach seems plausible and has been accepted by many scholars, it is problematic. Not only may the meanings have changed with passage of the centuries, but the contemporary relict Huichol may not have attained the cultural complexity of the creators of the shaft-chamber tomb traditions that must have been closely related to their religious-ritual systems. Critics could point out that using the Huichol to explain the significance of objects found in the shaft-chamber tombs is like using a contemporary Maya farmer to explain Classic Maya religion. Such an approach is certainly not without potential value, and it may be the best methodological technique available, particularly as one means of generating hypotheses, but its limitations must be recognized.

Finally, on a comparative basis we might assume that some of our best analogies would be with indigenous peoples of northern South America, particularly Colombia, which in ancient times displayed a parallel shaft-chamber tomb tradition. However, this comparison introduces the problem not only of considerable chronological difference but also great geographic distance. For this reason little in the way of detailed comparison has been attempted by scholars, although this approach would seem to remain an interesting possibility for future studies.

One of the most difficult questions concerning the interpretation of West Mexican mortuary ceramic figures is whether genuine supernatural beings are represented. Considerable differences of opinion prevail here. Most earlier students (Kirchhoff 1946; Toscano 1946; Covarrubias 1957) emphasized the secular orientation of this art, at times flatly affirming that no deities or even deity-impersonators are represented. Certainly ritual performers (dancers, both masked and unmasked, phallic performers, musicians in what is probably a ritual context) are depicted and, quite possibly, religious practitioners (priests or shamans [e.g., fig. 113]) as well. Whether any particular figure actually represented a clear-cut image of a discrete deity as such—an "idol," if you will—is perhaps doubtful.[4] In this connection it might be worth noting that among the thousands of Mesoamerican Preclassic clay figurines (even Olmec and Olmecoid), very few can be interpreted positively as depictions of specific deities. Not until Classic times does this appear to have become common, especially in Oaxaca, and it is precisely during the Early Classic period that West Mexico appears to have been most isolated from direct influences from the remainder of Mesoamerica.

This discussion inevitably leads to the most fundamental question of all: What was the specific purpose and function of these ceramic figures? Why were they placed in the tombs and burials? Unfortunately, with no concrete ethno-historical data to guide us, speculation must rule. Some (e.g., Toscano 1946) have suggested that these figures, super-naturally vivified, were thought to continue their earthly existence in the afterlife. In this view they would have represented both the deceased (the diseased figures representing the fatal illness?) and his or her retainers (spouse or spouses, servants). It is possible that retainer sacrifice and interment was a feature of the mortuary complex associated with shaft-chamber tombs, as it was in other parts of Meso-america. As Toscano pointed out, considering that hunchbacks and other deformed persons were a standard fixture of the palace retinues of late pre-Hispanic Central Mexican rulers, the hunchback figures (particularly common in Colima; no. 131) might lend this hypothesis some support. So might the figures ("palace" servants and/or slaves?) carrying various objects with the tumpline, which are frequent in Colima (nos. 108–9, 117, 123). Along this line Toscano also linked the Colima dog figures with the late

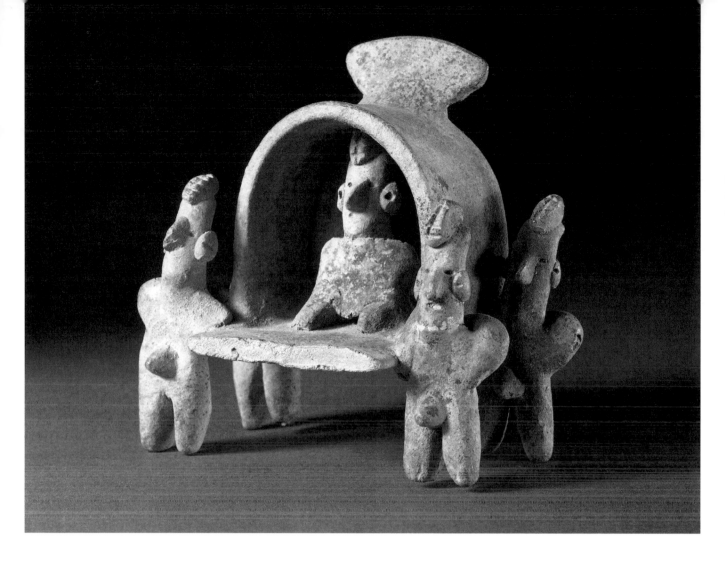

pre-Hispanic Central Mexican custom of slaying the deceased's dog, who was believed to ferry its master's soul across the River of the Underworld to his final resting place on the other side. Again, the precise function of most Preclassic and Classic Mesoamerican figurines (often placed in graves; e.g., Tlatilco, Jaina) is also uncertain. This problem of the specific purpose of ceramic figures, therefore, is by no means confined to West Mexico.

One basic ethnographic interpretation, particularly for Colima, seems likely (Kirchhoff 1946). These societies must have been characterized by some significant degree of stratification, with an elite group possessing considerable power and prestige. The mere existence of deep shaft-chamber tombs with as many as five carefully constructed chambers would suggest a considerable degree of social differentiation. The great expenditure of time and labor necessary to construct such elaborate mortuary chambers would most likely have been expended particularly on behalf of members of an important upper class (the members of ruling dynasties) rather than every member of these societies. Furthermore, the palanquins of Colima (no. 135), borne by four to eight bearers, give evidence of clear-cut status distinctions—as, perhaps, do the male figures, often holding what appear to be fans (a badge of rank elsewhere in Mesoamerica), leaning against the strange aviform reclinatorios (nos. 143f, l). The same might be true of

"umbrellas" (no. 35), and, as Kirchhoff suggested, four-footed stools on which males are seated (no. 127) may also have been rank indicators as in other parts of Mesoamerica (e.g., Tarascan Michoacan, Tlaxcala, and neighboring provinces). Figures seated on stools are not generally present in other parts of Mesoamerica but are prominent in the archaeology of West Mexico and northern South America; they also occur in Costa Rica. What appear to be elaborate Nayarit funeral processions imply clear distinctions of social class. A high social position for at least some women is suggested by various data, above all their presence alongside male figures on Colima palanquins (Mexico: Secretaría de Educación Pública 1946: pl. 81). The large, complex, two-story structures of some of the Nayarit house groups could be considered additional indicators of rank-status differences (residences of rulers?), as well as the considerable variations in elaborateness of attire of figures within the same tradition.

Certain classes of figures have given rise to several "obvious" interpretations based on appearances, such as the armed warriors, ball players (male figures holding balls; no. 13), mourners (?) (seated figures, often emaciated, leaning their heads on their arms; nos. 48–52, 56a-c), musicians (playing a variety of instruments; nos. 5, 14, 24–25, 103, 106, 143d, m-o), imbibers (possibly sucking liquids through tubes in vessels (?); no. 17a), dancers (in animated poses, often

Male Figure with Monkey on Back
(details)
Jalisco (?)
cat. no. 98

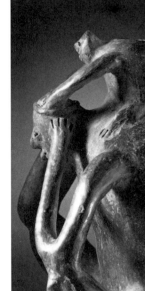
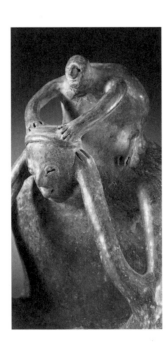
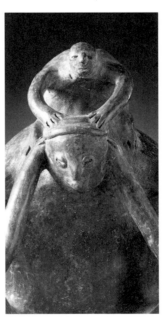

masked and/or wearing elaborate costumes; nos. 111, 113, 143a, c-e), acrobats (nos. 116, 118, 134), and others. Some of these interpretations may well be legitimate; others probably are not.

To take one representative example, an alternative explanation that has been suggested for the "mourners" is that such figures depict individuals in a narcotic trance from peyote or other hallucinogenic drug. Among the contemporary Huichol, persons in peyote trances sit the same way as do these figures. Given that peyote is a sacred plant of the deepest religious import, used as a means of passage to the spirit world, such a figure would be highly appropriate in the tombs of individuals involved in a peyote cult-type religion. At the time of the Conquest the peyote cult was flourishing among the groups located mostly north and east of the Río Grande de Santiago, known to the Central Mexicans as Teochichimeca; they apparently included the Cora, Huichol, Tepecano, Cazcan, Zacateca, Guamares, Cuachachil, and their neighbors. Whether this cult can be projected back many centuries and to another area located somewhat to the south is questionable. The characteristic peyote cactus bud may be represented in Colima ceramics, but this is not certain.

As mentioned, Furst has particularly emphasized ethnographic analogy in interpreting the significance of West Mexican figures, at times throwing out a virtually global net, especially in his interpretation of the "horned" Colima "warriors" as shamans (invariably, he maintains, depicted with a sinistral orientation) with "horns of power." He even cites at length the observations of modern Huichol medicine men when shown these figures or photographs. However, it is one thing to admit the likelihood that some of the mortuary figures, particularly some of the Colima figures, represent religious practitioners (shamans or priests—these societies were probably on a sufficient level of complexity to have had the latter, as elsewhere in Mesoamerica). It is quite another to interpret all the single-horned Colima figures and the double-horned Nayarit and Nayarit-Jalisco ones who display obvious martial attributes as "shamans whose frequently explicit fighting stance is related, not to any earthly warfare, but to the supernatural struggle against underworld demons threatening the deceased" (Furst 1965c: 60).

Whatever the precise significance of the horn(s), the more obvious interpretation of these figures as secular warriors in fighting gear is perhaps at least as likely as the hypothesis that they represented shamanic guardians of the dead. It is, of course, possible that both interpretations have some value. The discussion by Furst relates to the minority of figures with single horns, but even if the shamanic interpretation of these figures is considered probable, it may not be applicable to the diverse kinds of warrior figures seen in the total assemblage, which includes warriors with various

kinds of armor and accoutrements, some with two horns, some with pointed helmets, and so on.

Another interesting example of the use of ethnographic analogy to interpret a certain type of figure frequently found in the tombs is that of Delgado (1969), who explains the "babe in cradle" figures (nos. 94–95) as representing corpses on biers prepared for burial (Von Winning and Hammer 1972: 31–41). He notes as analogy modern mortuary practice in Ajijic, a mestizo town (descended from a native Cazcan or Nahua-speaking community) on the north shore of Lake Chapala in Jalisco. Some details that are consistent with such an interpretation include the projections on either side of the head, which can hardly represent a pillow or headrest but may be intended to hold the head in place, and the fact that the figures are tied to the platform with bands across the body. Weisman (*Pfizer Spectrum* 1965), by contrast, interprets these as "figures lying on primitive hospital beds." Lehmann (1951, 1953) had earlier suggested that they are sick persons being treated by shamans, whereas Morss (1952) holds that they represent infants lashed to cradleboards. These differences of opinion are typical of the problems encountered in attempting to arrive at solid, convincing explanations of the meaning, purpose, and function of many West Mexican mortuary ceramic pieces.

To cite another example: How are the Colima biomorphic figures (apart from the dogs) to be interpreted? Toscano suggested that the animal figures depicted the *nahual*, the "guardian spirit" or "companion animal" of the deceased. But some of the animals, especially the maritime ones, do not seem to qualify well for such a role, not to mention the problem of the group representations (especially pairs and trios of ducks; no. 173). Most are also vessels and may have contained foods and liquids placed in the mortuary chambers to accompany the deceased to the afterworld. Precisely why they represent these particular animals and birds, however, is obscure.

Other figures for which an interpretation based on ethnographic analogy might be suggested are the paired couples: a man and woman modeled as a single piece of ceramic sculpture, particularly characteristic of Nayarit (nos. 14, 18). In terms of our own culture patterns, these could be (and often are) interpreted as marriage scenes. Alternatively the pairs could well represent ritual performances of some kind. The man often holds what appears to be a rattle; the woman, a small bowl or cup in one hand with the other arm around the male figure. They may be scenes of a man singing and chanting, the woman holding an offering (or perhaps some narcotic to be taken by the man).

A separate issue is the identification and analysis of the many objects and appurtenances shown on the tomb figures. These include clothing, weapons, armor, pottery cups and vessels, musical instruments, and beads and ornaments.

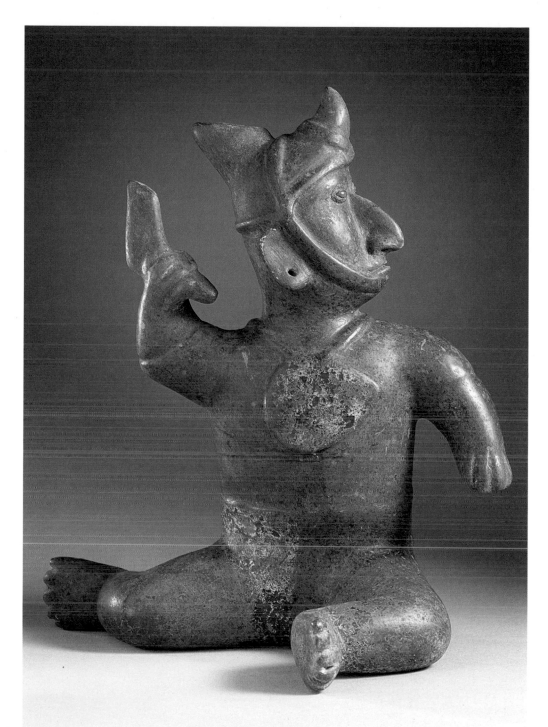

Seated Warrior
Colima
cat. no. 115

63

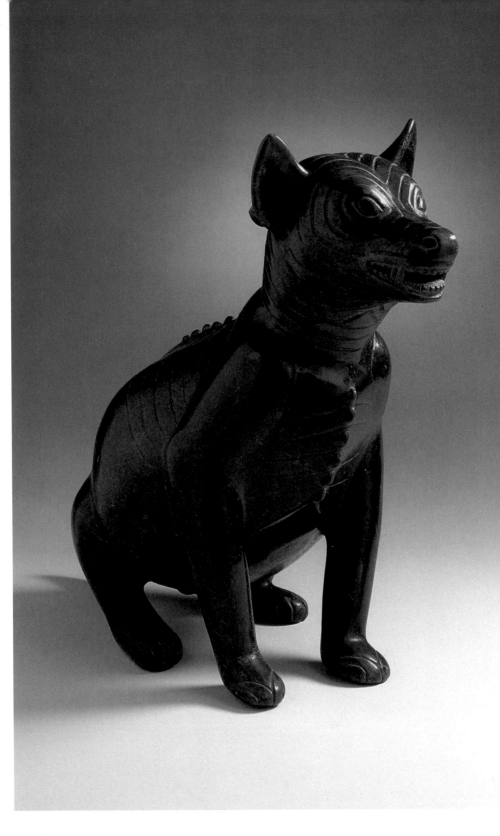

Large Dog
Colima
cat. no. 148

Some of these accessories are modeled in the clay; others are depicted by painted representations. Archaeologists can inspect the collections from the sites to see if any have been found as artifacts and can gain fuller cultural information from them rather than relying only on simplified representations on the figures.

Von Winning (1974: 25–27) provides a comprehensive list of objects and adornments represented on the tomb figures and points out that even naked figures have at least one item of jewelry. Of his extensive list of accompaniments, what items have been found archaeologically? We do not expect to find perishable items such as garments, the bags carried by many figures, wooden objects, remains of food offerings, and the like (although had the tombs been excavated by trained archaeologists, we would expect that traces of many of these things might have been recovered). What remains in tombs and village sites of the same period are the imperishable items made of stone, bone, shell, and clay.

Of pottery, the tombs contain many vessels aside from the figures themselves, including some identical to the small bowls held by some of the tomb figures. Also found widely in West Mexico are pottery whistles, rattles, and flutes (Crossley-Holland 1980). Other musical instruments occurring with the figures and also found as archaeological specimens include bone rasps, turtle carapace rattles or drums, and shell trumpets (no. 45).

The warrior figures portray armor, shields, clubs, atlatls, and slings. None of these has been found archaeologically, and only the chipped stone points of weapons and the curved shell or ceramic pieces that served as atlatl finger loops have been recovered.

The personal adornments portrayed on the figures are represented by a considerable variety of shell ornaments: solid and ring-shaped earspools and shell objects used as nose clips or ornaments in the septum. Rods worn in the nose are also shown; these were probably made of bone, but no actual examples are known. Many shell beads, pendants, and ornaments have been recovered, some from the shaft-chamber tombs themselves and many from contemporaneous sites. Shell arm rings have also been found; these are generally classified as bracelets, although Von Winning (1974: 27) points out that they occur on the upper arms of the figurines.

It is curious that no earrings have been found among the many adornments that can be recognized in the archaeological record. Earspools, both solid and ring-shaped, are well represented in West Mexican archaeological collections, but earrings are not recognizable in existing collections, and so far as is known none has been found in any of the tombs. Both Nayarit and Jalisco-style tomb figures often show multiple rings along the edges of the ears (nos. 13–18, 82) and perforated earlobes occur sporad-

ically in several styles. Such perforations, and sometimes multiple perforations along the edge of the ear, constitute a stylistic feature common in northern South America, where figurines have been found with metal earrings in place. They are portrayed on the West Mexican tomb figures as small rolls of clay that are "clamped" to the ear, but this is probably a function of the difficulty of manufacturing fine details in clay.

The earrings may have been made of perishable material such as fiber or cordage, but this seems unlikely. An interesting possibility is that some of these multiple earrings might have been metal. We know of no metal objects of the antiquity we ascribe to the West Mexican shaft-chamber tomb figures, though metal was in common use in South America by that time. The oldest dated metal objects in West Mexico are placed at about A.D. 600–700, three to five centuries later than the dated shaft-chamber tomb figures, and a great abundance of metal artifacts is characteristic of the Postclassic after A.D. 900. Nevertheless the oldest metallurgy in Mesoamerica appears to occur in West Mexico, and this is one of the features convincingly attributed to an introduction from South America by sea (Mountjoy 1969). Furthermore, later contexts do yield a considerable number of small rings made of copper wire (Mountjoy and Torres 1985: 141).

Given that metal is the most obvious material to use for the earrings portrayed and that nothing else in the archaeological record could represent such earrings, the multiple earrings shown on West Mexican shaft-chamber tomb figures are intriguing indications of some interesting possibilities. First, the use of metal may be older in West Mexico than is now known. Second, some of the tomb figures may continue later than our present dating evidence would indicate. Neither possibility is proven; however, it would not be surprising to find one or both borne out when fuller information is acquired.

Unfortunately, the uncontrolled way in which most of the shaft-chamber tombs have been dug compounds the problem. It is the tomb figures that have market value, and looters rarely collect plain pottery vessels or other small objects that may be present. In the excavations at Amapa (Meighan 1976) hired diggers referred to the copper objects in the site as "wire" and would throw them away as valueless unless trained to look for and collect them. Hence even if copper earrings were present in the tombs, it is unlikely they would be observed or collected. Gold objects, of course, are another matter, but there are no indications that gold has ever been found in shaft-chamber tomb contexts, although both gold and silver artifacts are known from later periods in West Mexico (Mountjoy and Torres 1985: 154ff.; Kelly 1985). All the West Mexican objects of precious metals have been considered Postclassic in age, but it is clear that copper objects at least are found in earlier contexts.

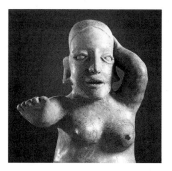
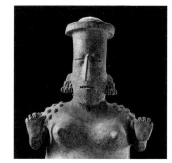

top left
Kneeling Female Figure (detail)
Jalisco
cat. no. 74

top right
Seated Female Figure (detail)
Jalisco
cat. no. 80

Seated Male Figure Wearing Necklace
Colima
cat. no. 104

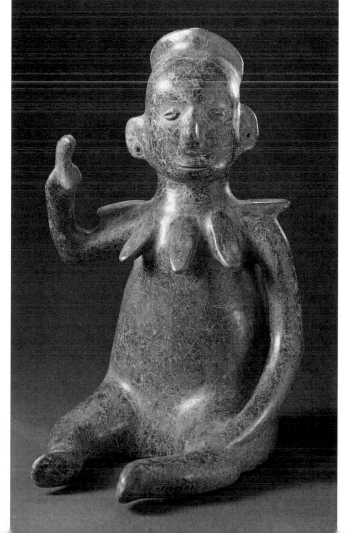

65

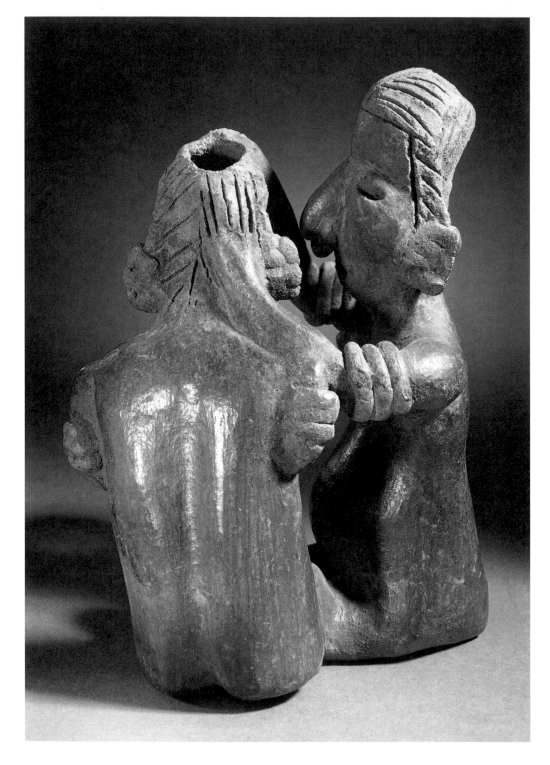

Not only are representations of artifacts found on the tomb figures, but interesting examples of animals and plants are reproduced in the form of vessels or adornments. The plant representations especially could yield important information about plants used by the shaft-chamber tomb peoples. We presume that the people of this era were primarily dependent upon standard New World crops, but there is no direct evidence for agriculture, and no shaft-chamber tomb has yielded preserved plant remains. It is remarkable how few such representations are present. The figures are almost never depicted holding identifiable plants or foods. Some vessels appear to represent squash or gourds (nos. 176, 190; Gallagher 1983: fig. 93), and one may depict a cherimoya (no. 193), but contrary to statements that have been made in the past, virtually nothing in the shaft-chamber tomb collections can be used as evidence of crops. Lacking entirely are representations of the key staples: beans and maize. This is in sharp contrast to later Meso-american cultures and even sharper contrast to such other representational ceramic assemblages as those of the Moche in Peru, whose realistically modeled ceramics include the full range of cultivated plants as well as representations of bowls of harvested foods.

Faunal representations in West Mexican shaft-chamber tomb ceramic sculpture are most commonly dogs, but other representations include wild animals: snakes, birds, turtles, coatis, armadillos, and marine creatures such as fish and crabs. Most of these are not food animals, and the meaning of most of these figures remains obscure.

Although our understanding of the precise meaning of the West Mexican shaft-chamber tomb ceramic figures remains fragmentary and uncertain, our appreciation of them as art objects is enhanced by even a partial under-standing of what the artists might have been thinking when creating these dramatic and expressive images. Detailed interpretations still remain to be worked out, but the overall purpose of these pieces seems most likely to be related at least in part to the makers' religious-ritual practices. This treatment of ethnographic-iconographic interpretations could be greatly extended, but sufficient examples have been adduced to illustrate the problems and challenges inherent in this type of analysis.

CONCLUDING OBSERVATIONS

The foregoing discussion, though too brief to cover all aspects of the rich and complex archaeology of West Mexico, should at least provide a general notion of current knowledge of the period of the shaft-chamber tombs and

contemporaneous burials of Nayarit, Jalisco, and Colima. The Proctor Stafford Collection was the subject of the first major exhibition in the United States dedicated solely to aesthetically superior pieces from West Mexican cemeteries. The collection provides an excellent cross-section of the creative genius of a group of culturally related peoples whose very existence had apparently long been forgotten when Europeans first reached the area. Only in relatively modern times have the remarkable objects they placed in their tombs and burials in such profusion been extracted in quantity and exposed to the curious, not fully comprehending scrutiny of collectors, museum visitors, and puzzled scholars.

Largely in this century a lost world of ancient America has been suddenly revealed. No hieroglyphic texts or even oral traditions are available to aid in the reconstruction of their histories or their beliefs. Only careful archaeological analysis of all extant mortuary and domestic pieces, combined with additional field investigations, can further our understanding of these long-vanished tomb excavators and extraordinarily gifted artists. Fortunately the essentially realistic depiction in durable fired clay of their cultural and natural world provides unique reconstructive opportunities. Much has been done, but much remains to be done. It is hoped that the catalogue of this remarkable collection will add significantly to our knowledge and appreciation of some of the most interesting and intensively vital cultures that ever flourished in the Western Hemisphere.

opposite
Joined Couple Delousing (?)
Nayarit
cat. no. 53

Mask
Colima
cat. no. 146

67

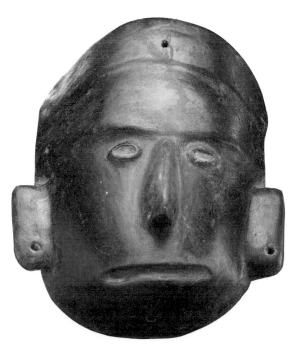

Chronological Chart of West Mexican Archaeological Cultures

This chart includes carbon-14 determinations on materials from sites other than shaft tombs. Abbreviations and numbers (e.g., UCLA 593) are numbers of radiocarbon samples that fall at the indicated time level and serve to date the associated named culture. Where these occur on the chart, direct dating of the remains by carbon-14 is indicated. Where they do not occur (e.g., Tuxcacuesco), it indicates that age is estimated on the basis of stratigraphy and stylistic similarity with finds in other sites. The dates of samples marked with an asterisk (*) are uncorrected.

68

STATE	NAYARIT			JALISCO							COLIMA				
ARCH. PROVINCE	NORTH NAYARIT		SOUTH NAYARIT	AMECA	CHAPALA	AUTLAN-TUXCACUESCO		RÍO BOLANOS	CIHUATLAN	SOUTH JALISCO	COLIMA			REFERENCE CHRONOLOGY	
SITE	Amapa	Peñitas	Ixtlan	Magdalena		Autlan	Tuxcacuesco	Totoate	Navidad	Tuxpan	Colima	Morett	Tesoro	BASIN OF MEXICO	PERIODS
	Amapa		Early Ixtlan del Río	El Arenal								UCLA 1034	UCLA 148		
500								GX 610 GX 609				UCLA 187		Xolalpan (Teotihuacan III–IIIA)	
400	Gavilán			UCLA 593C UCLA 1032 UCLA 966											
300				Ameca							Michigan 2341A*	UCLA 797 UCLA 912 UCLA 910		Tlamimilolpa (Teotihuacan IIA–III)	Early Classic
200		Tamarindo UCLA 973					Tuxcacuesco				Ortices-Chanchopa Chanchopa Tomb UCLA 1066			Miccaotli (Teotihuacan II)	
100			Tequilita Shaft Tomb UCLA 1012								UCLA 1438	UCLA 911 UCLA 909 UCLA 790 UCLA 798		Tzacualli (Teotihuacan I–IA)	
A.D. / B.C.				San Sebastián				Early Totoate				Early Morett UCLA 795 UCLA 188		Chimalhuacan/ Patlachique	
100				UCLA 593B UCLA 593A										Cuicuilco/Tezoyuca	Late Preclassic
200														Ticoman III Late Cuanalan	
300											Michigan 2341B*				
400										Michigan 2249*					

Radiocarbon Dates:
West Mexican Shaft-Chamber Tombs

LABORATORY	SITE	SAMPLE MATERIAL	C-14 AGE *(corrected*)*	ARCHAEOLOGICAL ASSOCIATIONS
UCLA 1012	Las Cebollas Tequilita Nayarit	Caribbean species marine shell	A.D. 100	Tomb containing Chinesco-type ceramic figures, vessels, etc.
Michigan 2249	Rancho del Escritorio Tuxpan, Jalisco	Shell	400 B.C.	Rifled tomb containing Comala-phase (?) offerings
UCLA 593A	San Sebastián Etzatlan Jalisco	Caribbean species marine shell	140 B.C.	Tomb containing both San Sebastián Red-type and El Arenal Brown-type ceramic figures, vessels, etc.
UCLA 593B	"	Pacific species marine shell	120 B.C.	
UCLA 593C	"	"	A.D. 400	
UCLA 966	"	Bone collagen	A.D. 300	
UCLA 1032	"	"	A.D. 335	
UCLA 1066	Chanchopa Tecoman Colima	Pacific species marine shell	A.D. 100	Tomb containing Ortices-phase offerings
UCLA 1438	Colima tomb site	Pacific species marine shell	A.D. 105	Rifled tomb containing offerings of uncertain phase affiliation
Michigan 2341A	Loma del Volantin Alcuzahue, Colima	"	A.D. 260	Rifled tomb containing Ortices-phase offerings
Michigan 2341B	"	"	280 B.C.	"

*Pacific shell dates corrected for ocean upwelling; Michigan dates uncorrected (shell not identified as either Pacific or Caribbean). Bone dates tree ring calibrated.

Nayarit

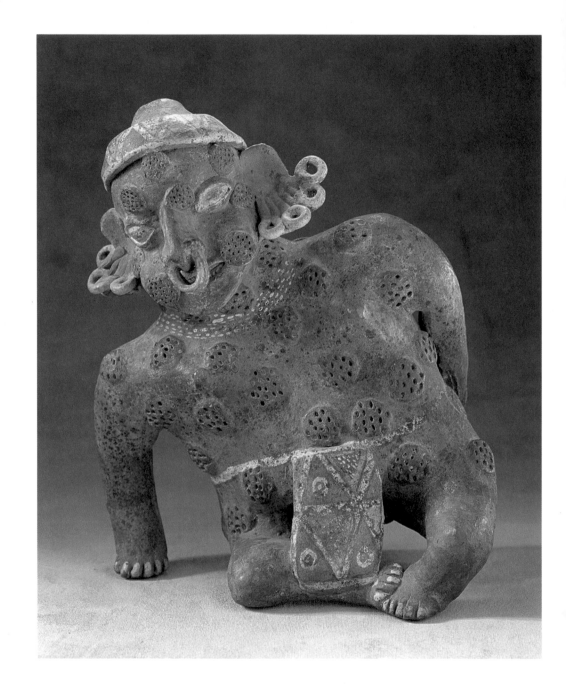

Jalisco

Colima

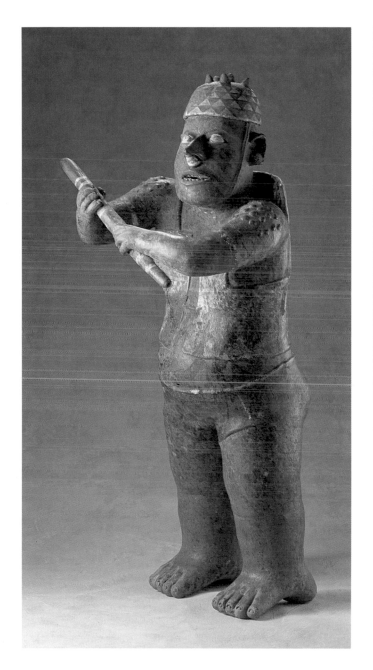

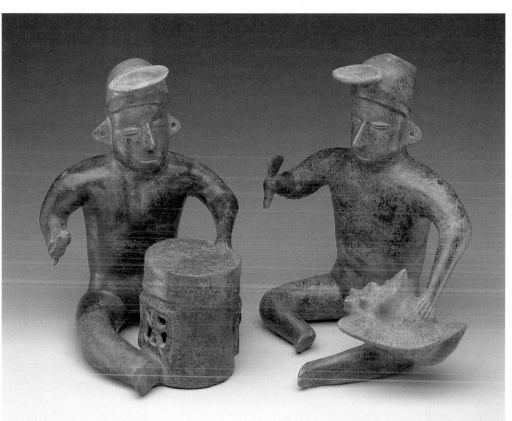

opposite
Female Figure Covered with Sores
Nayarit
cat. no. 23

left
Standing Warrior
Jalisco
cat. no. 79

right
Musicians
Colima
cat. no. 103a-b

NAYARIT

1.
Kneeling Female Figure
Chinesco type (Von Winning's
Type A)
Orange-red and light cream slip
with cream and traces of black
painted decoration
24 x 15 x 12 in.
(61 x 38.1 x 30.5 cm)
M.86.296.1
In color p. 12

Nude, wearing earrings, nose
rings, necklace, and waistband.
Kneeling posture and hands on
abdomen may represent birthing
position. One of the largest known
of these distinctive "realistic
Chinesco" figures. Very similar
pieces are illustrated in *Fondo de
la Plástica Mexicana* 1964: pl. 44;
Furst 1966: pls. 4–11; and Von
Winning 1974: figs. 309–10.

72

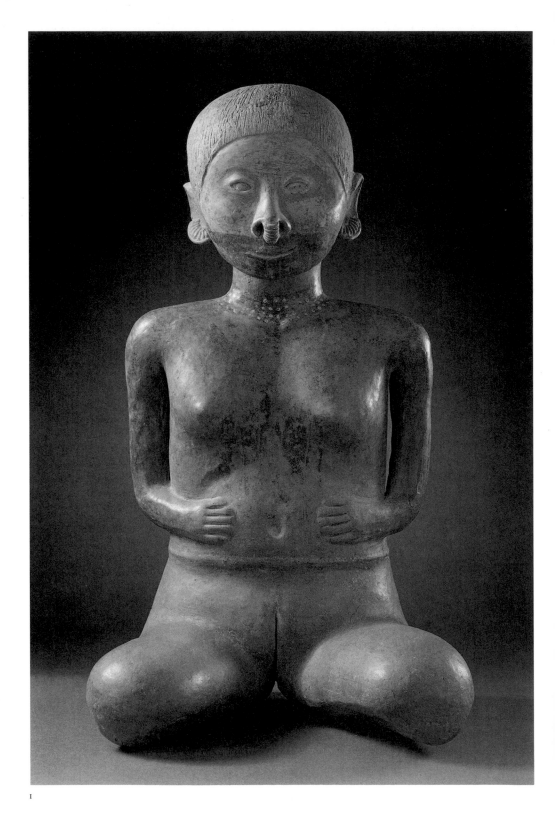

1

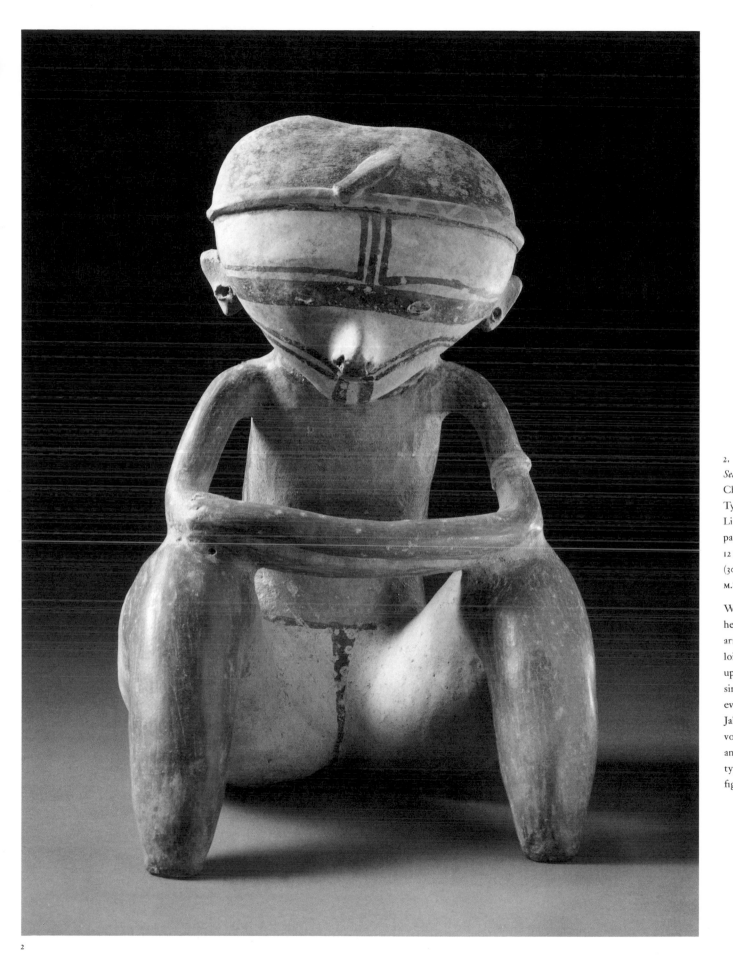

2.

Seated Male Figure
Chinesco type (Von Winning's
Type C)
Light cream and red slip with black
painted slip decoration
12 x 9 x 7 ¹/₂ in.
(30.5 x 22.9 x 19.1 cm)
M.86.296.2

Wearing a red and white
headband, nose plug, and single
armband. Black slip indicates
loincloth. Arms resting on
upraised knees. This piece is
similar to the first Chinesco figure
ever published, attributed to
Jalisco, Nayarit (Lumholtz 1902,
vol. 2: 294). For other red-white-
and-black slipped figures of this
type, see Von Winning 1974:
figs. 315, 317.

3.
Seated Female Figure
Chinesco type (Von Winning's
Type D)
Red and light cream slip with black
painted slip decoration
23 x 14 x 12 ½ in.
(58.4 x 35.6 x 31.8 cm)
M.86.296.3

Nude, wearing earrings, nose
rings, and necklace, armbands, and
waistbands in low relief. Legs
spread, hands on hips. Unusually
large example of this type.
Although popularly labeled
Chinesco, this type, commonly
found in the area inland from San
Blas, Nayarit (Mountjoy 1970b:
figs. 50–51), is distinguished from
nos. 1–2 by its more rectangular
head and hair carefully indicated
by striations. Compare nos. 4, 7.

74

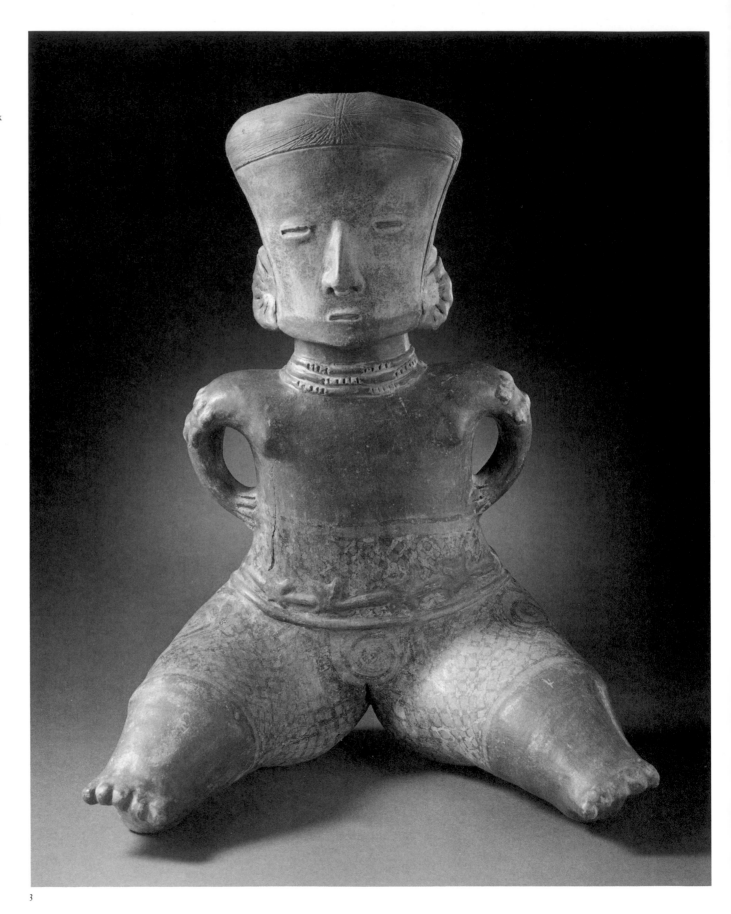

3

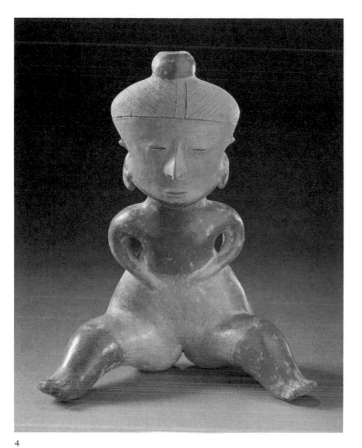

4.

4.

Seated Female Figure
Chinesco type (Von Winning's
Type D)
Burnished grayish cream and
red slip
9 x 7 ½ x 4 ¼ in.
(22.9 x 19.1 x 10.8 cm)
M.86.296.4

Nude, wearing earrings and
necklace. Legs spread. Supports
red slipped vessel on head.
Compare nos. 3, 7. Published: Von
Winning and Stendahl 1968:
pl. 164.

5.

Drummer
Chinesco type (Von Winning's
Type C)
Burnished red-brown slip with
light cream and black painted slip
decoration
5 ½ x 2 ½ x 5 ½ in.
(14 x 6.4 x 14 cm)
M.86.296.5
In color p. 22

Male figure, wearing headband
(with dependent bands trailing
over shoulders), armbands,
loincloth, and legbands. Playing
large gourd drum. Published: Von
Winning and Stendahl 1968:
pl. 173.

6.

Crouching Female Figure
Chinesco type (Von Winning's
Type B)
Burnished red slip with light
cream painted slip decoration
8 ¼ x 5 ¼ x 5 ¾ in.
(21 x 13.3 x 14.6 cm)
M.86.296.6
Alternate view, p. 21

Nude, wearing earrings, nose
ornament, and waistband. A good
example, somewhat more realistic
than others, of a recognized
Chinesco subtype often referred
to as Martian Chinesco. See
Alsberg and Petschek 1968: fig. 47.

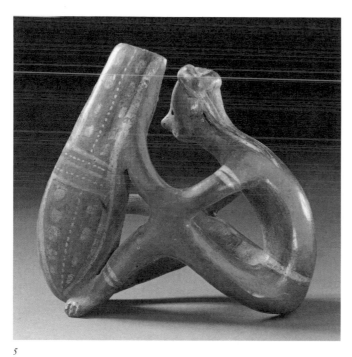

5

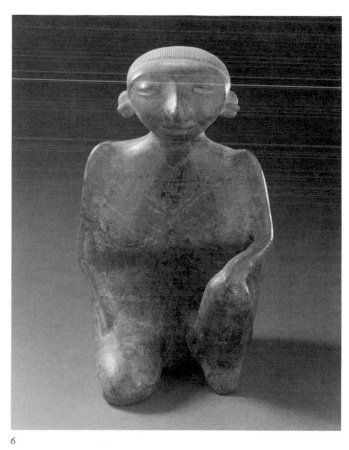

6

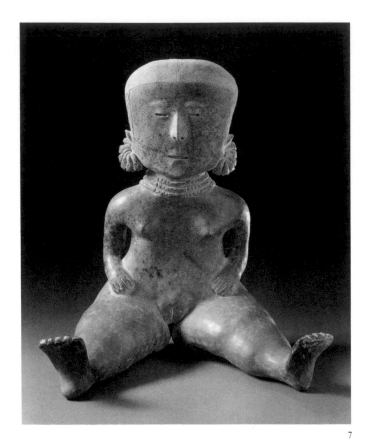

7

7.
Seated Female Figure
Chinesco type (Von Winning's
Type D)
Red and light cream slip with
traces of black resist decoration
on lower body
16 x 15 x 9 in.
(40.6 x 38.1 x 22.9 cm)
M.86.296.7

Nude, wearing earrings and
necklace. Legs spread. Compare
nos. 3–4.

8.
Double-Headed Dog
Chinesco type
Burnished light cream slip
3 ¼ x 5 x 5 in.
(8.3 x 12.7 x 12.7 cm)
M.86.296.8

9.
Dog Vessel
Chinesco type
Cream and red slip
7 x 5 ½ x 10 in.
(17.8 x 14 x 25.4 cm)
M.86.296.9

Opening on top of head.

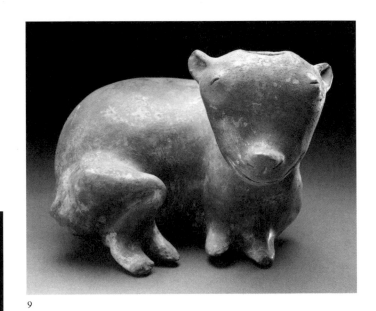

9

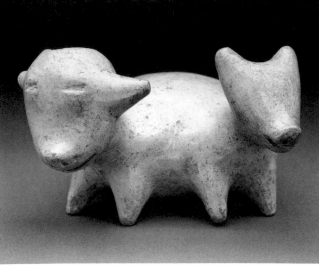

8

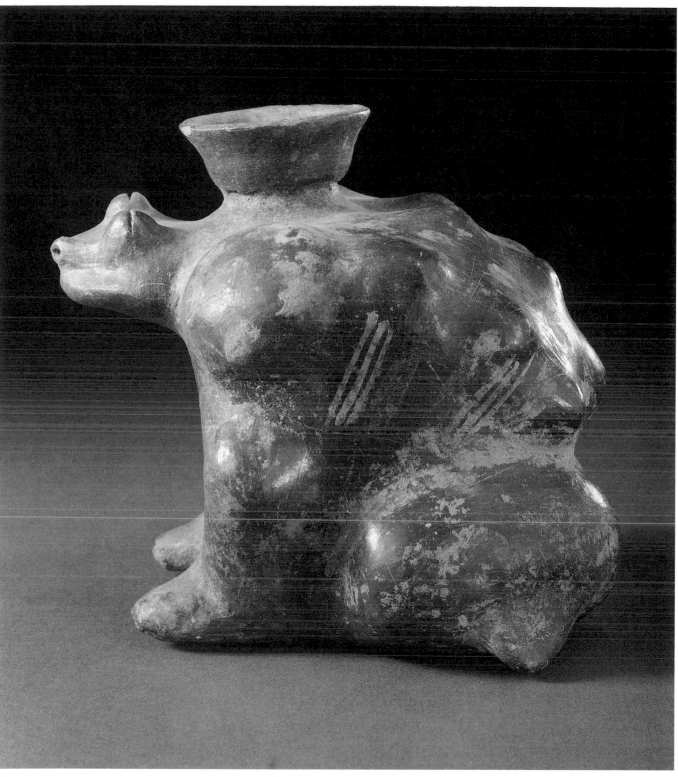

10.

10.

Toad
Chinesco type (?)
Burnished red slip with white
painted slip decoration
5 x 5 ½ x 4 in.
(12.7 x 14 x 10.2 cm)
M.86.296.10

Vessel. Spout projects from back.
An identical piece from the Rivera
collection is illustrated in México:
Secretaría de Educación Pública
1946: pl. 41.

11.
Crouching Female Figure
Chinesco type (Von Winning's
Type D)
Light cream and red slip with black
painted slip decoration
13 x 10½ x 12 in.
(33 x 26.7 x 30.5 cm)
M.86.296.11

Nude, wearing earrings, nose
rings, armbands, and waistbands.
Supporting hands and chin on
raised knee.

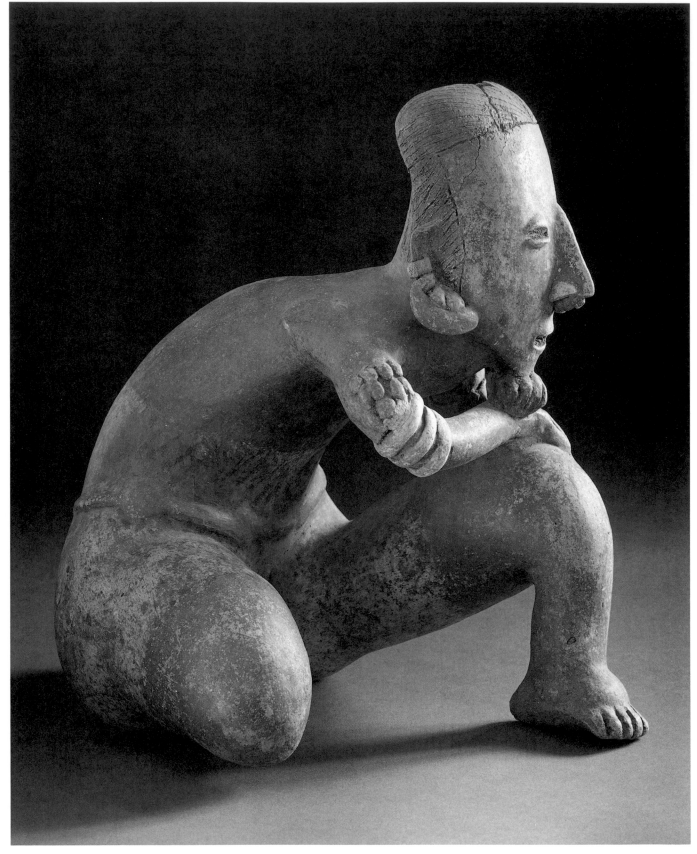

11

12.

*Standing Warrior Wearing
Patterned Shirt*
Burnished red-brown slip with
black and white painted slip
decoration
31 x 15 x 9 in.
(78.7 x 38.1 x 22.9 cm)
M.86.296.12

Male figure, wearing conical
headdress, earrings, nose plug,
necklaces, armbands, and short-
sleeved shirt. Holding fan (?) and
club or baton.

13.

Ball Player (?)
Mottled dark red slip with white
and black painted slip decoration
18¼ x 10 x 9½ in.
(46.4 x 25.4 x 24.1 cm)
M.86.296.13

Male figure wearing earrings,
serrated nose ornament, necklace,
armbands, short-sleeved shirt, and
short trousers with scoop
loincloth. Seated, holding ball in
right hand.

14.

Joined Couple
Red slip with black, white, and
yellow painted slip decoration
20½ x 15 x 11 in.
(52.1 x 38.1 x 27.9 cm)
M.86.296.14
In color p. 57

Female figure, wearing headband,
earrings, nose rings, crescentic
pectoral, armbands, and skirt.
Seated, holding vessel. Male
figure, wearing pointed, conical
headdress, off-shoulder mantle,
short trousers with scoop
loincloth, and virtually the same
ornaments as the female. Seated,
beating a drum with his left hand
and holding a rattle in his right.
(Pottery rattles have been
recovered from West Mexican
sites [Meighan 1972: pl. 10d;
Crossley-Holland 1980: pl. 1].
Such paired figures may represent
a male chanting (or entranced)
with a female supporting him and

offering a bowl of some liquid.
No. 18 is comparable, although
there the male holds the bowl.
Similar joined male/female figures
from Nayarit are illustrated by
Von Winning (1974: figs. 285–87);
in one pair the male plays a rasp.
Such figures are important because
they portray ritual activity.

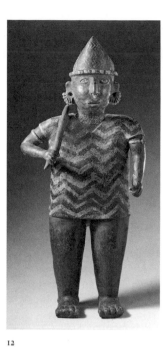

12

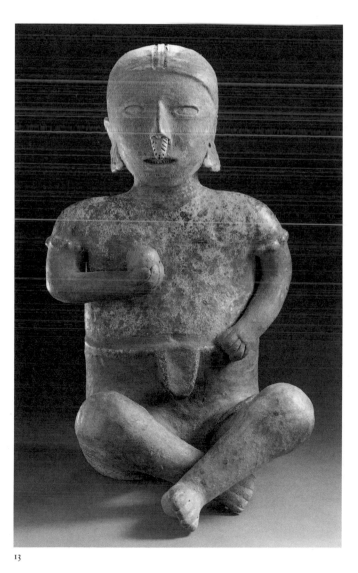

13

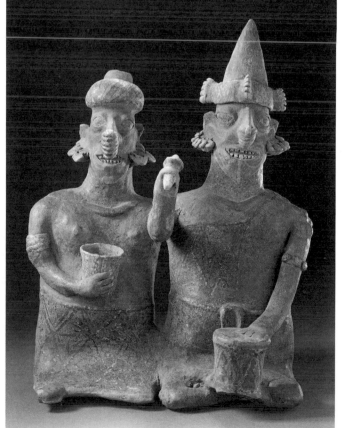

14

79

15.

Seated Male Figure Wearing
Fringed Headdress
Red-brown slip reduced to black
with incised decoration
19 x 11 x 9 in.
(48.3 x 27.9 x 22.9 cm)
M.86.296.15

Wearing woven, pointed
headdress with fringe, earrings,
nose rings, necklaces, armbands,
and short-sleeved shirt. Seated
cross-legged, holding small, flat
plate (?), knife (?) inserted beneath
right armband. Compare no. 12.

16a-b.

Standing Couple
Red slip with white and yellow
painted slip decoration
Male figure: 24 x 11 x 8 in.
(61 x 27.9 x 20.3 cm)
M.86.296.16
Alternate view p. 15
Female figure: 20 ½ x 13 x 6 in.
(52.1 x 33 x 15.2 cm)
M.86.296.17

Male figure, a warrior, wearing
pointed headdress with fringe,
earrings, nose ornament, necklace,
crescentic pectoral, armbands,
bracelets, short-sleeved shirt,
conch shell, and short trousers
with scoop loincloth. Holding

atlatl (Lumholtz 1902, vol. 2: pl.
va). Female figure, wearing thick,
striped headband, earrings, nose
ring, necklace, crescentic pectoral,
armbands, bracelets, and skirt.
Holding vessel in right hand.

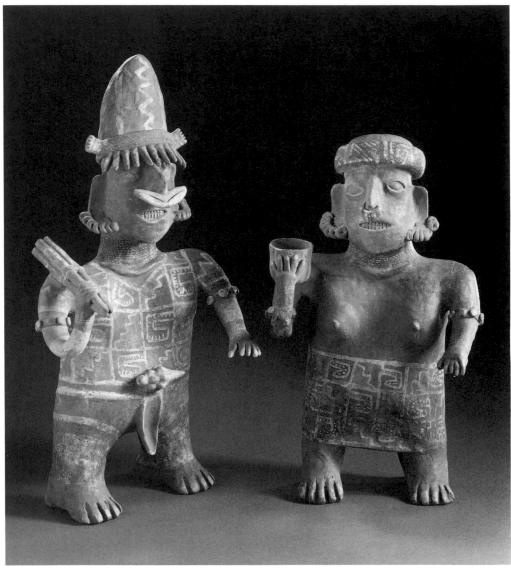

16 a-b

80

15

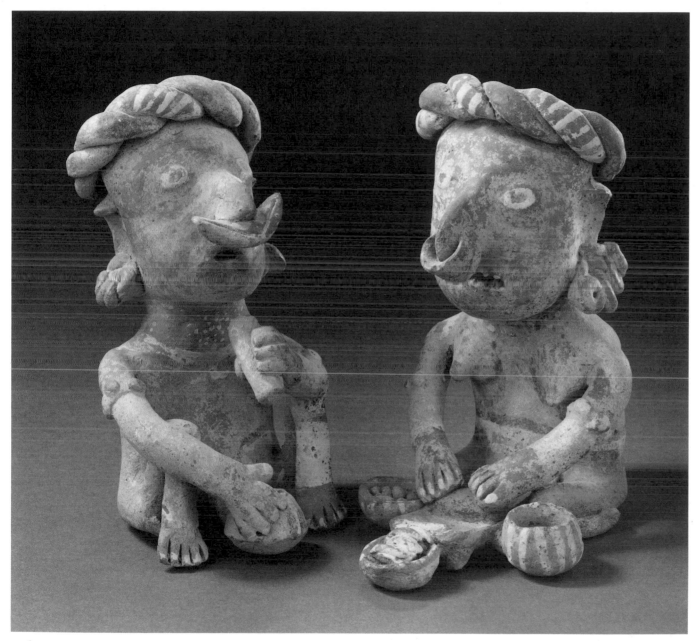

17 a-b

17a-b.
*Seated Couple Preparing
and Eating Food*
Red slip with cream and black
painted slip decoration
Female figure: 8 x 4 ¹/₂ x 7 in.
(20.3 x 11.4 x 17.8 cm)
Male figure: 8 x 4 ¹/₂ x 4¹/₂ in.
(20.3 x 11.4 x 11.4 cm)
M.86.296.18a-b
Alternate view p. 14

Female figure, wearing twisted
headband, earrings, nose ring,
necklaces, armbands, and skirt.
Kneeling, grinding maize on a
metate, pushing *masa* (dough) into
bowl. Two vessels flank the
metate, one containing maize.
Male figure, wearing twisted
headband, earrings, nose crescent,
necklaces, armbands, and scoop
loincloth. Seated, holding vessel
and cylinder (drinking tube,
foodstuff, or pipe?).

81

18.

Joined Couple

Red slip with white and traces of
black painted slip decoration

13 ¹/₂ x 9 x 5 ¹/₂ in.

(34.3 x 22.9 x 14 cm)

M.86.296.19

Similar to no. 14 except that the
male figure lacks the pointed
headdress and scoop loincloth and
holds a vessel instead of playing
a drum.

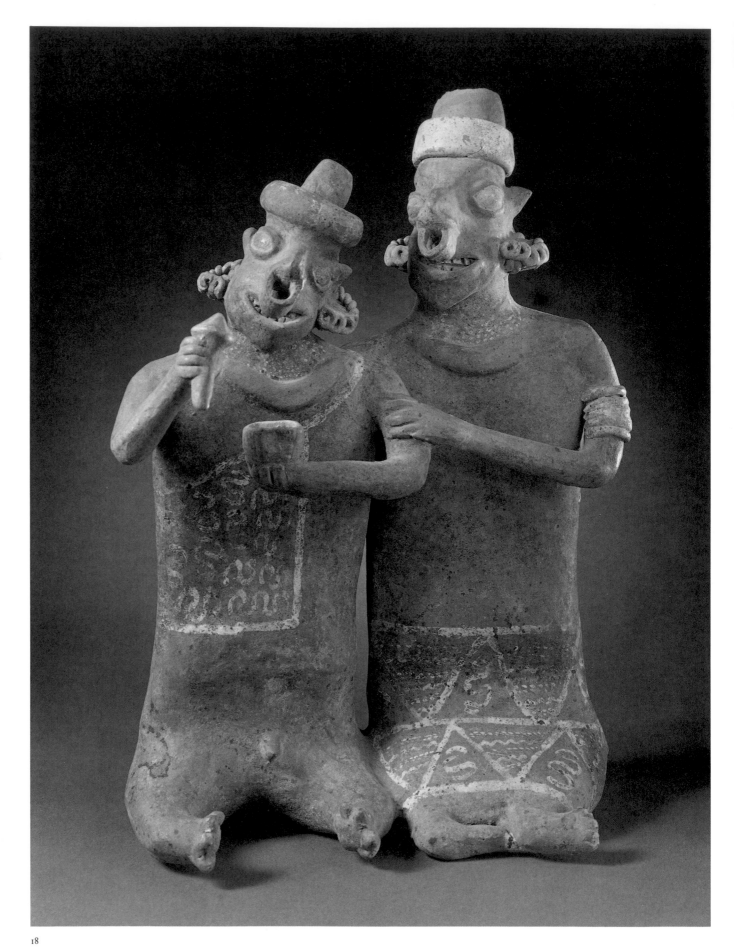

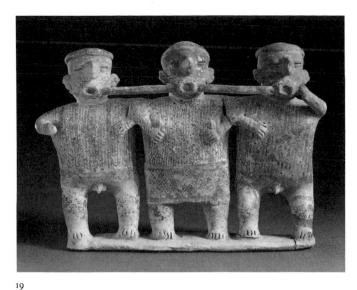

19

19.

Ceremonial Dancers (?)
Cream slip with red, black, and
yellow painted slip decoration
10 x 14 x 2½ in.
(25.4 x 35.6 x 6.4 cm)
M.86.296.20
In color p. 59

Female figure flanked by two male
figures joined by a rod thrust
through their cheeks. The woman,
wearing earrings, nose ring, and
skirt; the men, similarly decorated
with the addition of headbands.
The decorated areas resemble
Morett black-on-white ceramics
(Meighan 1972: 47, pl. 35). This
extraordinary penitential ritual,

unreported for any other area of
Mesoamerica, is undoubtedly
connected with the parallel-slit
mouth-cheek-area mutilations
(nos. 57–58a-b) and a related "box-
mouth" mutilation (Médioni and
Pinto 1941: pls. 41–42). Compare
no. 22, the similar four-figure
scene in the Rivera collection
(México: Secretaría de Educación
Pública 1946: fig. 35), and a two-
figure group in Von Winning 1974
(fig. 288).

20.

Seated Female Figure
Red-brown slip with light cream
and black painted slip decoration
5¾ x 4 x 4 in.
(14.6 x 10.2 x 10.2 cm)
M.86.296.21

Wearing headband, earplugs, nose
rings, necklace, armbands, and
broad loincloth. Holding pointed
headdress (compare no. 21) and
circular fan.

21.

Seated Male Figure
Red slip with light cream and black
painted slip decoration
7 x 3½ x 3½ in.
(17.8 x 8.9 x 8.9 cm)
M.86.296.22

Wearing pointed headdress above
headcloth (compare no. 20), large,
round earplugs, nose plug, neck-
laces, loose shirt, and loincloth.
Holding cylinder (drinking tube,
foodstuff, pipe, or rattle?).

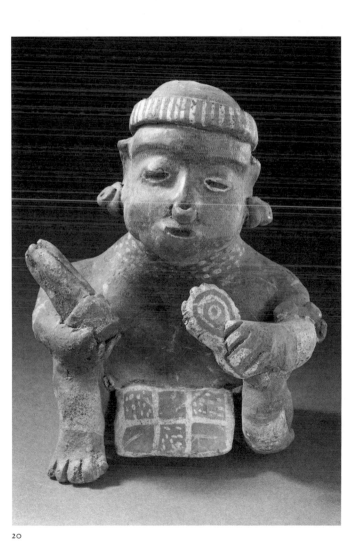

20

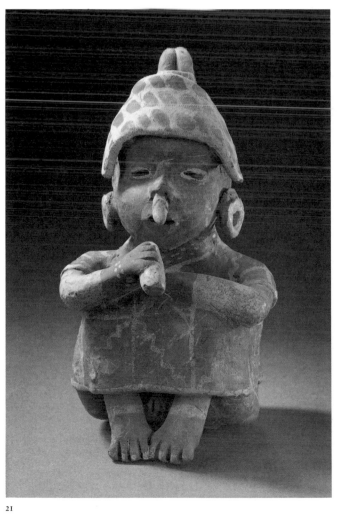

21

83

22.

Ceremonial Dancers (?)
Cream slip with black and red
painted slip decoration
6 x 6 x 3 in.
(15.2 x 15.2 x 7.6 cm)
M.86.296.23

Two nude male figures with
emaciated, ridged backs. Rod
through cheeks. Compare no. 19.

23.

Female Figure Covered with Sores
Burnished red slip with black,
white, and yellow painted slip
decoration
10 ¼ x 8 ½ x 5 in.
(26 x 21.6 x 12.7 cm)
M.86.296.24
In color p. 70

Wearing headband, earrings, nose
rings, necklace, and loincloth.
Seated, partially raised on right

leg. Pierced eruptions on face and
body. A number of representations
of this type are known. Compare
no. 38.

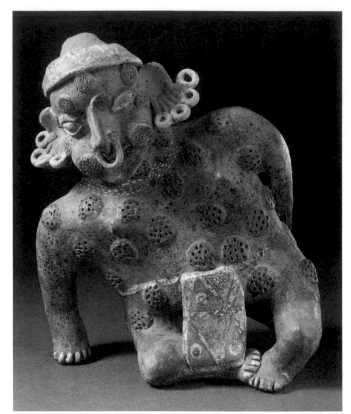

23

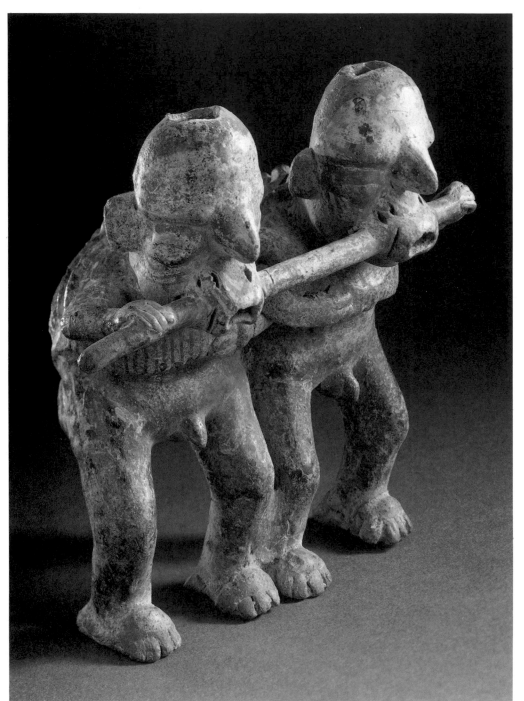

22

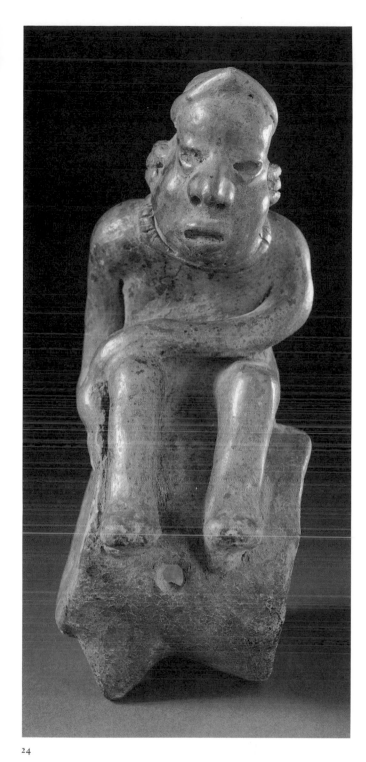

24.

25.

Drummer

San Sebastián Red type

Burnished red slip with black and
white painted slip decoration

10 x 3 ½ x 5 ½ in.

(25.4 x 8.9 x 14 cm)

M.86.296.25

In color p. 46

Nude male, wearing headband,
earrings, and necklace.

Musicians, Nayarit (?)

Buff slip with cream and red
painted slip decoration

6 ½ x 6 ½ x 3 ½ in.

(16.5 x 16.5 x 8.9 cm)

M.86.296.26

Three musicians—a flutist,
drummer, and player of a
tortoiseshell instrument—sit
together on a long bench. Each
wears a headband: a bird
descending from the head of the
figure on the left, a disk attached
to the back of the head of the
figure in the center, balls
encircling the head of the fig-
ure on the right.

24

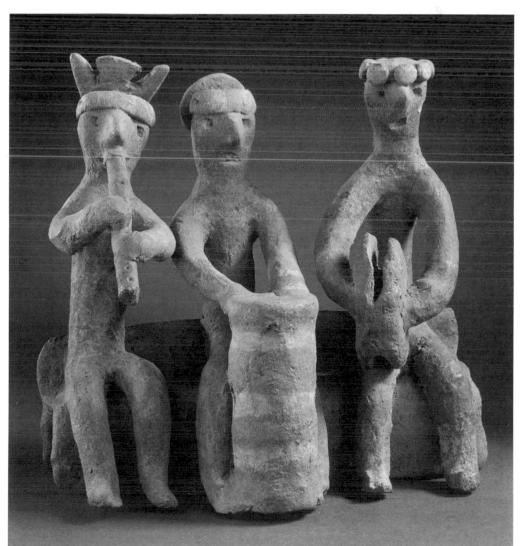

85

25

26.
Gathering before House
Cream slip with red painted
slip decoration
5 1/2 x 7 1/2 (diam.) in.
(14 x 19.1 cm)
M.86.296.27

Fourteen figures on a
circular base.

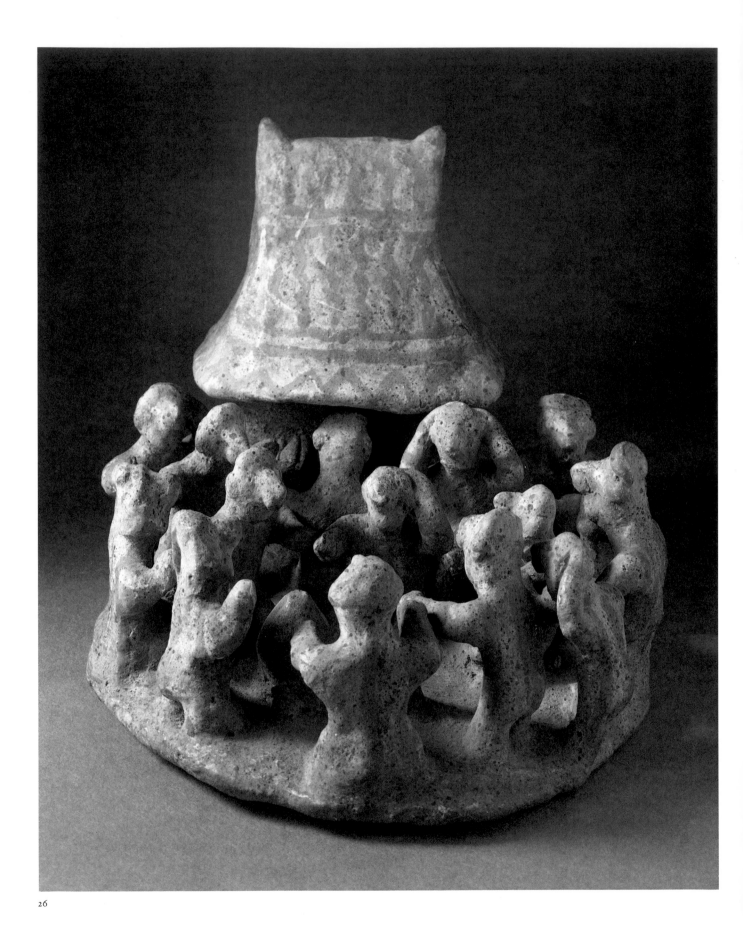

26

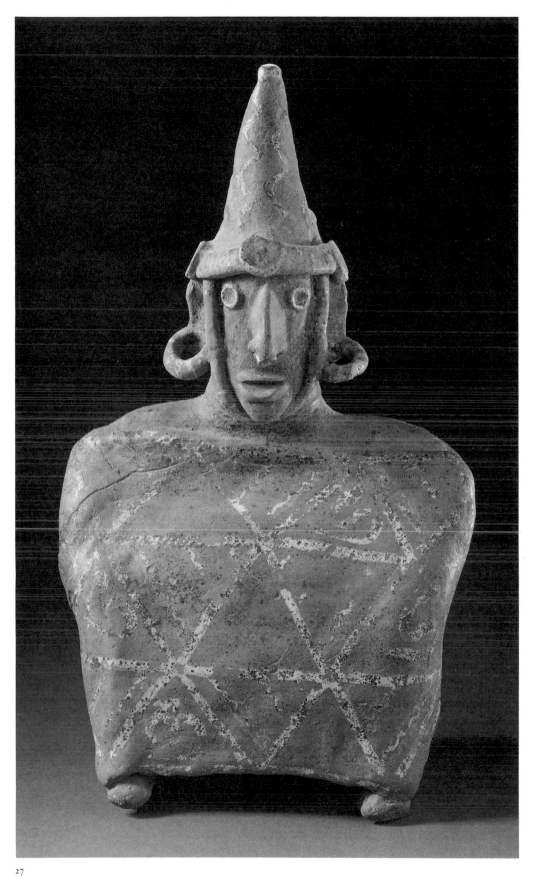

27

27.
*Seated Male Figure Wearing
Large Mantle*
Red slip with white and black
painted slip decoration
14 1/4 x 8 1/4 x 5 1/2 in.
(36.2 x 21 x 14 cm)
M.86.296.28

A well-recognized type, usually
with tall, pointed headdress, round
earspools, and a height of three to
four inches (Lumholtz 1902, vol.
2: 302).

28.
Two Joined Dogs
Red slip with white painted
slip decoration
4 1/2 x 6 1/4 x 4 1/2 in.
(11.4 x 15.9 x 11.4 cm)
M.86.296.29

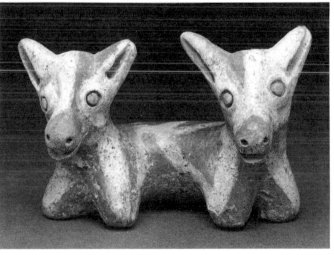

28

87

29.

House Group
Partially burnished red slip
with white and yellow painted
slip decoration
12 x 10 x 8 in.
(30.5 x 25.4 x 20.3 cm)
M.86.296.30
In color p. 28

Three joined structures with two
distinct rooflines. The parrots and
ravens on the rooftop and eaves
are an unusual feature.

30.

*Group Surrounding Prone
Figure*
Red slip with white and black
painted slip decoration
3 x 5 (diam.) in.
(7.6 x 12.7 cm)
M.86.296.31

Six figures surround a prone
body on tripod base. Possibly a
mourning scene.

31.

Joined Figures
Burnished red slip with cream
painted slip decoration
2 ¹/₂ x 2 ¹/₂ x 1 ³/₄ in.
(6.4 x 6.4 x 4.4 cm)
M.86.296.32

Wearing headbands, necklaces, and
armbands. Headbands are of a type
common in small Nayarit figures.
Seated, forming a tripod.

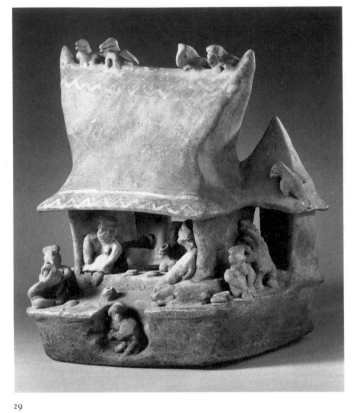

29

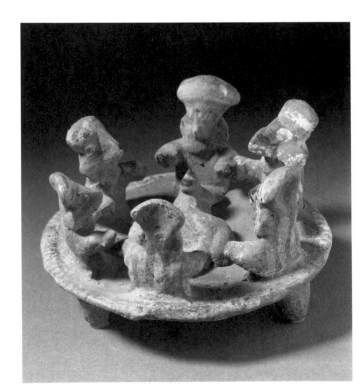

30

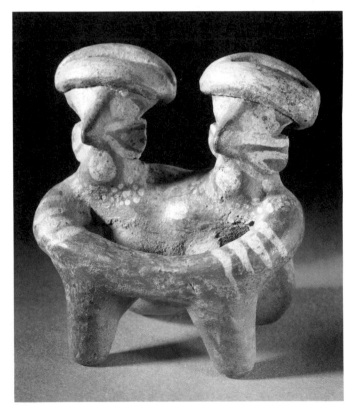

31

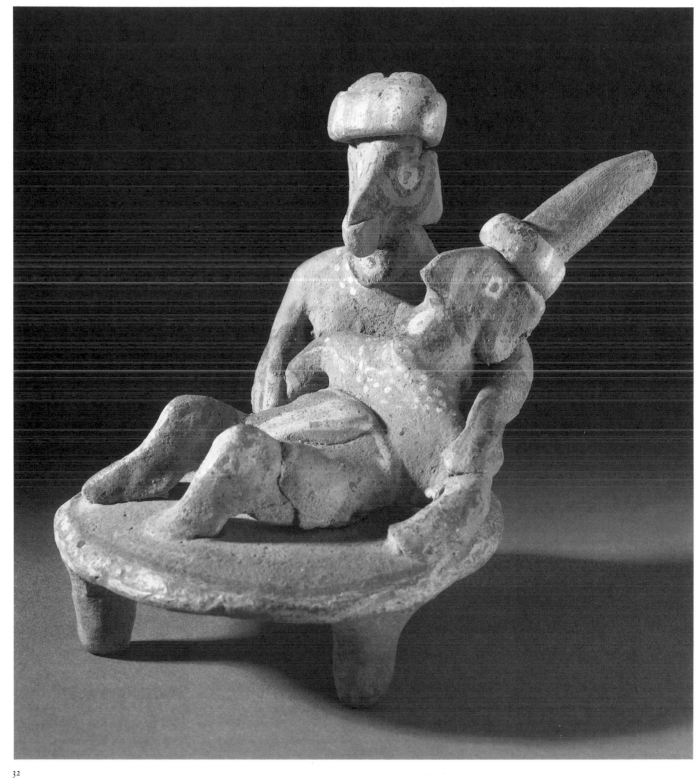

32.
Couple
Red slip with white and black
painted slip decoration
4 ³/₄ x 4 ¹/₄ x 6 ¹/₂ in.
(12.1 x 11 x 16.5 cm)
M.86.296.33

Two figures on a tripod base.
Wearing thick, striped headbands
(on the reclining figure the
headband combines with a very
tall headdress), necklaces, and
loincloths. The upright figure
wears a nose ring. Possibly a
shamanistic curing scene.

89

33.
Ceremonial Ball Game
Red slip with white and yellow
painted slip decoration
5 1/2 x 8 x 13 in.
(14 x 20.3 x 33 cm)
M.86.296.34
In color p. 53

Five (of perhaps seven or eight
original) players and twenty (of
perhaps a greater number of
original) spectators. Vertical walls
with benches (architectural
features, in general, display many
similarities with the Amapa,
Nayarit, ball court). Apparently in
the usual Mesoamerican version of
the game the ball could be struck
only with the elbows, hips, or
knees. Here a player is making a
hip shot (the size of the ball is
possibly exaggerated). The
missing part of the ball court
would have been a repeat of the
opposite, complete end of the
piece. This depiction differs from
ball courts such as the one at
Chichen Itza in that there is no
ring through which the ball is
passed. Note the markers (goals or
tees?); stone examples were found
at the center of the Amapa ball
court, excavated in 1959 (Clune
1963). See a similar, if somewhat
more elaborate, example in the
Rivera collection (*Fondo de la
Plástica Mexicana* 1964: pl. 68). On
pre-Hispanic West Mexican ball
courts and ballgame scenes, see
Taladroire 1979.

90

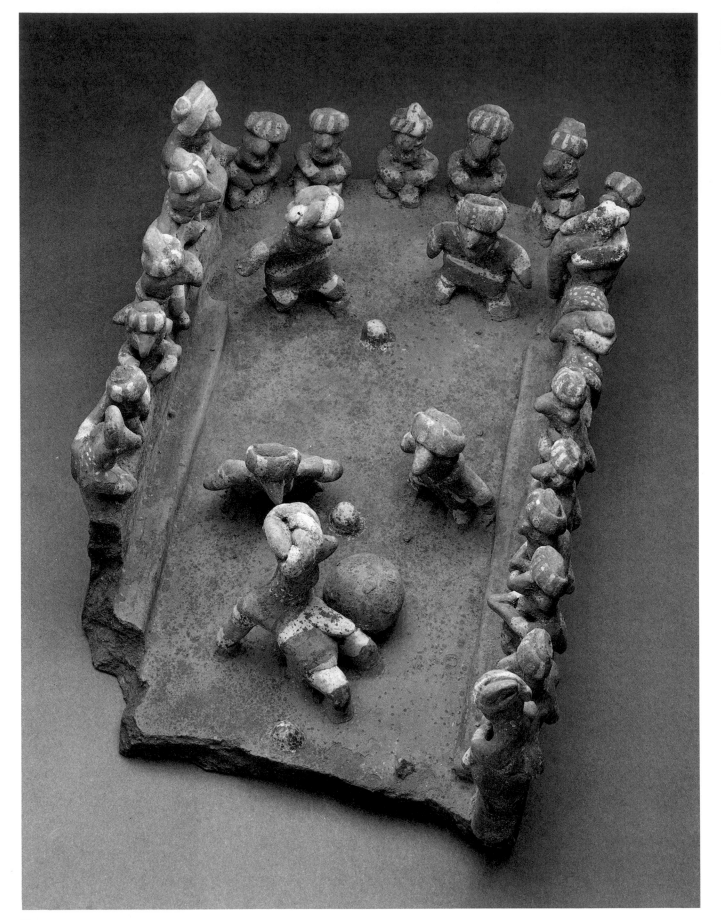

33

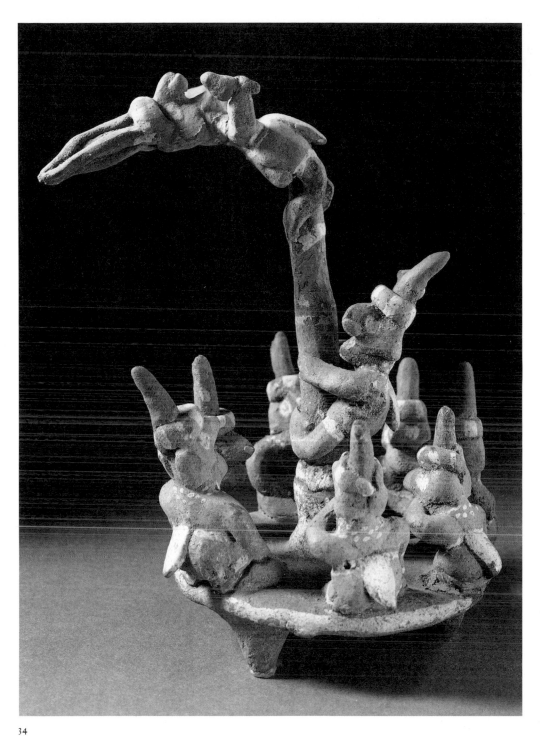

34

34.
Pole Ceremony
Red slip with white painted
slip decoration
8 x 6 (diam.) in.
(20.3 x 15.2 cm)
M.86.296.35

On a tripod circular base. A ritual
performer is suspended atop the
pole, another grasps the pole near
the base, while others are seated
around it. All wear tall, pointed
headdresses. This remarkable pole
ceremony has been identified as a
version of the *volador* (flying pole
dance) of the Mesoamerican
heartland but is probably a
distinct, though possibly related,
ritual. Other representations are
known (Bernal 1948–49; Von
Winning and Stendahl 1968: 75;
pl 155).

35.
Man with Dog under Umbrella
Burnished light cream slip with
red-orange and traces of black
painted slip decoration
7 1/4 x 4 1/2 x 4 in.
(18.4 x 11.4 x 10.2 cm)
M.86.296.36

On a tripod circular base.

91

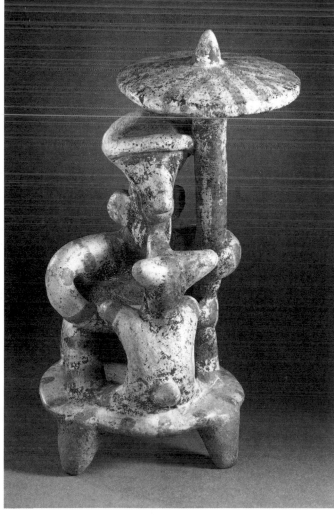

35

36.
Man and Child
Cream slip with red painted
slip decoration
3¹⁄₂ x 2 x 2 in.
(8.9 x 5.1 x 5.1 cm)
M.86.296.37

Similar in type to the small figures
of the house groups.

37.
House Group
Cream slip with red and black
painted slip decoration
11¹⁄₂ x 8 x 6 in.
(29.2 x 20.3 x 15.2 cm)
M.86.296.38

Two joined structures with
distinct peaked-roof types, both
decorated with the common
diamond motif (see Von Winning
1969a). Note basements.

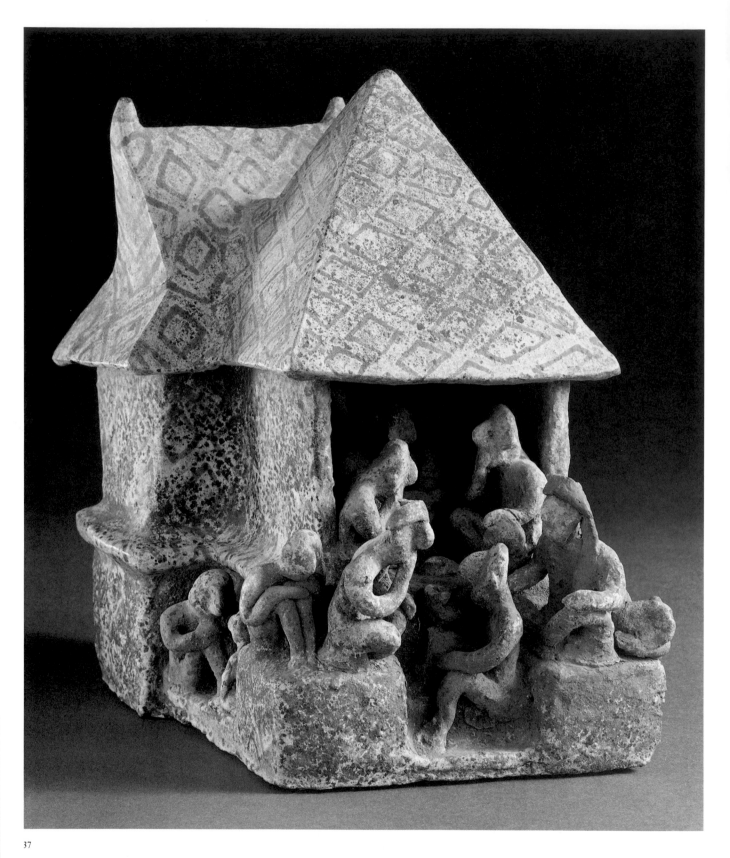

37

36

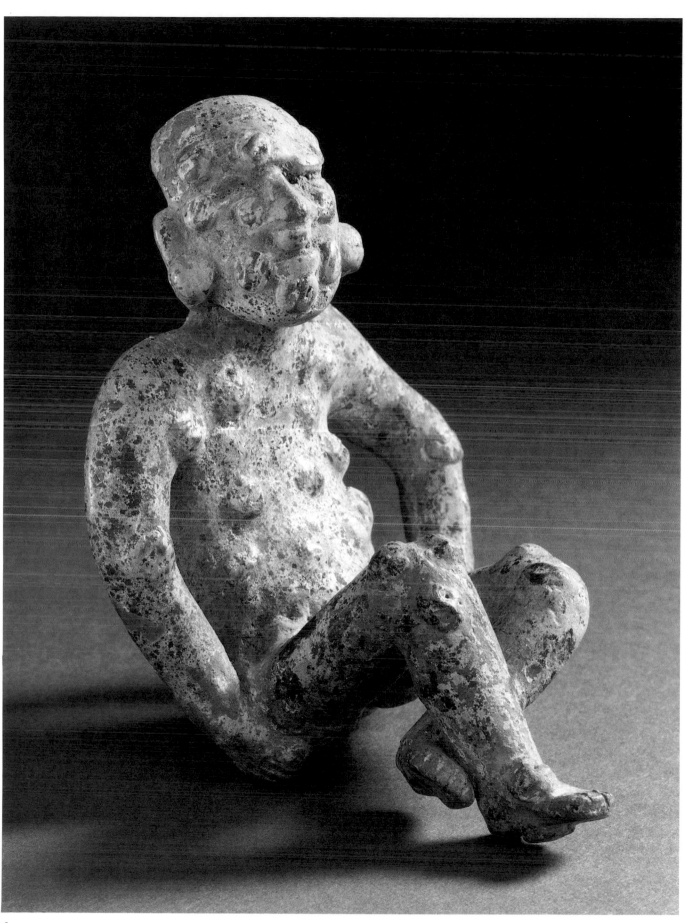

38.
Seated Male Figure
Covered with Sores
Burnished cream slip
5 1/2 x 3 3/4 x 3 1/4 in.
(14 x 9.5 x 8.3 cm)
M.86.296.43

Nude, wearing earplugs and nose plug. Legs crossed. Raised eruptions cover face and body. Representations of sick males are rarer than those of sick females. Compare no. 23.

93

39.
Seated Male Figure
Burnished red and buff slip with
incised decoration
26 x 15 x 13 in.
(66 x 38.1 x 33 cm)
M.86.296.44

Nude, wearing earrings and
armbands. Hands rest on knees.
Example of a recognizable Nayarit
subtype, often featuring a hairstyle
with a hooded effect (Von Winning
and Stendahl 1968: pl. 170).

40.
Stacked Bowls
Cream slip with red painted slip
decoration
3 ¼ x 3 ½ (diam.) in.
(8.3 x 8.9 cm)
M.86.296.45

A single vessel. Compare no. 41.

41.
Stacked Bowls
Cream slip with red painted slip
decoration
3 x 3 ½ (diam.) in.
(7.6 x 8.9 cm)
M.86.296.46

A single vessel. Compare no. 40.

94

39

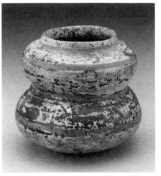

40

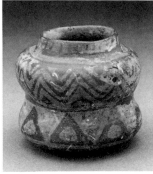

41

42 a-b

42a-b.
Incense Burners
White slip
4 x 2 ¹/₂ (diam.) in.
(10.2 x 6.4 cm)
3 x 2 ¹/₄ (diam.) in.
(7.6 x 5.7 cm)
M.86.296.47a-b

These incense burners are
identical to Postclassic-period
pieces found at Amapa, Nayarit
(Meighan 1976). With attached
spoons.

43.
Pectoral
Stone
3 x 10 x ³/₄ in.
(7.6 x 25.4 x 1.9 cm)
M.86.296.48

Crescent shape with serrations
along upper edge. Pectorals of this
type are frequently depicted on
Nayarit figures (e.g., nos. 14, 16a-b,
18). Compare no. 44.

44.
Pectoral
Stone
2 x 7 ¹/₂ x ¹/₂ in.
(5.1 x 19.1 x 1.3 cm)
M.86.296.49

Crescent shape with seven pairs
of holes drilled along upper edge.
Compare no. 43.

43

44

45.
Trumpet
Conch shell with incised
decoration
4 1/2 x 5 1/4 x 10 1/4 in.
(11.4 x 13.3 x 26 cm)
M.86.296.50
Alternate view, p. 51

A shaft-chamber tomb at Las
Cebollas, near Tequilita in south-
central Nayarit, contained 125
specimens of conch shells, many
decorated with designs of this
kind. See Furst 1966.

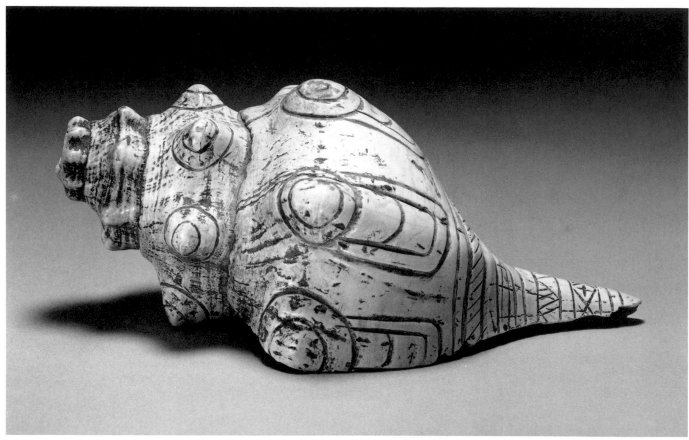

45

46a-b.
Atlatl Finger Loops, Nayarit (?)
Stone
Length: 2 in.
(5.2 cm)
M.86.296.52a-b

Such U-shaped objects were
attached to the wood shafts of
atlatls. The projections on the
convex edges are duck heads
(Ekholm 1962: figs. 1e, j, k). Such
objects are not uncommon in
collections (Long 1966: 216).

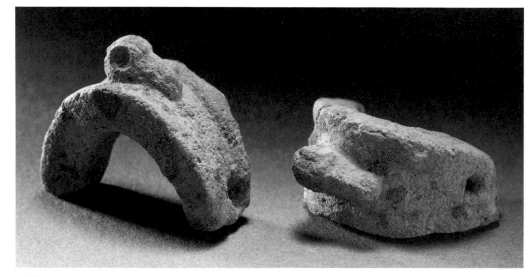

46 a-b

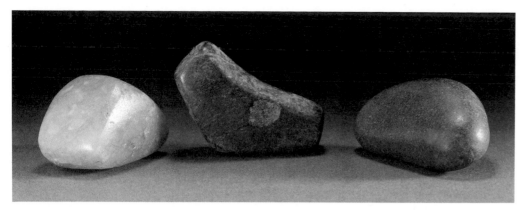

47 a–c.

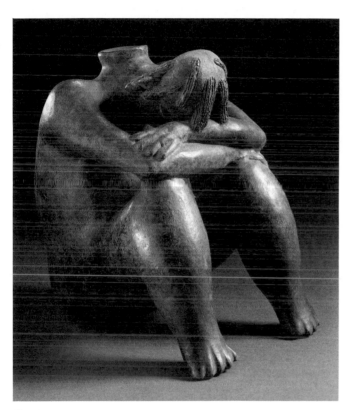

48

47a–c.
Burnishing Stones
Stone
1 x 2 x 1 in.
(2.5 x 5.1 x 2.5 cm)
1 x 1³/₄ x 1 in.
(2.5 x 4.4 x 2.5 cm)
³/₄ x 2¹/₂ x 1¹/₂ in.
(1.9 x 6.4 x 3.8 cm)
M.86.296.53a–c

Very similar specimens were found at Amapa, dating to the Postclassic period (Meighan 1976).

48.
Mourner (?)
San Sebastián Red type
Burnished red slip
10¹/₂ x 7 x 8¹/₂ in.
(26.7 x 17.8 x 21.6 cm)
M.86.296.54
In color p. 20

Vessel. Spout projects from nape of neck. Nude male, seated, knees drawn up, elbows on knees, head on forearms. These so-called mourners may depict persons who are ill or drugged. Compare no. 49.

49.
Mourner (?)
San Sebastián Red type
Burnished red slip with black and white painted slip decoration
6 x 4 x 4¹/₂ in.
(15.2 x 10.2 x 11.4 cm)
M.86.296.55

Vessel. Spout projects from nape of neck. Nude male, wearing headbands, earrings, and armbands. Seated, knees drawn up, elbows on knees, head resting on forearms. Compare no. 48.

97

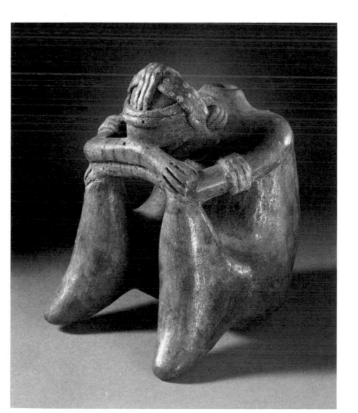

49

50.
Mourner (?)
San Sebastián Red type
Burnished red slip with light
cream painted slip decoration
6¹/₂ x 6¹/₂ x 7¹/₂ in.
(16.5 x 16.5 x 19.1 cm)
M.86.296.56

Nude male, wearing earrings and
necklace. Seated, elbows on
upraised knees, hands cradling
head. Published: Feuchtwanger
1954: pl. 74.

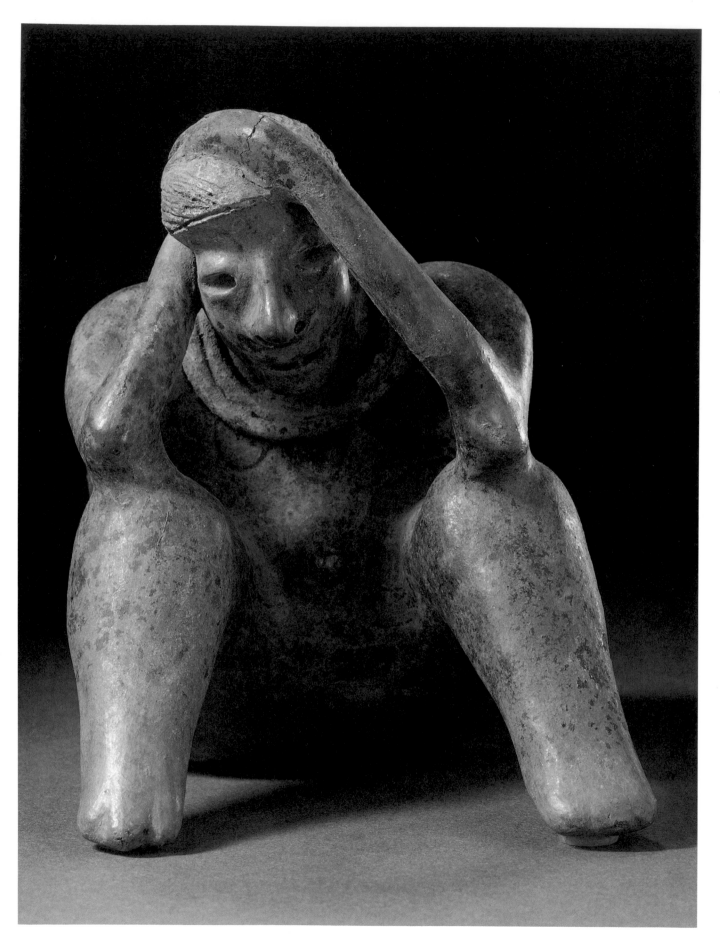

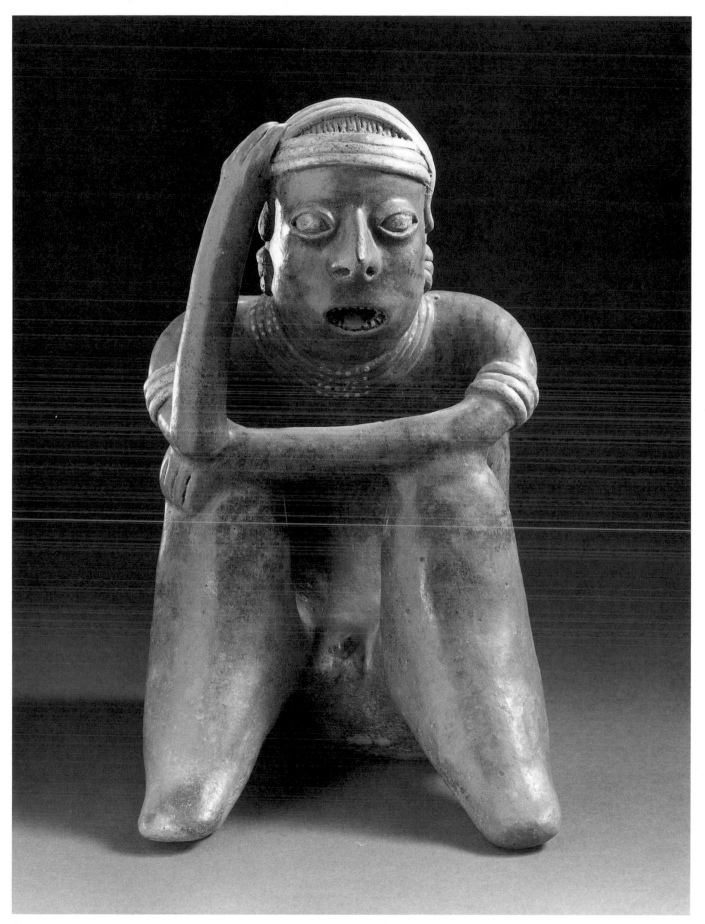

51.

Mourner (?)
San Sebastián Red type
(Ojos variant)
Burnished red-orange slip with
light cream and black painted slip
decoration
14½ x 9 x 9 in.
(36.8 x 22.9 x 22.9 cm)
M.86.296.57

Nude male, wearing headbands,
earrings, necklace, and armbands.
Seated, knees drawn up, elbows on
knees, right hand to head.

99

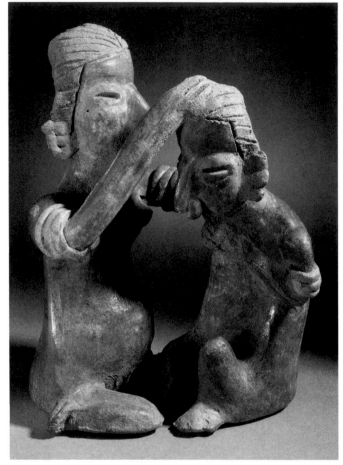

53

52.
Mourner (?)
San Sebastián Red type
Burnished red-orange slip
8 x 7 x 8 in.
(20.3 x 17.8 x 20.3 cm)
M.86.296.58

Vessel. Spout projects from nape
of neck. Nude male, wearing
headband decorated with circular
elements, earrings, and necklaces.
Seated, one knee drawn up, head
bowed, left hand on head, right
hand holding rattle.

53.
Joined Couple Delousing (?)
San Sebastián Red type
Burnished red-brown slip with
black and light cream painted slip
decoration
7 x 4 1/2 x 3 in.
(17.8 x 11.4 x 7.6 cm)
M.86.296.59
Alternate view p. 66

Nude, wearing earrings and
armbands. Seated.

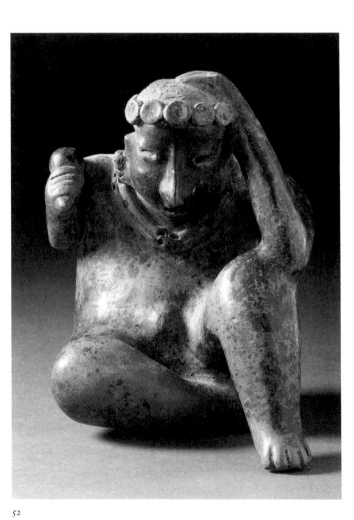

52

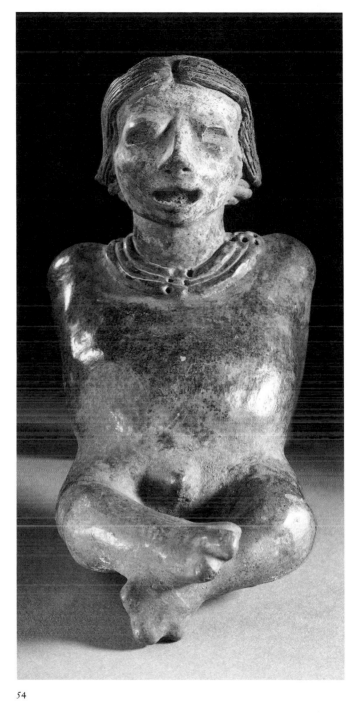

54

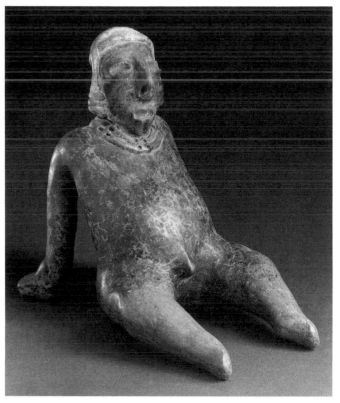

54.
Reclining Male Figure
San Sebastián Red type
Burnished red slip with light
cream and black painted slip
decoration
7 x 4 x 7 ³/₄ in.
(17.8 x 10.2 x 19.7 cm)
M.86.296.60

Nude, wearing earrings and
necklace. Supported on arms, legs
crossed.

101

55.
Reclining Male Figure
San Sebastián Red type
Burnished red-orange slip with
cream painted slip decoration
10 x 6 x 9 ¹/₂ in.
(25.4 x 15.2 x 24.1 cm)
M.86.296.61
Alternate view p. 33

Nude, wearing headband, earrings,
and necklaces.

55

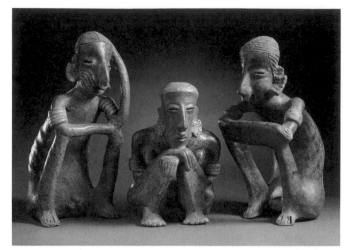

56 a-c

56a-c.
Mourners (?)
San Sebastián Red type
Male figure: burnished red-brown
slip with black and light cream
painted slip decoration
12 x 5 x 6 in.
(30.5 x 12.7 x 15.2 cm)
Female figure: burnished red slip
with black and cream painted slip
and black resist decoration
8 ³/₄ x 5 ¹/₂ x 5 ¹/₂ in.
(22.2 x 14 x 14 cm)
Male figure: burnished red slip
with black and light cream painted
slip decoration
12 x 5 ¹/₂ x 7 in.
(30.5 x 14 x 17.8 cm)
M.86.296.62a-c

Emaciated nude male figure,
wearing earrings, nose ring,
and armbands. Seated, right arm
resting on upraised knees, left
hand to head. Emaciated nude
female figure, wearing earrings,
necklace, and armbands. Seated,
hands grasping knees, chin
on hands. Female mourners
are rare. Emaciated nude male
figure, wearing earrings, nose ring,
necklace, and armbands. Seated,
arms crossed on upraised knees.

102

57.
Joined Male Figures
San Sebastián Red type
Burnished red slip with black and
cream painted slip and incised
decoration
12 x 9 x 5 ¹/₂ in.
(30.5 x 22.9 x 14 cm)
M.86.296.63

Nude, wearing earrings, nose
rings, and necklaces, both figures
display parallel-slit mouth-cheek-
area mutilations (compare no. 58a-
b). Figure on right holds rattle.

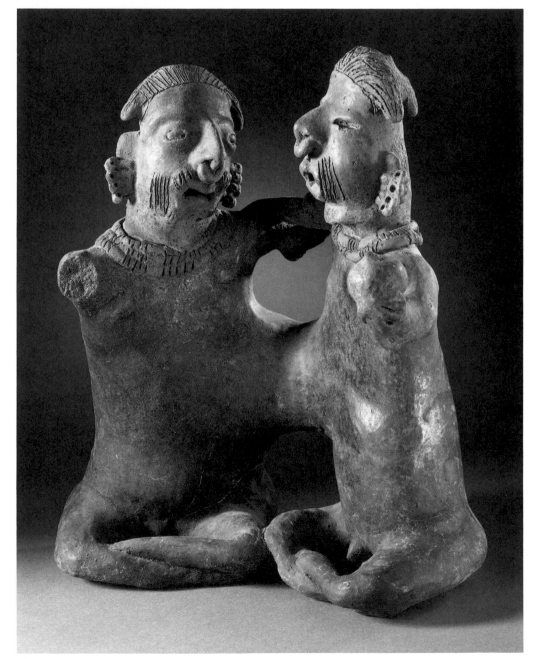

57

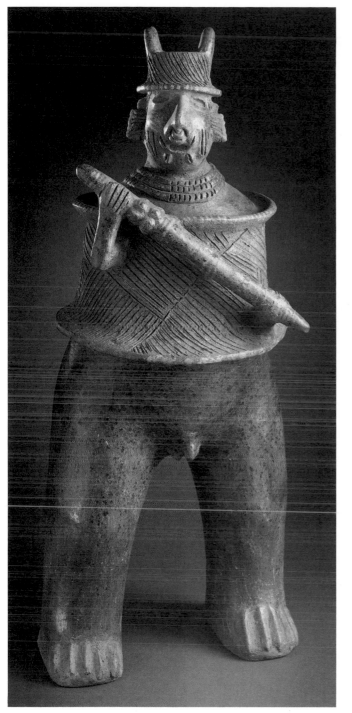

58 a-b

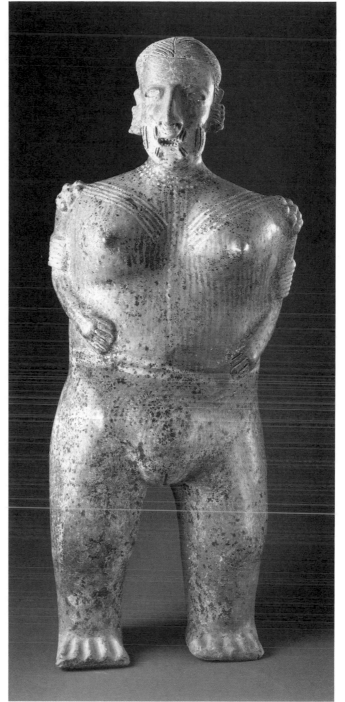

58a-b.
Standing Couple
San Sebastián Red type
Burnished red slip with black and
white painted slip decoration
Male figure: 27 x 12 x 9¹/₂ in.
(68.5 x 30.5 x 24.1 cm)
M.86.296.64
Female figure: 30 x 13 x 9¹/₄ in.
(76.2 x 33 x 23.5 cm)
M.86.296.65

Male warrior, wearing bicorn
helmet and body armor, earrings,
nose rings, and necklaces,
displaying parallel-slit mouth-
cheek-area mutilations (compare
no. 57). The armor may be stiff
basketry with padding of cloth or
cotton. Standing, holding long
mace. Female figure, wearing
earrings, nose rings, necklace,
applied shoulder pellets,
armbands, and waistband,
displaying parallel-slit mouth-
cheek-area mutilations. Standing
with hands on stomach.

103

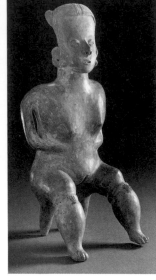

59

59.
Seated Female Figure
San Sebastián Red type variant
Burnished red-brown slip with
black painted slip and incised
decoration
18 x 8 x 9 in.
(45.7 x 20.3 x 22.9 cm)
M.86.296.66

Nude, wearing earrings and
legbands. Seated on a two-footed
stool, hands on waist.

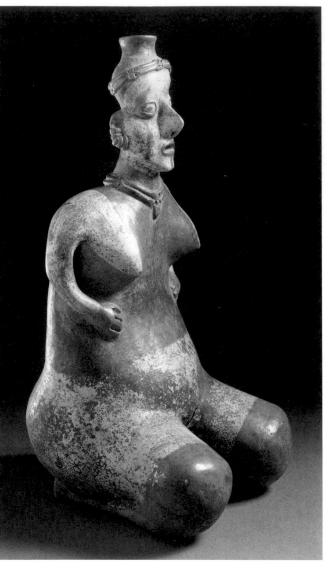

60

60.
Kneeling Female Figure
San Sebastián Red type (Ojos
variant)
Burnished red slip with cream
painted slip and black resist
decoration
15 x 7¹/₂ x 7¹/₂ in.
(38.1 x 19.1 x 19.1 cm)
M.86.296.67
In color p. 51

Vessel. Spout projects from head.
Nude, wearing headband, earrings,
and necklace.

61.
*Standing Female Figure Wearing
Snake Skirt*
San Sebastián Red type variant
Red slip with black and white
painted slip decoration
17 x 10¹/₂ x 4¹/₂ in.
(43.2 x 26.7 x 11.4 cm)
M.86.296.68

Wearing headband, earplugs,
necklace, armbands, and skirt
painted with S-shaped, double-
headed serpent design (black on
white). The irregular pattern of
snakes on the skirt suggests that
it represents a painted textile.

Representative of a type some-
what intermediate between San
Sebastián Red and a Jalisco type
characterized by elongated,
narrow heads, pointed ears, round
earplugs, and considerable white
painted slip decoration (see Marks
1968: 15, upper left). Compare
no. 66.

61

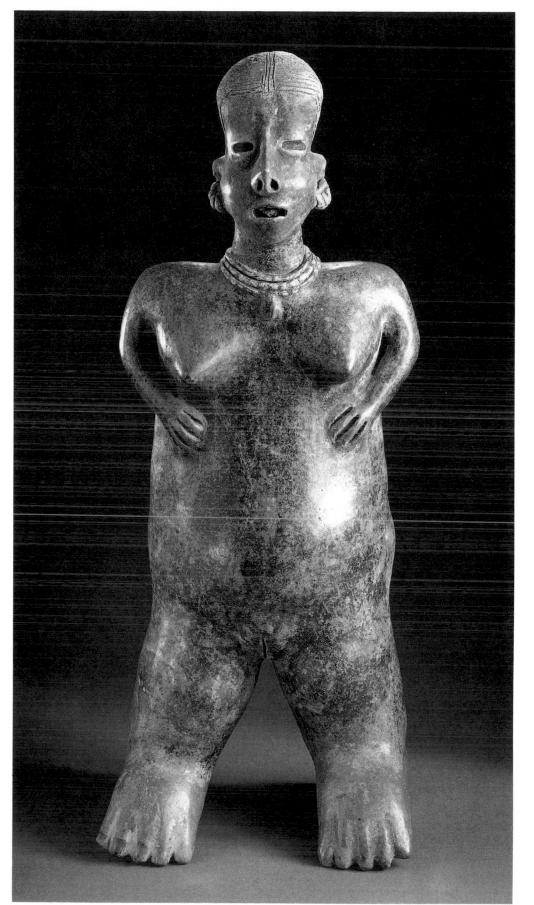

62.
Standing Female Figure with Hands on Abdomen
San Sebastián Red type
Burnished red slip with white painted slip decoration
21 x 9 ½ x 8 ½ in.
(53.3 x 24.1 x 21.6 cm)
M.86.296.69

Nude, wearing earrings and necklace.

105

63.
Dog Vessel
Burnished red-orange slip with
black resist decoration
6 x 10 x 6 ½ in.
(15.2 x 25.4 x 16.5 cm)
M.86.296.70

Compare no. 64.

64.
Vessel in the Form of Two Joined
Dogs
Burnished red-orange slip with
black resist decoration
5 ¾ x 12 ¼ x 8 in.
(14.6 x 31.1 x 20.3 cm)
M.86.296.71

Compare no. 63. See Dockstader
1964: pl. 6 (attributed to Jomulco,
Nayarit).

65.
Vessel in the Form of Four Joined
Dogs
Burnished orange slip with black
painted slip decoration
4 x 5 ½ (diam.) in.
(10.2 x 14 cm)
M.86.296.72

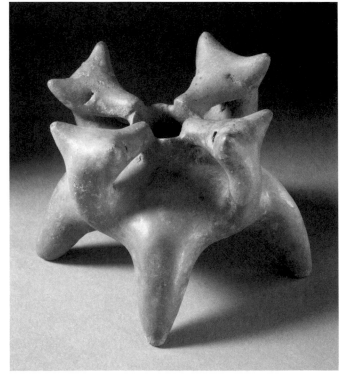

63

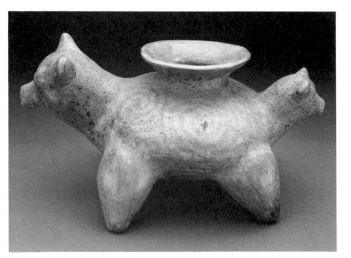

64

65

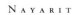

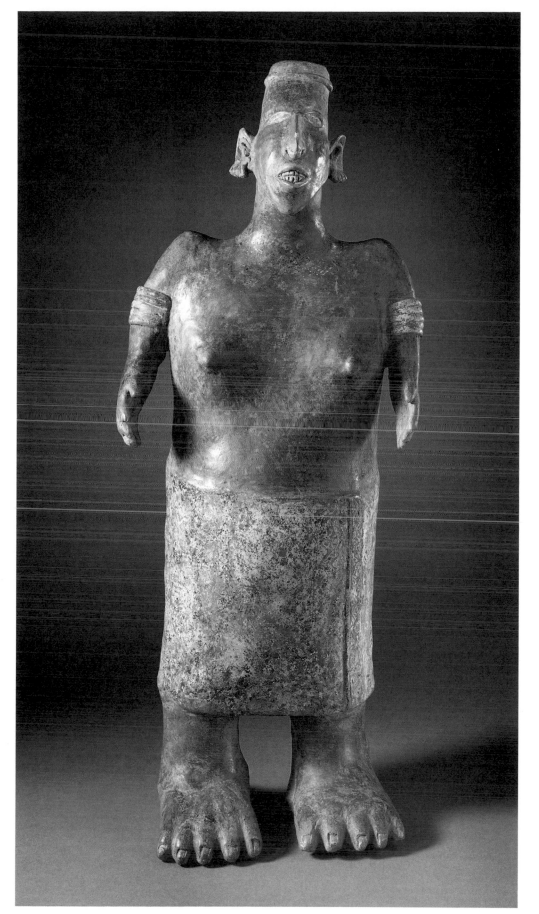

66

66.
Standing Female Figure
San Sebastián Red type variant
Burnished red slip with black and
white painted slip decoration
27 x 11 x 8 in.
(68.6 x 27.9 x 20.3 cm)
M.86.296.73
Alternate view, p. 23

Wearing wraparound skirt with
incised vertical hem band. Same
type as and virtually identical in
posture and costume to no. 61.

67.

Attacking Warrior
Ameca Gray type
Burnished cream slip with red
painted slip decoration
12 x 6½ x 9 in.
(30.5 x 16.5 x 22.9 cm)
M.86.296.74
In color p. 56

Wearing headband, earrings, nose
rings, and neck and shoulder
bands. Crouching, brandishing
mace-dagger and holding circular
shield.

68.

Joined Couple
Ameca Gray type variant
Burnished red-brown slip with
white painted slip decoration
15 x 16 x 13 in.
(38.1 x 40.6 x 33 cm)
M.86.296.75
In color p. 14

Male, nude, wearing crested
headdress. Seated cross-legged.
Female, wearing skirt and identical
headdress. Kneeling.

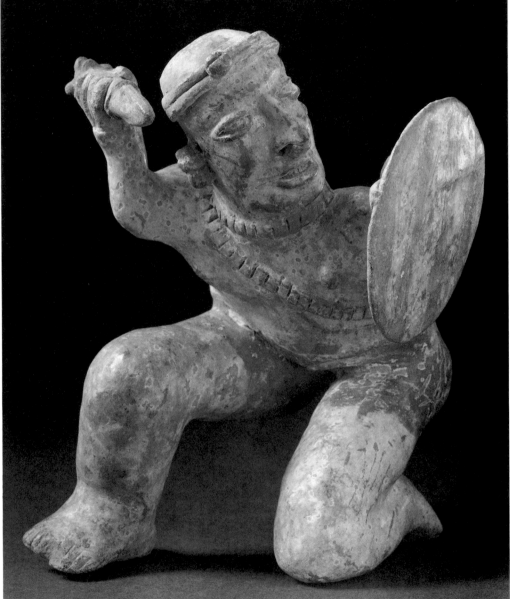

67

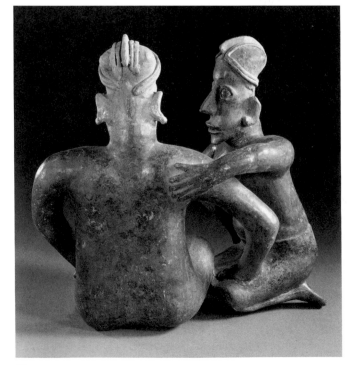

68

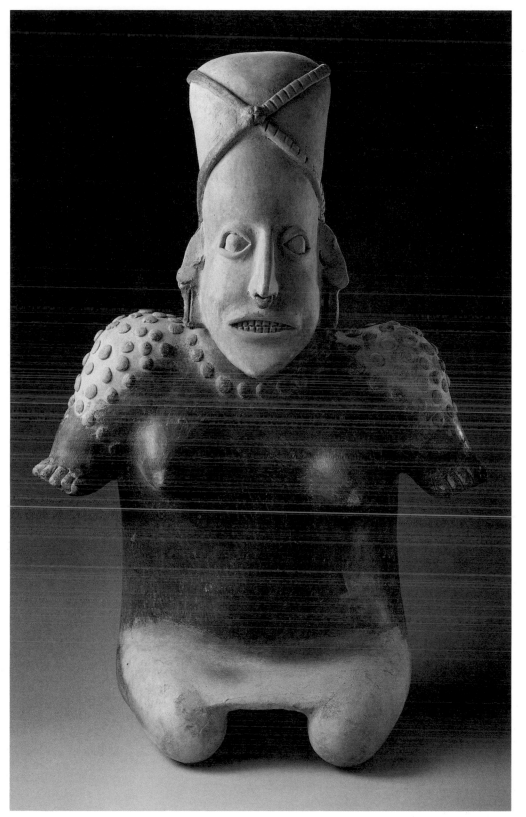

69

69.

Kneeling Female Figure
Ameca Gray type
Burnished light cream and red slip
20 x 12 x 6 in.
(50.8 x 30.5 x 15.2 cm)
M.86.296.76

Wearing crossed headbands, ear
pendants, skirt, and applied
shoulder pellets. These pellets
have been interpreted as scars, but
this seems improbable in examples
such as this. The epaulet-style
dispersion is more likely to repre-
sent some sort of ornamentation,
perhaps of shell beads. Note that
the necklace consists of the same
kind of pellets. This type of
decoration occurs on both Jalisco
and Nayarit figurines (see Von
Winning 1974: fig. 120, where the
shoulder area is differentiated in
color, as it is here with cream slip,
in addition to the applied pellets;
fig. 136; and figs. 263, 266, attributed
to Nayarit). Compare also nos.
75–76, 79–80, and 91. Excellent
example of Ameca Gray type. See
México: Secretaría de Educación
Pública 1946: pl. 52.

70.
Mother and Child
Yellowish slip with black and
red painted slip decoration
5 ¹/₂ x 3 ¹/₂ x 2 in.
(14 x 8.9 x 5.1 cm)
M.86.296.77

71.
Seated Male Figure
Ameca Gray type
Cream slip
18 ¹/₄ x 12 x 11 in.
(46.4 x 30.5 x 27.9 cm)
M.86.296.78

Wearing crossed headbands,
armbands, and short trousers.

72.
Seated Male Figure
Ameca Gray type variant
Burnished red-brown slip with
firing clouds and incised
decoration
12 x 8 x 7 ¹/₂ in.
(30.5 x 20.3 x 19.1 cm)
M.86.296.79

110 The hand held in front of the
mouth is an unusual gesture.
Related to Ameca Gray type with
some features of the San Sebastián
Red type.

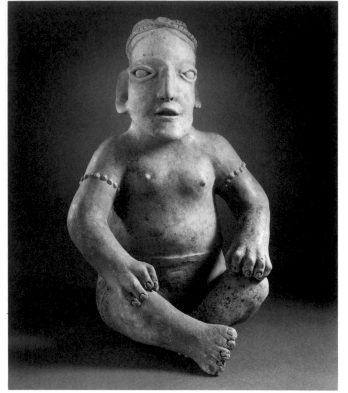

71

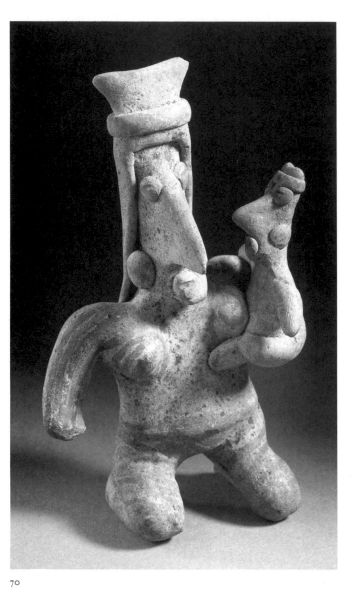

70

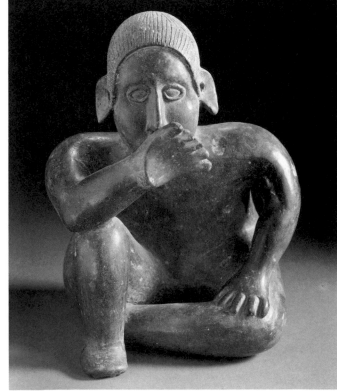

72

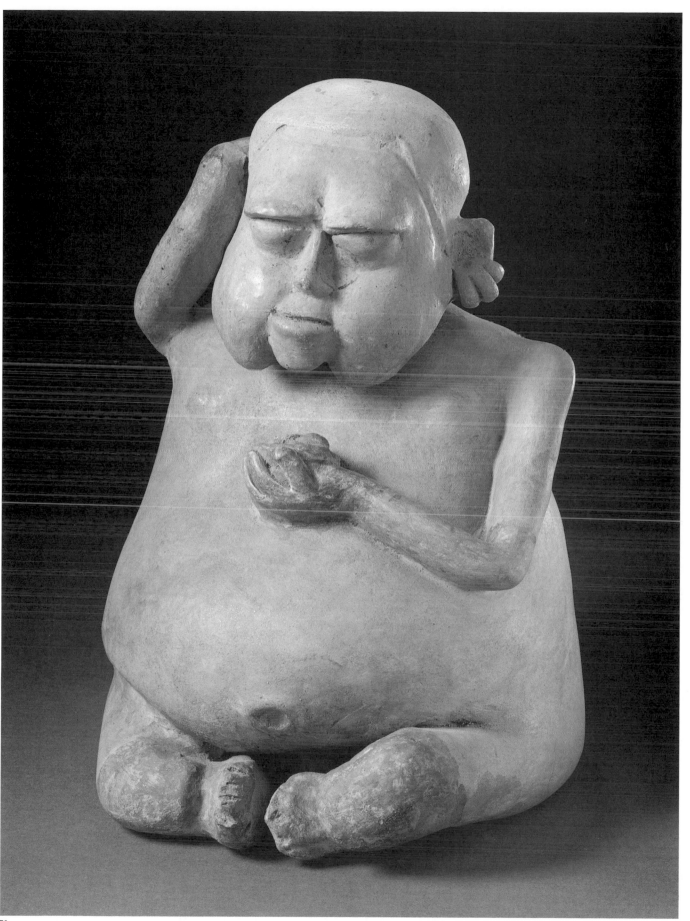

73.
Eunuch (?)
Burnished grayish cream slip with
red painted slip decoration
11 x 8 x 8 in.
(27.9 x 20.3 x 20.3 cm)
M.86.296.80

Nude, wearing earrings. Seated,
one hand behind head, the other
holding a food-filled vessel.
Unusually realistic for Jalisco
tradition.

111

73

74.

Kneeling Female Figure
Ameca Gray type
Cream slip with black painted slip
decoration and firing clouds
16 x 10½ x 8 in.
(40.6 x 26.7 x 20.3 cm)
M.86.296.81

Wearing skirt. Outstretched arm
gesture is fairly common (see Von
Winning 1974: figs. 138–39, 143,
145) but only among female
figures.

75.

Hunchback
Ameca Gray type
Burnished cream slip with black
painted slip decoration
12¼ x 10¼ x 8½ in.
(31.1 x 26 x 21.6 cm)
M.86.296.82

Nude male, wearing headband,
applied shoulder pellets, and
armbands.

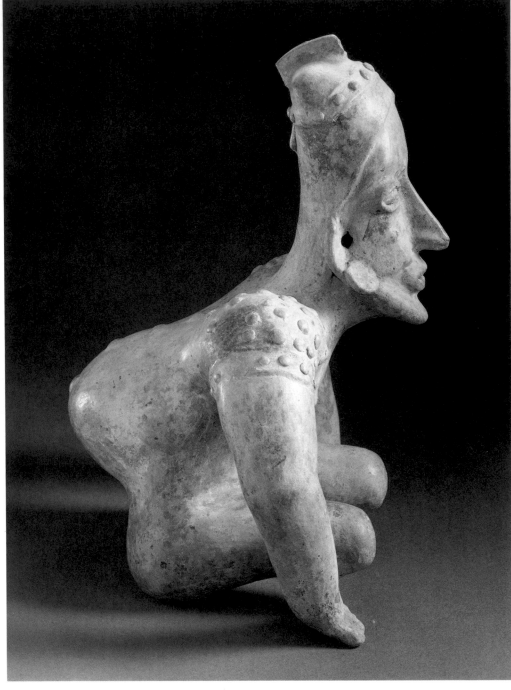

75

112

74

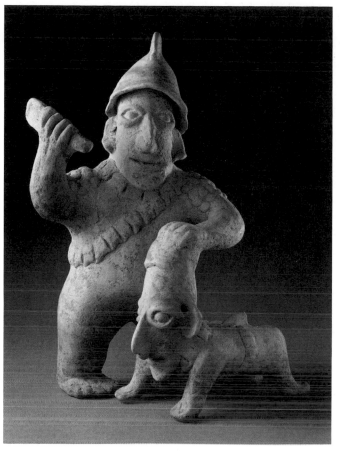

76.

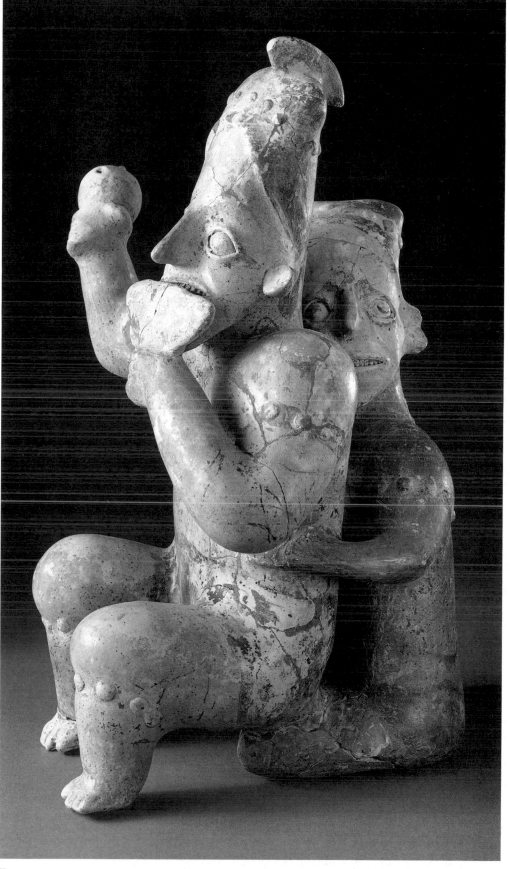

76.
Warrior and Captive (?)
Ameca Gray type
Buff slip with traces of red painted
slip decoration
17 x 12 x 10 in.
(43.2 x 30.5 x 25.4 cm)
M.86.296.83
In color p. 42

Warrior, wearing helmet, neck
and shoulder bands, and applied
shoulder pellets. Standing, threat-
ening prisoner (?) with club (?).
See Von Winning 1974: fig. 192.

77.
Joined Couple
Ameca Gray type
Burnished red and cream slip with
black and red painted slip
decoration
19½ x 13 x 11 in.
(49.5 x 33 x 27.9 cm)
M.86.296.84
In color p. 34

Male figure, wearing crested
headpiece with headband and
legbands. Seated, holding rattle
and fan. Female figure, wearing
headband and armbands. Kneeling,
embracing male from behind.
Unusual because of color
differences of figures. See Von
Winning and Stendahl 1968: pl.
135; Gallagher 1983: fig. 119.

113

77.

78.
Seated Male Figure
Ameca Gray type
Burnished cream slip with large
firing clouds
17 x 14 x 13 in.
(43.2 x 35.6 x 33 cm)
M.86.296.85
In color p. 18

Wearing wide, bossed arm and
leg bands and loincloth.

79.
Standing Warrior
El Arenal Brown type
Burnished red slip with black and
cream painted slip decoration
37 x 15 x 15 in.
(94 x 38.1 x 38.1 cm)
M.86.296.86
Alternate view, p. 30; in color, p. 71

Wearing a caplike, spiky helmet,
applied shoulder pellets, stiff
protective jacket (possibly padded
with cloth or cotton), and tight-
fitting, short trousers. Holding a
short, painted rod, possibly a club
or baton of rank. The largest
recorded example of this type.

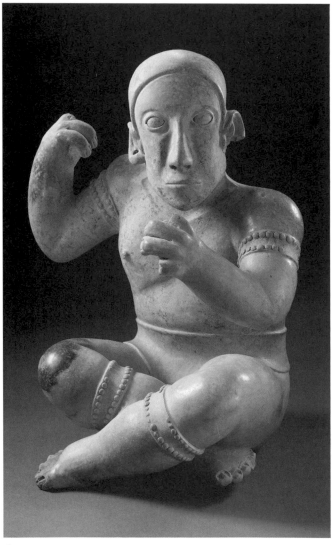

78

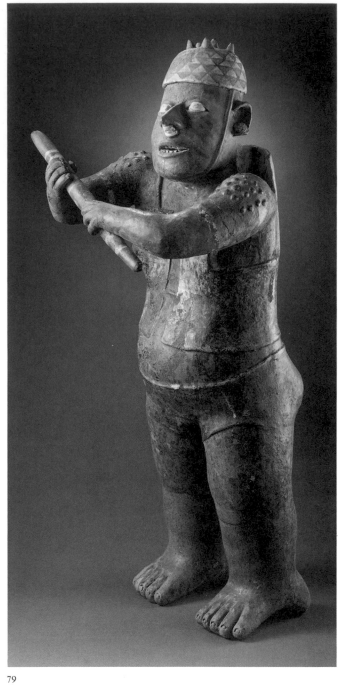

79

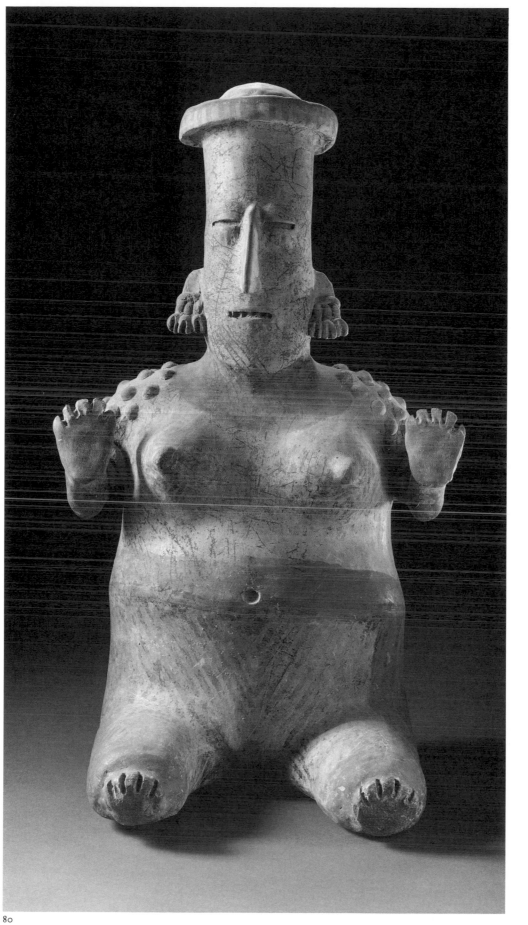

80

80.
Seated Female Figure
Burnished cream slip with black and red painted slip decoration
18 ½ x 12 x 9 in.
(47 x 30.5 x 22.9 cm)
M.86.296.87

Nude, wearing striped headband, earrings, applied shoulder pellets, and armlets. Hands upraised. This type, with elongated, tubular head and slit eyes, has been attributed to cemeteries in the region of San Juanito, *municipio* of Antonio Escobedo, about fifty miles west of Guadalajara (Parres Arias 1962).

115

81.

Kneeling Old Woman
San Sebastián Red type variant
Cream slip with black and red
painted slip decoration
20 x 10 ½ x 10 in.
(50.8 x 26.7 x 25.4 cm)
M.86.296.88

Wearing headband, earrings,
necklace, and skirt.

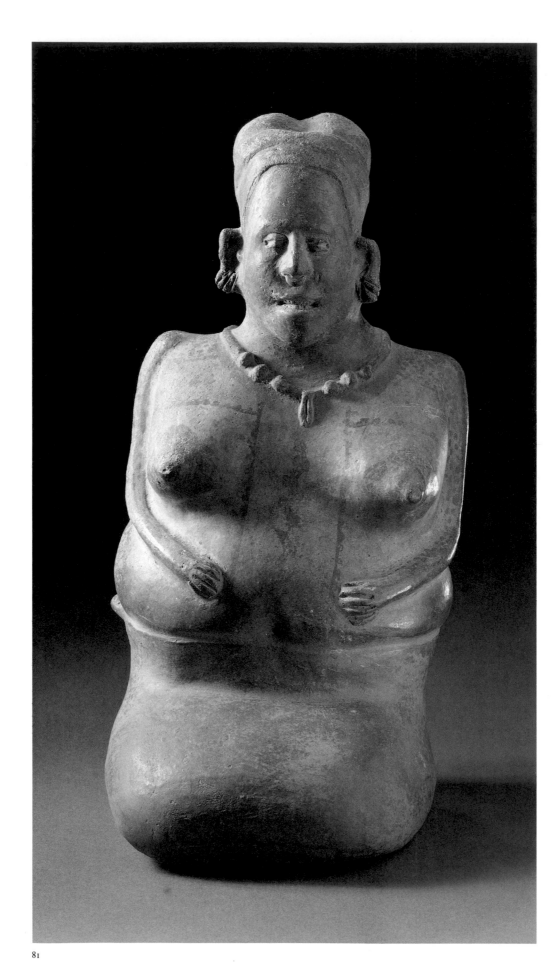

81

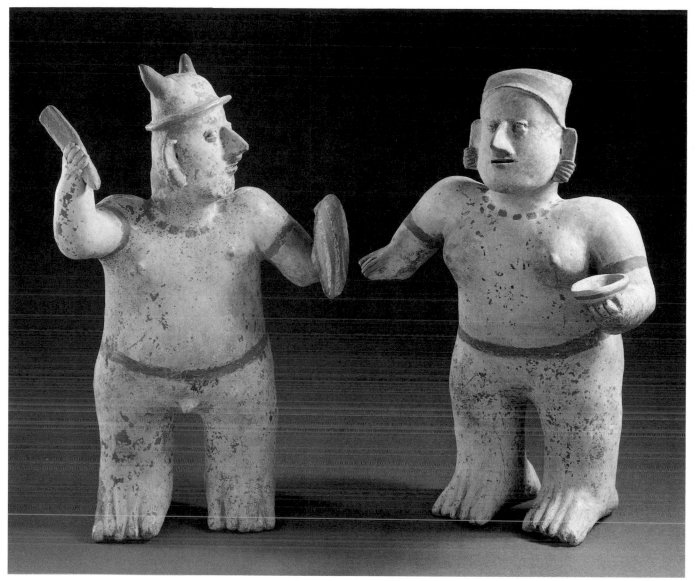

82 a-b

82a-b.

Standing Couple
El Arenal Brown type variant
Burnished light cream slip with
red painted slip decoration
Male figure: 20 x 12 x 7 in.
(50.8 x 30.5 x 17.8 cm)
Female figure: 20 x 14 x 7 ½ in.
(50.8 x 35.6 x 19.1 cm)
M.86.296.89a-b
In color p. 23

Male figure, a warrior, wearing
bicorn helmet, earrings, necklace,
armbands, and waistband.
Standing, holding round, striped
shield and club (?). Female figure,
wearing headband, earrings, nose
ring, necklace, armbands, and
waistband. Standing, holding bowl.
Both figures represent variants of
the El Arenal Brown type (with
some features of both the San
Sebastián Red and Ameca Gray
types). Probably found as a pair in
a single mortuary chamber or
burial.

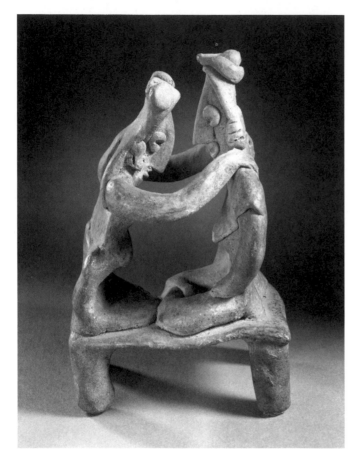

83

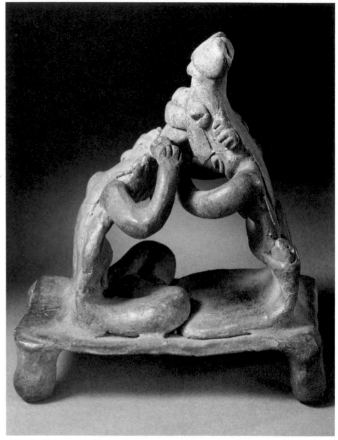

84

83.

Couple on Bench
Burnished red slip with cream
painted slip decoration
6 x 4 x 3 ¹/₂ in.
(15.2 x 10.2 x 8.9 cm)
M.86.296.90

Seated together on a four-legged
bench, the woman embracing the
man. Very similar to no. 84.

84.

Couple on Bench
Burnished red slip with cream
painted slip decoration
5 ¹/₂ x 5 ¹/₄ x 3 ¹/₂ in.
(14 x 13.3 x 8.9 cm)
M.86.296.91

Nude male, wearing headband and
earrings. Female, wearing
headband, earrings, and skirt.
Seated together on a four-legged
bench, embracing. Mourning
scene (?).

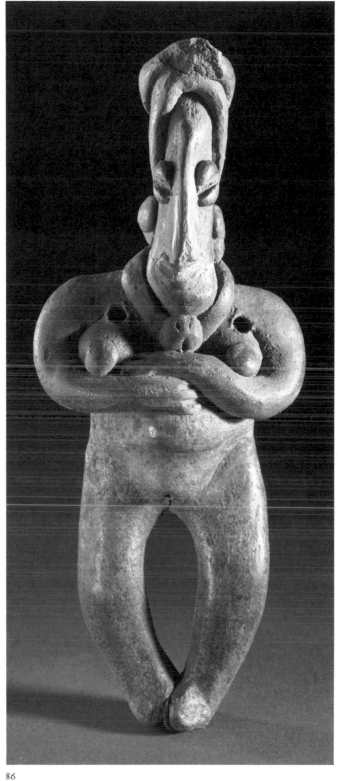

85

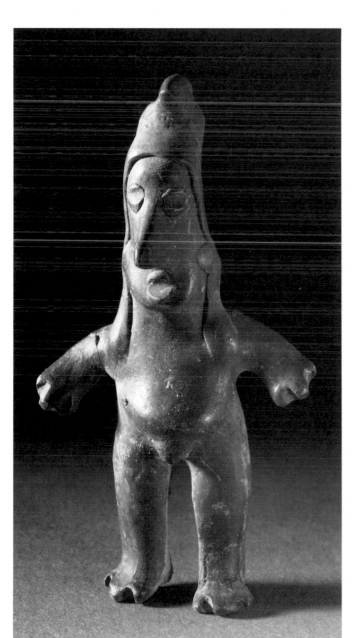

86

85.
Standing Figure
Burnished red slip
2 ¹/₄ x 2 x 1 in.
(5.7 x 5.1 x 2.5 cm)
M.86.296.92

Nude, wearing crested headdress.

86.
Female Figure
Burnished cream and red slip
7 ¹/₂ x 3 x 1 in.
(19.1 x 7.6 x 2.5 cm)
M.86.296.93

Nude, wearing headband and necklace with pectoral. Standing, arms folded across abdomen. Holes drilled in shoulders. Stylistically similar to nos. 83–84. See a nearly identical piece illustrated in Vaillant 1930: pl. XXXII, bottom row, 5 (attributed to Tala, Jalisco).

87.

Pregnant Female Figure

San Sebastián Red type

Red slip with buff painted slip decoration

6¹/₂ x 3 x 3 in.

(16.5 x 7.6 x 7.6 cm)

M.86.296.94

88.

Crouching Female Figure

Ameca Gray type

Burnished red and buff slip

14 x 9 x 10 in.

(35.6 x 22.9 x 25.4 cm)

M.86.296.95

In color p. 2

Wearing skirt. Resting on left knee, right hand on upraised right knee, chin on right hand. See Von Winning 1974: figs. 147–49; Dwyer and Dwyer 1975: figs. 43–44; Nicholson and Cordy-Collins 1979: fig. 33. Published: Malraux 1952: pl. 332; Rivet 1954: pl. 29 (reversed).

89.

Female Figure Carrying Bowl, Jalisco (?)

San Sebastián Red type variant (?)

Burnished brown slip

18 x 10¹/₄ x 7¹/₂ in.

(45.7 x 26 x 19.1 cm)

M.86.296.96

Stylistically somewhat aberrant, but the enormous legs relate it most closely to the San Sebastián Red type. Compare nos. 90, 93, 98.

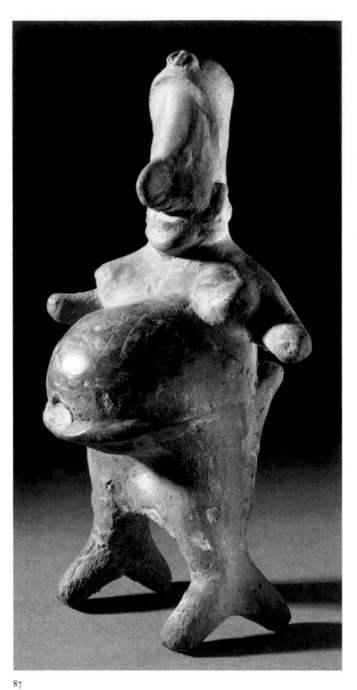

87

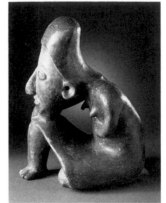

88

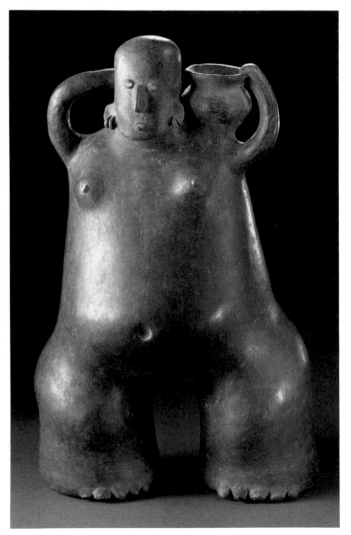

89

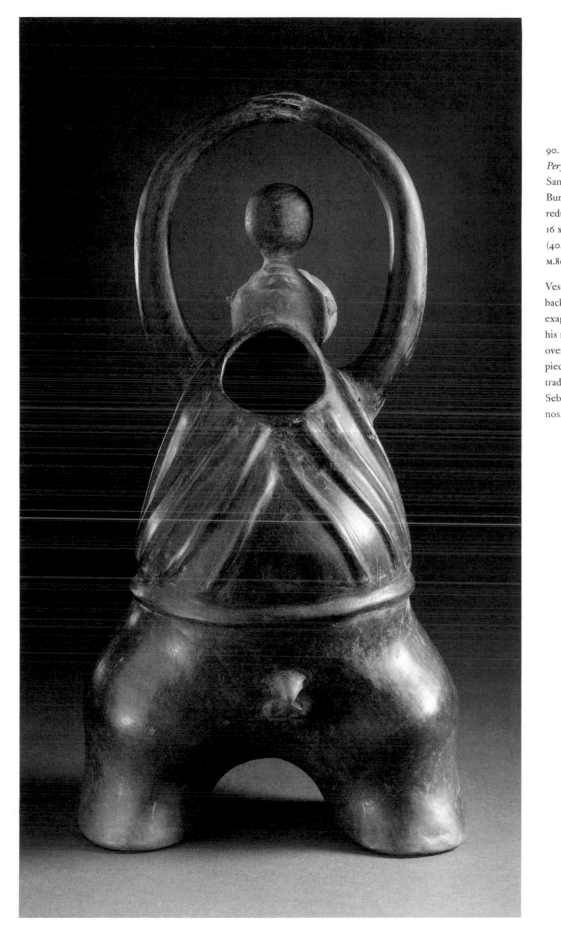

90.
Performer, Jalisco (?)
San Sebastián Red type variant (?)
Burnished black slip (uneven reduction firing?)
16 x 8 x 5 in.
(40.6 x 20.3 x 12.7 cm)
M.86.296.97

Vessel. Nude male, leaning backward, waistband (?) and ribs (?) exaggerated, balancing a ball on his nose, arms forming a circle overhead. Enormous legs link this piece with the Nayarit-Jalisco tradition, particularly the San Sebastián Red type. Compare nos. 89, 93, 98.

121

91.
Seated Male Figure
El Arenal Brown type
Burnished red-brown slip with
black and white painted slip
decoration
17 1/2 x 14 x 11 in.
(44.5 x 35.6 x 27.9 cm)
M.86.296.98

Nude, wearing headband, earrings,
nose rings, necklace, applied
shoulder pellets, armbands, and
waistband. Excellent example of
the El Arenal Brown type. See
Gallagher 1983: fig. 130.

92.
Crouching Male Figure with Pot
Ameca Gray type
Burnished buff slip with firing
clouds
12 1/2 x 7 1/4 x 10 in.
(31.8 x 18.4 x 25.4 cm)
M.86.296.99

Nude, wearing crossed headbands
with chin strap and earrings; small
pot at right side slung from left
shoulder. Seated, working (?) on
large pot. Published: Médioni and
Pinto 1941: pl. 197; México:
Secretaría de Educación Pública
1946: fig. 48.

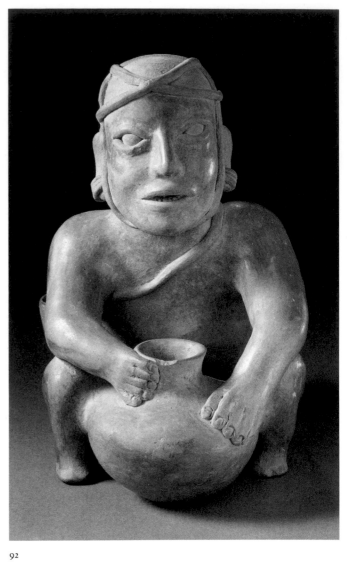

92

91

e

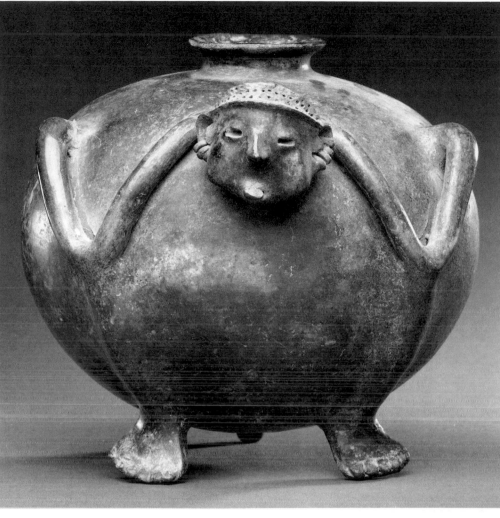

93·
Anthropomorphic Tripod Vessel,
Jalisco (?)
Brown-black slip with firing
clouds
9 x 10 (diam.) in.
(22.9 x 25.4 cm)
M.86.296.100
Alternate view p. 16

Nude female, wearing pierced
headband and earrings. Compare
nos. 89–90, 98.

94·
Male Figure on Pallet
Red slip with cream and black
painted slip decoration
2 x 4¹⁄₂ x 3³⁄₈ in.
(5.1 x 11.4 x 8.6 cm)
M.86.296.101

A figure, possibly a corpse, lies on
a four-legged platform, or bier, to
be placed in a mortuary chamber
(Delgado 1969). The figure wears a
headband and is covered with a
decorated blanket or mantle. Two
vertical pieces flank the figure's
head. Compare no. 95, in which
the figure is depicted strapped to
the platform.

123

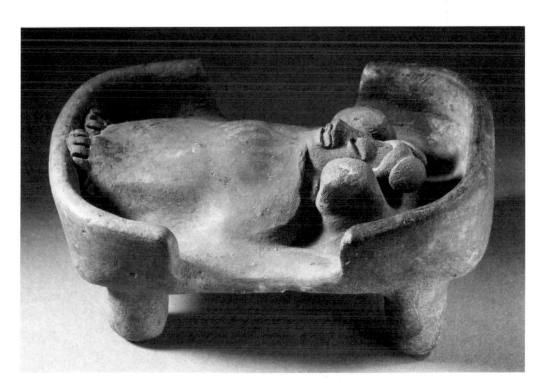

95.
Male Figure Strapped to Pallet
Red slip
3 ½ x 5 x 3 in.
(8.9 x 12.7 x 7.6 cm)
M.86.296.102

Four-legged platform with low
ends and two hoops arching over
the body. Vertical pieces flank
head. Compare no. 94.

96.
Headrest (?), Jalisco (?)
Traces of buff slip with black
painted slip decoration
4 ¼ x 8 ½ in.
(10.8 x 21.6 cm)
M.86.296.103

97.
Crawling Figure
Burnished red slip
4 x 5 x 3 ½ in.
(10.2 x 12.7 x 8.9 cm)
M.86.296.104

Nude with elongated head,
wearing headband, circular
earplugs, and nose buttons.

124

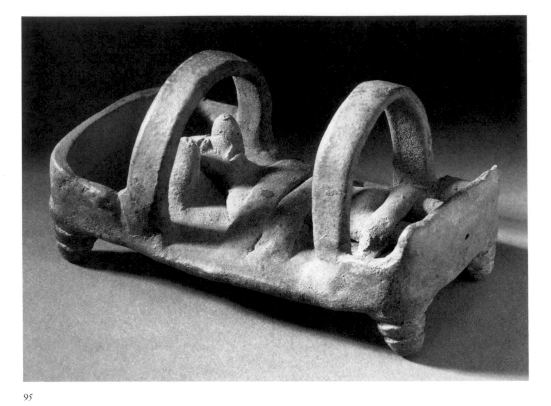

95

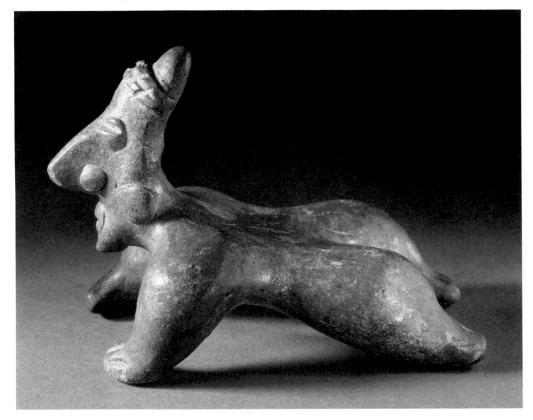

97

96

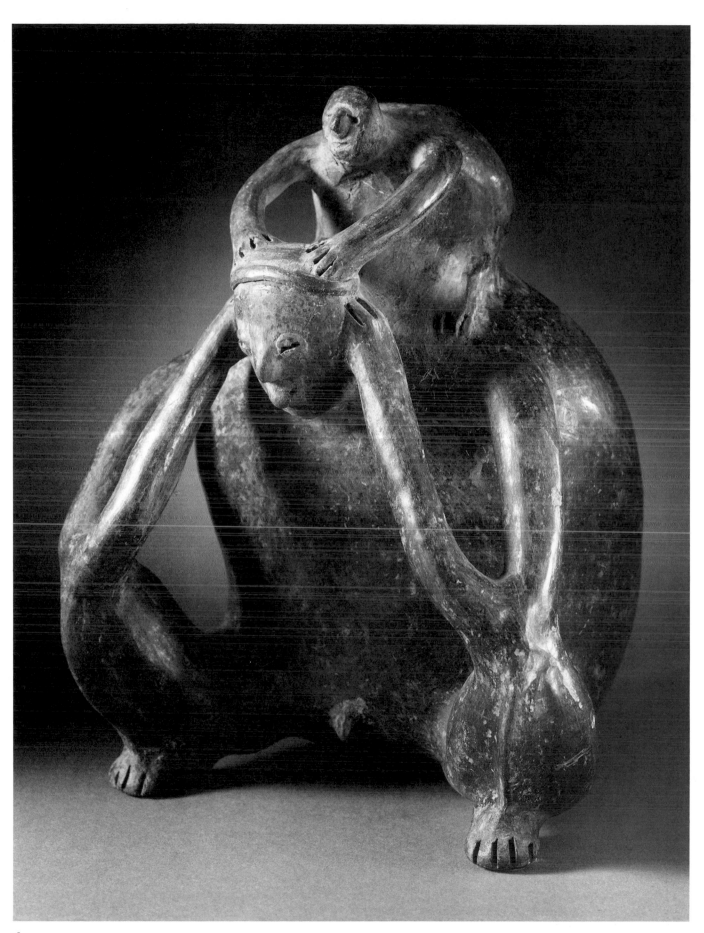

98.
Male Figure with Monkey on Back,
Jalisco (?)
Burnished black slip
10 x 7 1/2 x 7 in.
(25.4 x 19.1 x 17.8 cm)
M.86.296.105
Alternate view, p. 62.

Nude male, squatting, elbows on
knees, hands on head. The
monkey's hands rest on the man's
head. Possibly from the
Guadalajara area. Compare nos.
89–90, 93. See Parres Arias 1965b:
fig. 2; Von Winning 1974: 157.

125

According to archaeological findings (Delgado 1969; Bell 1972a, 1974), most Zacatecas-type figures (nos. 99a-b-102) derive from a small area in northeastern Jalisco centered near Teocaltiche and perhaps adjoining Zacatecas.

99a-b.
Seated Couple
Zacatecas type
Burnished red and buff slip with white and black painted slip and black resist (male) decoration
Male figure: 16 x 9 ½ x 8 in.
(40.6 x 24.1 x 20.3 cm)
Female figure: 15 ¾ x 7 x 6 in.
(40 x 17.8 x 15.2 cm)
M.86.296.39a-b
In color p. 8

Nude male, hair tied in the form of horns, wearing earrings. Seated, holding drum (?), wrists resting on knees. Nude female, wearing large, pierced earspools. Seated, hands on hips. Compare nos. 100-102. Such figures, including those decorated in the resist, or negative painting, technique (McBride 1969a: pl. 2c, f-j) are found in burials associated with ceramic vessels. One cemetery site was located near Teocaltiche, Jalisco, close to the border of Zacatecas (Delgado 1969: 49-52; Bell 1972a, 1974). Two radiocarbon dates (Taylor 1970a: 254) indicate a circa A.D. 200 date for one burial in this cemetery; this suggests the general contemporaneity of this distinctive type of figure with the large, hollow figures of the shaft-chamber tomb tradition farther west.

100.
Seated Male Figure
Zacatecas type
Burnished red and buff slip with black and white painted slip and black resist decoration
15 ½ x 9 ½ x 6 ½ in.
(39.4 x 24.1 x 16.5 cm)
M.86.296.40

Nude, hair tied in the form of horns, wearing earspools and necklaces. Seated, arms resting on knees. Compare nos. 99a, 101.

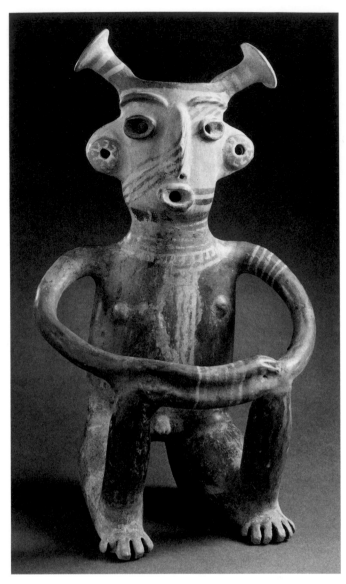

100

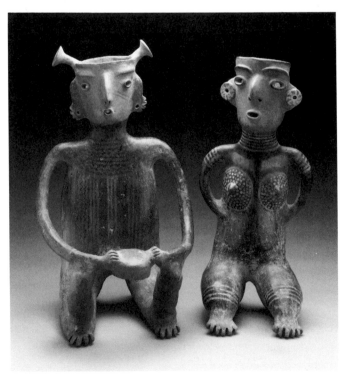

99 a-b

126

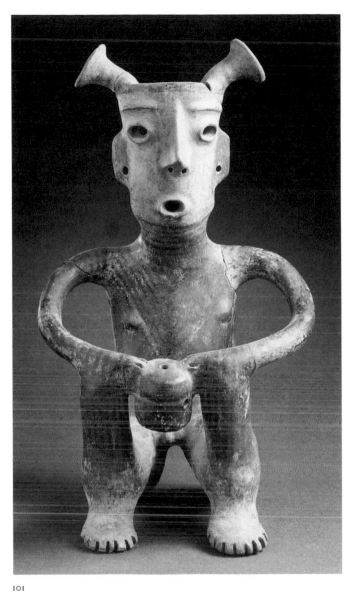

101

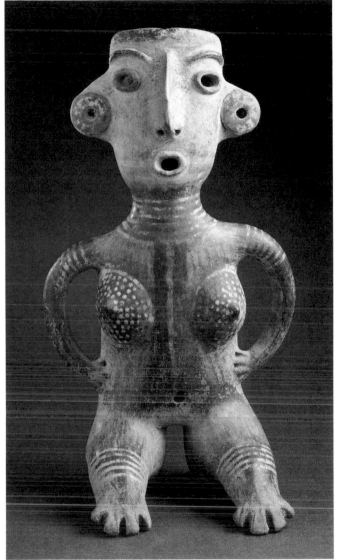

102

101.

Seated Male Figure with Drum
Zacatecas type
Burnished red and buff slip with
black and white painted slip and
black resist decoration
15 $\frac{1}{4}$ x 9 $\frac{1}{2}$ x 7 in.
(38.7 x 24.1 x 17.8 cm)
M.86.296.41

Nude, hair tied in the form of
horns. Seated, holding drum, arms
resting on knees. Compare nos.
99a, 100.

102.

Seated Female Figure
Zacatecas type
Red slip with white and black
painted slip and black resist
decoration
13 x 7 $\frac{1}{2}$ x 4 $\frac{1}{2}$ in.
(33 x 19.1 x 11.4 cm)
M.86.296.42

Nude, wearing large earspools.
Seated, hands on hips. Compare
no. 99b.

127

103a-b.

Musicians

Burnished red slip

Drummer: 15 x 9¹/₂ x 10³/₄ in.
(38.1 x 24.1 x 27.3 cm)

Trumpeter: 15³/₄ x 15¹/₂ x 11³/₄ in.
(40 x 39.4 x 29.8 cm)

M.86.296.106a-b

In color p. 71

Drummer, wearing headdress with
shallow, projecting, bowllike ele-
ment (shell?). Seated, left hand on
drum, right hand holding rattle (?).
Trumpeter, wearing identical
headdress. Seated, holding fan (?),
shell trumpet resting on left leg.

104.

*Seated Male Figure Wearing
Necklace*

Burnished dark red slip with
incised decoration and white
rootlet calcification

14 x 8¹/₂ x 9 in.
(35.6 x 21.6 x 22.9 cm)

M.86.296.107

Alternate view, p. 65.

Nude, wearing headdress,
earspools, and necklace of large,
leaf-shaped elements, probably
shell sections (see no. 200).
Seated, right arm raised in
"speaking pose," left arm on left
leg.

128

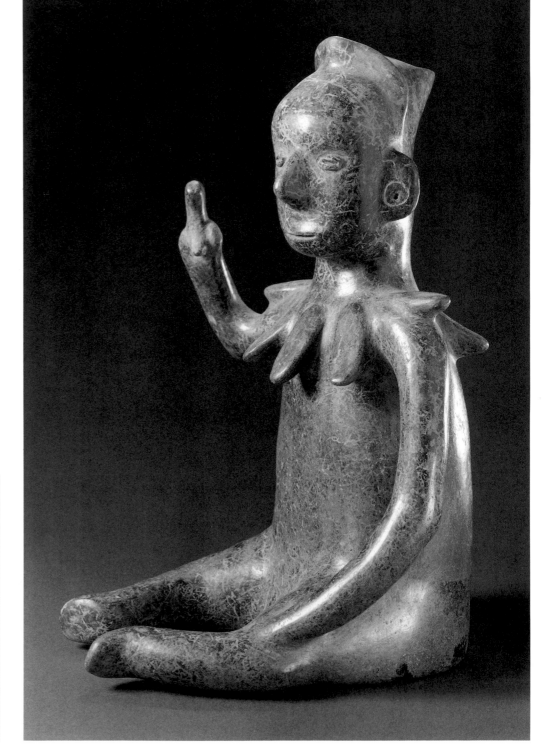

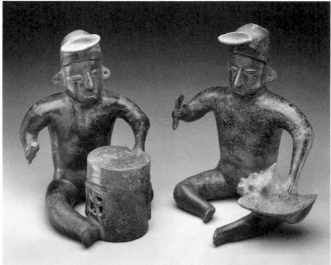

103 a-b

104

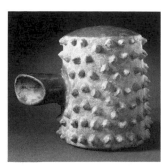

105

105.
Cylindrical Vessel (Drum?)
Burnished red slip
9 ¹/₂ x 7 x 8 in.
(24.1 x 17.8 x 20.3 cm)
M.86.296.108

Vessel with spout, encrustations
on body, and small cones over
surface. Spiky protuberances of
this type are most frequently
found on incense burners in
Mesoamerica. See Gallagher 1983:
fig. 105.

106.
Seated Drummer
Burnished red slip with orange
painted slip decoration
9 ³/₄ x 4 ³/₄ x 8 in.
(24.8 x 12.1 x 20.3 cm)
M.86.296.109

Vessel. Spout projects from back.
Nude, wearing headdress with
projecting tabs. Seated, drinking
from bowl. A good example of a
recognizable Colima type,
possibly also found in adjacent
Jalisco (Eisleb 1971: 24, fig. 3),
characterized particularly by
hollow eye sockets, originally
containing shell inlays. Compare
no. 113. See Von Winning 1974:
fig. 41; Nicholson and Cordy-
Collins 1979: fig. 48.

107.
Standing Female Figure
Burnished red slip with black
painted slip and incised decoration
7 ¹/₂ x 8 ¹/₄ x 3 ¹/₂ in.
(19.1 x 21 x 8.9 cm)
M.86.296.110

129

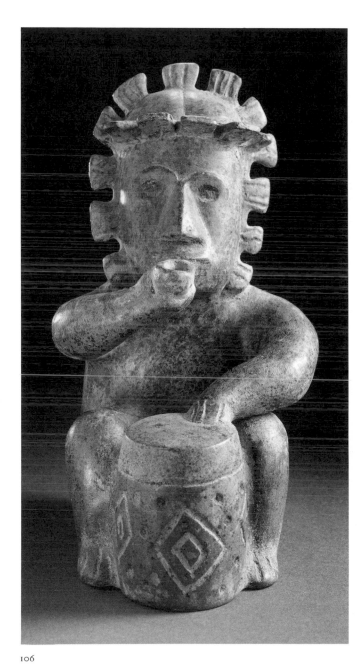

106

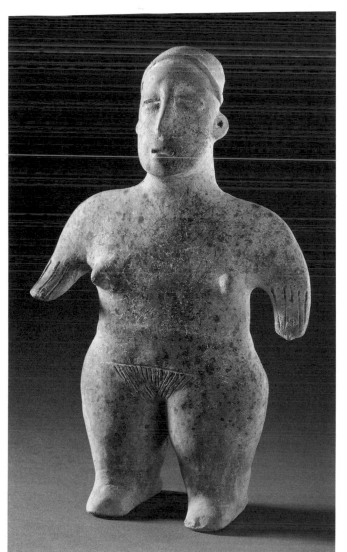

107

108.
Reclinatorio
Burnished red and orange slip
10 ½ x 8 ½ x 11 in.
(26.7 x 21.6 x 27.9 cm)
M.86.296.111

Aviform vessel supported by man
with tumpline. These backrests
(compare nos. 143f, l-m) are well
known in collections, but this
type, supported by a full human
figure, is more unusual (see Eisleb
1971: fig. 166).

109.
*Crouching Male Figure Carrying
Large Pot*
Burnished red and orange slip
15 x 7 ¼ x 12 ¾ in.
(38.1 x 18.4 x 32.4 cm)
M.86.296.112

Pot carried with tumpline.

110.
Seated Male Figure
Burnished red slip
12 x 7 x 10 in.
(30.5 x 17.8 x 25.4 cm)
M.86.296.113

Vessel. Spout on top of head.
Nude, wearing headdress with
forehead horn, earspools, and
waistband. Seated, knees drawn up,
elbows resting on knees, chin
resting on arms.

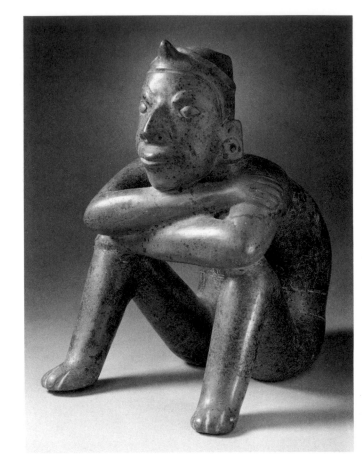

110

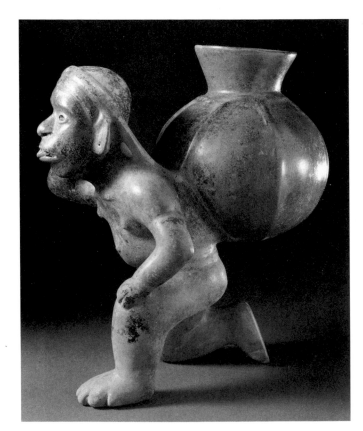

108

109

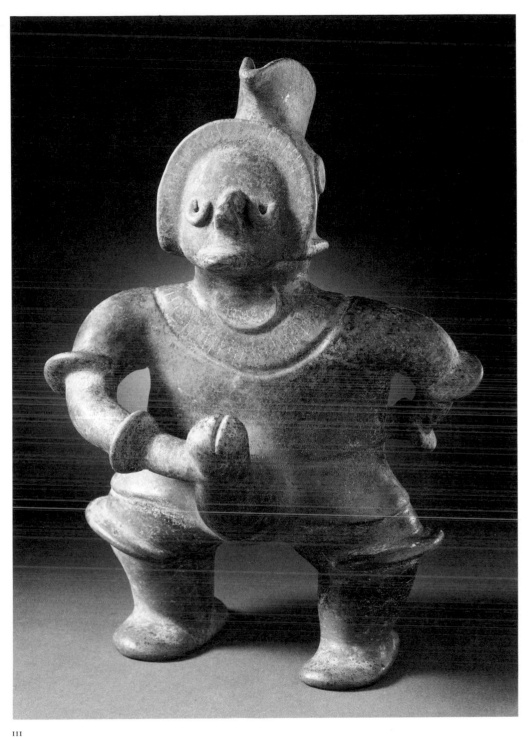

III

III.

Phallic Dancer
Burnished red slip
12 ½ x 8 x 6 ½ in.
(31.8 x 20.3 x 16.5 cm)
M.86.296.114
Alternate view, p. 35.

Effigy vessel. Figure accoutered in a mask, or headpiece, with a bill and crest (which also serves as the spout), and armor that includes a girdle to which an exaggerated phallus is attached. Similar putative masks are known on other Colima figures (Von Winning and Stendahl 1968: pls. 70, 83).

II2.

Phallic Figure
Burnished red and orange slip with incised decoration
9 ½ x 9 x 7 ½ in.
(24.1 x 22.9 x 19.1 cm)
M.86.296.115

Vessel. Male figure, wearing crested helmet and trousers. Seated, leaning backward, legs spread, hands on ground behind him. Good example of a type frequently encountered. See Von Winning 1974: figs. 18–20.

131

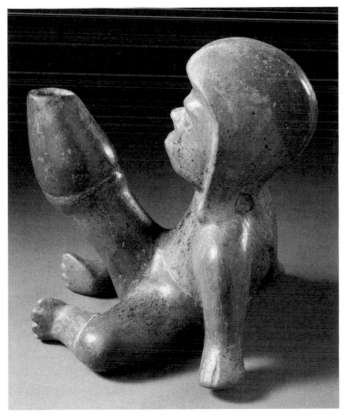

113.
Shaman (?)
Buff-orange slip
10 x 7 x 7 in.
(25.4 x 17.8 x 17.8 cm)
M.86.296.116

Vessel. Spout projects from back.
Ritual performer and/or shaman (?),
wearing a distinctive headdress
with a canine head, depending
earflaps, crescentic pectoral, cross-
slung side pouches, and aviform
penis-sheath (?). Standing, holding
a twisted staff and rattle.

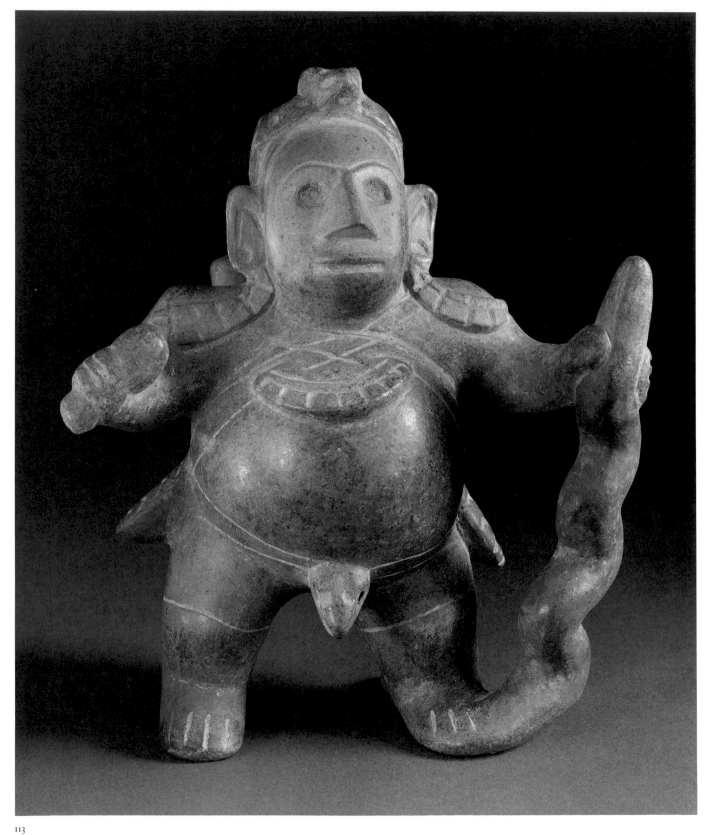

113

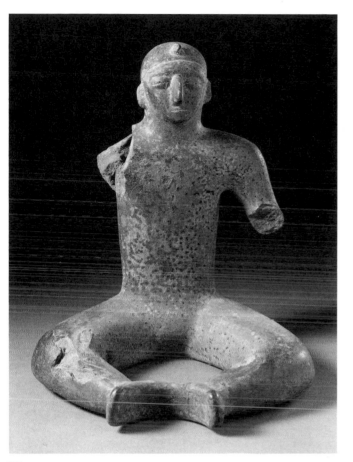

114

114.

Seated Male Figure
Burnished red-brown slip with
incised decoration
12 ½ x 10 x 9 ½ in.
(31.8 x 25.4 x 24.1 cm)
M.86.296.117
Alternate view p. 45

Nude, wearing small horn (?) on
forehead. Seated, legs flat on
ground, heels joined. Right arm
missing; left arm missing below
elbow. Originally the figure may
have held a bowl in his lap.

115.

Seated Warrior
Burnished red slip with traces of
cream painted slip decoration
14 x 13 x 9 in.
(35.6 x 33 x 22.9 cm)
M.86.296.118
In color p. 63

Vessel. Spout projects from back
of head. Figure wearing horned
headdress with chin strap, blade-
shaped pectoral, short-sleeved
shirt, and short, tight-fitting
trousers. Seated, twisting to left,
holding curved object (club?
boomerang?). A fine example of a
frequent Colima theme (Furst
1965c: fig. 4). Published: Von
Winning and Stendahl 1968: pl. 69
(color).

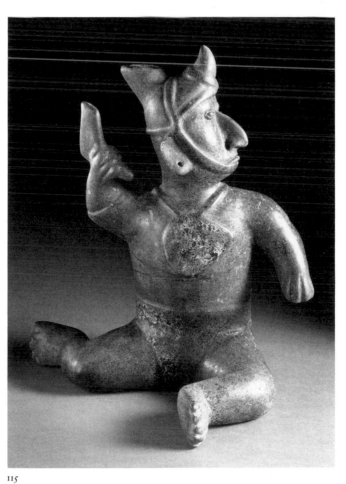

115

116.
Acrobat
Burnished red slip
9½ x 8 x 13 in.
(24.1 x 20.3 x 33 cm)
M.86.296.119

Vessel. Figure wearing crescentic
pectoral and skirt. Standing in
backbend position. Although
acrobats are known in collections,
those with backs so highly arched
are rare. Compare no. 118. See Von
Winning and Stendahl 1968: fig.
73; Nicholson and Cordy-Collins
1979: fig. 50.

117.
Seated Male Figure with Five Pots
Orange and red slip
10½ x 9½ x 10½ in.
(26.7 x 24.1 x 26.7 cm)
M.86.296.120
In color p. 55

Vessel. Mouth of top pot open.
Figure, wearing loincloth. Seated,
balancing five pots on back.

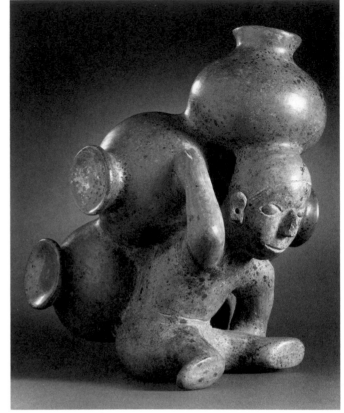

117

134

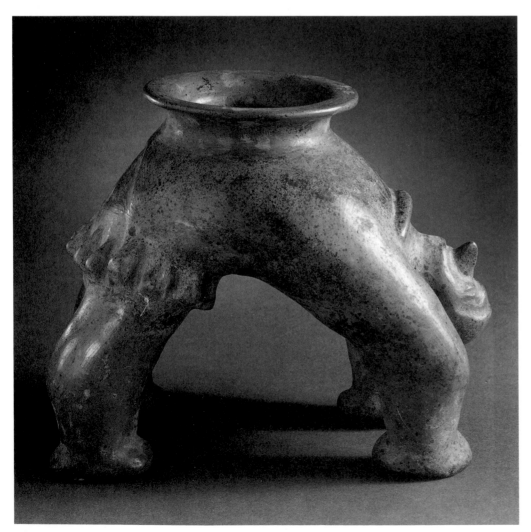

116

118.
Acrobat
Burnished red slip
9 x 12 x 10 in.
(22.9 x 30.5 x 25.4 cm)
M.86.296.121

Vessel. Nude, standing in
backbend position. A flat arch,
such as this, is more commonly
seen than the high arch in no. 116.
See Eisleb 1971: fig. 12; Von
Winning 1974: fig. 24; Gallagher
1983: fig. 14.

119.
Drinker
Burnished red and orange slip with
incised decoration
13 x 11 3/4 x 8 1/4 in.
(33 x 29.8 x 21 cm)
M.86.296.122

Vessel. Spout projects from back
of head. Male hunchback, wearing
horned headdress with chin strap,
earplugs, nose plug, crescentic
pectoral, and off-shoulder pouch
or mantle. Seated, arms upraised,
bowl in left hand. Published: Von
Winning and Stendahl 1968: pl. 75
(color).

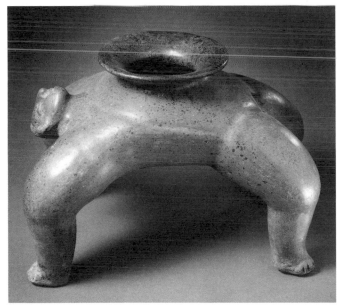

118

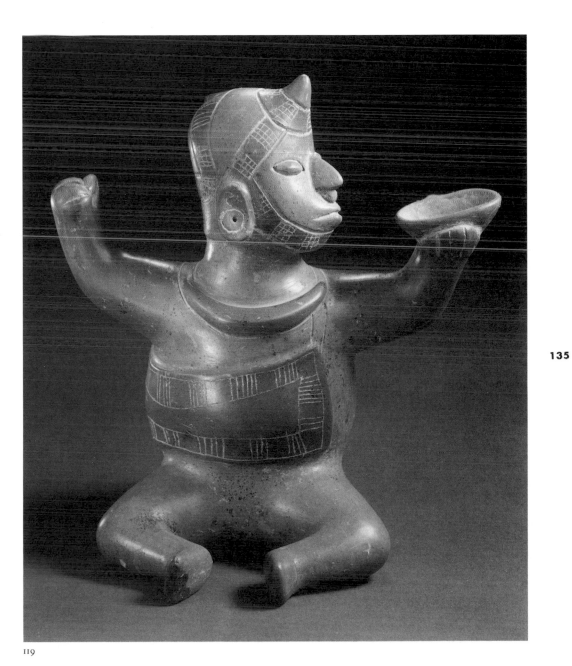

120.
Head Pot
Burnished red and orange slip with
large firing cloud
7 x 6¾ x 8½ in.
(17.8 x 17.1 x 21.6 cm)
M.86.296.123

Vessel. Prominent horn above
forehead, ridges in temporal
regions, and nose plug. Similar
specimens are known (Furst 1965c:
fig. 7; Von Winning 1974: fig. 56).

121.
Seated Male Figure with
Outstretched Arms
Burnished orange-red slip with
red painted slip and incised
decoration
15 x 10½ x 10 in.
(38.1 x 26.7 x 25.4 cm)
M.86.296.124

Wearing crossed headbands,
earplugs, and short-sleeved shirt.

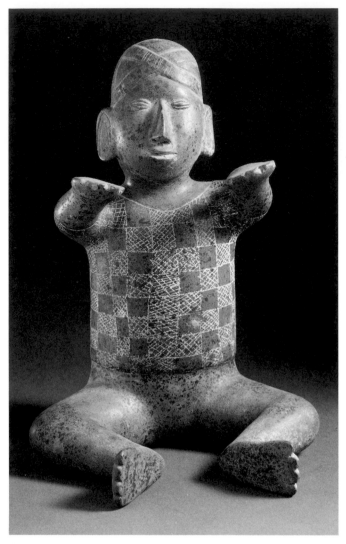

121

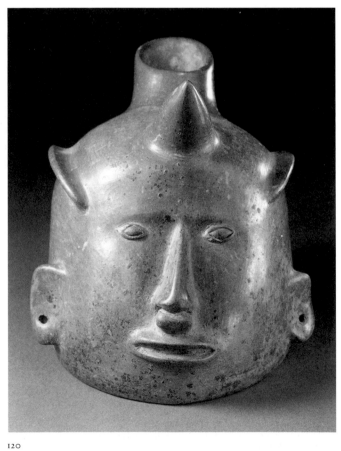

120

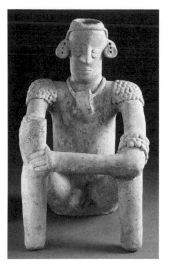

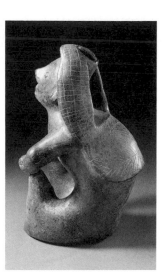

122

123

122.
Seated Male Figure
Coahuayana Valley type
Cream slip
13 x 8 x 9 in.
(33 x 20.3 x 22.9 cm)
M.86.296.125

Nude, wearing earspools, necklace with ring pectoral, applied shoulder pellets, and armbands. Right hand and lower arm missing. A rare, distinctive Colima type (see Anton 1965: pl. 55), characteristic of Coahuayana Valley (boundary between Colima and Michoacan).

123.
Seated Male Figure
Burnished red-orange slip with incised decoration
13½ x 8 x 9 in.
(34.3 x 20.3 x 22.9 cm)
M.86.296.126

Nude. Knees drawn up, elbows on knees, pouch suspended by a tumpline.

124.
Vessel with Four Heads
Burnished red slip with incised decoration
8½ x 12 (diam.) in.
(21.6 x 30.5 cm)
M.86.296.127

Similar multiheaded pots are known. Compare no. 125.

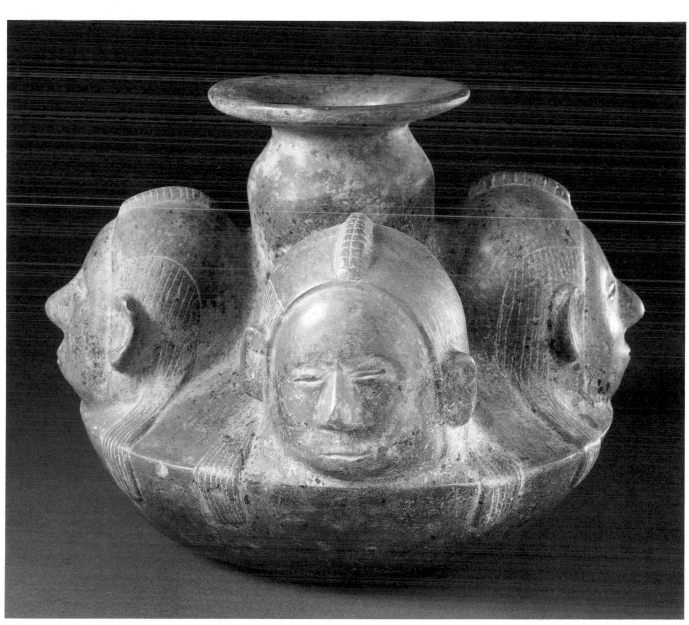

137

124

125.
Vessel with Nine Heads
Burnished red slip
9 x 12 (diam.) in.
(22.9 x 30.5 cm)
M.86.296.128
In color p. 25

Compare no. 124. See Von
Winning and Stendahl 1968: fig.
113; Dwyer and Dwyer 1975: fig. 48;
Gallagher 1983: fig. 92.

126.
*Seated Male Figure Holding
Head Pot*
Burnished black slip
4 3/8 x 3 1/2 x 3 1/2 in.
(11.1 x 8.9 x 8.9 cm)
M.86.296.129
In color p. 48

Actual Colima head vessels are
common (compare no. 120), but
depictions of figures holding them
are rare.

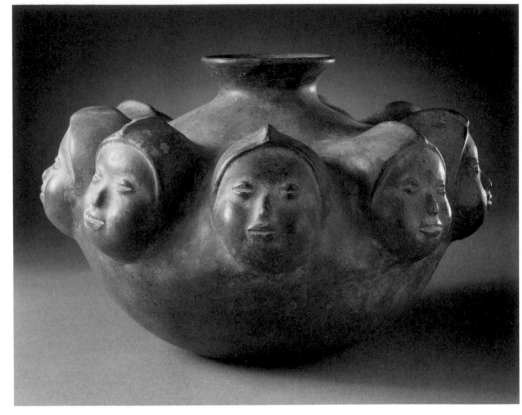

125

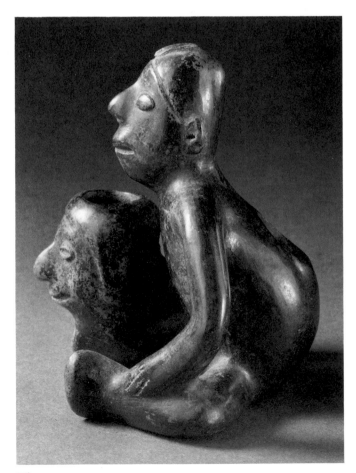

126

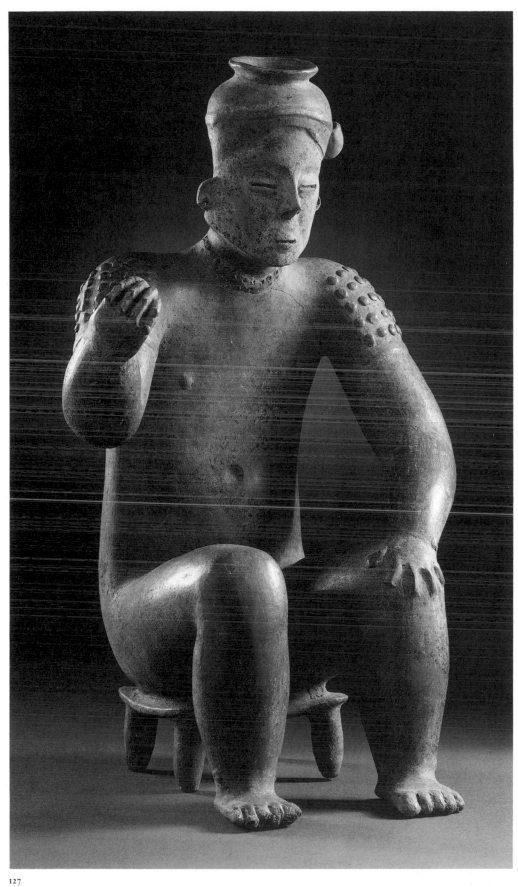

127.

Seated Male Figure
Coahuayana Valley type
Burnished red slip
21 1/2 x 13 x 12 in.
(54.6 x 33 x 30.5 cm)
M.86.296.130

Vessel. Nude, wearing headband
with small pot attached, necklace,
applied shoulder pellets, and
armbands. Seated on four-legged
stool. Style and shoulder
ornaments suggest Coahuayana
Valley type (compare no. 122 and
Von Winning 1974: figs 51 52;
Gallagher 1983: pl. 3, figs. 45–48).

128.

Standing Warrior with Slingshot
Burnished red-orange slip with
red and cream painted slip
decoration
12 x 7 x 5 in.
(30.5 x 17.8 x 12.7 cm)
M.86.296.131

Vessel. Spout projects from back
of head. Figure wearing crested
helmet with earflaps, short-
sleeved shirt, and loincloth.

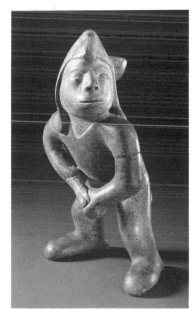

128

139

127

129.
Seated Female Figure with Child
Tuxcacuesco-Ortices type
Unslipped buff with white and
black painted slip decoration
11 ½ x 6 ½ x 6 ½ in.
(29.2 x 16.5 x 16.5 cm)
M.86.296.132

Both figures wearing headband,
ear ornaments (?), necklace, and
armbands; female also wearing
skirt. This is a large version of the
common small, solid figures of the
Tuxcacuesco-Ortices type
occurring at many Colima sites.

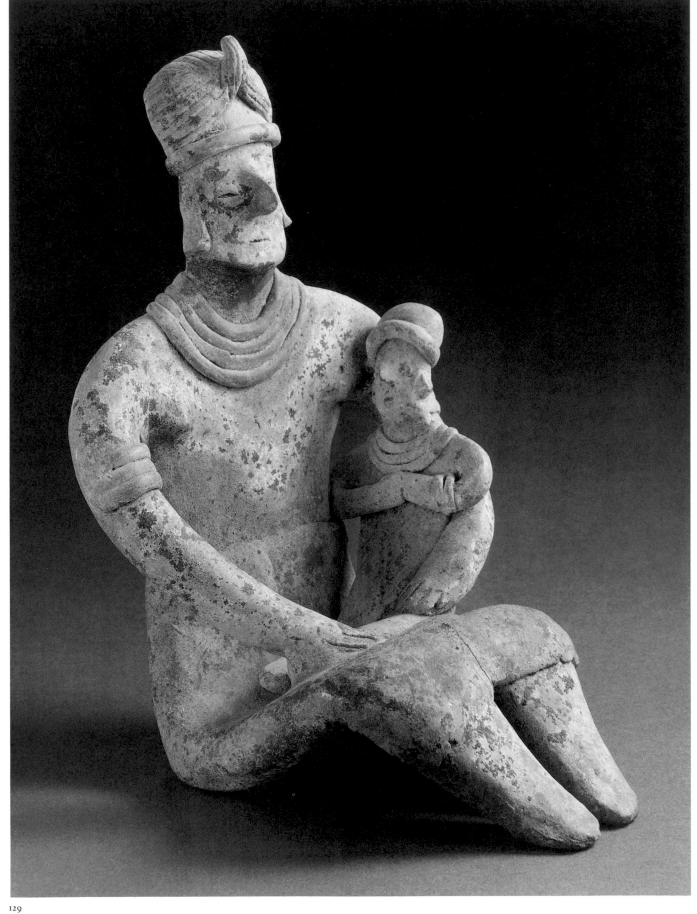

129

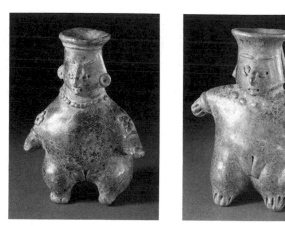

130 a-b

130a-b.

Two Standing Female Figures
Coahuayana Valley type
Burnished red-brown slip
a. 6½ x 5 x 1¾ in.
(16.5 x 12.7 x 4.4 cm)
b. 6½ x 4½ x 2½ in.
(16.5 x 11.4 x 6.4 cm)
M.86.296.133a-b

Effigy vessels. Nude, both
wearing necklaces; figure a (left)
also wearing earspools and applied
shoulder pellets. These distinctive
figures have been attributed to the
Coahuayana Valley. See McBride
1969b: pl. 41; Eisleb 1971: fig. 20–
24; Von Winning 1974: figs. 47–48;
Gallagher 1983: 41–43, pl. 4, fig. 33).

131.
Hunchback
Burnished buff-gray slip
9 x 8 x 8 in.
(22.9 x 20.3 x 20.3 cm)
M.86.296.134
In color p. 32

Hunchbacked figures are
renowned in Colima collections,
but pierced eyes, such as those in
this example, are extremely rare
in any Colima figure.

141

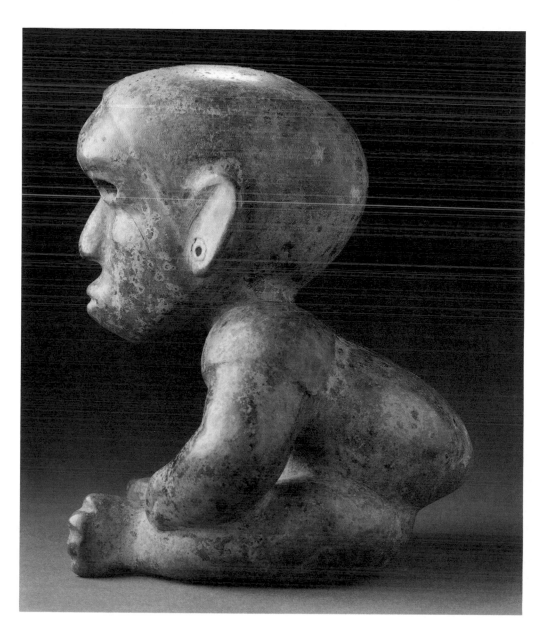

131

132.

Standing Male Figure
Coahuayana Valley type
Burnished mottled red and black
slip
22 ¼ x 10 ¼ x 4 ½ in.
(56 x 26 x 11.4 cm)
M.86.296.135

Very unusual manufacture with flat, solid body and hollow legs, wearing crossed headbands with asymmetrical horn (?), earspools, necklaces, applied shoulder pellets, armbands, and triangular loincloth. Holding mace (baton?). Face is nearly identical with no. 130a-b, so this type too may hail from the Coahuayana Valley (see Médioni and Pinto 1941: pl. 41; Baus Czitrom 1978: pl. 17). McBride (1969: 41) believes this type is connected with the "H4 figurine" of the Basin of Mexico Late Preclassic (Ticoman IV), a type also "associated with the Chupícuaro figurine tradition." Thus a relatively early date (c. 150 B.C.?) for this Colima type is a possibility.

133.

Joined Couple
Tuxcacuesco-Ortices type
Buff slip with traces of white painted slip and incised decoration
4 ½ x 5 x 3 in.
(11.4 x 12.7 x 7.6 cm)
M.86.296.136

Bearded male figure, wearing headband, large ear pendants, nose plug, necklace with pendant, and loincloth. Female figure, wearing necklace with pectoral and skirt. Seated, joined (in conflict?), male's right arm extended, holding object.

142

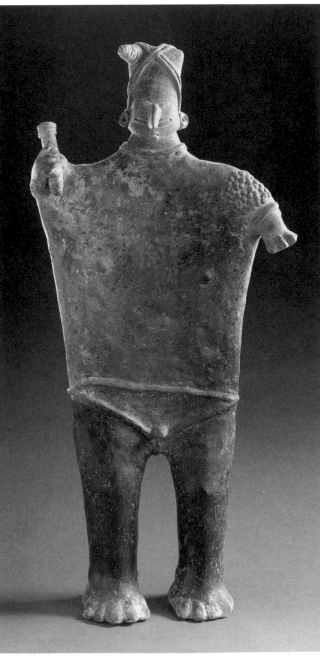

132

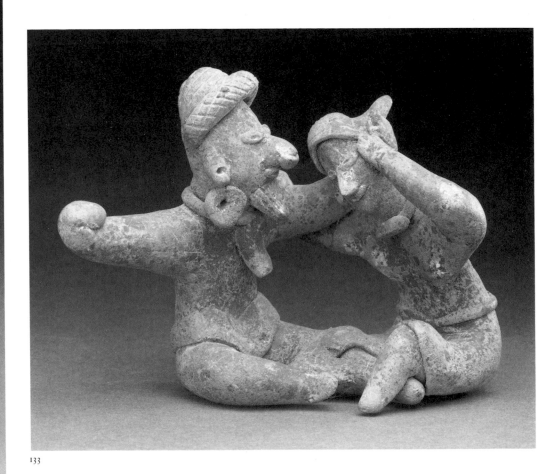

133

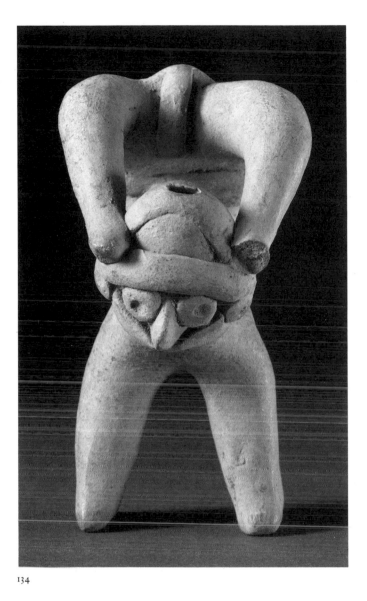

134

134.
Acrobat
Unslipped buff
3 ¹/₂ x 1 ³/₄ x 2 ¹/₂ in.
(8.9 x 4.4 x 6.4 cm)
M.86.296.137
Alternate view, p. 60

Whistle. Male figure, wearing
headband with chin strap, mask (?),
and skirt. Figure balancing in
handstand position. See Von
Winning and Stendahl, 1968: pl. 59.

135.
Figure Seated in Palanquin
Unslipped buff
³/₄ x 4 x 2 ³/₄ in.
(9.5 x 10.2 x 7 cm)
M.86.296.138

Litter with arched canopy
conveyed by four bearers. Note
unusual coiffures (headdresses?).
See Krutt 1975: figs. 34–35.

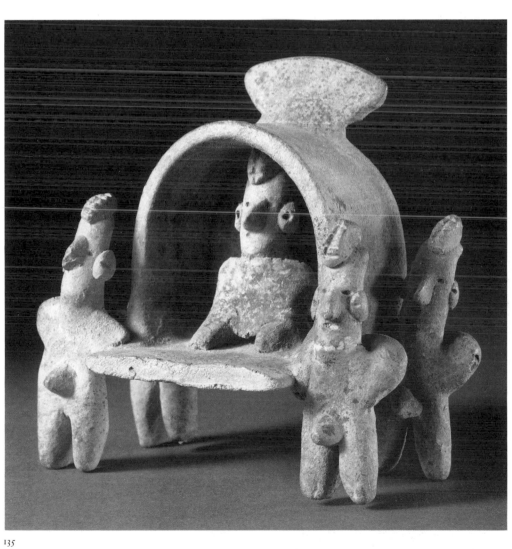

135

143

136.

Three Figures in Procession
Unslipped buff with traces of
white painted slip decoration
3 ¹/₂ x 2 x 3 ¹/₄ in.
(8.9 x 5.1 x 8.3 cm)
M.86.296.139

All three wear headbands and ear
ornaments. First figure playing
instrument (?); second, wearing
skirt, hands on shoulders of first;
third, hands on shoulders of
second. See Krutt 1975: fig. 36.

137.

Pregnant Female Figure
Unslipped buff
5 x 2 ¹/₂ x 1 ¹/₂ in.
(12.7 x 6.4 x 3.8 cm)
M.86.296.140

Wearing applied shoulder pellets
and short skirt.

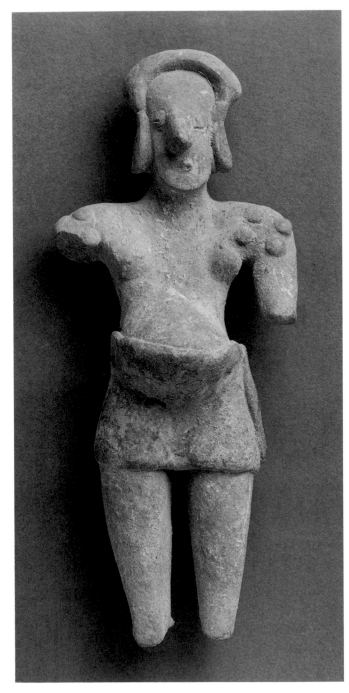

137

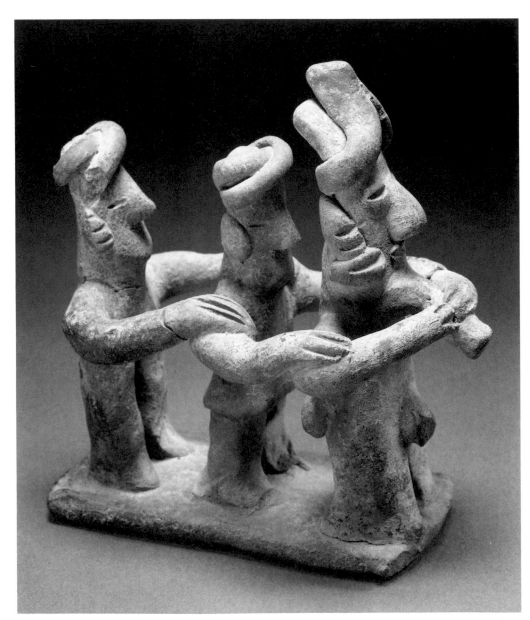

136

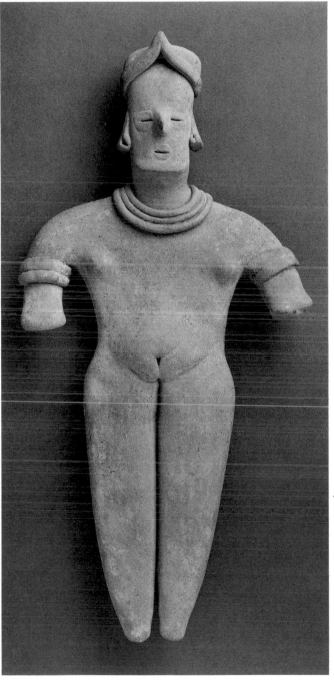

138

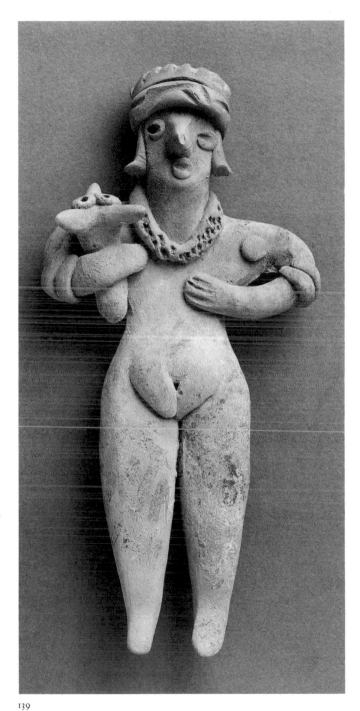

139

138.
Standing Female Figure
Unslipped buff-orange
13 x 6½ x 1½ in.
(33 x 16.5 x 3.8 cm)
M.86.296.141

Nude, wearing pointed headband, triple necklace, and double armbands.

139.
Standing Female Figure with Dog
Unslipped buff with black painted slip decoration and firing cloud
1¼ x 5¼ x 2¾ in.
(3.2 x 13.3 x 7 cm)
M.86.296.142

Wearing headband, thick necklace, and double armbands.

140.
Female Figure
Burnished brown-buff slip
7 x 4 x 1 in.
(17.8 x 10.2 x 2.5 cm)
M.86.296.144

Flattish figures such as this with athletic builds and heads exhibiting a considerable range from realistic to abstract depiction constitute a distinct and readily recognizable Colima type. See Von Winning and Stendahl 1968: pl. 61.

141.
Joined Couple
Unslipped buff with black painted slip decoration
4 x 3¼ x 1 in.
(10.2 x 8.3 x 2.5 cm)
M.86.296.145

Wearing headbands or coiffures and double armbands.

142.
Reclining Female Figure
Unslipped buff
3½ x 5 x 3½ in.
(8.9 x 12.7 x 8.9 cm)
M.86.296.146

Nude, wearing thick headband with perforations and double armbands.

146

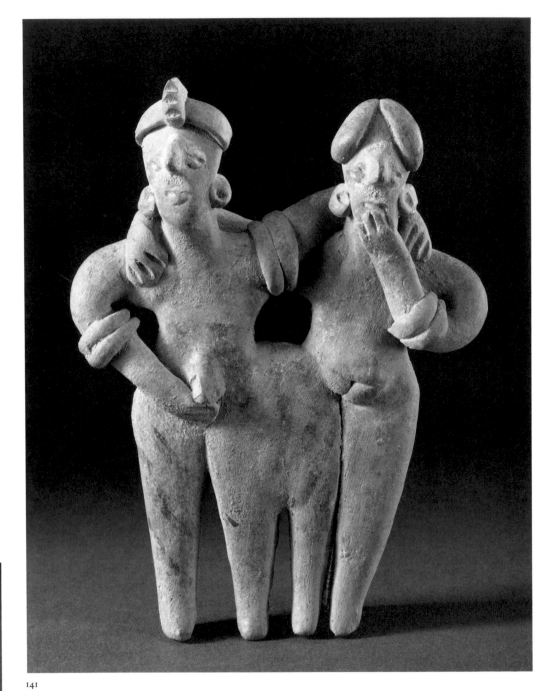

141

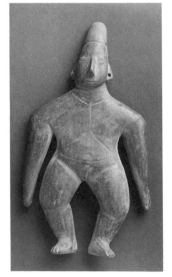

140

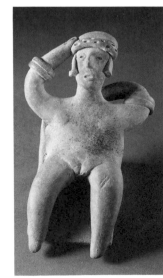

142

143a–o.

Group of Small Figures
Unslipped buff, some with black
or white painted slip decoration

a. *Standing Figure in Speaking
Posture*
5 x 4 x 3¹/₂ in.
(12.7 x 10.2 x 8.9 cm)

b. *Dog*
1³/₄ x 1³/₄ x 1³/₄ in.
(4.4 x 4.4 x 4.4 cm)

c. *Phallic Dancer with Arm behind
Head*
4 x 3 x 3 in.
(10.2 x 7.6 x 7.6 cm)

d. *Small Phallic Dancer Blowing
Conch*
3 x 1³/₄ x 1³/₄ in.
(7.6 x 4.4 x 4.4 cm)

e. *Phallic Dancer with Arms to the
Rear*
4 x 3 x 3 in.
(10.2 x 7.6 x 7.6 cm)

f. *Man with Fan Leaning against
Reclinatorio*
3¹/₂ x 2¹/₂ x 3 in.
(8.9 x 6.4 x 7.6 cm)
Compare no. 108.

g. *Small Warrior with Slingshot*
3¹/₂ x 2¹/₂ x 2¹/₂ in.
(8.9 x 6.4 x 6.4 cm)

h. *Warrior with Slingshot*
5 x 3¹/₂ x 3 in.
(12.7 x 8.9 x 7.6 cm)

i. *Figure Seated on Canopy Throne (?)*
4 x 3 x 1¹/₂ in.
(10.2 x 7.6 x 3.8 cm)

j. *Hunchback*
3 x 2 x 2 in.
(7.6 x 5.1 x 5.1 cm)

k. *Warrior with Staff or Long Club*
4¹/₂ x 4 x 2 in.
(11.4 x 10.2 x 5.1 cm)

l. *Man Leaning against Reclinatorio*
3¹/₂ x 2¹/₂ x 3 in.
(8.9 x 6.4 x 7.6 cm)
Compare no. 108.

m. *Drummer Leaning against
Reclinatorio*
4 x 3 x 4 in.
(10.2 x 7.6 x 10.2 cm)
Reclinatorio broken.

n. *Conch Player*
4 x 2¹/₂ x 2 in.
(10.2 x 6.4 x 5.1 cm)

o. *Drummer*
3 x 3¹/₂ x 3 in.
(7.6 x 8.9 x 7.6 cm)
M.86.296.147a–o
143c–e, m–o: alternate views, p. 26

These small figures (all whistles
except no. 143i) illustrate a wide
range of ritual and other cultural
activities. Such small figures are
reportedly found in the same
mortuary chambers with large,
hollow figures.

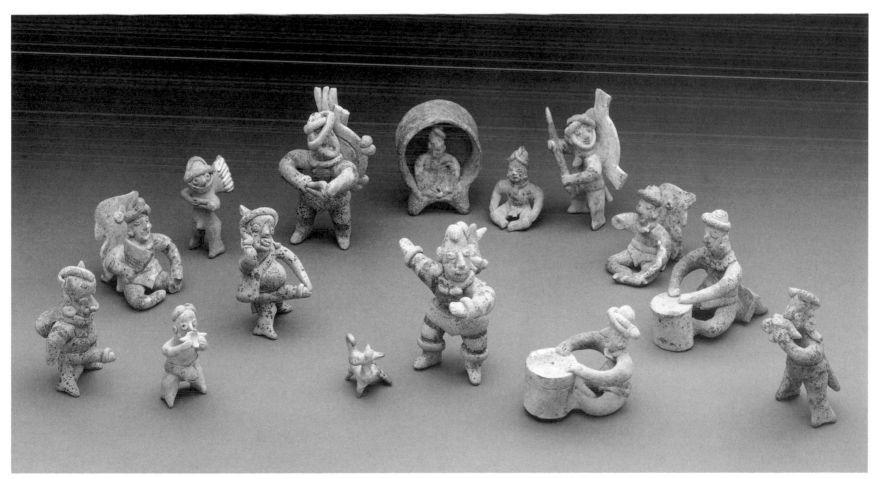

143a–o

147

144.
Mask
Brown-black slip (reduction
firing?)
9 x 7 ½ x 4 ½ in.
(22.9 x 19.1 x 11.4 cm)
M.86.296.148

Holes in ears and forehead. As the
eyes are not pierced, such Colima
masks, which are not uncommon,
were obviously not worn by ritual
performers. They may have
functioned as pectorals or have
been placed over the faces of the
dead. Compare no. 146. See Von
Winning 1974: figs. 58–60. For a
discussion of ceramic masks in
pre-Hispanic Mesoamerica, see
Borhegyi 1955.

145.
*Vessel in the Form of a Head with
Open Mouth*
Brown-black slip (reduction firing)
with incised decoration
3 ¾ x 3 ⅜ x 3 ¼ in.
(9.5 x 8.6 x 8.3 cm)
M.86.296.149

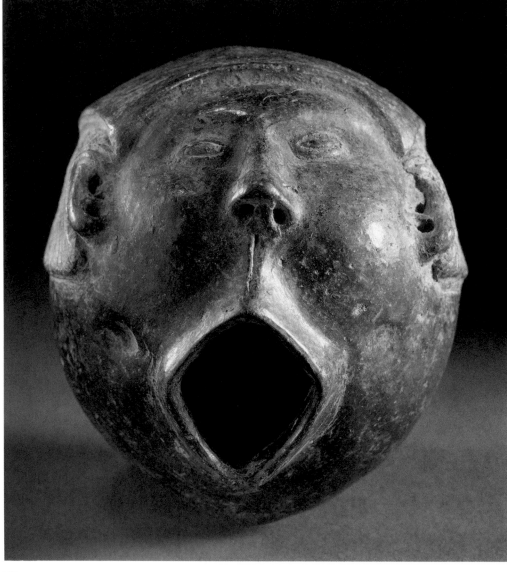

145

148

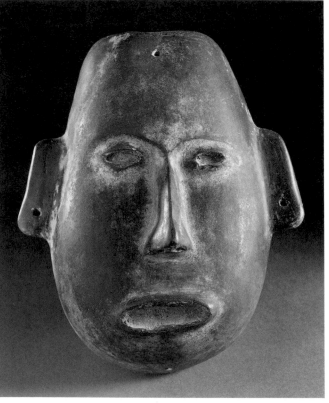

144

146.
Mask
Black slip (reduction firing?)
8 ¹⁄₄ x 8 x 3 ¹⁄₂ in.
(21 x 20.3 x 8.9 cm)
M.86.296.150

Holes in ears and forehead.
Compare no. 144.

147.
Mace
Red slip
9 ¹⁄₂ x 7 ¹⁄₄ x 3 in.
(24.1 x 18.4 x 7.6 cm)
M.86.296.151

Ceramic replica of a stone double-dog-headed mace. Small duck head projects from base of handle. For similar stone originals, see Disselhoff 1936: fig. 12a (Colima); Sawyer 1957: 19 (attributed to Jalisco).

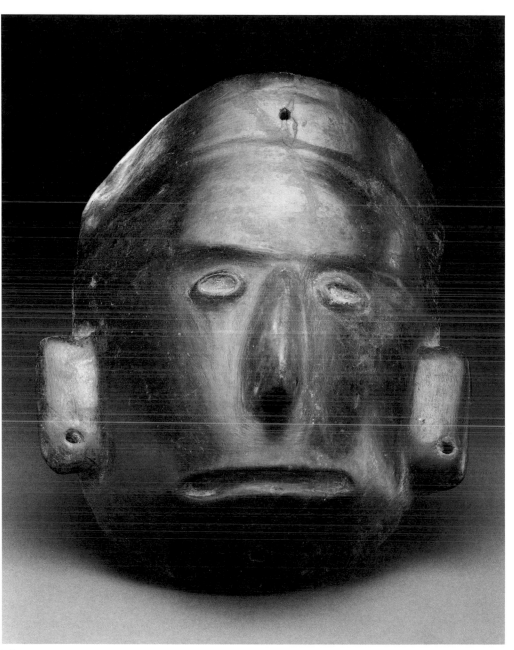

146

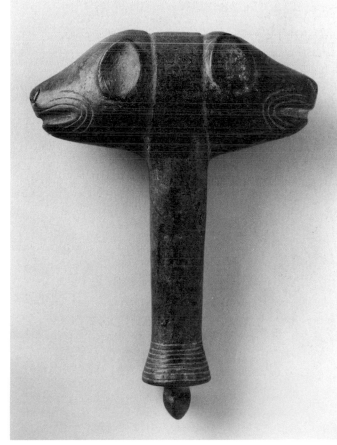

149

147

148.
Large Dog
Burnished red slip with incised
decoration
16 1/2 x 7 3/4 x 19 1/2 in.
(41.9 x 19.7 x 49.5 cm)
M.86.296.152
In color p. 64

Seated. An outstanding specimen
of the most famous and frequent
of the Colima animal figures.

149.
Dog
Burnished red slip
9 x 7 x 13 1/2 in.
(22.9 x 17.8 x 34.3 cm)
M.86.296.153

Recumbent, mouth open. The
plump body and posture suggest
this might represent a puppy.

150.
Dog Wearing Human Face Mask
Burnished red and orange slip
8 1/2 x 15 1/2 x 7 in.
(21.6 x 39.4 x 17.8 cm)
M.86.296.154
In color p. 40

Vessel with human face mask and
tail spout. Other examples are
known. The well-known specimen
in the Museo Nacional de
Antropología, Mexico, for
instance, was one of the first
Colima tomb pieces to be
published (Batres 1888: pl. 23, 5).

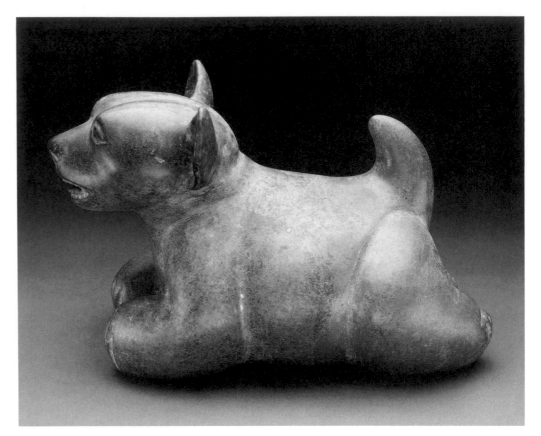

149

150

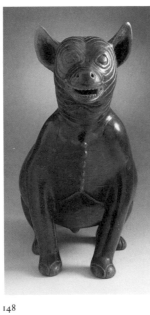

148

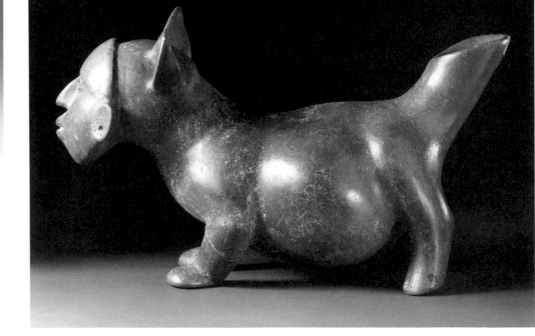

150

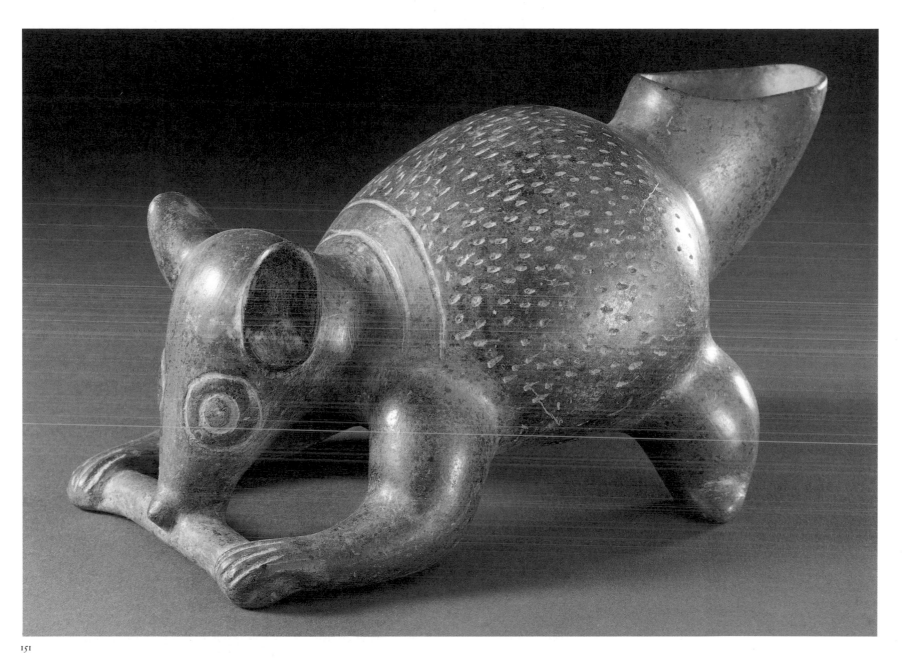

151

151.
Coati
Burnished red and orange slip with
black painted slip and incised
decoration
4 ½ x 8 ¼ x 5 in.
(11.4 x 21 x 12.7 cm)
M.86.296.155

Vessel with tail spout (see Sawyer
1957: 10–11). Nibbling on stick
(maize?).

152.
Vessel in the Form of a Curled Dog
Burnished red-brown slip
6³/₄ x 8 x 10 in.
(17.1 x 20.3 x 25.4 cm)
M.86.296.156

153.
Dog with Turtle Shell
Burnished red and orange slip
8 x 6 x 13 in.
(20.3 x 15.2 x 33 cm)
M.86.296.157

Vessel. Spout projects from rear of shell. Other examples of these composite animals are known (Eisleb 1971: fig. 30; Von Winning 1974: fig. 94).

154.
Sleeping Dog, Colima (?)
Cream slip with black painted slip decoration
6¹/₂ x 8¹/₂ x 13 in.
(16.5 x 21.6 x 33 cm)
M.86.296.158

Vessel. Spout issues from left ear. Probably Postclassic period (Toltec horizon).

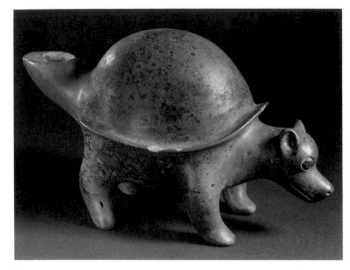

153

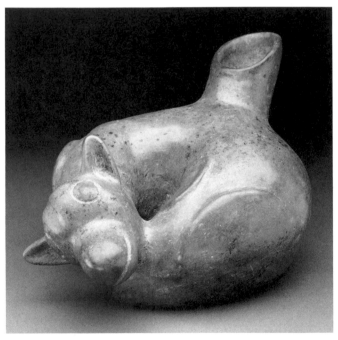

152

152

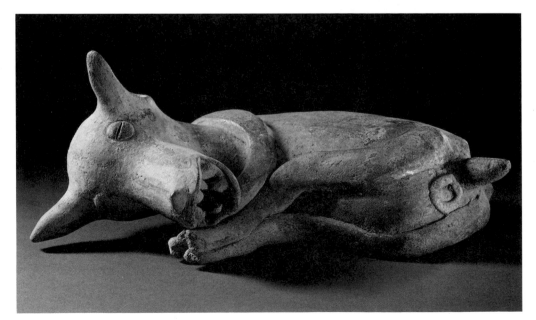

154

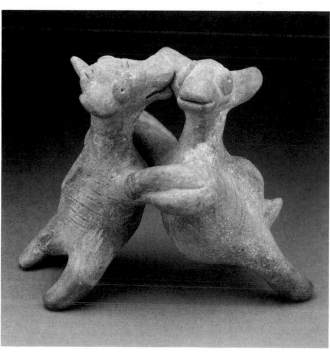

155

155.
Playing Dogs
Unslipped buff with incised
decoration
3 ½ x 4 ½ x 2 ¾ in.
(8.9 x 11.4 x 7 cm)
M.86.296.207

Joined at the forelegs. One dog
bites the ear of the other.

156.
Reptile Whistle, Colima (?)
Burnished red and cream slip with
red painted slip decoration
¾ x 2 x 1 in.
(1.9 x 5.1 x 2.5 cm)
M.86.296.159

157.
Monkey (?) Vessel, Colima (?)
Burnished red-orange slip with
black resist decoration
6 ½ x 4 x 3 ½ in.
(16.5 x 10.2 x 8.9 cm)
M.86.296.160

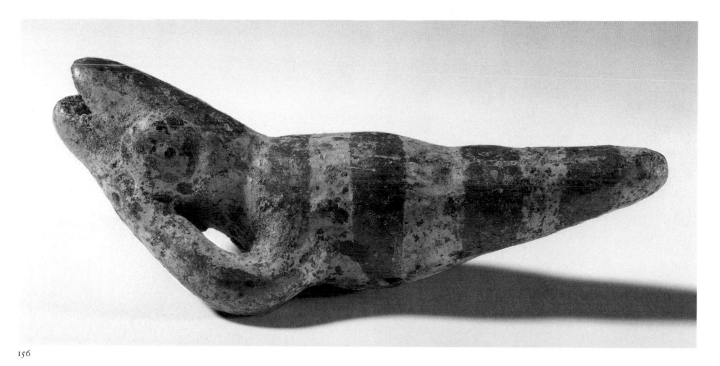

156

153

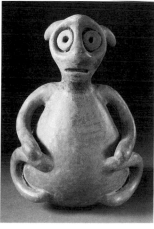

157

158a-b.
Gophers
Burnished brown-orange slip with
red painted slip decoration (b)
a. 4 x 9 ½ x 4 ½ in.
(10.2 x 24.1 x 11.4 cm)
b. 3 ½ x 6 x 4 in.
(8.9 x 15.2 x 10.2 cm)
M.86.296.161a-b

Vessels. Openings at tail (a) and
stomach (b).

159.
Turtle Vessel
Burnished red-brown slip with
incised decoration, much white
rootlet calcification
5 x 11 ½ x 9 in.
(12.7 x 29.2 x 22.9 cm)
M.86.296.162

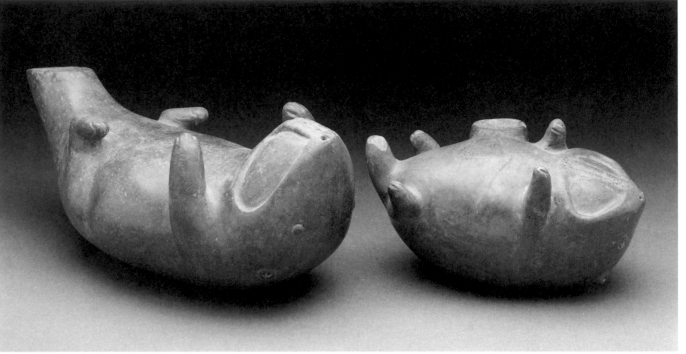

158 a-b

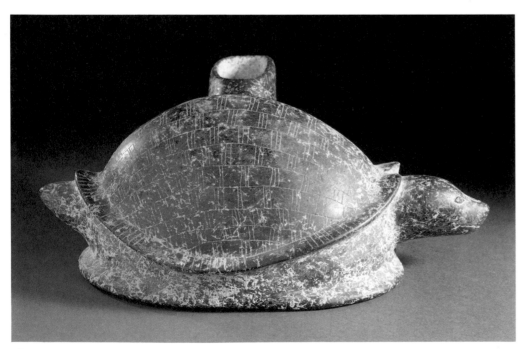

159

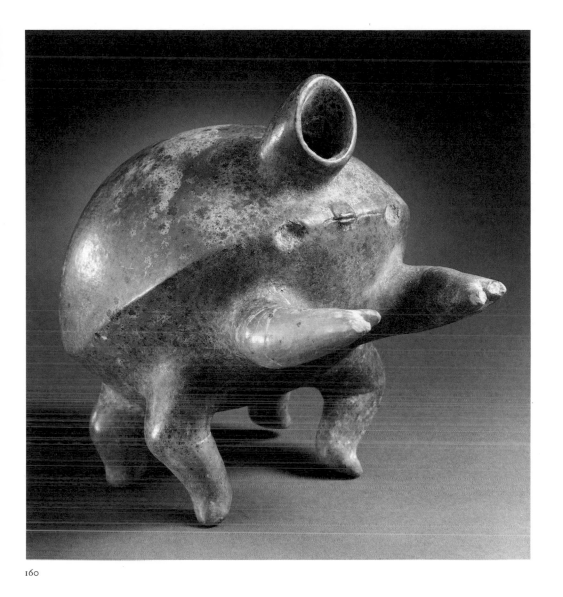

160

160.
Crab Vessel
Burnished red slip
8 x 5 1/2 x 7 in.
(20.3 x 14 x 17.8 cm)
M.86.296.163

161.
Horned Toad
Burnished brown-black slip
7 1/4 x 9 x 15 1/2 in.
(18.4 x 22.9 x 39.4 cm)
M.86.296.164

155

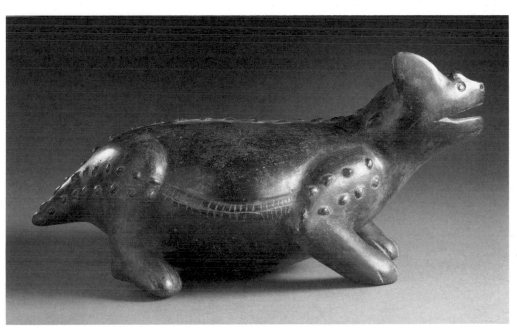

161

162.
Vessel with Four Fish
Burnished red slip with firing
clouds
13 x 8 ½ (diam.) in.
(33 x 21.6 cm)
M.86.296.165
In color p. 39

163.
Vessel in the Form of Joined Frogs
Burnished black slip with incised
decoration
6 x 3 ¾ x 5 ½ in.
(15.2 x 9.5 x 14 cm)
M.86.296.166

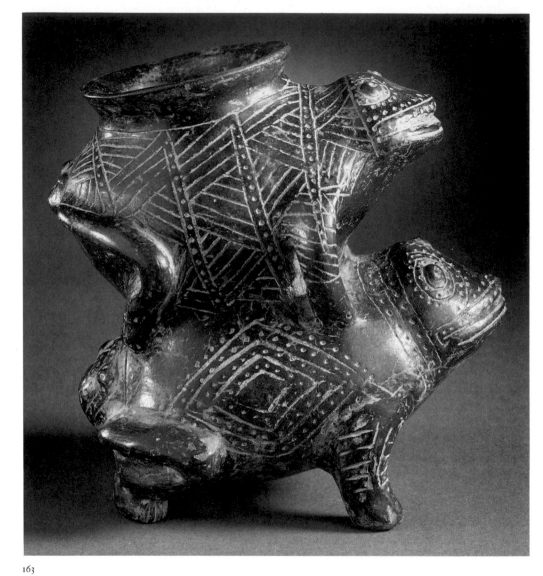

163

156

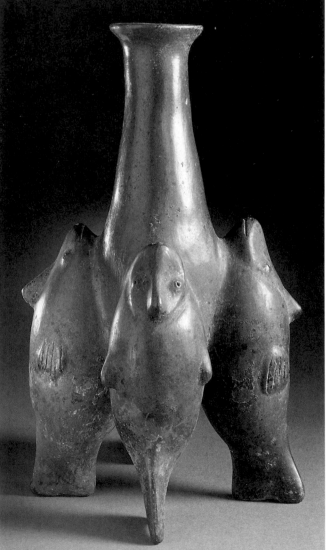

162

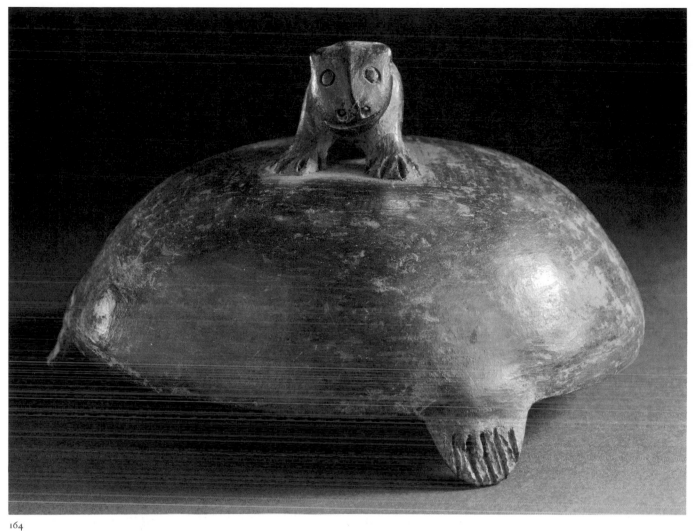

164

164.
Mouse, Colima (?)
Burnished gray-black slip
3³/₄ x 6¹/₂ (diam.) in.
(9.5 x 16.5 cm)
M.86.296.167

Seated atop three-footed *tapadera*.
Postclassic period (?).

165.
Frog Vessel, Colima (?)
Burnished buff-orange slip with
black painted slip decoration
3¹/₄ x 5 x 4 in.
(8.3 x 12.7 x 10.2 cm)
M.86.296.168

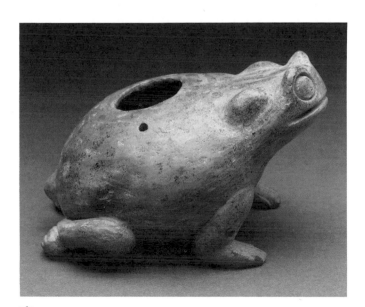

165

166.
Iguana Vessel
Burnished red slip
11 x 10 (diam.) in.
(27.9 x 25.4 cm)
M.86.296.169

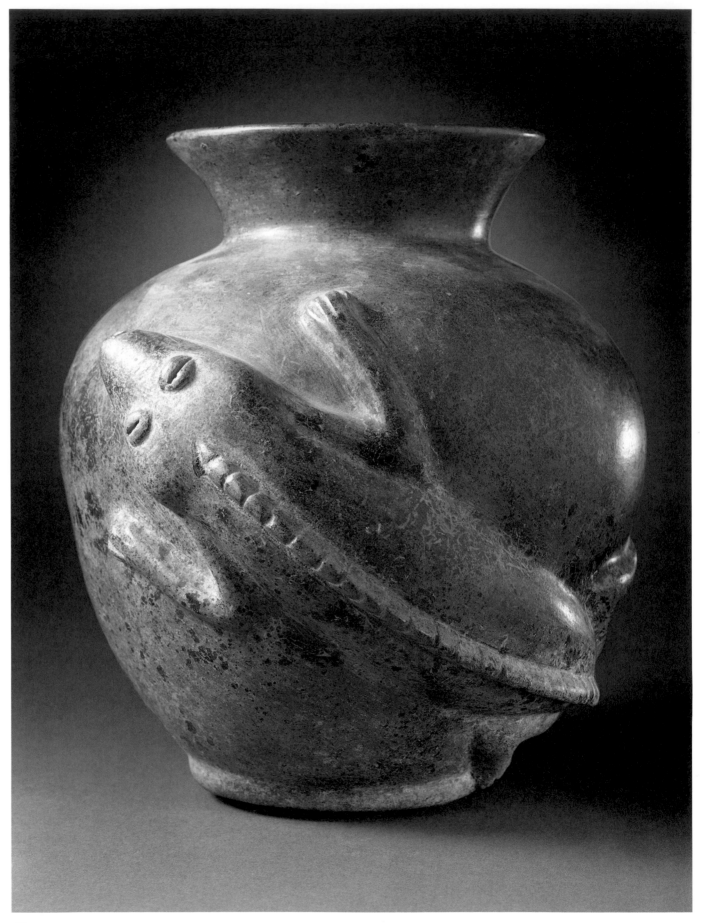

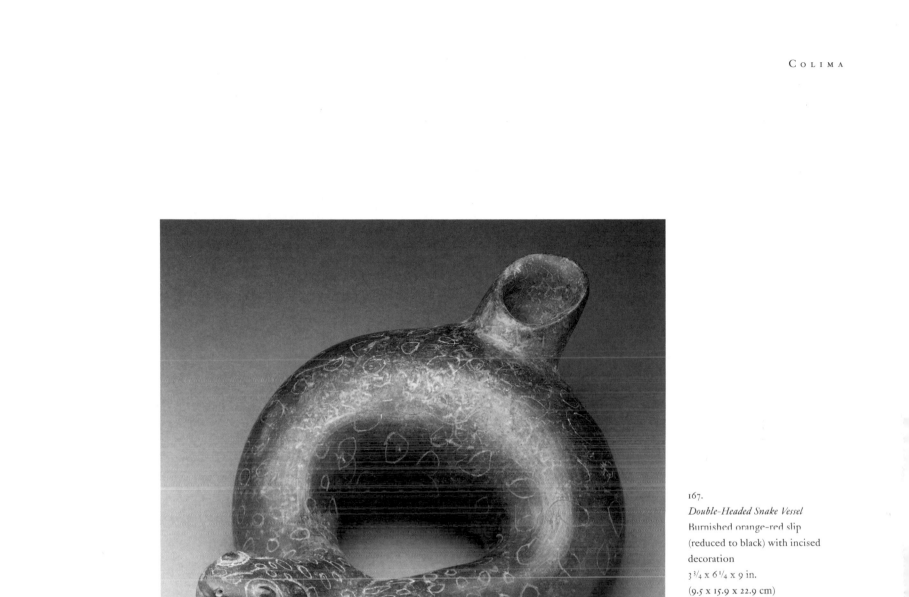

167.
Double-Headed Snake Vessel
Burnished orange-red slip
(reduced to black) with incised
decoration
3³/₄ x 6¹/₄ x 9 in.
(9.5 x 15.9 x 22.9 cm)
M.86.296.170

167

159

168.

Water Bird Vessel
Burnished orange-red and buff slip
13 ½ x 6 x 5 ½ in.
(34.3 x 15.2 x 14 cm)
M.86.296.171
Alternate view p. 43

169.

Turkey Whistle
Unslipped buff
2 ½ x 3 ½ x 2 ½ in.
(6.4 x 8.9 x 6.4 cm)
M.86.296.172

Tail feathers spread. See
Disselhoff 1932: fig. 10; Van
Giffin-Duyvis 1959: fig. 4.

170.

Vessel in the Form of a Duck (?)
Head
Burnished red-brown slip with
black painted slip and incised
decoration
4 ½ x 3 ½ x 7 ½ in.
(11.4 x 8.9 x 19.1 cm)
M.86.296.173

Bird and animal head pots are
much rarer than human head pots.

169

168

170

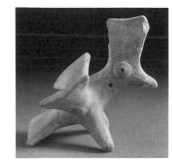

171

171.
Ocarina in the Form of a Roadrunner
Unslipped buff
4 x 4¼ x 3¼ in.
(10.2 x 10.8 x 8.3 cm)
M.86.296.174

Holes drilled in neck for use as pendant.

172.
Parrot
Burnished red and buff slip
10½ x 11 x 6½ in.
(26.7 x 27.9 x 16.5 cm)
M.86.296.175

Vessel. Spout projects from back of head. Published: Von Winning and Stendahl 1968: pl. 97.

161

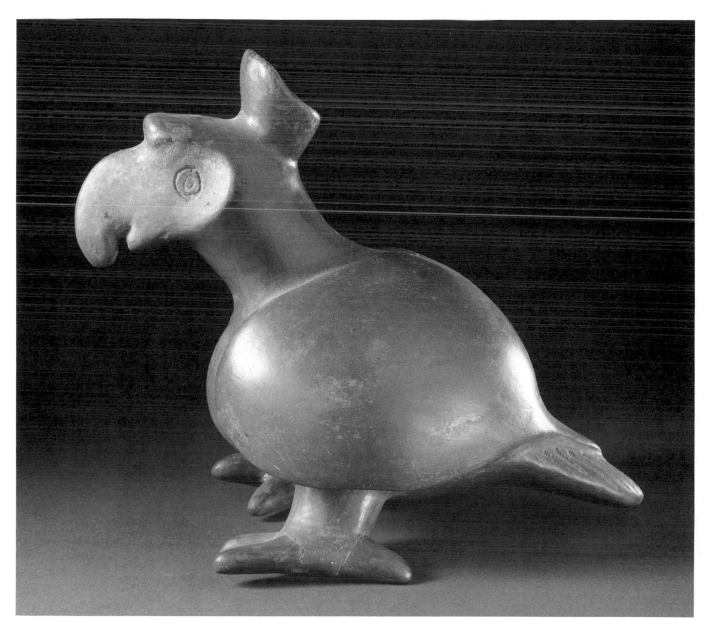

172

173.
Duck Family Vessel
Burnished red and orange-red slip
with incised decoration
8 ¼ x 10 x 9 in.
(21 x 25.4 x 22.9 cm)
M.86.296.176

174.
Owl Vessel
Burnished orange slip (reduced to
black; eroded surface) with incised
decoration on wings
10 ¼ x 8 ¼ x 9 in.
(26 x 21 x 22.9 cm)
M.86.296.177
Alternate view, p. 42

162

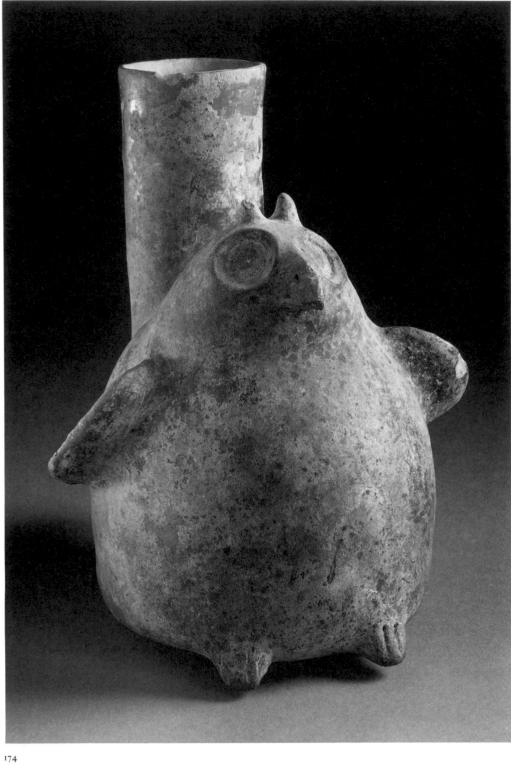

174

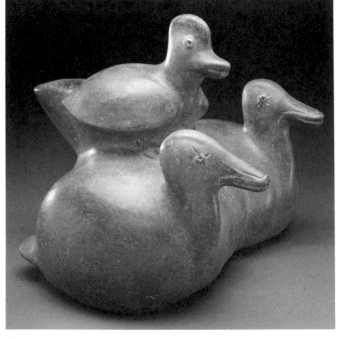

173

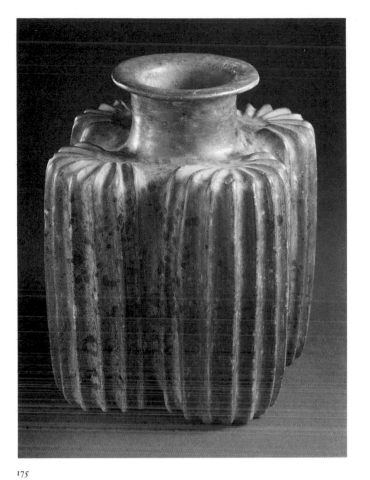

175

175.
Organ Cactus Vessel
Burnished red slip
10 x 9 1/2 (diam.) in.
(25.4 x 24.1 cm)
M.86.296.178
In color p. 31

176.
Squash (?) Vessel
Burnished red-orange slip
7 x 10 1/2 (diam.) in.
(17.8 x 26.7 cm)
M.86.296.179

177.
Phytomorphic Vessel
Burnished red slip
8 3/4 x 12 1/4 (diam.) in.
(22.2 x 31.1 cm)
M.86.296.180

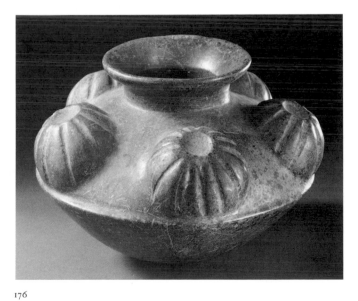

176

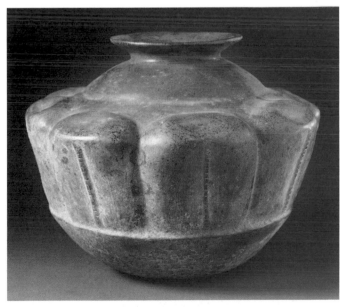

177

163

178.
Lobed Vessel
Burnished red slip with black resist
decoration
9 x 11 (diam.) in.
(22.9 x 27.9 cm)
M.86.296.181

Four lobes on body.

179.
Phytomorphic Vessel
Burnished red slip
8 ½ x 12 ½ (diam.) in.
(21.6 x 31.8 cm)
M.86.296.182

180.
Vessel
Burnished red slip
10 x 8 ½ x 4 in.
(25.4 x 21.6 x 10.2 cm)
M.86.296.183

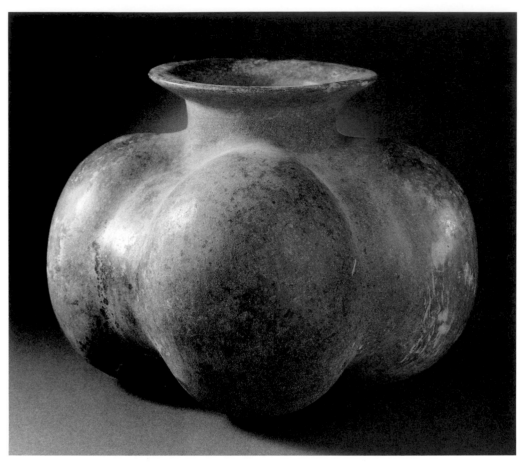

178

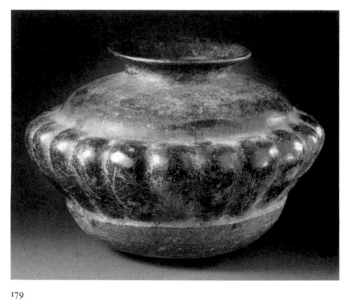

179

180

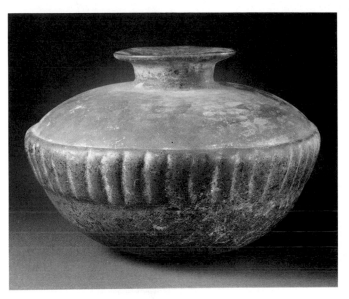

181

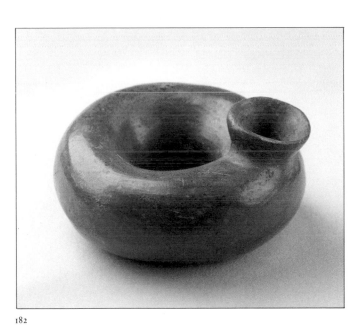

182

181.

Phytomorphic Vessel
Burnished red slip
9 x 11 ½ (diam.) in.
(22.9 x 29.2 cm)
M.86.296.184

182.

Circular Vessel
Burnished red slip
1 ¾ x 2 ½ (diam.) in.
(4.4 x 6.4 cm)
M.86.296.185

This distinctive vessel form, here
a miniature, is particularly
characteristic of the Chupícuaro
tradition centered in southern
Guanajuato-northern Michoacan
(Peterson 1955; for its pan-
Mesoamerican distribution, see
Parsons 1963). See, however, a
zoomorphic example attributed to
Zapotiltic, Jalisco (Lumholtz 1902,
vol. 2: 333).

183.

Cubical Vessel
Orange slip (eroded surface)
7 x 7 x 7 in.
(17.8 x 17.8 x 17.8 cm)
M.86.296.186

Straight sides are unusual in
Colima, although square vessels
are known at the Morett site
(Meighan 1972: pls. 22a-b).
A similar square container,
identified as a basket, is held by a
Colima figure illustrated by Von
Winning (1974: fig. 53).

183

184.
Grooved Vessel
Burnished black slip
9 x 8 (diam.) in.
(22.9 x 20.3 cm)
M.86.296.187

Stylized face on rim and
numerous parallel flutings on
upper surface of globular body.
Probably from the Periquillo area.
Postclassic period (?).

185.
Vessel
Burnished red slip
11 x 14 (diam.) in.
(27.9 x 35.6 cm)
M.86.296.188

Globular vessel supported by
tripod in the form of three human
figures. See Von Winning and
Stendahl 1968: fig. 103.

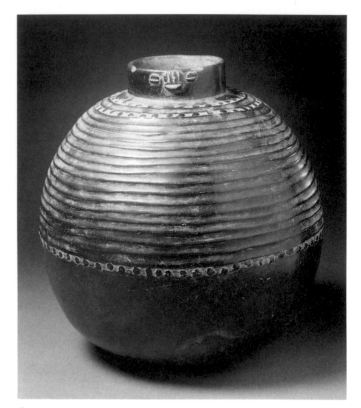

184

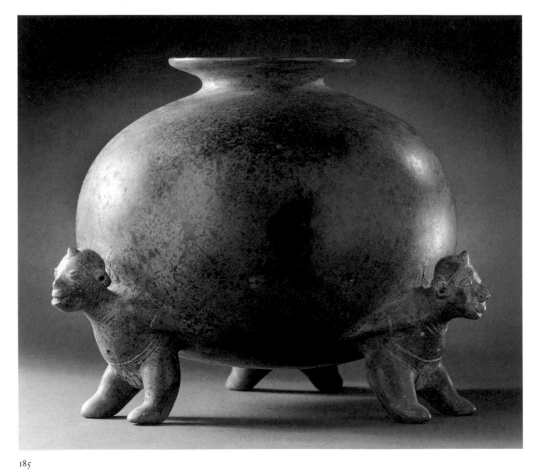

185

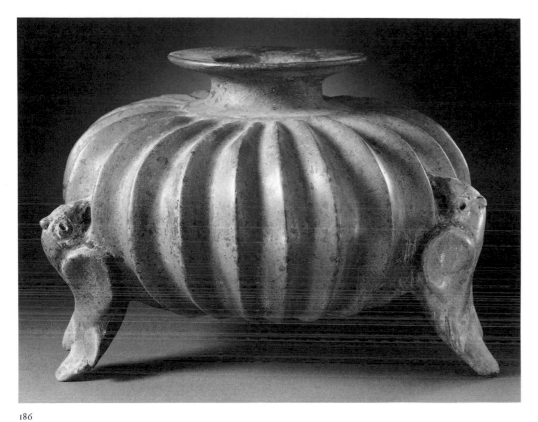

186

186.
Parrot Pot
Burnished red slip
9 ¹/₂ x 14 (diam.) in.
(24.1 x 35.6 cm)
M.86.296.189

Gadrooned, globular vessel,
supported by tripod in the form of
three parrots. Such vessels are
frequently found in Colima tombs
(Eisleb 1971: figs. 169–71).

187.
Teardrop-Shaped Vessel
Burnished red-orange slip with
firing clouds
14 x 9 ¹/₂ in.
(35.6 x 24.1 cm)
M.86.296.190

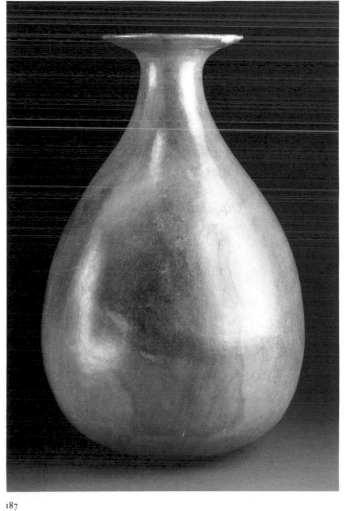

167

187

188.
Vessel
Burnished red slip (reduced
to black)
8 x 15 (diam.) in.
(20.3 x 38.1 cm)
M.86.296.191
In color p. 19

189.
Vessel with Handle
Burnished red slip with black
painted slip decoration
13 x 7 (diam.) in.
(33 x 17.8 cm)
M.86.296.192

Skeuomorphic representation of
vessel to be suspended from pole.
See Von Winning and Stendahl
1968: pl. 107.

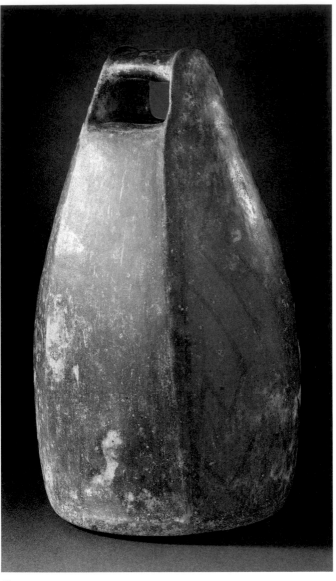

189

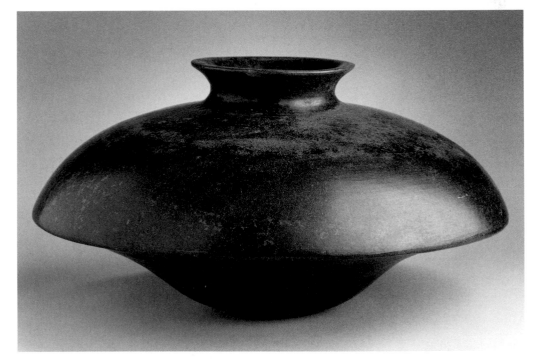

188

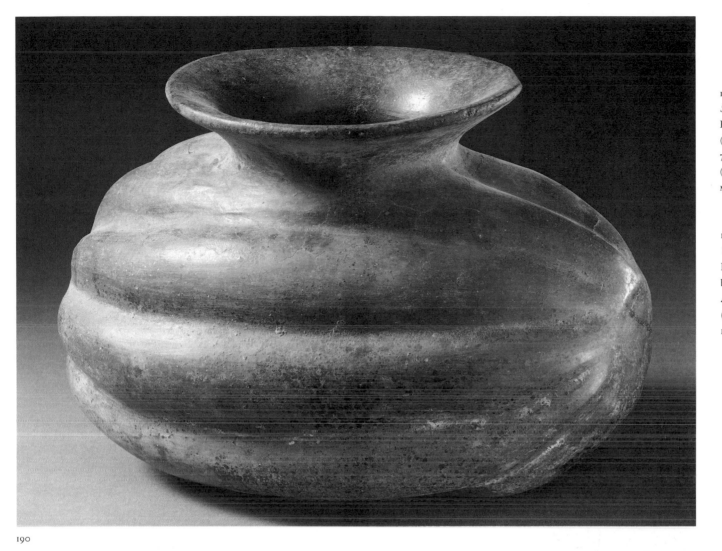

190

190.
Squash Vessel
Burnished gray-brown slip
(reduction firing)
7 x 10 x 6 in.
(17.8 x 25.4 x 15.2 cm)
M.86.296.193

191.
Vessel in the Shape of a Tied Form
Burnished orange-brown slip with
black painted slip decoration
4 x 5 ½ x 7 in.
(10.2 x 14 x 17.8 cm)
M.86.296.194

169

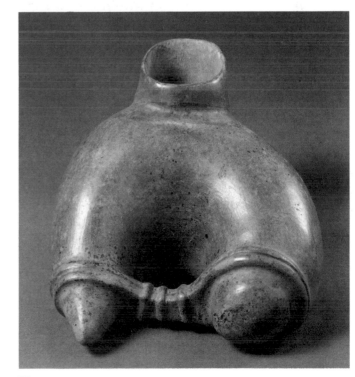

191

192.
Five-Spout Vessel, Colima (?)
Burnished brown slip
4 $\frac{1}{2}$ x 9 (diam.) in.
(11.4 x 22.9 cm)
M.86.296.195

193.
Cherimoya Vessel
Burnished red slip
5 x 7 (diam.) in.
(12.7 x 17.8 cm)
M.86.296.196

See México: Secretaría de
Educación Pública 1946: pl. 106b.

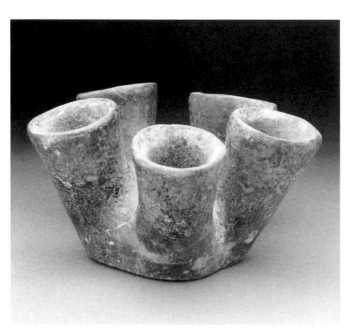

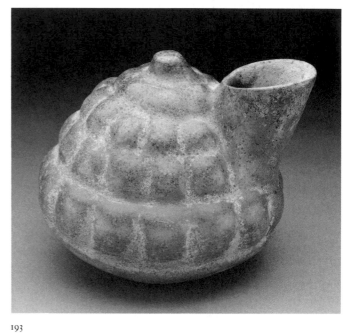

192

193

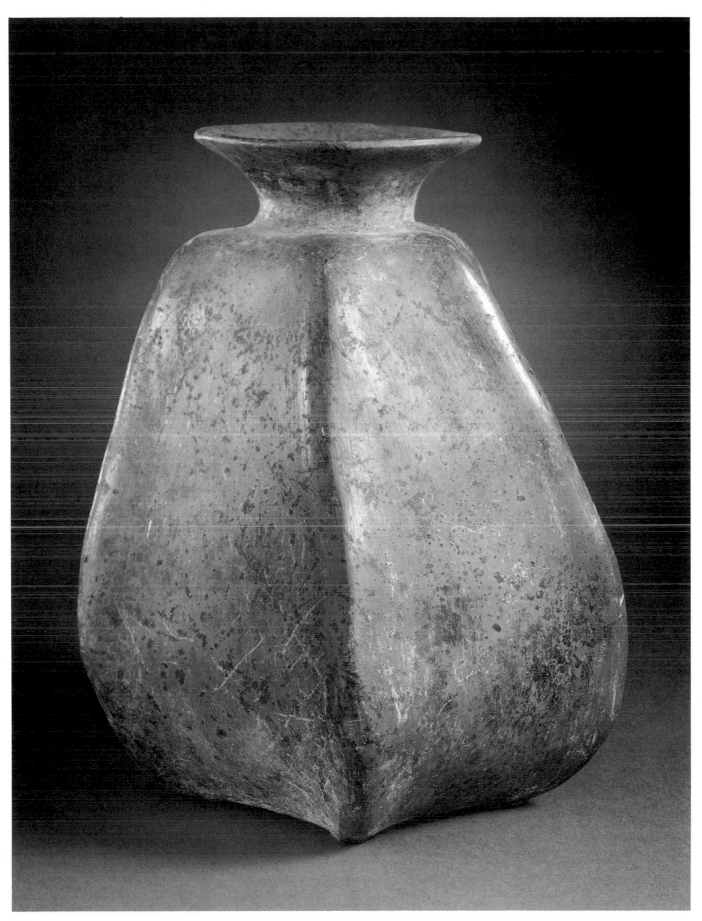

194.
Pentagonal Vessel
Burnished red slip
10 x 9 (diam.) in.
(25.4 x 22.9 cm)
M.86.296.197

171

195.
Ax Vessel
Burnished red-orange slip with
firing clouds
10 ¹/₂ x 9 ¹/₂ x 4 ¹/₂ in.
(26.7 x 24.1 x 11.4 cm)
M.86.296.198

Probably skeuomorphic
representation of monolithic stone
ax. See México: Secretaría de
Educación Pública 1946: pl. 105.

196.
Incense Burner
Orange slip with black resist
decoration and firing clouds
33 x 12 x 8 ¹/₄ in.
(83.8 x 30.5 x 21 cm)
M.86.296.199

Two grotesque figures stand back
to back. Such pieces, frequent in
collections, appear to date to
the Postclassic period and are
stylistically distinct from the
rest of the Colima tradition.
A particularly large example.

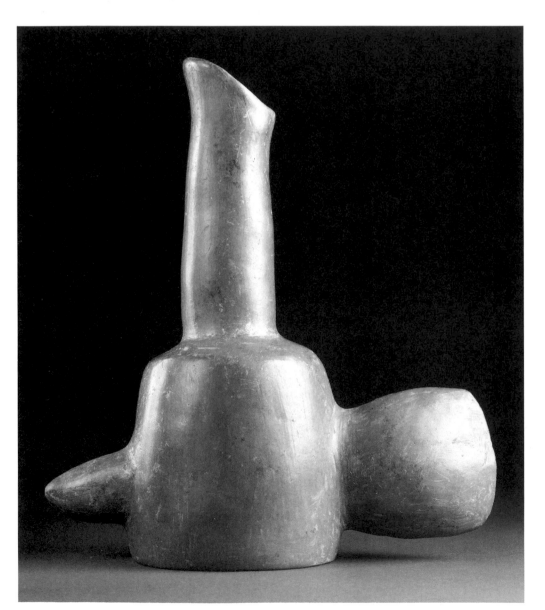

195

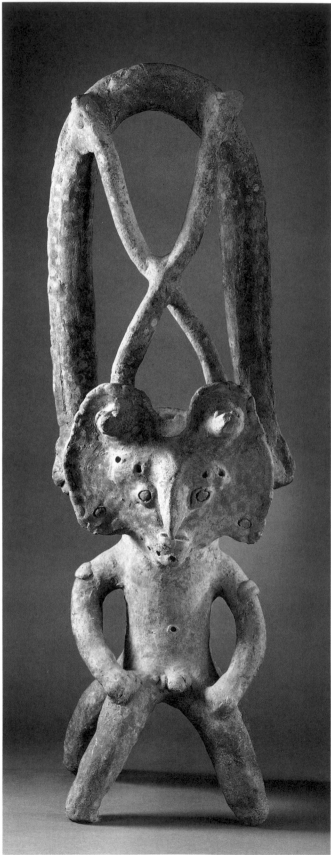

196

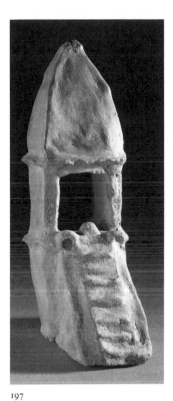

197

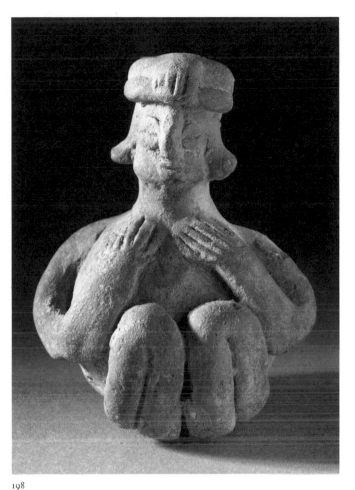

198

197.
Temple Model, Colima (?)
Buff-orange slip (roof burnished)
9 x 3 x 5 in.
(22.9 x 7.6 x 12.7 cm)
M.86.296.200

Sacrificial stone or altar in front
of doorway. Postclassic period.
Compare no. 199.

198.
*Rattle in the Form of a
Female Figure (?)*
Unslipped buff
3 x 2 (diam.) in.
(7.6 x 5.1 cm)
M.86.296.201

199a-b.
Temple Models, Colima (?)
Cream slip with red painted
slip decoration
a. 3 1/4 x 1 3/4 x 1 1/2 in.
(8.3 x 4.4 x 3.8 cm)
b. 2 x 1 1/2 x 1 1/2 in.
(5.1 x 3.8 x 3.8 cm)
M.86.296.202a-b

Sacrificial stone or altar in front of
doorways. Most features of these
models are shared with a larger
and more elaborate example from
Amapa, Nayarit (Meighan 1974;
discussed in detail in Meighan
1976). The latter is clearly late in
the Postclassic period, and these
small examples no doubt belong in
the same period. Compare no. 197.

173

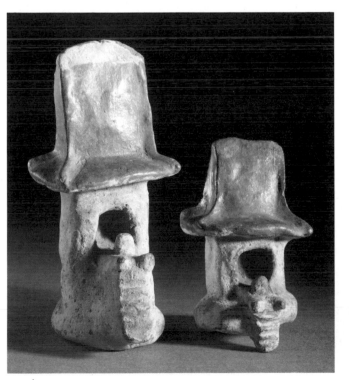

199 a-b

200.
Necklace
Shell
10 pieces, heights vary: 2–2 ½ in.
(5.1–6.4 cm)
M.86.296.203

Necklaces of this type are
probably depicted on ceramic
figures (e.g., no. 104). The age of
these specimens is unknown.
(Ribbon is not original.)

201.
Incense Burner
Unslipped buff
12 ¼ x 10 (diam.) in.
(31.1 x 25.4 cm)
M.86.296.204

Spikes (or hobnails) on surface.
Most likely Postclassic period.

174

200

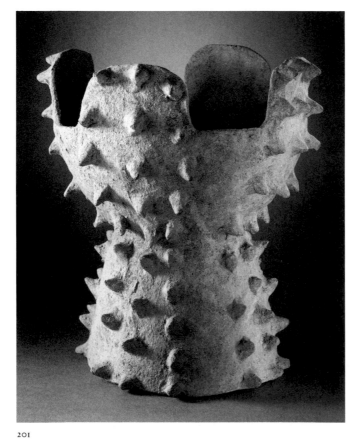

201

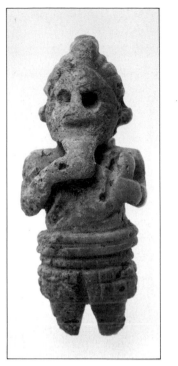

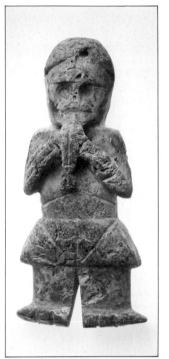

202 a-b

202a-b.
Two Musicians
Shell
a. 2 ³/₄ x 1 ¹/₄ x ¹/₂ in.
(7 x 3.2 x 1.3 cm)
b. 1 ³/₄ x ³/₄ x ¹/₂ in.
(4.4 x 1.9 x 1.3 cm)
M.86.296.205a-b

Male figures playing flutes or
panpipes. One (a) holds an
indeterminate object in the left
hand; the other (b) plays a double
flute. Examples of these flutes are
known from the Morett site,
Colima (Meighan 1972: pl. 45). A
general review of archaeological
musical instruments from West
Mexico is given by Crossley-
Holland (1980). Single and double
flutes as well as rattles are known
from Preclassic West Mexico, and
they, as well as other musical
instruments (drums, conch shell
trumpets, rattles, and rasps), are
also portrayed with the tomb
figures.

203.
Seated Male Figure
Jadeite
2 ¹/₄ x 1 ³/₄ x ¹/₂ in.
(5.7 x 4.4 x 1.3 cm)
M.86.296.206
In color p. 6

Highly polished blue-gray
pendant; hole at top of head.
These extremely rare, small stone
effigies are reported to be found
occasionally in tombs along with
ceramic pieces. See Alsberg 1968:
pls. 55–59.

175

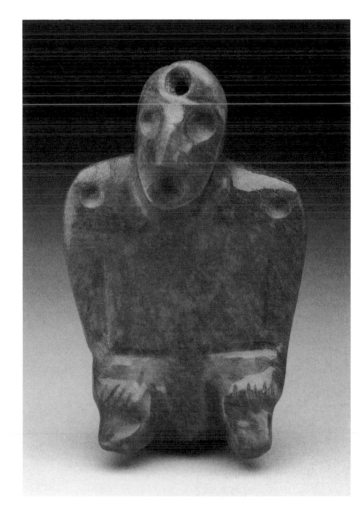

203

GLOSSARY

anthropomorphic
Formed in the shape of a human figure.

atlatl
A device used for propelling a spear.

aviform
Formed in the shape of a bird.

burnish
Surface polishing of ceramic objects, usually done with a stone.

cesium magnetometer, proton magnetometer, seismic hammer
Devices for locating underground tombs and large buried objects.

Contact
The time when Europeans first reached a given Mesoamerican area and were in a position to observe and describe the native way of life. In the case of the tomb arc of West Mexico: 1522–25.

Mesoamerica
That region of Mexico and Central America in which the higher aboriginal civilizations of North America developed; roughly from northern Mexico to El Salvador.

mortuary complex
The assemblage of features found in the death rituals of a people; specifically, the tombs, burial practices, and associated grave offerings.

obsidian hydration dating
A method of dating obsidian (volcanic glass) artifacts by measuring in microns the penetration of water; the hydration layer increases with the passage of time.

pectoral
An ornament for the breast.

phytomorphic
Formed in the shape of a plant.

Pre-Columbian, Pre-Hispanic
The time in Middle and South American history that predates the explorations of Columbus and the conquests of Cortés and other Spaniards.

provenience
The location in which an object is found.

radiocarbon dating
A technique for determining the age of organic specimens by the decay of the carbon-14 (C-14) they contain.

resist, or negative, painting
A technique of decoration in which part of the design is covered with a material that resists applied color.

skeuomorphic
Formed in the shape of a utensil or other implement.

slip
A thin coating of wet clay applied to ceramic objects before or after firing.

thermoluminescence dating
A method of dating ceramics by measuring the amount of stored energy and radioactive impurities that have accumulated since the original firing.

tumpline
A kind of sling (with strap worn over the forehead) used to suspend a load on the back.

zoomorphic
Formed in the shape of an animal.

BIBLIOGRAPHY

All sources cited in the text are included in the bibliography. Other sources particularly relevant to the archaeology and ethnohistory of the shaft-chamber tomb areas are also listed.

Alsberg, John L., and Rodolfo Petschek
1968 *Ancient Sculpture from Western Mexico: The Evolution of Artistic Form*. Berkeley: Nicole Gallery.

Anton, Ferdinand
1965 *Alt-Mexiko und seine Kunst*. Leipzig: Seeman.

Artes de México
1960 "Anahuacalli: Museo Diego Rivera." *Artes de México*, nos. 64–65.

Baer, Gerhard
1972 *Figuren und Gefässe aus Alt-Mexico*. Basel: Museum für Völkerkunde.

Basler, Adolphe, and Ernest Brummer
1928 *L'Art précolumbien*. Paris: Librairie de France.

Batres, Leopoldo
1888 *Civilización de algunas de las diferentes tribus que habitaron el territorio hoy mexicano, en la antigüedad*. Mexico: n.p.

Baus Czitrom, Carolyn
1978 *Figurillas sólidas de estilo Colima: una tipología*. Colección científica, no. 66. Mexico: Instituto Nacional de Antropología e Historia, Departamento de Investigaciones Históricas.
1982 *Tecuexes y Cocas: dos grupos de la región Jalisco en el siglo XVI*. Colección científica, no. 112. Mexico: Instituto Nacional de Antropología e Historia, Departamento de Investigaciones Históricas.
1985 "The Tecuexes: Ethnohistory and Archaeology." In *The Archaeology of West and Northwest Mesoamerica*, edited by Michael S. Foster and Phil C. Weigand, 93–115. Boulder: Westview Press.

Bell, Betty
1971 "Archaeology of Nayarit, Jalisco, and Colima." In *Archaeology of Northern Mesoamerica*, pt. 2, edited by Gordon F. Ekholm and Ignacio Bernal, 694–753. Handbook of Middle American Indians, edited by Robert Wauchope, vol. 11. Austin: University of Texas Press.

1972a "Archeological Excavations in Jalisco, Mexico." *Science* 175, no. 4027: 1238–39.
1972b *El Gran Xalisco: la historia cultural del occidente de México*. Guadalajara: Museo Local de Antropología.
1973 "Instrument Survey in the Vicinity of Etzatlan and Tala, Jalisco." Report to the Instituto Nacional de Antropología e Historia. Photocopy.
1974 "Excavations at El Cerro Encantado, Jalisco." In *The Archaeology of West Mexico*, edited by Betty Bell, 147–67. Ajijic, Jalisco: West Mexican Society for Advanced Study.

Bell, Betty, Bruce Bevan, and Elizabeth Ralph
1971 "Scientific Search for Shaft Tombs: Magdalena Basin, Jalisco." Report prepared by the University Museum, Philadelphia.

Berger, Rainer, and Willard Libby
1966 "UCLA Radiocarbon Dates v." *Radiocarbon* 8: 467–97.

Bernal, Ignacio
1948–49 "Exploraciones en Coixtlahuaca, Oaxaca." *Revista mexicana de estudios antropológicos* 10: 5–76.
1949 "El volador en Nayarit." *Tlalocan* 3, no. 1: 92–93.
1967 *Museo Nacional de Antropología, Salas de Arqueología*. Mexico: Aguilar.

Borhegyi, Stephan F.
1955 "Pottery Mask Tradition in Mesoamerica." *Southwest Journal of Anthropology* 11: 205–13.
1964 "Frozen in Clay." *Lore* 14, no. 3: 80–87.

Brand, Donald D.
1971 "Ethnohistoric Synthesis of Western Mexico." In *Archaeology of Northern Mesoamerica*, pt. 2, 632–56. See Bell 1971.

Bray, Warwick
1970 *Ancient Mesoamerica: Pre-columbian Mexican and Maya Art*. Birmingham, England: Birmingham Museum and Art Gallery.

Breton, Adela C.
1903 "Some Mexican Portrait Clay Figures." *Man* 3: 130–33.

Brown, Betty A.
1986 "The Past Idealized: Diego Rivera's Use of Pre-Columbian Imagery." In *Diego Rivera: A Retrospective*, 139–55. Detroit and New York: Detroit Institute of Arts/W. W. Norton.

Bushnell, G. H. S.
1965 *Ancient Arts of the Americas*. London: Thames and Hudson.

Castro Leal, Marcia Lorenzo Ochoa
1975 "El Ixtepéte como un ejemplo de desarrollo cultural en el occidente de México." *Época: Anales del Instituto Nacional de Antropología e Historia* 7, no. 5: 121–54.

Clune, Francis Joseph
1963 "A Functional and Historical Analysis of the Ballgame of Mesoamerica." Ph.D. diss.,University of California, Los Angeles.

Collier, Donald
1959 "Ancient Art of Western Mexico." *Chicago Natural History Museum Bulletin* 30, no. 2: 4–5.

Corona Núñez, José
1954 "Diferentes tipos de túmulos prehispánicos en Nayarit." *Yan* 3: 46–50.
1955 *Tumba de El Arenal, Etzatlán, Jalisco.* Informes 3. Mexico: Instituto Nacional de Antropología e Historia, Dirección de Monumentos Prehispánicos.
1960 *Arqueología: occidente de México.* Mexico: n.p.
1972 "Los Teotihuacanos en el occidente de México." In *Teotihuacan: XI mesa redonda,* 253–56. Mexico: Sociedad Mexicana de Antropología.

Cossío, José L.
1939 "Idolos de Colima." *Boletín de la Sociedad Michoacana de Geografía y Estadística* 51: 119–205.

Covarrubias, Miguel
1957 *Indian Art of Mexico and Central America.* New York: Alfred A. Knopf.

Crane, H. R., and James B. Griffen
1972 "University of Michigan Radiocarbon Dates XIV." *Radiocarbon* 14, no. 1: 155–94.

Crossley-Holland, Peter
1980 *Musical Artifacts of Pre-Hispanic West Mexico.* Monograph Series in Ethnomusicology, no. 1. Los Angeles: Department of Music, University of California.

de la Fuente, Beatriz
1974 *Arte prehispánico funerario, el occidente de México.* Colección de arte, no. 27. Mexico: Universidad Nacional Autónoma de México, Dirección General de Publicaciones.
1982 "Escultura en el occidente: periodos preclásico a clásico." In *Historia del arte mexicano,* vol. 3, edited by Jorge Alberto Manrique, 201–18. Mexico: Salvat.

Delgado, Diego
1969 "Arquitectura funeraria precolombina en el estado de Jalisco." Master's thesis, University of California, Los Angeles.

Díaz, Clara
1987 *El occidente de México: Museo Nacional de Antropología.* Mexico: García Valadés Editores.

Disselhoff, H. D.
1932 "Note sur le résultat de quelques fouilles archéologiques faites à Colima (Mexique)." *Revista del Instituto de Etnología de la Universidad Nacional de Tucumán* 2: 525–38.
1936 "Trachtstücke und Geräte der Bewohner des alten Colima." *Baessler-Archiv* 19: 16–21.
1960 "Notizen zur Archäologie Westmexikos." *Ethnologica* 2: 542–47.

Dockstader, Frederick J.
1964 *Indian Art in Middle America.* Greenwich, Connecticut: New York Graphic Society.

Dwyer, Jane P., and Edward B. Dwyer
1975 *Fire, Earth and Water: Sculpture from the Land Collection of Mesoamerican Art.* San Francisco: Fine Arts Museums of San Francisco.

Easby, Elizabeth Kennedy, and John F. Scott
1970 *Before Cortés: Sculpture of Middle America.* New York: Metropolitan Museum of Art

Eco
1960 "Fichas del catálogo del Museo de Arqueología del Occidente de México." *Eco* 4: [?].
1961 "Piezas arqueológicas de San Juanito, Municipio de Antonio Escobedo, Jal." *Eco* 6: [?].
1962 "Fichas del catálogo del Museo de Arqueología del Occidente de México." *Eco* 9: [?].
1966 "Museo de Arqueología del Occidente de México: la pieza del mes." *Eco* 25: [8–9].

Eisleb, Dieter
1971 *Westmexikanische Keramik.* Berlin: Museum für Völkerkunde.

Ekholm, Gordon F.
1956 "Art in Archaeology." *Aspects of Primitive Art.* New York: Museum of Primitive Art.
1962 "U-Shaped 'Ornaments' Identified as Finger-Loops from Atlatls." *American Antiquity* 28, no. 2: 181–85.
1970 *Ancient Mexico and Central America.* New York: American Museum of Natural History.

Ericson, J. E., and J. Kimberlin
1977 "Obsidian Sources, Chemical Characterization and Hydration Rates in West Mexico." *Archaeometry* 19, pt. 2: 157–66.

Feuchtwanger, Franz, and Irmgard Groth-Kimball
1954 *The Art of Ancient Mexico.* New York: Thames and Hudson.

Fish, Louise
1974 "Figurines with Up-Tilted Noses from Colima, Mexico." In *The Archaeology of West Mexico,* 212–14. *See* Bell 1974.

Fondo de la Plástica Mexicana
1964 *Flor y canto del arte prehispánico de México.* Mexico.

Furst, Jill Leslie, and Peter T. Furst
1979 *Pre-Columbian Art of Mexico.* New York: Abbeville Press.

Furst, Peter T.
1965a "Datación de una tumba de tiro de Etzatlán, Jalisco." *Eco* 22: [9–11].
1965b "Radiocarbon Dates from a Tomb in Mexico." *Science* 147, no. 3658: 612–13.
1965c "West Mexican Tomb Sculpture as Evidence for Shamanism in Prehispanic Mesoamerica." *Antropológica* 15: 29–80.
1965d "West Mexico, the Caribbean and Northern South America: Some Problems in New World Interrelationships." *Antropológica* 14: 1–37.
1966 "Shaft Tombs, Shell Trumpets and Shamanism: A Culture-Historical Approach to Problems in West Mexican Archaeology." Ph.D. diss., University of California, Los Angeles.
1967 "Tumbas de tiro y cámara: un posible eslabón entre México occidental y los Andes." *Eco* 26: [2–6].
1973 "West Mexican Art: Secular or Sacred?" In *The Iconography of Middle American Sculpture,* 98–133. New York: Metropolitan Museum of Art.
1974a "Ethnographic Analogy in the Interpretation of West Mexican Art." In *The Archaeology of West Mexico,* 132–46. *See* Bell 1974.
1974b "Kunst und Architektur von West-Mexiko." In *Das Alte Amerika,* 193–201, pls. 122–37, edited by Gordon Willey. Propyläen-Kunstgeschichte, vol. 18. Berlin: Propyläen Verlag.
1975 "House of Darkness and House of Light: Sacred Functions of West Mexican Funerary Art." In *Death and the Afterlife in Pre-Columbian America,* edited by Elizabeth P. Benson, 33–68. Washington, D.C.: Dumbarton Oaks.
1978 *The Ninth Level: Funerary Art from Ancient Mesoamerica.* Iowa City: University of Iowa Museum of Art.
1985 "Art for the Ancestors: Archaeology and Symbolism of West Mexican Shaft Tombs and Mortuary Sculpture." In *America before Columbus,* edited by Nancy L. Kalker, 15–46. San Antonio: San Antonio Museum Association.

Galindo, Miguel
1922 "Bosquejo de la geografía arqueológica del estado de Colima." *Anales del Museo Nacional de México* 4, no. 1: 165–78.
1923–24 *Apuntes para la historia de Colima.* 2 vols. Colima: n.p.
1925 *Geografía arqueológica del estado de Colima.* Colima: n.p.

Gallagher, Jacki
1983 *Companions of the Dead: Ceramic Tomb Sculpture from Ancient West Mexico.* Los Angeles: Museum of Cultural History, University of California.

Galvan Villegas, Javier Luis
1975 "Informe preliminar de las exploraciones efectuadas en la zona arqueológica de El Ixtetepe, Jal., durante el mes de mayo de 1973." In *Balance y perspectiva de la antropología en Mesoamérica y el norte de México,* XIII mesa redonda, vol. 1, 395–410. Mexico: Sociedad Mexicana de Antropología.
1976 *Rescate arqueológico en el fraccionamiento Tabachines, Zapopan, Jalisco.* Cuadernos de los centros, 28. Mexico, Instituto Nacional de Antropología e Historia, Dirección de Centros Regionales.
1984 *Las tumbas de tiro del Valle de Atemajac, Jalisco. Proyecto: contribución la historia indígena prehispánica del Valle de Atemajac.* 2 vols. Manuscript.

Gamboa, Fernando
1963 *Masterworks of Mexican Art, from Pre-Columbian Times to the Present.* Los Angeles: Los Angeles County Museum of Art.

García Cisneros, Florencio
1970 *Maternity in Pre-Columbian Art.* New York: Cisneros Gallery.

Gifford, Edward
1950 *Surface Archaeology of Ixtlan del Río, Nayarit.* University of California Publications in American Archaeology and Ethnology 43, no. 2.

Glassow, Michael A.
1967 "The Ceramics of Huistla, a West Mexican Site in the Municipality of Etzatlán, Jalisco." *American Antiquity* 32, no. 1: 64–83.

Greengo, Robert E., and Clement W. Meighan
1976 "Additional Perspectives on the Capacha Complex of Western Mexico." *Journal of New World Archaeology* 1, no. 5: 15–23.

Harbottle, Garman
1975 "Activation Analysis Study of Ceramics from the Capacha (Colima) and Opeño (Michoacán) Phases of West Mexico." *American Antiquity* 40, no. 4: 453–58.

Hosler, Dorothy
1988 "Ancient West Mexican Metallurgy: South and Central American Origins and West Mexican Transformations." *American Anthropologist* 90, no. 4: 832–55.

Kan, Michael, Clement W. Meighan, and H. B. Nicholson
1970 *Sculpture of Ancient West Mexico: Nayarit, Jalisco, Colima.* Los Angeles: Los Angeles County Museum of Art.

Kelley, J. Charles
1974 "Speculations on the Culture History of Northwestern Mesoamerica." In *The Archaeology of West Mexico,* 19–39. *See* Bell 1974.

Kelley, J. Charles, and Howard D. Winters
1960 "A Revision of the Archaeological Sequence in Sinaloa, Mexico." *American Antiquity* 25, no. 4: 547–61.

Kelly, Isabel
1944 "West Mexico and the Hohokam." In *El norte de México y el sur de Estados Unidos,* III mesa redonda, 206–22. Mexico: Sociedad Mexicana de Antropología.
1945 *The Archaeology of the Autlan-Tuxcacuesco Area of Jalisco.* Pt. 1, *The Autlan Zone.* Ibero-Americana, no. 26. Berkeley: University of California Press.
1947a "An Archaeological Reconnaissance of the West Coast: Nayarit to Michoacan." *XXVII Congreso Internacional de Americanistas* 2. Mexico: 74–77.
1947b *Excavations at Apatzingan, Michoacan.* Viking Fund Publications in Anthropology, no. 7. New York: Viking Fund.
1948 "Ceramic Provinces of Northwestern Mexico." In *El occidente de México,* IV mesa redonda, 55–71. Mexico: Sociedad Mexicana de Antropología.
1949 *The Archaeology of the Autlan-Tuxcacuesco Area of Jalisco.* Pt. 2, *The Tuxcacuesco-Zapotitlan Zone.* Ibero-Americana, no. 27. Berkeley: University of California Press.
1970 "Vasijas de Colima con boca de estribo." *Boletín del Instituto Nacional de Antropología e Historia* 42: 26–31.
1974 "Stirrup Pots from Colima: Some Implications." In *The Archaeology of West Mexico,* 206–11. *See* Bell 1974.
1978a "Archaeological Research in Colima, Mexico." In *National Geographic Society Research Reports: 1969,* 307–11. Washington, D.C.: National Geographic Society.
1978b "Seven Colima Tombs: An Interpretation of Ceramic Content." In *Studies in Ancient Mesoamerica,* vol. 3, edited by John A. Graham, 1–26. Contributions of the University of California Archaeological Research Facility, no. 36. Berkeley: University of California.
1980 *Ceramic Sequence in Colima: Capacha, an Early Phase.* Anthropological Papers of the University of Arizona, no. 37. Tucson: University of Arizona Press.
1985 "Some Gold and Silver Artifacts from Colima." In *The Archaeology of West and Northwest Mesoamerica,* 153–79. *See* Baus Czitrom 1985.

177

Kelly, Isabel, and Beatriz B. de Torres
1966 "Una relación cerámica entre Occidente y la mesa central." *Boletín del Instituto Nacional de Antropología e Historia* 23: 26–27.

Kirchhoff, Paul
1946 "La cultura del occidente de México a través de su arte." In *Arte precolombino del occidente de México*, edited by Salvador Toscano, Paul Kirchhoff, and Daniel F. Rubín de la Borbolla, 49–69. Mexico: Secretaría de Educacíon Pública.

Krutt, Michael
1975 *Les Figurines en terre cuite du Mexique occidental.* Brussels: Université Libre de Bruxelles.

Kubler, George
1962 *The Art and Architecture of Ancient America: The Mexican, Maya, and Andean Peoples.* Baltimore: Penguin Books.
1970 "Period, Style and Meaning in Ancient American Art." *New Literary History* 1, no. 2: 127–44.
1984 *The Art and Architecture of Ancient America: The Mexican, Maya, and Andean Peoples*, 3d ed. Harmondsworth, England: Penguin Books.

Kunike, Hugo
1912 "Musikinstrumente aus dem alten Michoacan." *Baessler-Archiv* 2: 282–84.

Labbé, Armand J.
1986 *Colombia before Columbus: The People, Culture and Ceramic Art of Prehispanic Colombia.* New York: Rizzoli.

Lathrap, Donald W.
1975 *Ancient Ecuador: Culture, Clay, and Creativity, 3000–300 B.C.* Chicago: Field Museum of Natural History.

Lehmann, Henri
1951 "Le Personnage couché sur le dos: sujet commun dans l'archéologie du Mexique et de l'Equateur." *XXIX Congreso Internacional de Americanistas* 1. New York: 291–98.
1953 "On Noel Morss's 'Cradled Infant Figurines.'" *American Antiquity* 19, no. 1: 78–80.
1964 "Maisons de céramique (Nayarit, Mexique)." *Objets et mondes: la revue du Musée de l'Homme* 4, no. 2: 107–18.

Lister, Robert
1955 *The Present Status of the Archaeology of Western Mexico: A Distributional Study.* University of Colorado, Series in Anthropology, no. 5. Boulder: University of Colorado Press.

Long, Stanley Vernon
1966 "Archaeology of the Municipio of Etzatlán, Jalisco." Ph.D. diss., University of California, Los Angeles.
1967a "Formas y distribución de tumbas de pozo con cámara lateral." *Razon y fábula* 1: 1–15.
1967b "Funerary Objects from San Marcos, Jalisco, Mexico." *Journal de la Société des Américanistes* 56, no. 2: 521–27.

Long, Stanley Vernon, and R. E. Taylor
1966a "Chronology of a West Mexican Shaft-tomb." *Nature* 212, no. 5062: 651–52.
1966b "Suggested Revision for West Mexican Archeological Sequences." *Science* 154, no. 3755: 1456–59.

Long, Stanley Vernon, and Marcia V. V. Wire
1966 "Excavations at Barra de Navidad, Jalisco." *Antropológica* 18: 3–81.

Lumholtz, Carl
1902 *Unknown Mexico*, 2 vols. New York: Charles Scribner's Sons.

Lynton, Marion, and Mark Lynton
1986 *Out of the Depths: Tomb Figures from West-Mexico.* Cologne: Rautenstrauch-Joest-Museum.

Malraux, André
1952 *Le Musée imaginaire de la sculpture mondiale*, 3 vols. Galerie de la Pléiade, nos. 5–7. Paris: Gallimard.

Marks, Sheldon
1968 *The Jules Berman Kahlúa Collection of Mexican Pre-Columbian Art.* Los Angeles: n.p.

Matos Moctezuma, Eduardo, and Isabel Kelly
1974 "Una vasija que sugiere relaciones entre Teotihuacán y Colima." In *The Archaeology of West Mexico*, 202–5. See Bell 1974.

McBride, Harold W.
1969a "The Extent of the Chupícuaro Tradition." In *The Natalie Wood Collection of Pre-Columbian Ceramics from Chupícuaro, Guanajuato, México at UCLA*, edited by Jay D. Frierman, 33–49. Occasional Papers of the Museum and Laboratories of Ethnic Arts and Technology, no. 1. Los Angeles: University of California.
1969b "Teotihuacan-Style Pottery and Figurines from Colima." *Katunob* 7, no. 3: 86–91 (Spanish translation: *Anales del Instituto Nacional de Antropología e Historia* 4 [1972–73]: 37–44).

McBride, Harold W., and Diego Delgado
n.d. "Cerámica de estilo Teotihuacana en Colima." Manuscript.

Médioni, Gilbert
1952 *L'Art tarasque du Mexique occidental.* Paris: Paul Hartmann.

Médioni, Gilbert, and Marie-Thérèse Pinto
1941 *Art in Ancient Mexico.* New York: Oxford University Press.

Meighan, Clement W.
1961 "Interrelationships of New World Cultures: Investigation by the Institute for Andean Research." Field activities of Project A (West Mexico) 1960–61, supported by the National Science Foundation. Mimeo.
1968 "Use of Obsidian Dating in Western Mexico." *Katunob* 6, no. 4: 10–17.
1969 "Cultural Similarities between Western Mexico and Andean Regions." In *Pre-Columbian Contact within Nuclear America*, edited by J. Charles Kelley and Carroll L. Riley, 11–25. Mesoamerican Studies, no. 4. Carbondale: University Museum, Southern Illinois University.
1972 *Archaeology of the Morett Site, Colima.* University of California Publications in Anthropology, vol. 7. Berkeley: University of California Press.
1974 "Prehistory of West Mexico." *Science* 184, no. 4143: 1254–61.
1976 *The Archaeology of Amapa, Nayarit.* Monumenta Archaeologica, vol. 2. Los Angeles: Institute of Archaeology, University of California.
1978 "Application of Obsidian Dating to West Mexican Archaeological Problems." In *Across the Chichimec Sea: Papers in Honor of J. Charles Kelley*, edited by Carroll L. Riley and Basil C. Hedrick, 127–33. Carbondale: Southern Illinois University Press.

Meighan, Clement W., Frank J. Findlow, and Suzanne P. De Atley
1974 *Obsidian Dates*, vol. 1. Archaeological Survey Monograph, no. 3. Los Angeles: University of California.

Meighan, Clement W., and Leonard J. Foote
1968 *Excavations at Tizapán el Alto, Jalisco.* Latin American Studies, vol. 11. Los Angeles: Latin American Center, University of California.

Meighan, Clement W., Leonard J. Foote, and Paul V. Aiello
1968 "Obsidian Dating in West Mexican Archeology." *Science* 160, no. 3832: 1069–75.

Meighan, Clement W., and Glenn S. Russell
1981 *Obsidian Dates*, vol. 3. Archaeological Survey Monograph, no. 16. Los Angeles: University of California.

Meighan, Clement W., and Janet L. Scalise
1988 *Obsidian Dates*, vol. 4. Archaeological Survey Monograph, no. 29. Los Angeles: University of California.

Meighan, Clement W., and P. I. Vanderhoeven
1978 *Obsidian Dates*, vol. 2. Archaeological Survey Monograph, no. 6. Los Angeles: University of California.

Messmacher, Miguel
1966 *Colima.* Colección de libros de arte, no. 1. Mexico: Instituto Nacional de Antropología e Historia.

Mexico: Secretaría de Educacìon Pública
1946 See Kirchhoff 1946.

Minnaert, Paul
1934 "Les Tarasques d'après la ceramique des collections des Musées Royaux d'Art et d'Histoire." *Bulletin de la Société des Américanistes de Belgique* 15: 132–52.

Morss, Noel
1952 "Cradled Infant Figurines from Tennessee and Mexico." *American Antiquity* 18, no. 2: 164–66.

Mountjoy, Joseph B.
1969 "On the Origin of West Mexican Metallurgy." In *Pre-Columbian Contact within Nuclear America*, 26–42. See Meighan 1969.
1970a "Prehispanic Culture History and Cultural Contact on the Southern Coast of Nayarit, Mexico." Ph.D. diss., Southern Illinois University.
1970b "La sucesión cultural en San Blas." *Boletín del Instituto Nacional de Antropología e Historia* 39: 41–49.
1974 "San Blas Complex Ecology." In *The Archaeology of West Mexico*, 106–19. See Bell 1974.
1982a "Algunas ideas sobre la validez de datos relacionados con la conquista de la costa de Jalisco en 1525." *Pantoc* 3: 19–27.
1982b *Proyecto Tomatlán de salvamento arqueológico: fondo etnohistórico y arqueológico, desarollo del proyecto, estudios la superficie.* Colección científica, no. 122. Mexico: Instituto Nacional de Antropología e Historia.
1983 "Investigaciones arqueológicas en la cuenca del Río Tomatlan, Jalisco (1975–1977)." *Pantoc* 5: 21–68.
n.d. "Cálculos de la población prehispánica en la cuenca del Río Tomatlán, Jalisco." Manuscript.
n.d. "Nuevos hallazgos sobre el formativo medio en San Blas, Nayarít." Manuscript.

Mountjoy, Joseph B., R. E. Taylor, and Lawrence H. Feldman
1972 "Matanchén Complex: New Radiocarbon Dates on Early Coastal Adaptation in West Mexico." *Science* 175, no. 4027: 1242–43.

Mountjoy, Joseph B., and Luis Torres M.
1985 "The Production and Use of Prehispanic Metal Artifacts in the Central Coastal Area of Jalisco, Mexico." In *The Archaeology of West and Northwest Mesoamerica*, 133–79. See Baus Czitrom 1985.

Mountjoy, Joseph B., and Phil C. Weigand
1975 "The Prehispanic Settlement Zone at Teuchitlan, Jalisco." *XLI Congreso Internacional de Americanistas* 1. Mexico: 353–63.

Museo de Arqueología del Occidente de México
1964 *Joyas del Museo de Arqueología del Occidente de México: cerámica jalisciense.* Guadalajara: Instituto Jalisciense de Antropología e Historia.

Nicholson, H. B.
1962 "Notes and News: Middle America." *American Antiquity* 27, no. 4: 617–24.
1963 "Interrelationships of New World Cultures: A Coordinated Research Program of the Institute of Andean Research, Project A: Central Pacific Coast of Mexico (Principal Investigators: Clement Meighan and H. B. Nicholson), Preliminary Report: Third Field Season, 1961–1962." *Katunob* 4: 39–51.
n.d. "The Cultures and Languages of the Native Peoples of Trans-Tarascan Michoacan West Mexico." Manuscript.

Nicholson, H. B., and Alana Cordy-Collins
1979 *Pre-Columbian Art from the Land Collection.* San Francisco: California Academy of Sciences and L. K. Land.

Nicholson, H. B., and Clement W. Meighan
1974 "The UCLA Department of Anthropology Program in West Mexican Archaeology-Ethnohistory, 1956–1970." In *The Archaeology of West Mexico*, 6–18. See Bell 1974.

Nicholson, H. B., and Jack Smith
1962 "Interrelationships of New World Cultures, Project A: Central and South Pacific Coast, Mexico, Preliminary Report, 1960 Season." *Katunob* 3: 5–8.

Noguera, Eduardo
1942 "Exploraciones en 'El Opeño,' Michoacán." *XXVII Congreso Internacional de Americanistas* 1. Mexico: 574–86.
1955 "Apéndice: distribución de tumbas de tiro o pozo." In *Tumba de El Arenal, Etzatlán, Jalisco*, 27–29. See Corona Núñez 1955.
1965 *La cerámica arqueológica de Mesoamérica.* Instituto de Investigaciones Históricas, Publicaciones 1, no. 86. Mexico: Universidad Nacional Autónoma de México.
1970 "Descubrimiento de tumbas en El Opeño." *Boletín del Instituto de Antropología e Historia* 40: 25–26.
1971 "Nuevas exploraciones en El Opeño." *Anales de Antropología* 8: 83–100.
1975 *La cerámica arqueológica de Mesoamérica*, 2d ed. Instituto de Investigaciones Antropológicas. Mexico: Universidad Nacional Autónoma de México.

178

Ochoa Salas, Lorenzo
1976 "Un hacha 'olmeca' de Etzatlán-San Marcos, Jal." *Anales de Antropología* 13: 47–54.

Oliveros, José Arturo
1974 "Nuevas exploraciones en El Opeño, Michoacán." In *The Archaeology of West Mexico*, 182–201. See Bell 1974.

Parres Arias, José
1962 "Nuevas adquisiciones del Museo de Arqueología." *Eco* 12: [?].
1963a "Cofradía: nueva zona arqueológica de Jalisco." *Eco* 14: [?].
1963b "Nuevas piezas de cerámica adquiridas por el Instituto Jalisciense de Antropología e Historia." *Eco* 16: [?].
1965a "Dos nuevas adquisiciones para el Museo de Arqueología del Occidente de México." *Eco* 20: [8–9].
1965b "Nuevas joyas del Museo de Arqueología del Occidente de México." *Eco* 21: [6–7].
1968 "Joya prehispánica del Museo de Arqueología del Occidente de México." *Eco* 28: [7].

Parsons, Lee A.
1963 "A Doughnut-Shaped Vessel from Kaminaljuyú, with a Distributional Analysis of This Unusual Form." *American Antiquity* 28, no. 3: 386–89.

Peterson, Fredrick A.
1955 "'Doughnut-Shaped' Vessels and Bird Bowls of Chupícuaro, Mexico." *Ethnos* 20, nos. 2–3: 137–45.

Pfizer Spectrum
1965 "Grand Rounds a Thousand Years before Columbus." *Pfizer Spectrum* 13, no. 2: 26–29.

Piña Chán, Román
1959 *Guía de la Sala de las Culturas de Occidente: Museo Nacional de Antropología.* Mexico: Instituto Nacional de Antropología e Historia.

Porter, Muriel Noé
1956 *Excavations at Chupícuaro, Guanajuato, Mexico.* Transactions of the American Philosophical Society, New Series 46, pt. 5.
1969 (as Muriel Porter Weaver) "A Reappraisal of Chupícuaro." In *The Natalie Wood Collection of Pre-Columbian Ceramics from Chupícuaro, Guanajuato, Mexico at UCLA*, 5–15. See McBride 1969a.

Ramírez Flores, José
1935 "La arqueología en el sur de Jalisco." *Boletín de la Sociedad Mexicana de Geografía y Estadística, junta auxiliar Jalisciense* 4, no. 2: 41–56.
1980 *Lenguas indígenas de Jalisco.* Colección historia: documentos e investigación, 1. Guadalajara: Secretaría General, Unidad Editorial, Gobierno del estado de Jalisco.

Ramos Meza, Ernesto
1960 *Arqueopatología.* Serie científica, 1. Guadalajara: Instituto Jalisciense de Antropología e Historia.

Redfield, Robert
1953 *The Primitive World and Its Transformations.* Ithaca: Cornell University Press.

Rivet, Paul
1954 *Méxique précolombien.* Paris: Neuchâtel.

Rubín de la Borbolla, Daniel F.
1946 "Los Tarascos." In *Arte precolombino del occidente de México*, 35–48. See Kirchhoff 1946.

Sáenz, César A.
1966a "Cabecitas y figurillas de barro del Ixtepete, Jalisco." *Boletín del Instituto Nacional de Antropología e Historia* 24: 47–49.
1966b "Exploraciones en El Ixtepete, Jalisco." *Boletín del Instituto Nacional de Antropología e Historia* 23: 14–18.

Sauer, Carl
1948 *Colima of New Spain in the Sixteenth Century.* Ibero-Americana, no. 29. Berkeley: University of California Press.

Sauer, Carl, and Donald Brand
1932 *Aztatlán: Prehistoric Mexican Frontier on the Pacific Coast.* Ibero-Americana, no. 1. Berkeley: University of California Press.

Sawyer, Alan R.
1957 *Animal Sculpture in Pre-Columbian Art.* Chicago: Art Institute of Chicago.

Schöndube Baumbach, Otto
1968 *Figurillas del occidente de México.* Museo Nacional de Antropología, Colección breve, 8. Mexico: Instituto Nacional de Antropología e Historia.
1969 "Culturas del occidente de México." *Artes de México*, no. 119: 5–13.
1971 "Arqueología de occidente: el territorio cultural del occidente y arqueología de Sinaloa." Museo Nacional de Antropología, Conferencias. Mexico: Instituto Nacional de Antropología e Historia.
1972 "La religión en el occidente de México." In *Religión en Mesoamérica: XII mesa redonda*, edited by Jaime Litvak King and Noemi Castillo Tejero, 357–63. Mexico: Sociedad Mexicana de Antropología.
1974a "Deidades prehispánicas en el área de Tamazula-Tuxpán-Zapotlán en el estado de Jalisco." In *The Archaeology of West Mexico*, 168–81. See Bell 1974.
1974b "Introducción: algunas consideraciones sobre la arqueología del occidente de México." In *The Archaeology of West Mexico*, 1–5. See Bell 1974.
1975 "Consideraciones cronológico-culturales sobre una vasija de occidente." *Epoca: anales del Instituto Nacional de Antropología e Historia* 2, no. 11: 59–61.
1978 "El occidente de México hasta la época Tolteca." In *Historia de México*, 221–46. Mexico: Salvat.
1983 "Hallazgos en el Hospital de Belén, 1789–1982." *Pantoc* 5: 51–68.

Schöndube Baumbach, Otto, and L. Javier Galván V.
1978 "Salvage Archaeology at El Grillo-Tabachines, Zapopán, Jalisco, Mexico." In *Across the Chichimec Sea: Papers in Honor of J. Charles Kelley*, 144–64. See Meighan 1978.

Smith, Michael E.
1978 "A Model for the Diffusion of the Shaft Tomb Complex from South America to West Mexico." *Journal of the Steward Anthropological Society* 9, nos. 1–2: 179–204.

Solórzano, Federico
1976 "Gancho de atlatl de occidente de México." *Cuadernos de los museos.* Mexico: Instituto Nacional de Antropología, Centro Regional de Occidente, Museo Regional de Guadalajara.

Spence, Michael, Phil C. Weigand, and Dolores Soto de Arechavaleta
1980 "Obsidian Exchange in West Mexico." In *Rutas de intercambio en Mesoamérica y el norte de México, XVI mesa redonda*, 357–61. Mexico: Sociedad Mexicana de Antropología.

Stern, Jean
1973 "The Art of Ancient West Mexico." In *Pre-Hispanic Mexican Art*, [22–44]. San Diego: Fine Arts Gallery of San Diego.

Taladoire, Eric
1979 "Ball-Game Scenes and Ball-Courts in West Mexican Archaeology: A Problem in Chronology." *Indiana* 5: 33–43.

Taylor, R. E.
1970a "Chronological Problems in West Mexican Archaeology: A Study in the Application of a Dating Systems Approach in Archaeological Research." Ph.D. diss., University of California, Los Angeles.
1970b "The Shaft Tombs of Western Mexico: Problems in the Interpretation of Religious Function in Nonhistoric Archaeological Contexts." *American Antiquity* 35, no. 2: 160–69.
1974 "Archaeometric Studies in West Mexican Archaeology." In *The Archaeology of West Mexico*, 215–24. See Bell 1974.

Taylor, R. E., Rainer Berger, Clement W. Meighan, and H. B. Nicholson
1969 "West Mexican Radiocarbon Dates of Archaeologic Significance." In *The Natalie Wood Collection of Pre-Columbian Ceramics from Chupícuaro, Guanajuato, Mexico at UCLA*, 19–30. See McBride 1969a.

Toscano, Salvador
1946 "El arte y la historia del occidente en México." In *Arte precolombino del occidente de México*, 9–33. See Kirchhoff 1946.

Valliant, George C.
1930 *Excavations at Zacatenco.* Anthropological Papers of the American Museum of Natural History, 32, pt. 1. New York: American Museum of Natural History.

Van Giffen-Duyvis, Guda E.
1959 "Einige Musikinstrumente aus dem Staat Colima." *Mitteilungen aus dem Museum für Völkerkunde im Hamburg* 25: 48–52.

Von Winning, Hasso
1958 "An Unusual Incense Burner from Colima, Mexico." *The Masterkey* 32, no. 2: 40–42.
1959 "Eine Keramische Dorfgruppe aus dem alten Nayarit im westlichen Mexico." *Mitteilungen aus dem Museum für Völkerkunde im Hamburg* 25: 138–43.
1969a "Ceramic House Models and Figurine Groups from Nayarit." *XXXVIII Congreso Internacional de Americanistas* 1. Stuttgart-Munich: 129–32.
1969b "A Toad Effigy Vessel from Nayarit." *The Masterkey* 43, no. 1: 29–32.
1971 "Keramische Hausmodelle aus Nayarit, Mexiko." *Baessler Archiv* 19, no. 2: 343–77.
1974 *The Shaft Tomb Figures of West Mexico.* Southwest Museum Papers, no. 24. Los Angeles: Southwest Museum
1984 "Der westmexikanische equipal-Stuhl: Ein ethnologisch archäologischer Vergleich." *Indiana* 9: 175–87.
1986 "Portrayal of Pathological Symptoms in Pre-Columbian Mexico." *Caduceus: A Museum Quarterly for the Health Sciences* 2, no. 4: 1–74.

Von Winning, Hasso, and Olga Hammer
1972 *Anecdotal Sculpture of Ancient West Mexico.* Los Angeles: Ethnic Arts Council, Natural History Museum of Los Angeles County.

Von Winning, Hasso, and Alfred Stendahl
1968 *Pre-Columbian Art of Mexico and Central America.* New York: Harry N. Abrams.

Weigand, Phil C.
1974 "The Ahualulco Site and the Shaft-Tomb Complex of the Etzatlán Area." In *The Archaeology of West Mexico*, 120–31. See Bell 1974.
1976 "Circular Ceremonial Structure Complexes in the Highlands of Western Mexico." In *Archaeological Frontiers: Papers on New World High Cultures in Honor of J. Charles Kelley*, edited by R. B. Pickering, 18–227. Southern Illinois University Museum Studies, 4. Carbondale: Southern Illinois University.
1979 "The Formative-Classic and Classic-Postclassic Transitions in the Teuchitlan/Etzatlan Zone of Jalisco." In *Los procesos de cambio (en Mesoamérica y areas circunvecinas): XV mesa redonda* 1, 413–23. Mexico: Sociedad Mexicana de Antropología y Universidad de Guanajuato.
1985 "Evidence for Complex Societies during the Western Mesoamerican Classic Period." In *The Archaeology of West and Northwest Mesoamerica*, 47–91. See Baus Czitrom 1985.

Weigand, Phil C., and Michael Spence
1982 "The Obsidian Mining Complex at La Joya, Jalisco." *Mining and Mining Techniques in Ancient Mesoamerica*, edited by Phil C. Weigand and G. Gwynne, 87–134. *Anthropology* (special issue) 6, no. 1/2.

Weisman, Abner I.
1966 *The Weisman Collection of Pre-Columbian Medical Sculpture.* Public Health Service Publication, no. 1539. Washington, D.C.: National Library of Medicine.

179

180